artists-in-labs
Recomposing Art and Science

Edited by
Irène Hediger & Jill Scott

DE GRUYTER

Publication:

Editors
Irène Hediger,
Jill Scott

Zurich University of the Arts
(ZHdK), Institute for Cultural
Studies in the Arts, Zurich,
Switzerland

Produced by
artists-in-labs program

Graphic Design
Bonbon — Valeria Bonin,
Diego Bontognali mit
Deborah Meier, Zurich

Editing, Coordination
Flurin Fischer

Copy Editing
Loni Brönnimann
Alexandra Carambellas
Mary Sherman

Translations
Staci von Boeckmann
(Hauser, Witzgall, Hediger)
Adam Brasnahan (Mersch)

Printing and binding
Holzhausen Druck GmbH,
Austria

This publication is also
available as an e-book
ISBN 978-3-11-047459-6

© 2016 Walter de Gruyter
GmbH, Berlin/Boston

artistsinlabs.ch

hdk

Zurich University of the Arts
Institute for Cultural Studies in the Arts

Schweizerische Eidgenossenschaft
Confédération suisse
Confederazione Svizzera
Confederaziun svizra

Eidgenössisches Departement des Innern EDI
Bundesamt für Kultur BAK

Image on cover generously
supplied by the artists
Christina Della Giustina,
Jérémie Gindre, Yvonne
Weber

Image Credits
(inside the book):

Christina Della Giustina
p 30, 31, 34, 38,

WSL
p 40, 4a WSL,
(D. Nievergelt)
p 40, 4b WSL
(Mallaun Photography)
p 42 WSL (A. Rigling)

Marie-France Bojanowski
p 62, 64, 66, 68

Nicole Ottiger
p 89, 91, 95, 96, 98, 100, 101

Jérémie Gindre
p 132, 133, 135, 136, 138
p 138 (Sophie Jarlier)

Sandra Huber
p 157, 159, 161, 163
p 165 (Felix Imhof)

Irène Hediger
p 189, 192

Steffen A. Schmidt
p 191, 193

@Montreux Jazz
p 194

Oliver "Olsen" Wolf
p 223, 224, 226, 228, 229
p 229 (Thorsten Strohmeier)

Yvonne Weber
P 253, 255, 256, 261, 262
p 258, 265 SLF (Ralph Feiner)

Printed on acid-free paper
produced from chlorine-free
pulp. TCF ∞

Printed in Austria

ISBN 978-3-11-047308-7
www.degruyter.com

Library of Congress
Cataloging-in-Publication

A CIP catalog record for this
book has been applied for
at the Library of Congress.

Bibliographic information
published by the German
National Library

The German National
Library lists this publication
in the Deutsche National-
bibliografie; detailed biblio-
graphic data are available
on the Internet at
http://dnb.dnb.de.

DVD artists-in-labs program:

Director
Marille Hahne, ZHdK

Producer
artists-in-labs program ZHdK

Coordinators
Karin Rizzi,
Niklas Thamm

Production Assistants
Harriet Hawkins,
Natalie McRoy

Interviewers
Irène Hediger,
Jill Scott

Camera
Thomas Isler,
Christine Munz

Editor
Annette Brütsch

Translation and Subtitles
Marille Hahne,
Annette Brütsch

Online Edit And Authoring
Annette Brütsch

DVD Print
Digicon

All films are in english or
have english subtitles.

MIGROS
kulturprozent

Prof. Dr. Sigrid Schade
Head of the Institute for Cultural Studies in the Arts, ZHdK

The artists-in-labs program situated within the Institute for Cultural Studies in the Arts at the Zurich University of the Arts was founded in 2003 by Professor Dr. Jill Scott. In 2005 Irène Hediger joined as the program's co-director; and in 2014, Hediger became the director.

The artist-in-labs program continues to offer residencies to artists in scientific laboratories and to accompany, support and supervise the artists and scientists who take part in the program. It also documents its activities and outcomes to refine its future programming and to share its findings — through exhibitions, articles, books, catalogues, symposia and other events — with the general public.[1]

As a result, over the past fifteen years the program has changed its focus, procedures and funding structures several times to accommodate the needs and offerings of the laboratories, scientists and artists involved (see www.artistsinlabs.ch).

The two preceeding volumes of the series artistsinlabs: *Processes of Inquiry (2006)* and *Networking in the Margins* (2010) document and reflect upon the discussions and collaborations between the artists and scientists during their residencies. They also feature pertinent essays to contextualize this research.[2] One of the main insights that came out of these studies was that real confrontation, juxtaposition, translation, transfer and mutual acknowledgement between such diverse cultural settings, frames of research, knowledge production and places for enabling insight, need much more time than short term residencies usually provide. So, during the last years the organizers extended the length of the national residencies to 9 months. In three cases, the artists — Tiffany Holmes, Monika Codourey and Nicole Ottiger — were so inspired by these longer engagements that they entered the PhD-program Z-Node[3] (a cooperation with the University of Plymouth), thus allowing them more time to pursue their research in greater depth. In other cases, the collaborations continued beyond their timeframe or were taken up again after the residency's end.

The third volume in the series *artists-in-labs: Recomposing Art*

1 For example in the context of the Agora-project *State of the Art — Science and Art in Practice* in cooperation with the University of Geneva and others, funded by the Swiss National Science Foundation from 2013–2015 accessed 1 March 2016, www.zhdk.ch/index.php?id=ios_popuplab; in exhibition catalogues as Hediger, I (ed.) 2010, 山水 *Shanshui — Both Ways* with DVD, Zurich; Hediger, I &

Perell. J 2010, *Think Art — Act Science*, Zurich; and Hediger, I & Schaschl, S (eds) 2015, *Quantum of Disorder*, Christoph Merian Verlag, Basel.
2 Scott, J (ed.) 2006, *artistsinlabs: Processes of Inquiry*, Springer, Vienna, New York, and Scott, J (ed.) 2010, *artistsinlabs: Networking in the Margins*, Springer, Vienna, New York,
3 accessed 1 January 2016, www.z-node.net

and Science focuses on eight projects, developed in 2011 and 2012, and includes eight essays on "Art and Science" from the perspectives of philosophy, cultural theory, human geography, social science and anthropology. As the reports of the artists and scientists in this volume show, a lack of a shared language was a major issue. In almost every instance the participants questioned the translation and transfer of notions and concepts of the other discipline.

Finding ways for the disciplines to communicate then has become a major task at the beginning of and during the collaborations. This task also has proven to be at least as time consuming as following the participants' transfer of knowledge about their technical devices and processes. From the perspective of cultural analysis this comes as no surprise. In fact, cultural and discourse analysis contributed to a seminal deconstruction of the concept of the "Two Cultures and the Scientific Revolution" (C.P. Snow) in the 1960s. Historical studies and discourse analysis of the sciences have shown that the complementary construction of the "Two Cultures" was an ideology, which produced the concept of objectivity, or neutrality of knowledge, as the exclusive purview of the sciences. Even in the hard sciences, it is now widely acknowledged that research is both dependent on the specific methods, procedures, media and tools that scientists use, and that the subjective cultural setting and framing affects their results. Therefore, knowledge or "truth" is not found, it is made. Every knowledge production is situated or unconsciously framed by disciplinary, spatial, social and economic power structures, leading to the claim that knowledge is positivist. Actually, in the German language there is a difference between the terms "Wissen" (knowledge) and "Erkenntnis" (the latter is not so easy to translate but it encompasses such notions as insight, perception, cognition, understanding etc.). Enabling "Erkenntnis" is a much more fragile formulation, but it might be more appropriate, at least, for the kind of knowledge-production art is responsible for! One of the first tasks of transdisciplinary research is to identify interests and power structures within the borders of the disciplines and to be able to articulate these. We can no longer speak of just one concept of art these days, particularly when a lot of artists continue to produce self referential market-driven art, while others see themselves as critical contributors to the relevant questions of our day. Therefore, it is very important for any collaboration that the participating artists reflect on their own concept of art as a discipline with its own discursive practices. The assumption that artists

have more "freedom" compared to other disciplinary approaches has to be questioned as well. From the perspective of cultural and historical analysis, there is no doubt that art production also requires research, which in some cases might be comparable to or made with the same instruments or methodologies that one can find in academic research, whether in the humanities or hard sciences. The same might be said of artistic research. This includes the media it uses and the different involvement of the viewer or participant. By de-composing, de-positioning and questioning these disciplines and their frames, the artists-in-labs program lays the ground for the re-composing and re-positioning of projects within new fields. Here scientists and artists might be able to collaborate and cooperate beyond the hierarchies and boundaries still effective today.

I would like to thank all the artists and scientists involved in the projects described and documented, and Irène Hediger and Prof. Dr. Jill Scott who both have been very engaged in promoting and reflecting on this program and in the editing of this volume.

This book and DVD documentation is based on the idea of "re-composition". The concept of re-composing has post-production connotations of reorganization and rearrangement, but it also means to restore composure, to remain balanced and calm. Therefore, the title: *Recomposing Art and Science,* calls for a reflective and deep investigation into the processes of theory and practice in the arts and sciences.

Here, eight case studies reveal how different artists collaborate within the disciplines of biology, environmental science and neuroscience. These come from the artists-in-labs program, where novel forms of expression, interpretation and behavior were documented. The results are as varied and unique as one can expect from such different learning environments. They are also indicative of how people can learn about science in different ways than scientists do. They range from designing augmented reality interfaces (Marie-France Bojanowski), to composing sound art about the life forces of trees (Christina Della Giustina), to comparing embodied cognition to disconnection in representation (Nicole Ottiger) and the combination of health with the heartbeat (Steffen Schmidt). In some cases, the artists added interpretations to existing experiments on perception (Jérémie Gindre), or explored the physical challenges of levitation, fiction and friction (Oliver Wolf). In other cases, poetics were applied to sleep patterns (Sandra Huber) and data was visualized so differently that scientists became re-fascinated about interpretations of their own research (Yvonne Weber).

The scientific reports from each residency were just as diverse. These range from computer systems analysis (Computer Systems Institute, Native Systems Group, ETH Zurich) to research into cognitive and affective sciences (Geneva Neuroscience Center and Swiss Center for Affective Sciences, University of Geneva) biomimicry in artificial intelligence (The Artificial Intelligence Lab, Department of Informatics, University of Zurich). Other researchers write about their experiences with artists in ecology, (The Swiss Federal Institute for Forest, Snow and Landscape Research WSL, Birmensdorf), the visualization of hazardous natural materials like snow (Institute for Snow and Avalanche Research SLF, Davos), the analysis and genetics of sleep (Centre for Integrative Genomics, University of Lausanne) and the investigation of the causes

of heart diseases (Center for Cardio-Vascular Surgery, Lausanne University Hospital CHUV).

Through these texts the reader can trace how these artists have been inspired by the research inside the science labs and simultaneously, how the very physical presence and consequent inquiries by the artists have affected the scientists and their research. We value the legacy of these reflections as unique contributions to a more modern reframing of science as well as art, and of the potentials to redesign our relationships to existing systems. While some artists are more concerned about the effects of science on society, others focus on the discoveries of poetic metaphors or the ethical interpretations about the future. As social scientists like Bruno Latour suggest, science and technology are cultural resources because they are now part of the social fabric that surrounds us. He claims that "we" humans are even starting to "see" or understand that our species might constitute one big global experiment. This notion may inevitably bring the public, scientists and cultural producers to the same question: "What is democratic behavior in the Anthropocene?"[1]

Such reflections in this book belong to a book-series in which we have featured other case studies and contextual essays that open up the art and science debate and help to shed light on the potentials of collaboration from different fields of practice. Over the last 14 years of our engagement we have certainly witnessed a diversity of artistic approaches, and have come to the conclusion that it is very difficult to compare such different experiences of the artists in the labs. We found out that know-how transfer is dependent upon similar levels of reciprocity, a shared experience between the known, the unknown and the learners. Artists now claim that crossing the boundaries of the science lab can provide them with a unique frame of reference, where complex schema of beliefs and values may be re-thought and re-questioned. This "reframing" is also a re-compositional exercise because to "reframe" is to step back from what is being taught and discovered and consider the frame as a "lens" through which new realities are being created. Indeed, it is very appealing for artists, theorists and the scientists to learn the facts but challenge the assumptions of any visual frame of reference. Some potential elements of this re-composition may generate awe and wonder for audiences, by revealing aspects of science and its processes of inquiry, without demanding that the public grapple with didactic categories of

1 Latour, B 'From Critique to Composition' lecture in *Recomposing the Humanities*, September 18, 2015, Nau Hall Auditorium, University of Virginia, USA newliteraryhistory.org/events_recomposing_the_humanities.php

12

Irène Hediger and Jill Scott

the scientific method. Artists with their knowledge of visual semiotics have the freedom to be able to question the rules and regulations of science by investigating freely. They may also choose to construct unique conduits between visual culture, tacit knowledge and explicit evidence.

For the relativist and social science philosopher, Latour, artists are very well trained to establish and correlate these different frames of reference and to explore practical links between the applied research of technical universities and the basic research of the humanities. Artists like to interrogate the distribution of power and agency. They challenge our beliefs about how the world is organized. They pose very novel trans-disciplinary questions here — ones that call for a reorganization of the relationship between art and science. Perhaps this is why, in the last twenty years, it is arts and humanities researchers who have often been driving the interest to open up science to public scrutiny, which can do more than inspire scientific researchers to explore new discourses centered on creativity and education. Latour also sees technology as a paradox — because technology now encompasses and encircles the earth, even though there are still many parts of humanity that do not share this universal belief. He concludes that this shift in reality cannot be handled without a third representation — that of art or film because these mediums might capture and reorganize changes in our thinking in much more profound ways than theory or technology can[2].

Consequently, we collaborated with Marille Hahne from the Department of Performing Arts and Film at the Zurich University of the Arts, to produce documentary films based on interviews with participants of the artists-in-labs residencies. These films are complimented by essays from writers in the fields of art history, philosophy, social science and anthropology in order to look at the various aesthetic, epistemological and ontological potentials of these investigations. In addition, contributions by Irène Hediger, Jill Scott and Harriet Hawkins provide a context for most of the case studies by the artists. Both Hediger and Scott talk about the sharing of creativity in this context and claim that the facilitation of such programs are essential for the re-composing of a third culture to help people think outside the constraints of their disciplines.

Hediger's essay *Exploring the Unknown* explores the role of "Nicht-Wissen" as a liberating element in such art and science exchanges and how this state of mind often creates an unusual "space" for more explorative collaborations to develop. She examines the intersection of mutual interest and how positivist

2 Ibid. Latour 'From Critique to Composition'

differences between artists and scientists can become productive drivers to expand disciplinary boundaries. These expansions are often helped by long-term engagements, because (social) relationships with uncertain outcomes always need a long time to develop. In Scott's essay, *Creative Incubators* for a *Common Culture,* she investigates the idea of the "incubator" in the life sciences, as a metaphor for the novel growth of a set of common thematic discourses about the act of experiment building. She posits that such discussions might provide more "tacit" and "affective" potentials for the sharing and communication and solving of societal problems in the future.

The third contribution by Harriet Hawkins is a synopsis that came from an analytical study of our program from another relatively new discipline: human geography. As part of a grant entitled *Art-Science: Collaborations, Bodies and Environments,* Hawkins conducted an international, collaborative research project about art-science programs in the US, UK, Europe and Australia. Based on a number of case studies, the research team explored the institutional, political, epistemic and technological matrixes that allow these interfaces to emerge and that shape their development and wider impact.[3] She traced how participating artists adapted to different surroundings and how the scientists hosted and watched the artists' creative processes unfold. As she accurately concluded, in such exchanges knowledge is often shared in such an amazing variety of ways and different environmental contexts, that it is hard to make any real comparisons between the projects.

While the most ambitious aim of creating new knowledge at the interface of art and science would be to cause a paradigm shift that helps researchers think differently, the other essays in this book feature examples of new knowledge that has actually been generated or re-composed. They all ask if "true" collaborations are really possible and call for a paradigm shift in the way we think about subjectivity and objectivity (Kuhn 1962)[4]. These writers were asked to contextualize the processes of experiment building at the interface of art and science research and how this fusion might generate new levels of knowledge.

Today, many researchers acknowledge that there are many different kinds of "truth" — not only those truths that are found in the "objective" knowledge associated with the sciences and mathematics. As facilitators, we realized that such comparisons of "truth" can also be found in the discipline of visual anthropology.

3 http://artscience.arizona.edu
4 Kuhn, T 1962, *The Structure of Scientific Revolutions.* 1962. Universty of Chicago Press (second edition 1970; abbreviated SSR)

Irène Hediger and Jill Scott

Therefore, we asked Arnd Schneider to contribute an essay on the relationship between anthropology and art. By dealing with issues like agency and relationality, mimesis and appropriation, materiality and phenomenology, visual anthropology and material culture as well as larger disciplinary fields, he argues for a recognition of the practice-led theoretical engagement that might not only stretch the boundaries of both disciplines but contradict stereotyping. This inquiry is further explored by art historian Susanne Witzgall. She suggests casting a critical view on the generalizing and polarizing analysis and descriptions of artistic and scientific research. Instead she calls for a positivist approach — a drop of hierarchies and a very equal celebration and recognition of the differences between art and science.

The value of these differences are further highlighted by theorist, Lisa Blackman, who scrutinizes psychology experiments and social technology by exploring "proper" psychological experiments with their definitions of evidence or "truth" and phenomenological experiments with their labels of anomalies, paradoxes, puzzles and the paranormal. She claims that the later set of experiments have a much closer relationship to media, artistic and theatrical practices. By using the example of Gertrude Stein and automatic writing, she then explores "fiction-which-functions-in-truth" and "haunted data" and why both artists and scientists often like to experiment with impossible or improbable things. Blackman agrees with social scientist Isabel Stengers, who advocates "innovative propositions" and a celebration of difference as a way to help open up the sciences to creativity, intervention and surprise. (1997 Stengers)[5]

Writer and philosopher, Dieter Mersch takes an even stronger stance, arguing for a much deeper distinction between artistic and scientific research. He believes that artistic thought is unique — that it is not similar to propositional or discursive ways of thinking. Instead art will always have its very own niche and conversational structure that has graduated beyond the "linguistic turn". This he claims is a trajectory that insures art's own survival and generates a particular kind of wisdom, unlike any other. Alternatively, art historian Jens Hauser looks at the issue from the position of bio artists, who not only employ methodologies and tools from biotechnology, but also create and manipulate "lifeforms" as an artistic medium. These artists question the evidence and substance of biological forms used in the laboratory environment, as well as the

5 Stengers, I 1997, *Power and Invention: Situating Science*, University of Minnesota Press, Minneapolis

aesthetics of "life-likeness". This he calls "biomediality": an "epistemological turn" that questions how knowledge is produced (which is very different from the aestheticized images currently being produced by scientists).

Many of these authors' writings are reflective of the current debate about "art as research", a concept that is generating many critical opinions about the relationship between art and science. It seems that the type of knowledge that can be shared between art and science not only depends upon similar levels of reciprocity, but also on similar levels of respect. Additionally, some acknowledgment of the differences of each researcher's experience, training and understanding of their practice must also be taken into consideration. As the case studies in this book show, there is an enormous value in being able to actually inhabit the other's processes of inquiry.

Consequently, we wish to thank the theorists, scientists and artists who have contributed to this book and who all share our main aim: to help people think about the boundaries between science and art in a very expansive way.

Irène Hediger and Jill Scott

References

Prof. Bruno Latour *From Critique to Composition* Recomposing the Humanities with Bruno Latour September 18, 2015, Nau Hall Auditorium | University of Virginia, USA http://www.bruno-latour.fr

Ibid. Latour *From Critique to Composition*

Kuhn, T 1962, *The Structure of Scientific Revolutions.* 1962. Universty of Chicago Press (second edition 1970; abbreviated SSR)

Scott, J 2005, *Artistsinlabs: Processes of Inquiry* Springer Vienna New York

Scott, J 2008, *Artistsinlabs: Networking in the Margins.* Springer Vienna New York

Irène Hediger is the head of the artists-in-labs program at the Institute for Cultural Studies in the Arts (ICS), Zurich University of the Arts (ZHdK). She studied Business Administration and Management, holds a certificate in Group Dynamics and Organisation Development (DAGG) and has a MAS in Cultural Management from the University of Basel. She has curated numerous exhibitions, performances and accompanying programmes about issues related to contemporary art, science and technology, such as *Lucid Fields*, Singapore 2008, *Think Art—Act Science*, in Barcelona, San Francisco and Salt Lake City 2010–2011, *"experimenta13—Natur Stadt Kunst"*, Basel 2013, *Quantum of Disorder* 2015, *(in)visible transitions* 2015 and *re<connecting senses*, Connecting Space / ISEA Hong Kong 2016. She specializes on long-term inter- and transdisciplinary creative practices and on how artistic and scientific processes can move out of the lab or studio and into the public realm. Her published books include: *Shanshui—Both Ways*, ZHdK, 2011, *Think Art—Act Science* (ed. Irène Hediger, Josep Perello), Actar, Barcelona, New York, 2010 and *Quantum of Disorder* (ed. Irène Hediger, Sabine Schaschl), Christoph Merian Verlag, Basel, 2015.
She is also the deputy Equal Opportunities and Diversity representative at the Zurich University of the Arts.

Exploring the Unknown

Irène Hediger

For more than a decade now the artists-in-labs program (ail program) has been organizing and mentoring residencies for artists in scientific laboratories. The program strives to create opportunities for cultural and intellectual exchange, activate new ways of thinking, broaden modes of perception and expand existing disciplinary, institutional and sensual spaces. When I joined the program as co-director in 2006, a pilot project[1] had already provided a base for us to continue to develop and refine our expertise at enabling and creating such encounters ever since.

Like entryways, corridors, stairwells and rooftops, the ail program constitutes space for encounters with open-ended outcomes. It forms what I like to call "in between spaces", which — as a rule — have a structure and role but also can offer new opportunities for unexpected exchange and dialog. As such, these areas open up spheres of possibility and serve as a path to and from defined (disciplinary) space. They are passageways where new ideas and projects develop, and heated debates take place. They provide spaces for contemplation, listening, speaking and encountering the arena of others in order to brood, plant, experiment and create.

However unique the appearance of these in-between spaces may be, they share a central concept that will serve as the focus of this essay — the concept of "Nicht-Wissen". "Nicht-Wissen" is difficult to render in English. Literally, it means "not-knowing". What I want to express is something more like a mental stance than a concrete entity; more like a dynamic, productive relationship than a deficit to overcome; more like a potential that enables something new to emerge. Artists and scientists, alike, enter a place of "not-knowing" that is a motivation for, or better, a precondition of their experimental collaboration. In assuming this state, they do not cast aside their roles as representatives of their institutional, artistic and scientific disciplines. Much more, they create the space of possibility in the field of tension arising from the confrontation between their respective disciplinary knowledge (cf. Rammert 2003, p. 488 and Glauser 2010, p. 13). The encounter makes us aware how our work in highly specialized fields create very specific mindsets. They challenge us to overcome these mental habits, to recognize the over estimation of our knowledge, especially by those of us who seek to define and defend the disciplinary boundaries of that knowledge. As Gugerli and Sarasin write, "The bearers of knowledge know less and less what they cannot know, the more successful their work in defining their expertise" (Gugerli, Sarasin 2009, p. 8).

1 see Scott, J (ed.) 2006, *Artistsinlabs: Processes of Inquiry*, Springer, Vienna, New York.

It should be noted as a rule "that every endeavor to acquire knowledge must be understood in the first instance as an attempt to transform "not-knowing" into knowing" (Gamper 2012, p. 12). Assuming this principle is inherent to the creative activity of both the artist and the scientist, it is in the encounter between the two disciplines that the negative understanding of "not-knowing" (ibid, p.11) first becomes positive. It is then that the playing field has the potential to be leveled and a transformative, heterogeneous horizon between disciplinarily and institutionally defined canons of knowledge and the concomitant dynamics of power become possible (Proctor, Schiebinger 2008). As a result, the focus shifts to "the relationship between knowledge and its bearers," and the "discursive status of knowledge becomes negotiable" (Gamper 2012 p. 11), so that "not-knowing" essentially becomes a "prerequisite for moving epistemological processes forward" (Gamper 2012, p. 12). The unknown, then, to borrow again from Gamper, appears "as a dynamic conglomeration of objects and practices, whose irritating potential constitutes a substantial force for fluctuations in the formations of knowledge" (Gamper 2012, p. 14). It is precisely this tension between the unknown and new knowledge that we seek to create through our activities at the artists-in-labs program.

Collaborative projects between artists and scientists make a significant contribution to these developments and to new forms of knowledge production. It has been and will continue to be these in-between spaces in which the productive, mutual confrontation of knowledge and the unknown takes place and which bring about heterogeneous and hybrid forms of research, production, learning, art and science. I would like here to offer some examples of the possibilities of the unknown in the collaborative projects of the ail program. Just as it is for the artists and scientists for whom we provide time and space to explore and investigate, so, too, is it important for artists-in-labs' managing board to continually analyze its practices (and the knowledge generated by them), create new in-between spaces, and promote and explore innovative practice-based, intercultural and boundary-crossing methods of knowledge production and transfer.

When artists and scientists collaborate, people from entirely distinct, clearly demarcated professional territories with different disciplinary requirements and fields of expertise come together. The two parties are united by their mutual interest in new experiences and the willingness to accept the difficulties inherent in the confrontation with

the unknown — to see things through each other's eyes. They also share the desire for new (social) relationships with uncertain outcomes, relationships in which the parties bring their own experiences and admit the potential for expanding their knowledge base. Before the residency begins, this desire is generally expressed in stereotypical projections of each other's discipline. These stereotypes serve as a kind of point of orientation within the uncertainty of mutual "not-knowing". Martin Seel speaks, in this context, of a kind of service that "not-knowing" offers the knowers. He distinguishes, here, between "contingent" "not-knowing", (which refers to relationships of which we either incidentally or through some fault of our own have no knowledge) and "constitutive" "not-knowing" (which is connected as a whole with ideas and projections) (Seel 2009, p. 40).

"Not-knowing" in the encounter between artists and scientists is something I would consider, in this sense, constitutive "not-knowing" — something that also "represents an indispensable condition of the freedom to act" (Seel 2009, p. 47), acquire knowledge, and create "that moment of possibility to be surprised and, as such, celebrates the variability of our selves" (ibid, pp. 47–48). In this space of "not-knowing", the participants are thrown back on their own willingness to step outside of their disciplinary isolation and enter a space of uncertainty.

When artists and scientists encounter one another while in residency at the ail program, two discriminate social systems, "thought collectives" — as defined by Ludwik Fleck — (Fehr 2005, p. 26) and institutional contexts confront one another leading to a "dialectic of knowing and "not-knowing", of proximity and distance" (Schmitz 2004, p. VII) which require the conscious consideration of both parties. In the (social) process of collaboration, the most important working tools of artists and scientists are communication and reflection. Even though I consider these tools crucial for a successful collaboration, they are often neglected by both parties at the beginning of the process.

International projects introduce another, particularly challenging factor for collaboration — cultural exchange, which refers, as well, to different knowledge constructs. My point is well illustrated by the ail residency of Swiss-French artist Aline Veillat at the Institute of Mountain Hazards and Environment (IMHE) in Chengdu, China, in 2010. In addition to the everyday, fundamental challenges presented by such things as language barriers, the artist was faced with the question of the differences between the scientific priorities and working hypotheses in China

and in Switzerland. The artist opened herself up to not only a new way of working with different procedures, methods and hierarchies but also a new way of perceiving her field of interest, the environment. She came to realize that the environment in China is more commonly viewed as contrary to human interests - even as a danger.

To familiarize herself with the lab's research Veillat read the scientists' papers. She gathered French and English translations of Chinese poetry to surmount the language barrier and understand the Chinese concept of nature. These two activities were then brought together in an installation that depicted a landscape layered with ancient artifacts embedded in the sediment. The idea was that over time, the sediment would erode (with climate change and industry), leaving behind only the artifacts. In this space filled with "not-knowing", she offered the scientists a new way of perceiving nature.

In the same period, the Chinese photographer Aniu Chen (from Shenzhen) came to Switzerland through the ail program to work with the Swiss Federal Institute of Aquatic Science and Technology (Eawag) in Dübendorf. During his stay, he set aside his accustomed medium and began a survey distributing questionnaires to the scientists and then processing their answers similar to the way one develops analog film. (He took their handwritten answers and put them into wet petri dishes, letting the ink take on a new form just as film in the darkroom is transformed through chemical processes). This visual "distortion" mimicked the way direct translation software programs altered his understanding of the lab's scientific texts, making the already difficult process of communication even more challenging. However, it also became a blessing in disguise. The attempt to find a common language became a central part of the encounter on both sides and, thus, the resulting "not-knowing" (which was steady throughout the collaboration) became a motor for new inquiries and artistic production.

The international residencies lead participants to discover hidden, personal "not-yet-knowing" through the confrontation with others and develop new perspectives for their own (knowledge) culture. Their embeddedness in a professional context enables both scientists and artists' more direct access to the deeper lying concerns of a particular society. What at first glance may have been superficial and sometimes overwhelming impressions, through the "disciplinary filters" can now appear more complex, differentiated and surprisingly other. In the international residencies the local context also takes on greater importance. What is

taken for granted in one location may actually offer surprising insights to someone from another locale. International standards and conventions, thus, often crumble in the face of regional and local priorities and the meta-level of the disciplines is made more significant.

Whether in an international or Swiss context, freeing oneself from delusion or self-delusion is a pivotal moment in the communication process between artists and scientists. The more levels on which communication and confrontation take place, the more (one's own) expectations and mutual reflection on the misunderstandings or failures of understanding break down, the greater the surprise and more sustaining the effects and influences on one's own work. The deconstruction of stereotypes is a prerequisite insofar as it enables participants to open themselves up to the perspectives of others. "The necessary shift away from a language that impairs mutual understanding is a *continual* process [. . .] between scientists, poets and philosophers, even between philosophers themselves" (Hampe 2009, p. 63) — and we might add between scientists and artists, as well. In the array of common interests and opposing methods, differences and misunderstandings can occur, the unfamiliar and asymmetrical can raise new questions and discussions, and, in turn, make new developments possible. As such, fascinating and sometimes heated debates are also part of these relationships, just as the continual negotiation of position, language and meaning are. I introduce the notion of "relationship" here, because the way in which artists and scientists relate to one another in the course of their collaboration has a significant influence on the development and learning process of each. As in any (professional/intercultural/romantic) relationship, the willingness to open up and listen to one another is a key factor in its success. Building relationships is not about negating one's own certainty but, much more, about acknowledging the "both-and" of various approaches in order to gain new experience and initiate a process of discovery.

The interaction between different highly productive, knowledge-generating disciplines during the residency forges paths to new knowledge. Artist and author Jérémie Gindre described his state of mind after his first months at the Geneva Neuroscience Center as "a real pleasure to feel [himself] roughly out of context, but not lost". In response to his "not-knowing" vis-à-vis the fields of research at the Geneva Neuroscience Center, he began his residency with a process that might best be compared to the geographical measuring of uncharted land.

He gathered general information (in scholarly articles and books) and worked systematically to acquire fundamental disciplinary knowledge in the context of the Centre for Affective Sciences (in lectures and presentations of the Centre's scientists) to get an overview of the broad and multidisciplinary "new land" of the neurosciences. After numerous exchanges with various specialists, he focused his work on neuropsychology and emotions research.

As an artist and novelist, Gindre both creates and tells stories. He regularly invited the scientists with whom he worked into his "terrain of knowledge". He used museums, galleries and his studio to "tickle" the scientists out of their comfort zone. Discussions about how an artist and novelist processes such topics as hallucinations, memory, spatial neglect, prosopagnosia, mental imagery, dreams, word associations and cerebral disorders took place regularly in his studio and at selected exhibitions from that point on. I cannot help but draw a parallel here between spatial neglect — i.e. one-sided spatial perception — and the truncated disciplinary view. The change in perspective for both parties, the artists in the laboratory and scientists in the atelier, expanded the perception and, in turn, the insights of both. This expansion develops neither from the melding of the disciplines nor from the adaptation of the one to the other, but through a genuine extension of their respective space. The residency created space and time to work with that moment in which the shift away from one's own (disciplinary) language becomes necessary (Hampe 2009, p. 63) to meet one another beyond the hierarchizations in the space of "not-knowing" and to develop new perspectives out of this space.

During his ail residency with surgeons and researchers in the cardiac surgery department of the University Hospital CHUV in Lausanne, Steffen A. Schmidt stumbled upon "disappearing knowledge": heart auscultation. This form of diagnosis concerns listening to the body and is only employed superficially today. While auscultation remains important for outpatient care, it has been and continues to be largely replaced in clinical medicine and in cardiological diagnostics, in particular, by imaging processes and technologies.

As a musician and musicologist, Schmidt used his time in residence to (sound)track this "lost acoustic" phenomenon, exploiting the auditory possibilities of various pieces of hospital equipment, in particular, the echocardiograph, and weaving the vast spectrum of sounds into a soundscape. The live performance on the stage of the Montreux Jazz

Festival,[2] featuring cardiological surgeon and echocardiograph special-
ist Prof. von Segesser, accompanied by the artist at the piano, literally
put this "forgotten knowledge" in the spotlight.

The experience so ignited Schmidt's enthusiasm for the poten-
tial of acoustic procedures so that he acquired a digital stethoscope and
continues to this day to experiment with the "art of listening." A tool that
has become part of the "not-knowing" of many physicians of a younger
generation working with state-of-the-art technologies now serves as
an instrument in the artistic, research practice of a musician. A belief in
the superiority of latest developments can clearly blind us to the value
of "forgotten" knowledge in our fields to which the view of specialists
from other disciplines can reawaken.

While the artist and philosopher Christina Della Giustina (who
collaborated with scientists from the Swiss Federal Institute for Forest,
Snow and Landscape Research WSL in the field of long-term climate
data) and the poet Sandra Huber (who conducted sleep research with a
EEG at the Center for Integrated Genomics CIG) explored entirely dif-
ferent fields of knowledge, they both worked extensively with scientific
data collected with sensors. Della Giustina works with sensors and trees;
Huber, with sensors and humans. In different ways, both researched the
language of science in their respective fields of activity. Semantics and
epistemology played as important a role in their laboratory research as
did the rhythms and cycles of nature. Both attempted to form a "whole"
from the various partial specialized knowledge of the scientists. The pro-
cess necessitated extensive dialogue and debate, as well as the willing-
ness of the scientists to move beyond the boundaries of their discipli-
nary knowledge, to confront their "not-knowing" vis-à-vis the process
of artistic production and, in part, to open themselves up to the critique
or lack of understanding from colleagues. The result was "a different,
more subjective dynamic of critical exchange and knowledge creation"
(Schirrmeister 2004, p. 12) in that "specialists" on both sides undertook
unfamiliar forms of interaction.

Della Giustina's personal linguistic, poetic and visual records
established connections that enabled the WSL scientists to gain an over-
view of the "combined" knowledge of their specializations to achieve
a holistic understanding of the forest and its ecosystem and, in turn,
to identify gaps in their own knowledge. The scientists benefited from
the ability of art "to articulate what
cannot be sufficiently articulated

2 As part of the event *Art and Science on Stage, Montreux
Jazz Festival*, 2012.

through propositional logic" (Seel 2009, p. 46). The scientists were intrigued by the "network of connections," "its density, opacity and plurivalence" in Della Giustina's work (Seel 2009, p. 46). In its interplay with the clearly defined rules of scientific research, the unobjectifiable specificity of art becomes a process in which the unknown is not the missing piece of the puzzle but a motor for the continual search for something new. This is so, above all, because art offers its recipients the opportunity "to define themselves from autonomous fragments through undetermined processes of experience and understanding in a generally unforced situation" (Seel 2009, p. 46).

Both artists thus developed projects that produced new linguistic/poetic and sound/musical compositions based on abstract scientific data. Both lent data a (resonating) body that reflected the complexity, density and (dis)proportionality of language and data, which built a bridge to open up and provide access to new levels of understanding.

In closing, I would like to discuss one final aspect of "not-knowing" between the parties in our art-science collaborations. The artists-in-labs residencies take place in rather exclusive contexts: When artists work in scientific laboratories, the public is largely left out. The outcomes of these residencies is something we consider new knowledge or, as the title of this volume suggests, as "re-composed" knowledge. One of the tasks of the ail program is to bring these processes and outcomes out into the broader public sphere in order to stimulate new debates and inspire new ideas. Exhibitions, publications, films, workshops, concerts and performances serve as a kind of "outreach" into the space of "not-knowing" within the public sphere[3]. The exhibition *Quantum of Disorder*, which took place at the *Museum Haus Konstruktiv* in Zurich, is a good example of this strategy. Physics and mathematics underlined the concept and making of many of the artworks in this co-curated group show - a surprise for many visitors. The exhibit was accompanied by scholarly lectures, tours guided by artists and scientists alike, as well as a variety of forums for discussion that conveyed a new image of art and its manifold relationships to science, society and technology. To see the disciplines in unexpected relations created a lot of excitement and desire for understanding. It is this intrigue of the "not-knowing" that keeps the public curious, the artist' studios creating, the laboratories brooding, and all of our debates unending — yesterday, today and tomorrow.

3 Among them, the SNF-Agora project *State of the Art — Science and Art in Practice* (2012 to 2015) and included, among other events, a project week for secondary school children and a sound and light installation in the New Botanic Garden of the University of Zurich.

References

Fehr, J 2005, 'Vielstimmigkeit und der wissenschaftliche Umgang damit. Ansätze zu einer Fleck'schen Philologie', in R Egloff (ed.), *Tatsache — Denkstil — Kontroverse: Auseinandersetzungen mit Ludwik Fleck*, Collegium Helveticum Heft 1, Collegium Helveticum, Zurich, pp. 25–37.

Gamper, M 2012, 'Einleitung', in M Bies, M Gamper (eds), *Literatur und Nicht-Wissen. Historische Konstellationen 1730–1930*, diaphanes, Zurich.

Glauser, A 2010, 'Formative Encounters: Laboratory Life and Artistic Practice', in J Scott (ed.), *Artistsinlabs: Networking in the Margins*, Springer, Vienna, New York.

Gugerli, D, Sarasin, P 2009, 'Editorial', in *Nicht-Wissen*, Nach Feierabend, Zürcher Jahrbuch für Wissensgeschichte 5, pp. 7–9.

Hampe, M 2009, 'Existentielle und wissenschaftliche Revolutionen. Zur Differenz von Wissen und Nicht-Wissen', in *Nicht-Wissen*, Nach Feierabend, Zürcher Jahrbuch für Wissensgeschichte 5, pp. 51–68.

Proctor, RN, Schiebinger, L 2008: *Agnotology. The making and unmaking of ignorance*, Stanford, London.

Rammert, W 2003, 'Zwei Paradoxien einer innovationsorientierten Wissenspolitik: Die Verknüpfung heterogenen und die Verwertung impliziten Wissens', in *Soziale Welt,* 54 (4), pp. 483–508.

Schirrmeister, C 2004, *Geheimnisse: Über die Ambivalenz von Wissen und Nicht-Wissen*, Deutscher Universitäts-Verlag, Wiesbaden.

Schmitz, W 2004, 'Geleitwort', in C Schirrmeister, *Geheimnisse: Über die Ambivalenz von Wissen und Nicht-Wissen*, Deutscher Universitäts-Verlag, Wiesbaden.

Seel, M 2009, 'Vom Nachteil und Nutzen des Nicht-Wissens für das Leben', in *Nicht-Wissen*, Nach Feierabend, Zürcher Jahrbuch für Wissensgeschichte 5, pp. 37–48.

Christina Della Giustina is currently a lecturer in Fine Art at HKU University of the Arts Utrecht and enrolled in a practice-led PhD program at Slade School of Fine Art, UCL, London. She studied Philosophy, Art History, and Linguistics at the University of Zurich; and Fine Art and Political Theory at the Jan van Eyck Academy Maastricht. Her trans-disciplinary artistic practice includes site-specific work with live and/or interactive audio-, video-, and light, performance, composition, drawing and writing. She focuses on translating the data from specific sites into artistic notations that are conceived to be interpreted and experienced in the form of a collective enactment of the site. The resulting performance re-creates the site as sensory event and calls for questions that cross disciplines about our ways of being with ourselves *and* the world, and that modify the "self" related to the site. Her work has been shown internationally at Haus der Kulturen der Welt, Woburn Research Centre, *Montreux Jazz Festival*, Netherlands Institute for Media Art NIMK, Gallery Soledad Senlle Amsterdam, Shanghai Contemporary Art, the International Art Triennial in Lublin, Botanical Garden Zurich and Kunsthalle Zurich.

Forest Dynamics, Tree-Rings & Long-Term Forest Ecosystem Monitoring (LWF) groups of the Swiss Federal Institute for Forest, Snow and Landscape Research WSL, Birmensdorf ZH.

WSL is the Swiss federal research institute for forests, snow and landscapes. We are primarily concerned with the use and protection of natural, cultural and urban habitats in Switzerland, while also monitoring and exploring landscapes and forests. Another central focus is the evaluation of how to handle natural hazards and developing solutions for socially relevant issues. We work closely with partners in the sciences, industries and society but we also create think tanks with artists.[1]

Researchers involved in the residency: Arnaud Giuggiola (Ecophysiology, Scientist), Madeleine Günthart-Goerg (Ecophysiology, Scientist), Peter Jakob (Databank Manager, Scientist), Terry Menard (Microscopy, Technician), Daniel Nievergelt (Tree-Ring Analysis, Technician), Andreas Rigling (Forest Ecology, Head Research Unit), Marcus Schaub (Ecophysiology, Head of Research Group), Gustav Schneiter (Climate Monitoring, Technician), Fritz Hans Schweingruber (Dendrochronology, Prof. Emeritus), Pierre Vollenweider (Ecophysiology, Scientist), Peter Waldner (Biogeochemistry, Scientist).

Composing

you are variations: An On-Going Series of Events

An Unusual and Extravagant Interpretation of Our Data

Christina Della Giustina

you are variations: An On-Going Series of Events

An Unusual and Extravagant Interpretation of Our Data

I came to the Swiss Federal Institute for Forest, Snow and Landscape Research WSL to study ecophysiological processes within trees (that is, processes as seen by science) and the creative processes within me that eventually would lead to the aesthetic processes. What I mainly did during the residency was to study the subjects, the language, and the different methods that the institute is working with, and to closely observe my reception, response and reactions to them. The idea was to compare these different processes, exploring the very manner of connections and disconnections between them, asking if evolving processes inform, and/or reflect upon each other. Can cultural and natural processes be brought into relation? And what might be the adventure, the difficulty, and the value of doing so?

How can we get in touch with a tree? Is it possible to get to know trees, to hear them and become familiar with them? How intensely, under what conditions, and through what forms of knowledge do we experience and engage with "creation", including ourselves?

These Reflexions and experiences come from Andreas Rigling, Marcus Schaub and Peter Waldner who worked with Christina at the Swiss Federal Institute for Forest, Snow and Landscape Research WSL

Andreas Rigling, Head of Research Forest Dynamics Unit

Before Christina came to WSL, we had no clear expectations. It was more curiosity about the artist, her personality, motivation, background and her expectations. The creative part of this collaboration was clearly to be on the side of the artist—hence the role of us researchers was to contribute data and scientific

How is it we ethically relate to the environment?[1] Entangled within this epistemological probing is the question: what forms of intimacies with the organic world[2] do our known approaches distinguish, prevent, suggest, envision, and enable?[3] Are there further questions that speak to a common inquiry across disciplines concerning our ways of being with the world and with ourselves? The artwork, *you are variations* examines the environmental sensitivity of these forms of *being*.

In collaboration with the Forest Dynamics Research Unit (WSL) I explored the stems, leaves and root systems of trees. In my earlier attempts — *Tree [Vol. 01–06]* — I listened to individual foliage trees one at the time by means of an extended, amplified stethoscope. I started to wonder how trees acoustically effect their neighboring *environment:* I focused on several trees, a section of forest, and trees in relation to various locations within a landscape. It is for me most intriguing to create a spatial and temporal, acoustic environment as a "landscape" wherein it becomes possible to listen, from diverse perspectives, to sonic events generated by diverse trees simultaneously, and/or alternately.

The impact and dynamics of environmental changes and tree responses to climate and environmental factors, as researched by the unit, build an exceptionally rich platform for further research in this project. Several Research Units' projects relate directly to my research and are of great interest for my work. To be able to access the technical infrastructure, and to detect and record trees' microclimate with ecophysiological methods like dendrometers, sap flow sensors etc., with the aim to turn the data effectively into artistic material

1 "Ethically" is used here in a etymological sense of ἦθος, meaning "accustomed place", "habitat", as well as the extended meaning of "habit".
2 "Organic", etymology: from Latin organum, Ancient Greek ὄργανον (organon), is an instrument, implement or tool, also an organ of sense or apprehension, an organ of the body, a musical instrument, etc., "from" ἔργειν (ergein), "to work"; possible translations: *"what works"*, *"that which works."*
3 Additionally, are there actual possibilities to combine these different ways of knowing?

knowhow. We were supposed to be the artist's counterparts in the discussions. This clear division of roles changed over time, however, and we gradually became more and more involved in the conceptual framing of the art part. We formulated a first working concept and decided to meet for monthly brainstorming and exchange sessions. Christina's work at WSL focused on the sap flow from the soil through the tree stem to the leaves and finally to the atmosphere. In this context she wrote, composed or—rather—she built books on and from the wood of the tree species Black Alder (Alnus Glutinosa), Hornbeam

1 In August, 2011 we created a think-tank with: Christina Della Giustina, artist-in-lab at WSL, Dr. Andreas Rigling, Head of Research Unit Forest Dynamics, Dr. Marcus Schaub, Head of Ecophysiology Group, Prof. Dr. Fritz Schweingruber, Emeritus, Dendroecology, and Dr. Matthias Dobbertin, former Head of the Long-term Forest Ecosystem Research (LWF), all from the Swiss Federal Research Institute WSL. Matthias suddenly passed away on October 31, 2012. He placed great emphasis on the multi-disciplinarity of his research field in order to gain a profound understanding of the influences of environmental changes on the processes taking place in forests. His formidable skills, combined with his distinct curiosity, allowed him to continuously discover new connections and relationships between trees and their environment. *You Are Variations, Version 01/01* [Pfynwald, April 2014] is dedicated to Matthias.

for a spatial and temporal light-and-sound-scape, was the most promising approach.

The research tried to draw on the resources of science and art practice to examine them as epistemological borderlands, and to experiment with suggestions of how encounters might be formed that enable us to meet differently, to interact, and to know otherwise. The differences in terminologies built just the tip of the iceberg. But in probing the interface, the meeting points, and the fault-lines of these different knowledge regimes, oscillating between the scientific and the aesthetic, we tried to set in motion relationships between these modes of exploration and understanding. In doing so, we created the potential for something hybrid, something else, something maybe new!

Under the title *art + science lab: cat+* I created a trio of conversations and studio visits around the project, bringing together the scientific community and artist friends from Zurich. The result of these meetings and conversations are two artists' books:[4] *Tree 9-2071 — Pinus sylvestris, 1919–2008 —*, Pfynwald, Valais, CH [Volume 01: Temperature]; and *Tree 2-395 — Pinus sylvestris, 1915–2009 —*, Pfynwald, Valais, CH [Volume 02: Energy].□1

Tree 9-2071 documents my inquiry and outlines my questions to the scientific community at WSL. *Tree 2-395* collects the questions addressed to me by the scientific community at WSL. Both volumes are conceived to welcome and value our collective concerns,

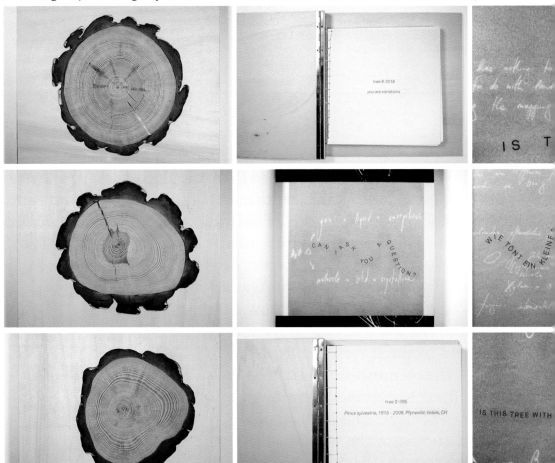

□1 *Tree 8-2018; Tree 9-2071; Tree 2-395 (Pinus sylvestris)*

which are the questions themselves. In giving each question the time and space to connect to brief scientific remarks, drawings of *Pinus sylvestris,* my questions, and the questions of the scientists, an interwoven context is created that reflects the residency's timespan: unfolding as it did over a nine-month residency at the Research Institute, and living on in the time the reader takes to be with these books. In both books, the layout of the questions on the page follows the tree-ring chronology of *Tree 9-2071's* and *Tree 2-395's* density profiles of their growth pattern, measured by the tree-ring cell size, the maximum latewood density and the ring width by means of X-ray radio densitometry and image analysis.[5]

Both books ask, what "temperatures" were decisive for the structure, growth and evolvement of these trees?[6] What

4 Each of the pages in both volumes consists of three layers: a) Questions displayed according to the tree-ring chronology of *Tree 9-2071's* and *Tree 2-395's* density profile. b) Notes on the principles of energy transformation processes boosted by the water cycle through pine trees. c) Drawings from nature, and drawings from illustrations of *Pinus sylvestris.*
5 The dendroclimatology research unit at the WSL quantifies the impacts of environmental change on tree growth and reconstructs

climate variations over the past centuries to millennia, using ring width, maximum latewood density, and other parameters such as isotopes, investigating methodologies relevant to tree-ring and global change research. The group addresses socially, politically, and scientifically relevant questions centred on the earth's climate, exploring various techniques to provide understanding of past climate variability supportive for validating global, as much as regional, climate models.

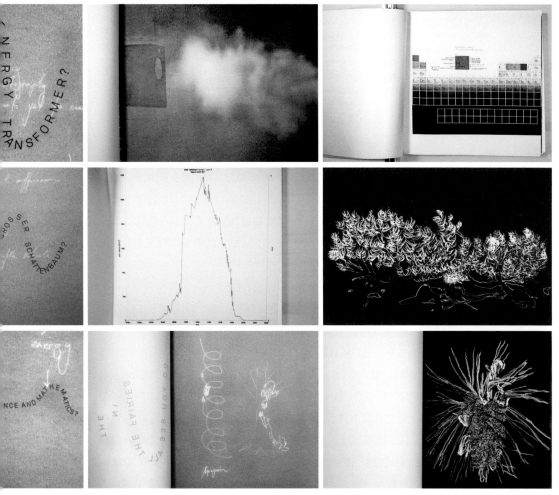

"temperatures" were decisive for the structure, growth and evolvement of these works? Even though these "temperatures" differ greatly—the one indicating climatic conditions in specific ecosystems; the other referring to the "climate" of the atelier in the WSL as scientific institute—the central challenge to create pieces of art that work as gatherings for diverse bodies and different minds remained.

From the beginning of the residency I collected the documents, images and ideas I was gathering. These were personal notes which eventually became books. The first book is called *Alnus glutinosa, Carpinus betulus,* and *Acer pseudoplatanus.*[7] It collects information on the three species in the form of basic scientific facts on soil, roots, and their interactions; on stem anatomy, morphology, and architecture; and on leaves and their gas-exchange with the air. Daily thoughts and observations I made while working built additional layers. The experiment with this collection consists in the overlap and intertwining of images, data, and texts from different–although related–sources, in search for connections, relationships, and meaning which were yet unknown. I was especially interested in the resulting constel-

6 The impacts of temperature on tree growth, and the correlations of tree-ring structure chronologies, together with the temperatures in Pfynwald over a period of 89 years show that early summer temperature and date of snow melt were decisive factors for the tree ring structure and seasonal growth of *Tree 9–2071* and *Tree 2–395* from 1919–1965, and from about 1985 onwards until 2008. In 1965, selective trees were removed and the forest in Pfynwald was thinned. In the cumulative growth chart you can observe a steep growing curve for these years, indicating a growth rate for *Tree 9–2071* and *Tree 2–395* that is not affected by the prevailing climatic conditions of the Valais.
7 The book *Alnus glutinosa, Carpinus betulus, Acer pseudoplatanus* [Birmensdorf, CH, June 2011] provides visual and textual insight into the trees' basic anatomy and morphology, the very geometry and architecture that allows tree-specific metabolic cycling. It was presented in the frame of *libri di versi 03* at the Venice Biennale 2011; at the art manifestation KadS in Amsterdam, NL, 18 September–30 October, 2011; at the AkkuH Aktuele Kunst Hengelo, NL, 22 April–3 June 2012; at the Museum zu Allerheiligen, Schaffhausen, CH, 10 March–5 May 2013; *in the frame of time space silence light* in punt-WG, Amsterdam, NL, 20 September–20 October; as well as at the Haus der Kulturen der Welt, Berlin, DE, 24–30 August.

(Carpinus betulus), and Sycamore Maple (Acer pseudoplatanus). She created video installations visualizing the flow of the water through the tree and as a final project composed a live concert inspired by the four seasons of the tree water balance.

Peter Waldner, Biogeochemistry, Scientist

It quickly became clear that an artist's mindset is much more open and broader than the one of a scientist. There are fewer restrictions in thinking and imagination is a central element in the creative concept of an artist. As a result, the discussions were very open and sometimes they developed in unprecedented directions, which can be very interesting and inspiring. Discussions among scientists seem to be more vectored towards specific objectives, more focussed and straightforward.

lations, the overlaps that occurred, and the relating transitions. Trees are experts in non-obstruction, and interpenetration. They are made and fit for certain aspects to be determined and others not, allowing complex orders to emerge by themselves and being carried out in(ter)dependently. Trees work with the coexistence of dissimilar elements, a blending and transformation of these very diverse elements, meeting in several overlapping cycles, each with its own centre: an ongoing circuit of processes with their own rules and timings. There are many central points, and each circle deserves attention, while no one circle can be isolated and looked at alone. It was clear that a follow-up edition in the form of a series of books will concentrate on conifers, especially particular pine trees of the alpine region, in relation to dendro-climatological technologies developed and applied at the Institute.

Parallel to the decision to concentrate on and experiment with books as forms and formats to accompany this research, I explored the potential of working with sound as an abstract and evocative medium. My first sound experiment was to transpose young oak trees' root growth into minimal sound shifts: data on root lengths and root depths were related to pitch shifts of sine waves, while the roots' environment was composed by sound clouds according to the physical soil composition. This built a slightly vivid, sonic background for the root-sound to grow into. It was the start of the on-going series *you are variations.* For me, the process of getting to know microscopy, the use of dendro-chronological methods, and being introduced to data collecting and distributing technologies as instrumental and operative in the LWF Project was challenging, constitutive, and especially rewarding.□ 2/3

The first time I directly collaborated with Dr. Andreas Rigling, Head of the Forest Dynamics Research Unit, Swiss Federal Research Institute (WSL) was about a year later, in the preparations for the introduction to *you are variations 04/01: tune of trees at Lake Leman—4 songs from inside a tree.* We held the performance on July 18, 2013 at the Montreux

Communication across disciplines is always a challenge, not only between arts and science. It took time, but we eventually reached a high level of understanding. The most important aspect was that the artist and the scientists really wanted to understand each other as they sincerely believed in the collaborative potentials. How did we do this? Very simply put: We just did it! Christina jumped deeply into the water of forest science and invested days in reading scientific literature to gain an insight of the current "state of the art" of science on the topic. She read numerous scientific papers, had discussions with scientists and was introduced in protocols, measuring methods and analytics by our technicians. Our results, graphs, microscopic photographs were further developed and translated, then interpreted into the arts-context—a difficult and time-consuming work.

Christina Della Giustina

Swiss Federal Institute for Forest, Snow
and Landscape Research WSL

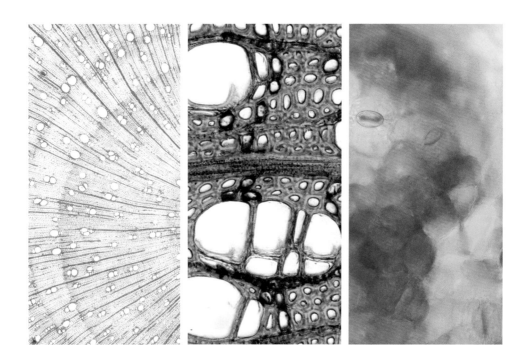

□ 2 *Alnus glutinosa, Carpinus betulus, Acer pseudoplatanus*
(three book sample pages)

Marcus Schaub, Ecophysiology, Head Research Group

We were the scientists, keen on understanding why certain research was included in this process and why? Thus the curiosity on both sides bridged gaps and helped overcome difficulties in communication. We discussed emerging questions and cleared misunderstandings—which of course took time and commitment on both sides for long discussions. The different vocabulary was a handicap and an opportunity at the same time. It was a handicap when sometimes exhausting discussions ensued but it was an opportunity to explain one's work and own position, a process that always contributes to the clarifying of one's thoughts and sharpening of one's argumentation. By the end of the residency, however, communication was not that difficult, as both sides were curious as well as experienced in working across disciplinary borders.

Jazz Festival. Reflecting upon my working process at the Institute, I seemed to encompass the study of self-generating and self-organising processes. I especially tried to expand my understanding of self-organisation in physical terms involving energy, especially entropy cycling, working towards the study of ecosystems as complex, integrated systems composed of interacting biotic and abiotic components—that is, ecosystems as metabolisms cycling energy and matter. The study follows the basic experience that living organisms and physical factors are intrinsically connected, building ecosystems that continuously transform energy. It needs purpose, dedication, and endurance to engage and relate, but it does move things.

As a whole, looking back, this trans-disciplinary (at times un-disciplinary) approach might be described as "composing"—interweaving drawing, writing, rubbing (frottage), grinding, installing, inviting, collecting, programming, recording, projecting etc., together with the scientific methods I borrowed from the Institute like soil science profiling, and various techniques from dendrochronology and microscopy. This acquisition of an arsenal of tools for composition in itself might describe one of the methodologies at stake: that is, not to reduce oneself to one means, one perspective, or one outcome, but rather to describe the same tree continuously, simultaneously and differently, again and again.

Is this working method a force for enhancing the sheer possibility of uncovering one or some of our blind spots? Or is it a way to exhaust oneself in order to create an entrance for spontaneity, immediacy, improvisation and other means to wake up, trigger, and intensify our intuition and sensibilities? I don't know. I am still wondering. On the other hand, visits to the studio, and especially the programming of the score, were spontaneously intriguing and jointly interesting to most of the scientists.

When I arrived at the Institute in March 2011 a buoyant source precisely in the middle of the refectory was shown to me—a chromium-nickel, steel-winged water fountain. For

Andreas Rigling, Forest Ecology, Head Research Unit

Us scientists who collaborated and discussed with Christina realized that our measured data on climate, tree response, or soil water content can be interpreted in a completely different way than we are used to. We realized that also our scientific interpretations of the data are also interpretations, similar to what an artist creates. The point is not what interpretation is correct or true, the point is to be aware that in our scientific work, too, interpretation is omnipresent. It was surprising to see that there are in fact many parallels in the working methodology between our artist and us and that art also can be hard analytical work.

When we take a closer look at the research process, the first step is always to get an overview on the state of knowledge: What is known, where are the open questions, gaps

9 months I gratefully drank from it every day. Now, far away from this canteen, I still ask myself how artistic work can keep on contributing to its flow. It must be an art in the form of extraordinary generosity: an art of removing oneself and creating space for the other. "The other" is not "the scientist". "The other" is "the tree": an observer, a perceiver, an actor and a transformer.

The direct and uninterrupted feed back loop between the practical experiments and the theoretical research during my residency at WSL was a fundamental force in the development of the work's potential for insight and innovation. It allowed me to closely explore the relationship between my making and thinking, and that of others.

Parallel to this first attempt to use LWF data as artistic material feeding sound compositions, we set up a think-tank within the Forest Dynamics Research Unit of the WSL. This entailed a mutual decision to cooperate closely and structurally in the continuation of artistic and scientific experiments in transforming ecophysiological processes into tangible events.

In my diary I wrote:

"this is not a straight line, this is the beginning of a circle, the beginning of an embrace."

My work might suggest the need to expand and transform our concept of science and art through looking at nature, not in an assignment of nature to music, for example, but in an attempt to perceive nature in a complex and interwoven continuum with culture. Nature changes at the slightest move. The concept "nature" is of modification, not of essence. These modifications are generative: when a natural body grows, it is in movement. It does not coincide with itself; it coincides with the transition, its own variation. In growth a body is in an immediate, unfolding relation to its own now-present potential to vary. The link to the title comes in here with the thereby added remark that what we conceive and feel of nature are variations in intensities: a process understood as *nature —culture continuum of variations,* always as

of knowledge and what are the experiences within the community? Literature and internet research is always the starting point of a longer process. Either you decide on the question to be answered and collect the required data, or you start with your data sets and reflect on questions that could be answered with the available data. Once you have the data you need to get a feeling, an overview and deep insight about it before you start working with it. Then you do the analysis, the interpretation, you decide on the storyline, and how you want to present it. This is almost exactly the same procedure in the arts, even though at first glance the two communities seem to differ very much. Differences, however, seem to exist in the framing of the working process. The scientist thinks and acts very focussed within the conceptual framework of natural sciences with its conventions

co-evolvement in variations of transitions in a continuous process of becoming.

A process, by nature, is relational. The only autonomy is of unfolding relations, where the natural and the cultural feed-forward and back into each other. It is our decision—subjectively and collectively, while not universally; intentionally and not necessarily permanently—to listen to and enjoy data from nature converted into an audio composition that might become sound as in music and art. In the proposed allocation of data to sound, both values are abstract and deeply rooted in our culture. The sound you hear is not the tree; it is affected and inspired by the tree. The transposition I worked on for 9 months is not a form of representation, reflection or mirroring of these trees. Rather, it is a transmission—maybe the very mode of operation of becoming itself, a self-propagating movement that seeds several further self-organizations. Each differing in nature from the last, but connected by its shared generative impulse, and resulting in a creative uncertainty with emphasis on the genesis; from within a vision of change that insists that what emerges does not conform or correspond to anything outside itself, nor to its own condition of emergence. In other words, *you are variations* suggests addressing trees as beings, and not as traces, as beings that by their very nature are always in a state of becoming, always differentiating, and emerging from these differences. *you are variations* does not reflect these beings, or this becoming, or these processes of formation. It actually calls upon them. Getting inside these sounds bears the potential to lead you inside these trees, not to represent, reproduce, mirror or echo the physical event, but to become the actual embodiment of the event. In this sense the resonations of *you are variations* can be seen as attempts to convert distance into intensity. It is a qualitative transformation of distance into the immediacy of relation between "tree" and "self". ☐ 4

The conception of a musical score as a generative system—that is a vivid and vital self-organisation—needs to manifest itself in

and standards—the artist's way of thinking and working is also focussed but has many more degrees of freedom. That openness in thinking can lead to unexpected insights and results, which might be different from our scientific reality but valuable in different contexts.

Imagine, for example the impact of artistic interpretation of our measured data on trees, forests and the environment being presented in an arts-exposition in a museum in Schaffhausen. The exhibition included our data among paintings and installations of artists and the visitors were fascinated, not only by the artistic installation and interpretation by Christina but also by our scientific data, our scientific work. In another joint art and science project, we had the opportunity to perform with children on the stage of the *Montreux Jazz Festival*. In science, you hardly enter

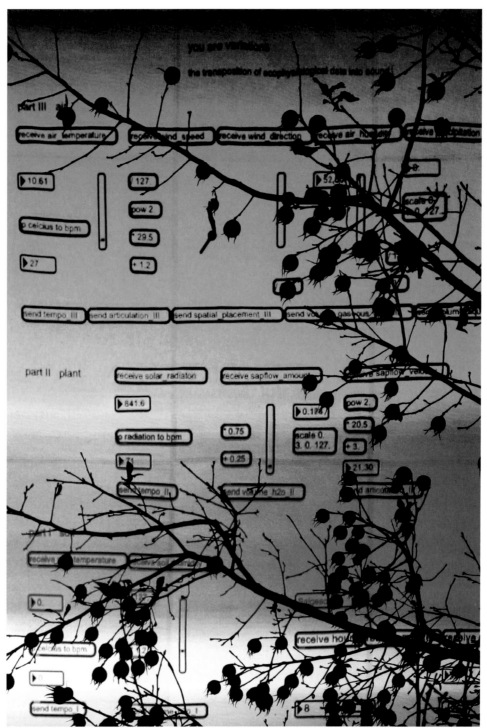

□ 3 *you are variations, version 01* audio-video installation (data-driven) –
24 loud speakers, 2 audio interfaces, 2 laptops, 2 projectors

experience, that is the realm of events; events that co-embody (or, as Donna Haraway suggests become "figures": a proposition that necessarily "collects up the people"[8]). Here experiment and experience might be the very junction where science and art can meet: at a pivot point where—I would like to suggest—artists hang out, delve, and feel at home. This is a space where complex coded pasts come alive in a new light called *now: the light of a self-inventing present: a meticulous, polyvalent, experimental research of experience based on generic nature.*

The score is an act of organizing and arranging information (the data), it is committed to "making consequential meaning" [the data read by the periodic table] and the composition is a proposition to co-construct knowledge [the collaborative performance of the score, together with its simultaneous public reception]. The concept is generative and speculative: it acquires meaning not by a supposed capacity to mirror reality or to postulate any form of truth, but by generating "consequential

meanings". It generates a circular flow of energy and matter; nurturing reasons and opportunities to come together to rehearse, play, and learn. It generates the events of the meetings, relationships and exchanges. In my view this emphasis on a more prolific, revelatory agency of and by the project itself suggest a kind of "view from nowhere": one that transforms and thereby *creates* meaning. This is a meaning that is constantly on the move, together with all its collective histories and diverse senses of knowing.

8 Haraway, DJ 2000, *Birth of the Kennel.* European Graduate School. Lecture by Donna Haraway. August 2000. "…figures to be those who collect up and reflect back the hopes of a people. Figures are about collective yearning. Figurations somehow collect up and give back the sense of the possibility of fulfilment, the possibility of damnation, or the possibility of a collective inclusion in figures larger than that to which they explicitly refer." see also: Sehgal, M 2014, *Diffractive Propositions: Reading Alfred North Whitehead with Donna Haraway and Karen Barad,* p. 9; Parallax, 20:3, 188–201, DOI:10.1080/ 13534645.2014. 927625; accessed 26 October 2015, <dx.doi.org/10.1080/ 13534645.2014.927625>

these stages other than to give a talk or a presentation. But through this collaboration the main point was that we got in contact with new stakeholder groups we normally do not reach with our science. We talked about our climate change impact research in front of the visitors of an internationally known jazz festival, which is remarkable. This interpretation of our work is a healthy arts-science interface that culminated in a very special live concert about trees undergoing changes from climate change. This was an important experience and definitely constituted virgin territory for us.

Andreas Rigling, Marcus Schaub and Peter Waldner

Christina's works were highly valued. Many researchers, including the heads of the institute, repeatedly visited her installations, products and performances. For months, the

◻ 4 a) Measuring and crossdating of tree-ring series
with a semi-automated measuring system
(Lintab, D; accuracy 1/100 mm)
b) Analyzing wood anatomy under a binocular

◻ 5 Scaffolds on the research platform Pfynwald
to research the crown architecture, phenology
and physiological processes, including gas exchange
and photosynthesis

◻ 6 Phytosynthesis measurements in pine needles with a chamber for coniferous trees (LI-COR, USA)

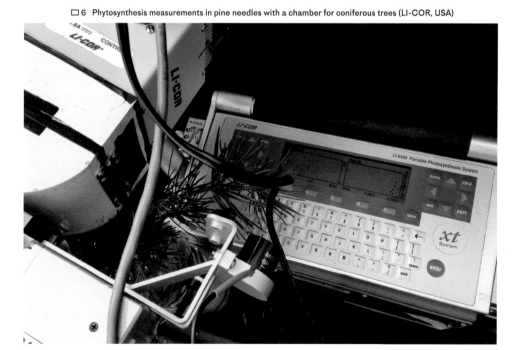

Let us try to name it, just for now; a sketchy, temporary record. Let us call it "con-science". Can "con-science" become a form of "intense knowledge", with amazement, curiosity, and experiment as its siblings, and experience as the actual embodiment by and through which the event (of "co-knowing") appears?

Or asked otherwise: how do we sensitize ourselves to this world? When are we open, respective how do we open ourselves to new connections, what is actually necessary for such a meeting to be primate, mammal, animal, a life form and energy itself? This is not an attempt to becoming "other", but on the contrary—in *relating?* And if so, how can we learn to relate? How can I relate to you, for example? Here language is understood as a voice; here the words and sentences become a voice with grain, and tone, and inflection; a voice that pauses and repeats itself; a voice that transcends my inside as much as yours; a voice that creates us as collectivity; a voice, perhaps, with a sliding relationship between the eye and the ear.

you are variations
hey, but who are you?
you, yes…
do you hear me?
could you do me a favour?
could you keep on listening?
keep listening while looking at the trees?
do you see them?
can you hear them?

art project was constantly discussed during coffee breaks at the cantina. Hence, the very goal of the ail program has been reached; to stimulating interactions and collaborations between scientists and artists who were both forced to reflect on their own work form the experience. The final highlight was at the institute's Christmas party, where many people saw Christina's work and attended the live musical performance that was inspired by the four seasons of a pine tree growing in a dry inner-Alpine valley. The majority of the institute's staff was interested, and even fascinated by this unique performance in a greenhouse, next to experimental set-ups with young trees.

During the course of the experiment the line between art and science changed in the sense that it became clear that both disciplines, arts and science, have very similar

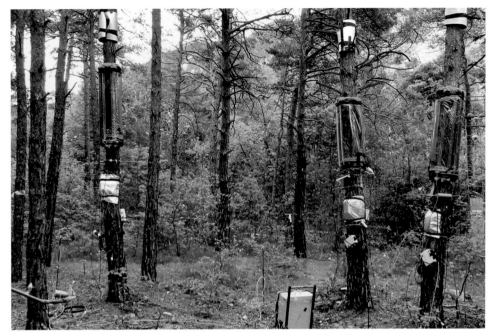

The research platform Pfynwald, Valais.
In a long-term irrigation experiment tree response
to varying water availability is tested.

☐ 7 Ecophysiological sensors are installed to measure
stem- and soil respiration, soil water content
and soil temperature, air temperature and humidity
(University of Edinborough, GB).

☐ 8 Tree growth (Natkon, CH) and sap flow in the stem

☐ 9 Photosynthesis in needles (LI-COR, USA)

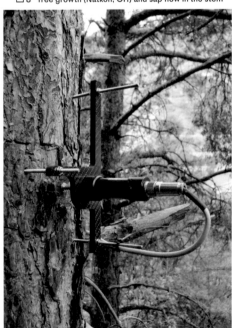

working approaches. Getting familiar with a new topic requires a lot of reading and reflection, the current state of knowledge, and already existing experiences. In the next phase you need to find your niche, the focus of your planned contribution—this is normally a difficult process, a hard time with a lot of self-doubt. Our central work is to implement the ideas, to work on the data, to analyse and synthesize, which is normally liberating, exciting and satisfying. The last phase is highly decisive for the final success of each project. In the case of the arts, this phase is more open, more possibilities and uncertainties exist in terms of how to shape and implement the final product—be it an exposition, a performance or a concert. In science this step is more straightforward as usually the primary product is a publication. For publications, you have to decide who the target audience should be and subsequently which would be the best journal. In case of applied research you need to decide on how to communicate your research results to your stakeholders.

An important precondition of a successful collaboration is to be open, interested and curious on working at this interface. You need to be committed and ready to invest time even if there might not be an immediate and direct scientific benefit. Christina's strong interest to understand the functioning of the trees prior to starting the creative work, created many opportunities to review our scientists' current knowledge, it stimulated efforts to gain an overall view on the understanding of the functioning of forest ecosystems and to identify important gaps in knowledge.

Our collaboration with the artist continues, as there will be more follow-up performances and concerts. In addition, we received funding from the Swiss National Science Foundation SNF for an AGORA project, to organize and perform with Christina and other musicians, at the regional

Pfyn-Finges Nature Park. This project was based on a study week in the primary school in Susten, in the Canton Valais. During one week at the end of April 2015, we worked with students and teachers on climate change impacts on forests and how to translate this scientific knowhow into an art performance. At the end of that week, there was a joint concert. This project was certainly a challenge for all of us, but it offered new possibilities to work and communicate at the interface of art, science and the broader public—we really valued this experience.

The unusual and extravagant interpretation of our data by the artist sensitized us about the need to explore the impact and future communication of our scientific research. For us transdisciplinarity describes the communication at the interface between science and implementation, the knowhow-exchange with stakeholders and with the public. In this sense our collaboration with the artist was more of an interdisciplinary collaboration, and at the beginning it was not clear whether transdisciplinary aspects would also be included. This changed towards the end of the project, with our joint art-science performance at the *Montreux Jazz Festival,* the arts exposition in a museum in Schaffhausen and it culminated in our project week in the primary school of Susten also in 2015. These activities lie clearly within the focus of transdisciplinarity, with the aim of communicating arts and science to the broader public.

Harriet Hawkins is a Reader in Geography at Royal Holloway, University of London. She works on the geographies of art works and art worlds. Most recently she has investigated questions of interdisciplinarity and collaboration, between artists and scientists or between artists and geographers. Recently, she has focused on issues of art, science and global environmental change, based on collaborations with international artists and arts organisations. Her research has been funded by the National Science Foundations of the US and China, The Arts and Humanities Research Council and the Leverhulme Trust (UK). She has published two monographs and over 50 papers/book chapters and writes regularly in the fields of Science and Nature. She has also commissioned new art works and collaborated as a curator on a series of artists books and participatory art works (Arts Council England, Iniva and Tate Local). She is currently collaborating on a radiophonic piece on "sounding environmental loss" commissioned by Liquid Architecture and the Australian Broadcasting Corporation. She also worked at the Universities of Exeter, Bristol and Aberystwyth (UK) and the University of Arizona (USA) on projects funded by the Arts and Humanities Research Council (UK) and the National Science Foundation (USA).

Art-Science and (Re)Making Worlds: Shaping Knowledge, Transforming Subjects, Challenging Institutions

February 2011, I arrived in a warm spring-like Barcelona for the exhibition *Think Art — Act Science* at Arts Santa Monica. This project showcased eight of the works produced by the artists-in-labs program (ail) from Switzerland and marked the start of over four years of research and engagement with the programme. I listened to sound works, observed robots, joined in with electronic dance activities and watched the accompanying videos in which the artists and scientists discuss their involvement in the residencies. As I did so I was struck by the diversity of the activities, the richness of the disciplinary exchanges and the myriad forms these took. It was clear, as the artists and scientists reflected on their involvement in the residencies, that they were often open not only to new things being learnt and made during the residencies but to how the residencies opened up space for lasting shifts in their thought processes, in the ways they produced knowledge, in their institutional settings and in the ways in which they communicated their ideas to the public. In short how it was that these residencies reshaped how these individuals — scientific and artistic experts alike — understood and practiced art and science.

This visit marked the beginning of an on-going research project into art-science collaborations in particular those that engage with themes of bodies and environments. Our research team, funded by the US National Science Foundation and the UK Arts and Humanities Research Board, explored a series of art-science organisations around the world.[1] Some of the projects we studied specialized in particular scientific issues such as climate change (Cape Farewell) others in particular scientific techniques as the way to make art (SymbioticA, for example, experiment with wet-ware biological techniques). We also studied programmes aimed at high school students (UCLA's NanoLab) experimental science facilities (Biosphere 2, USA), innovative display spaces (Art-Science Museum Singapore) as well as a series of on-going projects that sought to use art-science collaborations to develop environmental practices. It is well acknowledged that we lack accounts of interdisciplinary projects as they unfold in practice (Barry, Born 2013). As a result, our studies seized on key questions regarding how such projects might generate novel objects and practices as well as new understandings and theorizations. Importantly, we also explored how they might transform the knowledge-making practices and the subjectivities of those involved and reshape the institutional and organizational structures that frame and often enable such projects.

1 Project details 1 March 2016, accessed www.artscience.arizona.edu

In our research we sought to explore and learn from contemporary art science endeavours, drawing out their impulses, philosophies, products and wider intellectual and public import. We were interested in the context, mechanism and procedures that have shaped the dynamic and engaging forms of these collaborative projects. In addition, we explored the wider intellectual and to a lesser extent, the public impacts of such art-science projects. Across the projects we studied we found less a sense of "fusing" distinctions of thought, technique or ethical practice between art and science, and more a realisation of these projects as enabling a change in each participant's ways of thinking, the knowledge they create and the kinds of interactions they have with their institutions and the potential publics for their work.

As such, using ethnographic research methods we investigated questions around the spatialities and materialities of the production of art-science projects, we explored what networks and organisations are enabling and shaping art-science projects? We queried how these projects tackled the ethical and political dimensions of complex scientific problems and examined what kinds of technologies emerge from art-science projects and what their impact is. We reflected on how art-science collaborations might engage with audiences and assemble different stakeholders for science. We explored the effects of art-science collaborations on those artists and scientist who participate in these collaborations, on the knowledge that is produced, on the institutions who are involved in catalysing or hosting these collaborations and on the various publics and stakeholders who might be part of these projects.

During my time with ail, I explored the history of the organisations and reviewed a cross-section of the residency projects. I worked most intensively with the programme in 2011, spending time doing ethnographic research alongside the residencies of Christina Della Giustina at the Federal Institute for Forest, Snow and Landscape Research WSL, Birmensdorf, with Marie-France Bokanowski, based in the Native Systems Group at ETH Zurich, Steffen Schmidt based at CHUV Lausanne and Jérémie Gindre at the Geneva Neuroscience Centre and Swiss Center for Affective Sciences. These case studies were set within the wider frame of the international art-science projects we studied. Building on the findings from our multi-site project I want to develop here three key findings with respect to our research at the artists-in-labs program and more broadly. Firstly that these projects can transform those artists and scientists involved in them. Secondly, that they shape

artistic and scientific knowledge, importantly, not only the knowledge developed during the projects, but also wider knowledge making practices. My third point concerns the potential we see in these projects to reshape the institutional worlds in which they are produced. The remainder of this discussion is going to frame further investigation of these ideas through examples from our research.

Shaping Knowledge

One of the most common claims made about art-science projects is that these ways of working produce new knowledge. Oftentimes claims are made about the value of bringing together different sectors and practices of disciplinary knowledge with respect to the complex ideas of our time, whether this be the environment or neuroscience. Such claims are often based in a sense of the collaborations exceeding what was possible from the perspective of one discipline alone. Looking at the new knowledge generated we can see both knowledge that is "new" to each discipline, whether that be a novel perspective arts practices might bring to neuroscience (in the case of Jérémie Gindre's project), or whether that be set of different techniques for visualisation that science might offer the artist (in the case of Christina Della Giustina's project). We also however see the production of knowledge that is "new" to both disciplines, innovative for all those involved. The impacts that art-science projects can have on art and science as bodies of knowledge and sets of practices are varied. As this discussion will explore, to talk about the shaping of knowledge through art-science projects is reflect on the production of new ideas and concepts and the transformation of existing ones. It is also to explore the development of findings in a substantive domain, the production of new experimental practices as well as new technologies as a result of the coming together of approaches. Furthermore, we should also remain aware of how the reshaping of knowledge through art-science projects also requires consideration of how such projects might mount radical critiques to existing, sometimes stultified, knowledge-making practices. In doing so we might think of art-science projects as producing an alternative knowledge politics.

As our research at ail proceeded we saw contributions being made to experiment design and implementation; to the scope and tenor of research questions addressed and in helping to formulate new research agendas. The presence of the artists within the science institutional context yielded, on a number of occasions, significant insights

Harriet Hawkins

and developments in the interdisciplinary research questions pursued, and prompted critical reflectivity regarding the philosophy and conditions of knowledge production. In the case of collaborations built with computer and applied engineering laboratories, the artist's aesthetic and design-based knowledge and skill set often became directly incorporated into the development of the research team's products.

Focusing on process, rather than output, something ail excels at, our research demonstrated the important role that art-science projects play in developing experimental processes and technologies that push the frontiers of science. Oftentimes, for example, posing challenging questions through a repurposing of artistic or scientific technologies that unsettled existing well-trammelled practices and experimental conditions and in doing so generate the conditions for the emergence of something new. As our research showed, the process of art-science projects can foster new encounters between those involved and the technologies central to their production. In doing so, these projects reconfigured the technological orientation of users, shaping their bodies and minds in the process, as well as fostering the emergence of critical spaces in which to reflect on the use of these technologies.

We regularly saw, for example, how art-science projects resulted in the prototypes of technical objects that extend and /or reconfigure both the technological capacities of existing devices of art and sciences as well as of individuals encountering them. We witnessed this very clearly in Marie-France Bojanowski's work with Native Systems on her immersive panoramic experience. Developing her previous work on virtual reality Marie-France was keen to work with the computer scientists to explore how she could incorporate neurofeedback into her immersive experiences. She explored how to programme head-mounted virtual reality units, looking to extend the possibilities of these in terms of decision making within the space of virtual reality. One of the dimensions she explored was how users of the device could navigate through doors and across environments by learning to manipulate their brain waves, shifting for example the ratio of Alpha and Beta waves by calming themselves down and slowing their thoughts. As I observed Marie-France working on the project over a number of months, I saw her becoming more adept with the technology. I saw her pushing it in directions and taking it to places that the computer programmers and scientists working in the lab had not thought about, challenging the limits of their and her skills as she did. I witnessed the mutual frustrations when trials did

not work, and the resulting brainstorming sessions as everybody tried to come up with ways forward.

One of the on-going points of discussion around projects that involve multiple disciplines is how it is that such projects have a propensity to engage publics and assemble stakeholders. As we explored through a number of the environmentally based art-science projects (Hawkins et al. 2015) there is more to these projects than the transformation of degraded or overlooked environments, or the transference of knowledge from scientific experts to those within the communities who don't "know" about climate change or the scientific issue at stake. Indeed, common to many art-science projects is a sense that that knowledge they develop is often less the privileging of the "scientific expert", and rather seems to value other forms of knowledge. Such "other" knowledges are often not just those of the artist, but might also be those of local communities and sometimes even non-humans. Thus, with respect to environmental arts projects we explored how the arts might not only enable forms of socio-ecological transformation (Hawkins et al. 2015) but that they might lay the ground work for how things might be different in the future. Such alternative futures enabled through an exploration of how, who and what might play a part in defining and moving towards a more environmental sound and just future.

Christina Della Giustina's project *you are variations* and the iterations of it that she developed after her residency term offer a clear indication of the potential of art to reshape the politics of environmental knowledge. Following the residency further funding for public engagement iterations of these projects could be secured from the AGORA fund of the Swiss National Science Foundation. In the course of the project entitled *State of the Art — Science and Art in Practice*, the ail program was able to support artist and scientist teams from the original residencies to extend the public development aspects of their projects. In Della Giustina's case she worked with Dr Andreas Rigling from WSL to take her sound installation to the local communities in the Valais, the location of the permanent plot sites from which data was obtained. The scientists were not used to working with these communities, indeed oftentimes their only contact with these locations was remotely or on rare fieldwork visits. Working with the local communities makes possible other ways of knowing this landscape, other ways of thinking, for example, about the drought that has struck the trees in this region. Della Giustina worked particularly with the local school children to help them

understand through a musical score how it was that they might know and engage with the trees and climate change. Such enchanting methods enabled the children to explore climate change not as a distant phenomena that involves polar bears and penguins, as a local occurrence that will impact them, but also one they can intervene within.

Transforming Subjects

Within the art world many claims are made for the transformative potential of art, often with respect to issues of social change. One of the dimensions of our research included reflections with the artists and scientists involved in the residencies on how it was that these projects had changed them. This might involve shaping their subjectivities and identities, honing new skills or shifting their orientation to their work. Sometimes this involved direct questioning in interviews or group discussions, other times our results came from ethnographic work that involved watching and thinking through how it was that the artist and scientists interacted with each other and the objects and technologies of each others' processes.

In the course of our study we developed a range of different ways of thinking through how artists and scientists were transformed through their involvement in the projects. Examining a collaboration based at the Advanced Visualisation Laboratory (AVL) University of Illinois, Urbana-Champagne (USA), working with atmospheric scientists from the National Centre for Atmospheric Research (NCAR) in Boulder Colorado we explored what happened in the course of the team's production of visualisations. The project, as we explore elsewhere (Woodward et al. 2015), brought together AVL's artists and programmers with NCAR's scientists to develop modern, high-end visualisations of large datasets. Termed "renaissance teams" we explored how these groups collaborate, seeking to understand how the technical objects (after Gilbert Simondon), such as the computers and the visualisations themselves might also be thought of as collaborators transforming the human collectives through the problems they present.

In the course of the ail projects we observed a number of technical objects that the projects evolved around and developed. I watched artists printing 3D hearts and valves, I saw them learning how to use microscopes and advanced scanning equipment, I witnessed them trialling sensors, heart rate monitors and brain wave scanners in order to develop their projects. In these examples there were very clear ways in which the mental understandings and physical bodies of the artists involved in the

processes were changed by their engagement with these technologies. Not only were the knowledge bases and skills of these artists shaped by the practices they explored and developed during their residencies, but often their bodies were shaped too. Such shifting bodily morphologies often occurred in microscopic ways whether this be through the honing of muscles required for fine motor control needed to manipulate the machines, or the muscles of their eyes reshaped over months of looking through lenses.

Perhaps more crucially we also witnessed how the artists and scientists involved in these processes became aware of different ways of thinking about their research subjects. This was not just therefore about shaping new knowledge but was about changing how it was they came to know. One of the projects we explored was UCLA's Art-Science Nano-Lab project for high school students (Hawkins et al, forthcoming). In the course of this research we followed how this art-science programme unfolded in practice. We focused our discussion on exploring how the programme developed a series of transdisciplinary activities that developed the context in which the participants were encouraged not just to make new knowledge but to think in different ways about the problems they encountered. The project was set up around the exhortation that the students "imagine the impossible" and a series of activities paved the way for them to do so. Through workshops, practical explorations and lectures they were encouraged to think outside the box, or sub-disciplinary boxes, in order to find solutions to global challenges. The focus of this transdisciplinary project was less one of the creation of new knowledge and rather more about enabling people to think in new ways.

In *you are variations* Della Giustina invites us to meet *Anlus glutinosa, Carpinus betulus, Acer pseudoplatanus* and *Pinus sylvestris,* four common tree species that populate landscapes around the world. The artist's audio and visual installation invites us to encounter these trees, but also asks us to question the terms upon which we do so, whether as scientific experts or as artistic audiences. During her residency she worked alongside scientists to explore how they engage with and think about the trees that are their research subjects. She went into the field, she worked in the lab, with microscopes and in the test gardens. She explored different ways in which the scientists know and did not know the trees they studied, conceiving of them primarily through streams of numbers and data. Through drawings, soundings, rubbings, data collection, graph creation and specimen collection, Della Giustina explored

how the trees were known mainly through various modes of visualisation. She sought to expand those understandings of the trees that fixated on them as data points, as abstract streams of numbers or graphed changes, to encourage the scientists to appreciate trees in other ways. She challenged them to explore what it might mean to know the trees through touch or hearing, what it might mean to conceive of trees through multi-sensuous means. In doing so she sought to tease out from the scientists a sense of how they know the species they work with, to encourage them to query the sensory basis of their scientific procedures. Whether consciously or unconsciously the scientists came to know their trees differently. The result is a human subject transformed through an extension of the ways in which they know. Working principally through registers that asked scientists to "sense" trees differently Della Giustina's project sought to develop alternative ways of knowing and engaging the environment.

Challenging Institutions

One of the things that became clear during our study was how many of the art-science projects came either explicitly or implicitly to challenge the institutional, scientific and artistic contexts and frameworks within which they were produced. At times such challenges were the r*aison d'être* for the project and drove its forms of enquiry and mechanisms of practice. More often however, such challenges emerged through the very presence of the artist, through the questions asked, the daily practices undertaken and the work produced. Oftentimes these challenges, as discussed above, saw the knowledge making practices of scientists, their technologies, experimental procedures and their own ways of knowing reshaped and transformed. What we saw perhaps rarely, although importantly was the reworking of institutional practice as a result of these projects.

The science-art programme at UCLA's NanoLab offered us the chance to explore how it is that art-science projects, in this case a two-week college credit course for high school students, might enable the reforming of institutions as well as the shaping of knowledge and subjects (Hawkins et al. forthcoming). As the students experimented with science and art technologies and practices they were encouraged to think out of the box. Both the students and the instructors involved repeatedly set their activities up against the stultifying forms of disciplinary boxes and the hierarchies of knowledge and expertise they create. One of the

outcomes of the NanoLab experiments was not only the development of the conditions for new ways of knowing, but also for the conditions for the critique of institutions and the formation of institutional spaces and educational practices that encourage thinking differently.

The benefits of art-science engagements for teaching across STEM subjects are now well-acknowledged. Where ail has proved particularly successful is in their ability to bring such benefits to fruition. This has taken a number of forms, alongside the perhaps more standard educational programming, ail have worked closely with scientific institutions and organizations to implement specific programmes. Focused principally on the "Pop-up Labs" of the AGORA funded *State of the Art — Science and Art in Practice* project, this includes work around critical thinking and public engagement and in bringing collaborative activities into the under-graduate and post-graduate settings. In addition, individual discussions with scientists involved in the ail program have suggested that working with artists has filtered into their own individual classroom and seminar practices. Perhaps where the benefits of these have been made most apparent is in post-graduate training programmes and developments. In such events we find new masters groups coalescing around questions of art and aesthetics in the context of questions around risk and anxiety in the Anthropocene, as well as the development of research relationships during these collaborations that lead to funded research projects and PhD studentships. As such then, the interdisciplinarity that is so valued for the researchers themselves is also engaged with at undergraduate and post-graduate levels as well. This is increasingly important when it comes to engage the next generation of scientists with the skills.

A further way in which we witnessed art-science projects challenging institutional practices was through the raising of ethical issues. Many art-science endeavours created a set of critical spaces and practices for the artist and scientist alike in which reflections on the ethical and political dimensions of scientific processes could take place. These projects create rich experiential and informational contexts through which audiences can explore the ethical and political dimensions of problems often in complex and participatory ways. As our research showed, art-science projects enable critical interventions into the ethical and political dimensions of contemporary science, challenging its often unquestioned power. The participatory engagements at the centre of some art-science projects will provide community members with

the opportunity to express their own views rather than rely on artists or scientists to do so on their behalf. art-science projects also appeared to provide non-experts with the chance to engage with issues that concerned them, often outside of the context of debilitating hierarchies that would devalue their knowledge or contribution. Further we witnessed how, in their facilitation of technology development art-science projects could also raise questions surrounding the politics and ethics of such technologies, whether this be the use of brain wave monitors to keep tabs of people's mental health or long running debates about GMO.

Art-Science: Remaking Worlds

Over the course of our research we found a range of examples of how art-science projects work to transform the subjectivities of the artists and scientists involved in their production. We also witnessed how these projects might be considered to reshape knowledge not only making new knowledge that is perceived as impossible through previously separate understandings, but also how they might be understood to reshape the terms upon which we understand art and science and how it is that we consider these knowledge making practices. As we saw here, we can understand the challenges and problems posed by these projects as themselves collaborators in the project, moving the artists and scientists onto new territories. While the transdisciplinary activities that often constitute these projects can challenge radically the institutional boxing of knowledge and the hierarchies of expertise.

The result, we would argue, is a way of thinking about what is it that art-science projects and the processes of being involved in them do, how such projects reassemble the artistic and scientists themselves, transforming their subjectivities and skills as well as their bodies. How these processes also reassemble what it is we might consider to be knowledge of and about art and science and the ways by which knowledge making practice should proceed and further more who it is we consider to be artists and scientists. In sum, what we witnessed in our studies of art-science projects, including those we studied at artists-in-labs program, were a whole suite of ways in which art and science practices came to remake worlds. These worlds might be the institutional and knowledge making spaces of the artist's studio, the science lab and the field or the wider worlds beyond the institution, spaces of political and ethical debate and public engagement with scientific knowledge that shape the social and environmental contexts in which we live.

References

Barry, A, Born, G (eds) 2013, *Interdisciplinarity: recon-figuration of the social and natural Sciences*, Routledge, London.

Hawkins, H, Marston, S and McCallum, S (under review), 'Doing Interdisciplinarity – Imagining the Impossible', in *Transactions of the Institute of British Geographers*.

Hawkins, H, Marston, S, Ingram, M. and Straughan, E 2015 'The Arts of Socio-Ecological Transformation', in *Annals of the Association of American Geographers*, 105 (2), pp. 331–341.

Woodward, K J, Marston J P, Hawkins, H and Dixon, D 2015, 'One Sinister Looking Hurricane: Rethinking Collaborative Visualization', in *Annals of the Association of American Geographers*, 105, pp. 496–511.

Marie-France Bojanowski currently works as an inter-action designer for the ICT industry. Her background includes art, design, filmmaking and information technology, and she focuses on transdisciplinary creative processes where ideas can be challenged from different human, social, cultural and scientific perspectives. In 2011, she was a resident artist-in-lab at the Native Systems Lab (ETH Zurich), where she focused on computer science, body sensors and neuro-interaction. There she utilized tangible media for haptic neurofeedback (further funded by the European Union 2016). She is also founder and artistic director of the Montreal collective *Farine Orpheline* (1996–2006) an initiative for time-based art and site-specific projects in city neighbourhoods, derelict factories, museums, psychiatric hospital and boats. She believes that creative capacity lies at the heart of innovation and she researches how new methods, tools and environments act as a real catalyzer to blur the boundary between art, science and technology. She studied Industrial Design (1992) but then made over 100 short and medium documentary films for North-American and European television channels, as well as media installations for scenic purposes (Digital Art Weeks CA). Her current research is on haptic inter-action with an object aiming at enhancing our connection to the present moment.

The Native Systems Group focuses on researching and teaching the construction of programming language as well as compiler and custom systems. Our goal is to design and implement novel languages and system models that optimally support the development of future computer applications, emphasizing simplicity, clarity and resource efficiency. Aiming at uncompromising lean designs and utmost transparency, we construct software systems and frameworks that directly drive commercial or custom hardware. Finally, we develop computer runtime systems to be used in various fields such as digital arts, healthcare and robotics.

Researchers involved in the Residency: Prof. Dr. Jürg Gutknecht, Head of Native Systems Group, Dennis Majoe, Research Coordinator, Dr. Felix Friedrich, Post Doc, Kevin Collins, Consultant, Art Clay, Consultant, Sven Stauber, PhD Student, Lars Widmer, PhD Student, Hong Peng, PhD Student, Chi Chen Kao, PhD Student, Urs Fässler, Grad Student, Viktoria Kluckner, Research Assistant, Irena Kulka.

www.cs.inf.ethz.ch

Embodying

Processing Brainwaves into Pixels and Haptic Feedback: This Is Not A Quilt

Other Ways to Approach Problems and Their Solutions

Marie-France Bojanowski

Processing Brain-waves into Pixels and Haptic Feedback: This Is Not A Quilt

Other Ways to Approach Problems and Their Solutions

Prior to the ail program residency, most of my artistic research took place in the real world with everyday people rather than in academic or cultural institutions. I conducted site-specific projects in urban areas, industrial spaces or psychiatric hospitals with interdisciplinary art collectives over extended periods of time. I made documentary films in remote locations around the world with minimal resources. Direct contact with local communities, with my audiences and with the physical world provided me with creative food for thought. Curiosity and intuition played an important role. As this kind of anthropological artist, I developed my own methodologies and set-up my own research labs in foreign environments. I was used to working outside of established networks. These types of storytelling, interpretative and intuitive aspects of my work were not easy to import to a computer science framework, but sometimes I found moments of poetic appreciation, like when mathematician Felix Friedrich told me he chose computer science research to listen to the music of mathematics.

Comments from the Native Systems Group researchers who were involved in the residency

Jürg Gutknecht, Head of Native Systems Group, Institute of Computer Systems, Swiss Federal Institute of Technology — ETH Zurich

We think that computer science is actually quite close to art, and the Native Systems Group in particular has a long history with electronic arts. We are not creating a visual image, and although it is not architecture it's very similar. I would call it "virtual architecture". Therefore software design is a creative act

When I first came to the lab I knew nothing about computer science and programming, so I had to learn a lot in the beginning. I wanted to learn about the ways that computer researchers think and talk and not simply program and then weave material together like a quilt. I wanted to experiment with more immaterial or unexplainable patterns from brain waves and connect immersive photography to smart sensors and digital code so as to emulate a more dream-like experience of spatiality. I believe that we have to employ a variety of sensory perceptions and immersive experiences to explore this emulation. This level of immateriality requires learning to think about unusual programming systems and language codes. At the end of the nine months residency I can still not necessarily write my own programme but I can go through one and understand it.

Right from the start, I knew that my immersion in the Native Systems Lab at the Computer Science Institute, ETH Zurich, was a "real" project. I not only wanted to feel displaced but also be contaminated by their scientific environment: their ways of thinking, their methods and their tools. *The Hidden Room* project was a good pretext to explore computer science research, and soon it became the main project to connect with the scientists. I regarded the project as a traveling metaphor, one that would be changed by living with the locals (programmers), learning their language and their culture. I hoped that this would let the project be impregnated with a long-lasting affect. Little did I know that this 9-month ail resident journey would turn into a twenty-month collaboration!

I soon realized that I had little idea of the research at the Native Systems Lab. Although I could relate to some terms such as sensor interfaces and immersive imaging systems using wearable computing, their terminology was a complete mystery. I found two research projects at the lab fascinating: an existing prototype called the *Virtual Panorama*

and everybody who is in this field is an artist at heart. Therefore we are very close in spirit with what you call real visual creative artists. Still, interacting with an artist as opposed to other scientists required us to really think before we talked. It meant that we had to revisit our assumptions about what we could easily "get away with" among our peers. Something that would seem obvious in our world was suddenly not so necessarily obvious or indeed valid in Marie-Frances' world. Fortunately, our group has a very strong sense of collaboration and we are always trying our best to help out fellow researchers. As a result, we always welcomed requests, questions and comments from Marie-France — as did she with our requests and comments. We applied different methods in order to teach and learn from each other and covered the technical topics through one-on-one presentations and hands-on training.

(VP) and an on-going international research project about depression prevention (Project *OPTIMI)* in whose context the lab was creating a network of wireless wearable computing body sensors.

My original ideas were pragmatic and I aimed to create a type of container for this content (the computer being the container). At the beginning this was the only way I could envision interacting with this lab's expertise. By using the lab's computer prototypes and assigning them something to say; however, I soon discovered that computer science researchers who are interested in the virtual and augmenting reality are also very interested in *recursion*[1], *cognitive computing*[2] and *artificial, neural networks*[3]. Therefore, I graduated from working on such a conceptual and an aesthetic level that was foreign to the understanding that computer science is an architectural space that enables us to *make things* in relation to our physical world. I started to see things through the lens of being a kind of "architect of the immaterial". For me this is where my own art

and their science could meet. These pragmatic actions to build an experiment that ended in an immaterial architectural prototype were continuously challenged by the scientists and their input generated new questions and changed my process.

[1] Recursion is one of the central ideas of computer science. It is a method where the solution to a problem depends on solutions to smaller instances of the same problem. [2] Cognitive computing addresses complex situations that are characterized by ambiguity and uncertainty; in other words it handles human kinds of problems. In these dynamic, information-rich, and shifting situations, data tends to change frequently, and it is often conflicting. The goals of users evolve as they learn more and redefine their objectives. To respond to the fluid nature of users' understanding of their problems, the cognitive computing system offers a synthesis not just of information sources but of influences, contexts, and insights. To do this, systems often need to weigh conflicting evidence and suggest an answer that is "best" rather than "right". Cognitive computing systems redefine the nature of the relationship between people and their increasingly pervasive digital environment. They may play the role of assistant or coach for the user, and they may act virtually autonomously in many problem-solving situations. The boundaries of the processes and domains these systems will affect are still elastic and emergent. Their output may be prescriptive, suggestive, instructive, or simply entertaining.

More general topics, such as introductions to sensors or EEG analysis, we transferred through discussion, by answering specific questions from her and taking the time for free flow conversations. We found that communicating technical ideas to Marie-France required us to use less technical and more general analogies as well as the use of more specific examples or scenarios. When she first came to the lab, Marie-France didn't know a lot about computer science but she was very interested and quickly learned the basics. She had a very steep learning curve at the very early stage of her stay.

Dennis Majoe: Research Coordinator

In *Panorama,* formerly called *The Hidden Room* Project, Marie-France explored the concept of so-called "cerebral scenography" by using the Native Systems Lab's *Virtual*

I began to work on a project called *Virtual Panorama*. Here the goal was to explore a kind of "cerebral scenography" that used the *Virtual Panorama Device* developed by the Native Systems Group. □1/2

Virtual Panorama is a wearable immersive system or head-mounted display connected to a small belt size computer that enables the user to observe and navigate inside panoramic images by using his or her head movements. My first idea was to combine EEG sensors with the VP to create an immersive, brain-controlled, panoramic experience with photography. I hoped to influence one's cognitive, emotional and behavioural response towards a non-linear narrative photographic experience by affecting the perception of space with filters that could be actually placed over the user's vision. □4/5

One haptic mockup being tested by a subject during a neurofeedback session in a user study a participant can load several images of

his or her choice into the application and it will take the data coming from a compass to determine the position of your head. Then you can navigate within these images just by moving your head. It is very easy and intuitive. It creates the illusion of actually being in a room or in a landscape. One important thing that you can do is switch the panorama from one displayed environment to a completely different one in the fraction of a millisecond. That allows you to immerse yourself not just in one but in a variety of virtual worlds. Using this programme I created links between panoramic spaces with doors and keys. I took the images just outside of Zurich under an exchange where many

3 In machine learning and cognitive science, "artificial neural networks (ANNs)" are a family of models inspired by biological neural networks (the central nervous systems of animals, in particular the brain) and are used to estimate or approximate functions that can depend on a large number of inputs and are generally unknown. ANNs are generally presented as systems of interconnected "neurons" which exchange messages between each other. The connections have numeric weights that can be tuned based on experience, making neural nets adaptive to inputs and capable of learning.

Panorama Device. This wearable system allows users to immerse themselves in a 360 degrees panoramic visual experience. Using Electroencephalography (EEG) sensors Marie-France measured various users' brain frequencies, with the goal to use their brain waves to enable them to navigate through the virtual panoramic space in relation to the different functions of their brain waves. The project was successfully completed with a public exhibition at the Digital Arts Week in Victoria (Canada).

Marie-France was also involved in *OPTIMI* for which she developed multimedia content such as video, photography and text. Based on her results and material, we generated a series of explanatory video clips for the trial subjects as well as for the support staff. As she became more involved in the sensory side of the project, Marie-France also contributed

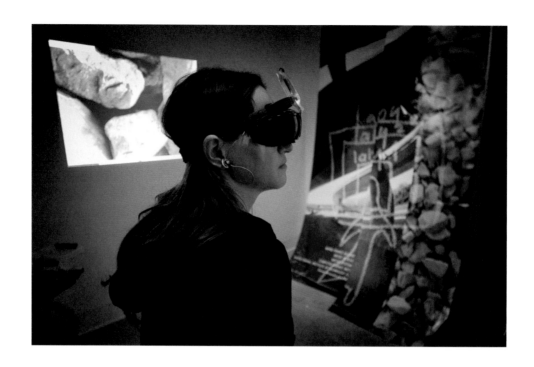

1 *The Hidden Room* prototype, OFF Label Festival / Digital Arts Week, Victoria Canada, November 2011
2 Testing haptic perception in the barn with early mock-ups (Dennis Majoe, Marie-France Bojanowski), August 2012

highways meet. I was very interested in this particular site, because it's a network of traffic and it's a *non-site*. It's like a hole in the urban fabric. There is just one house left under these highways, otherwise it looks like an industrial wasteland. I was interested in the concept of the *Hidden Room*, which was the original title of my artist-in-resident application. The origin of the idea actually came from a recurring dream that I had; a dream of being in a room where you know everything by heart. It's familiar just like in your own house. And for the first time you notice a door. You've never seen it before and you decide to open it and you access a space that you hadn't been aware of. It's different every time and it's always surprising. Like a crack in the wall, the door is a metaphor for the openings in our own mind leading to our own inner spaces. I wanted to evoke this dreamlike feeling of having a conversation with oneself through an encounter of various different spatial situations and related emotions.

OPTIMI was a completely other project—a collaboration with the scientists that was funded by the European Union. Our aim was to predict mental illness by using physiological sensors and self-reporting. I was asked to contribute my media art and hands-on experience with smart body sensors and software to this project. My role was to create soundscapes for the neuro-feedback training application and test prototypes for the pilot studies. I had acquired a lot of ease with the prototypes and became experienced enough to help project partners and pilot study participants troubleshoot system problems in user-experience environments. This amplified my own cognitive friction that was associated with the technological complexity of the project and eventually led to another sub-project called *The Ball* Project in which my insights into transdisciplinary research at the Native Systems Lab was applied.

3. Emerging – Transdisciplinary Researcher, *The Ball* Project

This included a device called *The Ball*: or the development of a hand-held computer towards generating graphic content for biofeedback.[1] Through visual landscapes she illustrated different levels of arousal and created audio landscapes with a wide set of environmental depictions such as waterfalls or thunderstorms as an integrated part of our EEG biofeedback meditation work.

After being deeply involved in EEG sensing and noticing our other robotic work in the lab, Marie-France developed *The Ball* project, which combines EEG sensing with forms of robotic mechanisms and haptic sensual feedback. She created a variety of paradigms for *The Ball*, including physical actuators, embodiment potentials and graphic interfaces that supported the intended effect. She conducted several user tests with the aim of describing the EEG relaxation process and its integration with the prototype physical content. This project was successfully completed, and we

□ 3 Marie-France trying an early version of the brain sensor in room H.14, March 2011

were able to prove the concept as well as identify the best approaches for further development in the future.

Dr. Felix Friedrich, Post Doc

When the researchers had conversations about Marie-France's work while she was not present, we all wondered why she could think about things in a way we could not think about them. By being exposed to her completely different kind of thought processes, we realized that there were other ways to approach problems and their solutions. For example, when you go into a researcher's office, the walls will typically be covered with calendars and white boards. Marie-France's office, on the other hand, was covered in photos, graphics and all sorts of media—a way for visualizing information that is very particular to artists. The creation of content in a computer science lab is typically

controlled by the user's brainwaves and direct tactile feedback.□3

In *The Ball* I aimed to create a tangible user interface that reacted to the user's brainwaves with a direct tactile and kinesthetic feedback, in other words: a brain-controlled handheld haptic computer. Held in one hand, it would act like an extension of the body, or provide the sensation of holding our mind in the palm of our hands. One hypothesis was that by having the normal manipulative aspects of computer use disappear, (i.e. the keyboard, the screen and the mouse) we could make it transparent and more intuitive. With the addition of responsive and low-level haptic feedback, the communication between brain and computer could be enhanced. We used the neuro-feedback system from *OPTIMI,* and worked together to develop *The Ball*'s hardware, software, low energy wireless communication and skin. Through iterative mock-ups and prototypes we investigated haptic perception and feedback with various actuators and materials and conducted a pilot study at the lab.

4. Reflections

At the very beginning of my residency, I was introduced to smart sensors and how artefacts must be filtered out of the raw brain data that these sensors record. Interestingly enough, the word artefact has a double-sided connotation: in computer science artefact has a negative connotation, while in culture it has a positive one. Therefore, using the same terms did not mean that we spoke the same language and good communication had to start with swapping the definitions of these terms. At first I felt more like an ethnographer, an exotic creature in these surroundings, but as I actively engaged with people and tried to absorb everything like a sponge, it eventually worked out. Daily exposure was necessary to understand and make sense of it all. After the 9 months of ail program, I finally blended in as "doer," and as part of the scientific team. The more I understood the technology, the more I could contribute my media art expertise and, the more I spoke "the language," the more I felt part of the group. In the third phase,

restricted to producing A1 posters for poster sessions in conferences. They are incredibly boring and often nobody reads nor understands them. So when Marie-France was talking about her work process to us, we profited most from her drawings and visualizations. She used the entire room for her mind maps, where she hung up posters and made sketches and notes that basically represented an image of her associative processes. Using those mind maps and those visual representations of her thoughts were extremely useful for us to understand her incentives and her vision. Furthermore by drawing cartoons she communicated emotions and ideas that allowed us to grasp what she was trying to say much quicker than words. Within a few months Marie-France showed us the possibilities of using graphics, photography, video and finally re-invented how the department might presents itself in the future.

I emerged as an author and a researcher and felt at home with my team. I had earned credibility and recognition and sensed that people were also learning something different from my approach and media art experiences.

I often seek to be at the crossroads of things, networks and directions, and such a position challenges me to question where I come from and where I'm going. It obliges me to learn other ways to observe, collect information and interact with my environment. In *Gödel Escher Bach* Douglas Hofstadter writes about how sense emerges from patterns and how self-reference and formal rules allow systems to acquire meaning despite being made of "meaningless" elements.[4] Data is actually meaningless in itself and meaning only comes with a pattern, just like language is a pattern made of letters. Or just like individual neurons in the brain coordinate to create a unified sense of the coherent mind.

Learning something outside the realms of my knowledge was made easier because the interpersonal contact at the lab was very strong. I attended contextual lectures on various topics and interviewed researchers from different research computer science groups: Native Systems, Disney Research, Wearable Computing Lab, Computer Vision, Computer Graphics, EMPA Material Research, to name a few. Fundamental computer science was hard to grasp because it seemed too abstract, but I was very inspired by how it could manifest itself physically.

Another thing I learned in the computer science method is to study parameters in isolation and to work with them one by one in order to build or debug a system. The prototypes I was working with (sensors, Oberon software, Virtual Panorama) each had their potentials of unpredictability. Alongside these problems of unpredictability, I worked on my *Hidden Room* experience with panoramic photography, and mapped the content on a recursive narrative structure by writing stories within stories and using many parameters at once.

4 Hofstadter, D 1999 (1979), Gödel, Escher, Bach: *An Eternal Golden Braid*, New York: Basic Books.

□ 4 a) One haptic mockup being tested during a neurofeedback session in a user-study
b) Kevin Collins: one of the main collaborators on the *The Ball* project's organic user interface.
□ 5 Early sketch of *The Ball* project idea, April 2012.

I soon found out that I was more agile with brain sensors, virtual reality and XML scripts, but that all the errors and crashes made me feel very out of control. While some people could control my prototypes with their mind (EEG alpha and beta brainwaves), others could not. Also brainwave amplitudes vary greatly among people and signals are sensitive to environmental interference, thus calibrating a brain-computer interface for different people is not a trivial pursuit. Smart devices just made me feel dumb, I lost track of simplicity and created complexity. At that moment, I wished I had made a quilt: just a dumb quilt!

Soon I became an experienced user of the lab's Alpha enhancement neuro-feedback system. I tested it and made recommendations to improve user experience and I created sonic feedback and tutorial videos for the study of it. The psychology researchers who were in charge of the pilot studies had difficulties with the system so I helped them and their participants. Like a chameleon, I ended up blending into the scientific team somehow, after being a neophyte for so long and I was ready to move on to the next phase.

The third phase had a different equation: I was part of a transdisciplinary team working on the same question from the start, and putting forward knowledge and skills to contribute to the building of a computer. *The Ball* prototype was created to act as a "mirror of the mind" and be perceived as a "mental control button," in order to help self-regulate the brain frequencies. This tangible interface collects brain signals from the user wearing an EEG sensor and renders the brain's behaviour (from alert to calm) with vibration, pulse, shape change, or temperature change. Together we focused on building this vision: a hand-held neurohaptic computer.

Our methodologies merged in a natural way. On the one hand, the research on hardware, software and wireless communication was technical and iterative, involving several mock-ups and prototypes that we tested on ourselves or on external people. On the other hand, I made sure that the spaces we worked

Her residency has profoundly changed our perception about how we can promote our work—and how necessary it is to engage professional artists in computer science teams. Computer scientists do not tend to use these creative processes in their innovation, instead their processes are based on incremental and known approaches. So what we learned is that to make a larger jump you need to change the way you look at things. In fact, her method was so effective that we decided to work with her more and use her artistry within formal grant applications, in order to communicate complex ideas in a series of single images.

Jürg Gutknecht: Head of Native Systems Group

Before Marie-France came to the lab, the Panorama project had been the only step we had taken towards interaction with

in—our silicone-moulding office rooms in the ETH bunker and a barn in the countryside where I live—were included in the process and added multiple layers of content. This included many brainstorming sessions on the walls with post-its, images and quotes, prototypes in their different iterative states, a pilot study haptic table with neurofeedback devices, a cooking zone in the office to make wax moulds, a workshop and a testing zone in the barn.□6

Art or science did not matter; what mattered was that we live in the same world and are curious about similar things, but look at them from different angles. An experiment was conducted to study how haptic feedback could affect the neuro-feedback experience. Twelve subjects participated in the study and were asked to focus on the haptic perception in the hand and try to modify the mock-up's behaviour in order to "calm it down". This required each subject to calm his/her mind state in order to calm down *The Ball* (neuro-feedback loop). A significant finding was that the action required the subject to "be mindful" while focusing on haptic perception induced by a brain-responsive object. The merging of body-related and physical objects could then provoke stronger emotions, vivid visualisations or contrarily create distinct comfort or discomfort. Controlling the interface was not easy, mainly because the very idea of "controlling things with the mind" requires training. Nonetheless, the subjects adapted relatively fast. When they did not feel "in control", they felt that the object was controlling them, which was described as negative. On the contrary, the feeling of controlling the object was overwhelming. Most interestingly, if the programmed behaviour of the haptic ball changed (for example, reversing the vibration volume), the perception of the subject executing the same task again would cause a completely different effect. In both cases, the connection to the self is amplified and uniquely linked to the level of "intelligence" of the haptic feedback. I surprised myself one day when I tested this haptic neuro-feedback with my eyes closed, and I experienced a "cerebral

□ 6 Designing *The Ball* a brain-controlled hand-held haptic computer
by the artist and the scientists, Dennis Mojoe and Kevin Collins.

scenography" or different visualisation narratives, induced by the feedback loop of control and perception of control.

5. Immersion, technology, transdisciplinarity

One knows instinctively how to hold a delicate object or living creature in one's hands, such as an egg or a bird, and how to interact with it by holding, touching, looking or listening. Nowadays a lot of our everyday encounters are embedded with computers, but what makes an object "smart"? Theories suggest that "smart things" emphasize the difference between objects with embedded information processing from objects without it.[5] We wish to make things that mirror our own behaviour or even persuade us to change it, we ask them to coach us and want them to express our emotions or have a personality of their own. Computing has become an affective embedded interface that can be social and information is becoming much more tangible. Soon tangible and tactile media, will be able to be miniaturized enough to give us instantaneous knowledge about how to interact with small objects, regardless of the complexity of their function. Similarly, Csikszentmihalyi developed the *Flow Theory* or "being *at one with* things".[6] The question is: Will this make us smarter, or even wiser? Through this project we thought that the notion of control was an essential consideration. Which controls which? Is this only a matter of perception?

6. Conclusion

It's a unique experience to learn something outside the realms of your knowledge, but one must stay humble and accept the permanent role of a beginner. It's disturbing at times, but rewarding once you realise you are feeling a bit more at home everyday. And then new perspectives start to emerge. Having access to the lab's methods and technology influenced my

5 Kuniavsky, M 2010, *Smart Things: Ubiquitous Computing User Experience Design*, Amsterdam et al.: Morgan Kaufman Publishers

of Elsevier.
6 Csikszentmihalyi, M 1991, *Flow: The Psychology of Optimal Experience*, New-York, Harper Perennial.

users outside of the scientific context. Having her there allowed us to generally move our research further into interaction with the public. Particularly, *The Ball* project highlighted new challenges for us that meant involving other scientists like neurofeedback specialist John Gruzelier (Goldsmiths University, London) and neuropsychologist Roberto Pascual-Marqui (University of Zurich) and material researcher Gabor Kovacs (ETH Zurich). Also interaction designers like Karmen Framinovic (University of the Arts, Zurich).

Dennis Majoe: Research Coordinator

Marie-France was our "lab celebrity". She was often invited to meetings in order to illustrate that computer science must cross disciplinary boundaries. By showing that we had an artist in our lab as a resident, we underlined our commitment to

work in practical and theoretical ways and understanding science helped me to bring new questions to the lab's team. How can interacting with a physical object enhance the connection to the self? As an example, neurofeedback training could be compared to "smart meditation" as you are able to measure your skill to "calm the mind". In a world where things are becoming our mirrors and monitors, the ultra-connectedness of "smart" objects questions the very notion of "connection," particularly the one to the self. Take away the technology and you are left with the simplicity of connection to the self through meditation.

I came from art and dove into science. My approach was interpretative, poetic and impregnated by storytelling. Like a musician I took the lab's tools as musical instruments, but didn't know how to play them. I learned how to use them and tried to modify them, so the exchange was engaging and changed the line between art and science for me, making it wider and much more blurred.

References

Cahn, B R & Polich, J 2006, 'Meditation states and traits: EEG, ERP, and neuroimaging studies'. In *Psychological Bulletin* 132(2), pp. 180–211.

Csikszentmihaly, M 1991, *Flow: The Psychology of Optimal Experience*, Harper Perennial, New York.

Gruzelier, J H 2002, 'A review of the impact of hypnosis, relaxation, guided imagery and individual differences on aspects of immunity and health', in *Stress 5*, p. 147–163.

Hofstadter, D R 1999 (1979), *Gödel, Escher, Bach: An Eternal Golden Braid*, Basic Books, New York.

Majoe, D & Gutknecht, J & Peng, H 2015 (2012), 'A low cost ergonomic sensor for predicting mental illness', in *IEEE transactions on nanobioscience* 04/2015, 14(5).

Majoe, D & Kaegi-Trachsel, T & Gutknecht, J 2010, 'A Smart Wearable Sensor Assisting in Mental Health', in *Ubicomp* 24(10), p. 20.

Van Boxtel, G J M et al. 2011, 'A novel self-guided approach to Alpha activity training', in *International journal of psychophysiology: official journal of the International Organization of Psychophysiology* (11/2011; 83(3), pp. 282–94.

Kuniavsky, M 2010, *Smart Things: Ubiquitous Computing User Experience Design*, Morgan Kaufman Publishers of Elsevier, Amsterdam et al.

engaging in the digital arts. The nature of our mutual appreciation might be summoned up with an analogy: while we (the band of computer scientists) have the role of a large infantry force with the heavy artillery, the armour of software etc., the artist (in this case Marie-France) sent out to explore and to establish new directions, physical constraints, dangers and opportunities. The artist remains agile and has a lighter load, but must perceive things as they are, and in a way, perhaps, that we cannot. Ideally, she provides a pull to our push, so that we are better equipped to deal with change and the unknown. This seems to match the modern development in sensory devices or in social media where computer scientists view change and the unknown as risky territory. Marie-France was our first "scout" and we are currently working on various new proposals and ideas with Marie-France to work together with her in the future.

Jill Scott is professor
in the Institute of Cultural
Studies in the Arts at the
Zurich University of the Arts,
Founder of the artists-in-
labs program and Vice Direc-
tor of the Z-Node PhD pro-
gram on art and science at
the University of Plymouth,
UK. She has focused on Art
and Neuroscience Research
for many years. Her artwork
and theoretical discourse
spans 38 years of media art
production about the human
body, behaviour and body
politics and more recently on
neuroscience, culture, ecol-
ogy and sensory perception.
Her publications include
*Transdiscourse 2: Turbulence
and Reconstruction* (2015)
Birkhauser-De Gruyter, and
with Springer; *Neuromedia:
Art and Science Research*
with Esther Stoeckli (2012),
*Transdiscourse 1: Mediated
Environments* (2011), *Art-
ists-in-labs: Networking in
the Margins* (2011) and *Art-
ists-in-labs: Processes of
Inquiry* (2006). A monograph
entitled, *Coded Characters*
(ed. M. Hahne, Hatje Cantz
2002) traces her video
artworks, conceptual per-
formances and interactive
environments in USA, Japan,
Australia and Europe from
1975 to 1992. Her most re-
cent exhibitions involve
interactive media and elec-
tronic sculptures based on
studies she has conducted in
neuroscience and under-
standing the sensory system.
Recent solo shows include
Kulturama in Zurich (2012),
at the Winchester Science
Centre UK, (2013), and ZE-
MAK, Poznan, Poland (2014).

Creative Incubators for a Common Culture

In science, an incubator is a machine used to regulate temperature, air circulation, oxygen levels and humidity; controlling the conditions that can help a premature life to survive. There are also feminist connotations: surrogate mothers for example, often regard their wombs as incubators in order to separate their maternal feelings from the offspring inside them, a perspective that undermines the dominance of the patriarchy. And as Bruno Latour posits, there are also macro-connotations, like our catastrophic realities of the Anthropocene, which portray the whole earth as a giant incubator.[1] Certainly, as our "natural" environments become more complex and less sustainable both physically and psychologically, there is an increasing need to design representations of the "artificial" and to construct experiments that explore how our afferent and efferent sensory processes cope with this increasing complexity: One in which we have also become perpetrators of change.

For the purposes of this paper about creative experiment building, I define the incubator as a physical space and a psychological environment conductive to a growing collaboration between art and science practitioners and theorists. This is an interspatial zone that encourages the sharing of findings through interactive, often disciplinary-specific technology combined with an increase in intuitive unspoken methods that Michael Polanyi recently framed as "hands on learning" or "tacit knowledge" (Polanyi 1958).[2] On a metaphorical level this version of the incubator is a creative space of mutual understanding for discussion of not just new inventions and discoveries, but those matters which are unformed and in-process, difficult to describe even in the language of one's "home" discipline. What kind of artists and scientists are willing to blur conventional boundaries and familiar practices to participate in such creative incubators? Well, ones who can think critically and laterally!

1. The Boundaries of Experts

In 1959, when scientist and novelist C.P. Snow famously lectured about the cultures of the humanities and sciences into which he asserted Western society had split, he complained of the general lack of interest in experiential learning from other disciplinary contexts than one's own,[3] since this analysis,

1 Excerpt from Lecture on 26 March 26 2012, From Critique to Composition, by Bruno Latour, produced by E Campbell, published at Dublin City University, Ireland.
2 More information about "tacit knowledge" can be found at Michael Polanyi (1958), last accessed 2 March 2016, www.wikipedia.org/wiki/Michael_Polanyi, www.lse.ac.uk/economicHistory/Research/facts/tacit.pdf.
3 CP Snow's Lecture *The Two Cultures and the Scientific Revolution* — delivered at Cambridge University's Senate House in 1959 is well described on, accessed 2 March 2016, www.age-of-the-sage.org/scientist/snow_two_cultures.html.

however, the relationships between science and society have changed from a top down approach to a more democratic interest in the sharing of expertise. Also, the role of the artist has been liberated from formalist concerns emanating from a practice confined to an isolated studio and dependent on critic, dealer and/or collector for validation. By contrast, many contemporary artists of the past quarter century collaborate with others and contextualize their research with the hands-on experience and input of varied publics and researchers from diverse disciplines. Some socially-concerned artists are taking cues from scientific research about the environment and the body, as well as social-scientific research about economic inequality and health-care. A concern for both the body and the ecosystems that surround and sustain us is likely to be of special appeal to the *media artist,* who is traditionally interested in engaging with the audience's audio, visual and tactile experiences.

Some artists might turn to communication theory and semiotic analysis to reflect upon how our body reacts to stimuli like biofeedback. Other artists are focusing on the impact of science on diverse societies by thinking critically about the lack of access to information among them, the levels of the social responsibility demanded of those who aim to change people's minds or the ethical climate of those who control the interface between publics and scientists. These are new roles for artists, who want to work directly with scientists or social scientists to formulate new approaches and hybrid methodologies. I believe that art-science incubators can provide an ideal environment for expanding the boundaries and discourses of the traditional disciplines.

Changes in art production tend to be catalysed by artists. Ironically, trends in scientific research have become amenable to research funds from public institutions, and more recently, the direct connection between industry investments and economic outcomes. By the mid-1990s, challenges to scientists about the quality and objectivity of their findings and their isolation from social needs were being posed by what such *scientific realists* as Thomas Kuhn and *postmodernist* critics as Bruno Latour called "the Science Wars."[4] Postmodernists interpreted Thomas Kuhn's ideas about scientific paradigms on objectivity and subjectivity to mean that scientific theories can be social constructs, while orthodox scientists claimed that the thinking of those in cultural, feminist and media studies, cultural anthropology or comparative literature encompassed dangerous subjectivity that rendered the "truth"

4 A comprehensive report on the science wars can be seen on, accessed 2 February 2016, en.wikipedia.org/wiki/Science_wars.

conditional. During this time, scientists were taken to task about the impacts of their research on society and theorists like Paul Feyerabend were even criticised because they wished to include science in their discussions about subjectivity and objectivity. Finally, an attempt at peace between warring camps came in the form of a book by Jay Labinger and Harry Collins. Here, through a method called "culture mapping", arguments can be seen more clearly between disputing experts (Labinger and Collins 2001).However, it still seems that this dichotomy between the value of objective and subjective analysis (as well as qualitative and quantitative methodologies or realist and post-modernist thinking) may long be with us. For example, in "standpoint theory", scientists are often criticised for theirlack of social consciousness, simply because each person's private ethicsand perspectives are mostly shaped by his or her social and political experiences.Social scientists such as Evens and Collins use this theory to point to different research methodologies within particular disciplinary environments as the source of isolated and problematic perspectives and outcomes (Collins and Evens 2015). Their criterion of value is based on the general public's access to explicit knowledge from scientists and their chart compares the three waves or eras of scientific investigations termed by them as authority, democracy and expertise.

Collins and Evens: The Third Wave of Science Studies: studies of Expertise and Experience, 2015

Wave 3 and Wave 1 differ epistemologically and politically. Knowledge and truth are grounded in scientific procedures; expertise is most often grounded in experience. Expertise extends into the public sphere whereas access to knowledge and truth is strictly bounded.

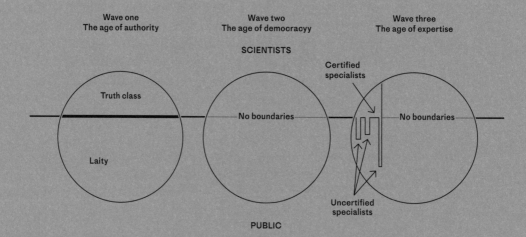

Wave one
The age of authority

Wave two
The age of democracyy

Wave three
The age of expertise

SCIENTISTS

Certified specialists

Truth class

No boundaries

No boundaries

Laity

Uncertified specialists

PUBLIC

As the chart indicates, by wave three, the activities of both certified and uncertified specialists represent a shift toward social consciousness, which has developed its specific character from several related phenomena: The public's frustration with top-down style communication methods by experts and the scientists' need to address citizens who are both more educated and more sceptical than in the past. All this, within a general climate of increasing mistrust for expertise, authority and institutions in general! Traditionally experts were divided into two categories, interactive and contributory experts, but now these boundaries are being blurred and as Evens and Collins suggest, the only difference is that the contributory group also make practical experiments.[5] "Interactive experts" begin with "no expertise" then delve into social interaction and contexts to learn about the science (they often provide questions about the topics even though they are not specialists) and finally, they do not conduct practical experiments in the field. By contrast, contributory experts follow the same path, but in addition gain the necessary practical expertise to contribute fully to an investigation or field of endeavour. It is in this contributory group that the modern art researchers are starting to locate themselves.

Just five years ago, the authority of scientific expertise was challenged yet again in a series of revelations of the apparent, increasing commercial manipulation of scientific information favouring private, corporate interests over public, scientific interests. One of the most infuriating examples of this intervention is the funding of GM research professorships in universities by the US-GM seed company Monsanto. Members of newly-formed groups such as "The European Network of Scientists for Environmental and Social Responsibility" (ENSSER)[6] now regularly meet with social scientists and NGOs to consider matters related to the commonweal. As a member of this group, it is clear to me that most scientists are very concerned about the shift in science away from the public good and toward commercial gain. Science communicators are also concerned about the determination of the course of science education. Should their efforts include more community engagement and input or should their content be dictated by the concerns of industry sponsors? As shown by a document in the proceedings of the annual conference for European Science Museums (ESCITE) a re-examination of the roles of the arts and the sciences can be a means to further critical thinking in the public realm and cultivate an open response to

5 Ibid Collins, H, Evens, R 2015
6 See, accessed 2 February 2016, www.ensser.org.

failure as a not unusual part of scientific investigation.[7] Therefore creative approaches to communicating and engaging in science are being sought with the hope that the processes and politics of experimentation in science can slowly become more available to the public.

Today few would dispute the wisdom of these so-called "socially responsible inquiries" to speak across outmoded disciplinary boundaries and to engage multiple audiences. But there are, of course, still problems in bringing together artists and scientists in these debates. Social scientists still complain about a lack of information and access to research, while art historians lobby for interpretation and poetic metaphor at the expense of description and widely understood analogies (Bippus 2014). Even the definitions of terms like "value", "knowledge production" and "contribution", not to mention "innovation", need to be addressed. The culture of science is undoubtedly changing, as is the culture of the arts. I claim that the facilitation of art-science incubators may simultaneously be able to help clarify some of this confusion about experts and to forge novel approaches from the sharing of experimental processes and evidence.

2. Explicit Evidence as Inspiration

For this incubator to be nurtured, it is necessary for artists to experience how scientific evidence is made "first hand", because consistently surveys have overwhelmingly proven that experts are always made, not born (Ericsson 2006).

Furthermore, for artists, tacit knowledge can be increased by social interactions in a given spatial environment where explicit knowledge is prioritized.

While scientific evidence may seem less open to interpretation, what happens when more socially-attuned researchers, like contemporary media artists, filmmakers, theatre directors, social writers or exhibit builders work from "what is", rather than only from their imaginations? For them the challenge is to find poetic metaphors, analogies or other resonant imageries that can be abstracted from scientific evidence and applied to pressing social issues. Cultural constructivists assert that knowledge and reality are products of cultural contexts and change accordingly, but I argue for the potential of art research to become "useful": In other words, to become more scientific. Both artists and scientists are likely to emerge

7 KiiCs: Knowledge Incubation in Innovation and Creation for Science was a European Union project involving both art and science institutions that promoted creativity as a means of reaching new audiences, accessed 2 March 2016 www.ecsite.eu/activities_and_resources/projects/kiics.

stronger from it! This trajectory is an extension from some of the post-renaissance history, where art was locked in step with scientific advances to understand how sight worked and visual representation. Artists have long been interested in perspective, evidence of "reality" and the process of filtering their own interpretations about the world, and realize that by entering foreign environments many "ahah" moments can unfold. Many artists share the passion of the scientists to investigate the behaviour of life forms. We found that this experience was reciprocal and it encouraged further collaboration and the exchange of research practices. For example, some artists might actually appropriate some methodologies from neuroscience, environmental ecology or computer science for their own work. It seems that their own more "tacit" processes of collecting evidence and new technical methods to represent data are especially interesting for scientists, because novel ideas and surprises may emerge.

In my case, this interest was concretized fifteen-years ago when I founded the artists-in-labs program in Switzerland, which initially aimed to provide artists with immersion inside the lab's culture of scientific research. The goal was and still is the development of artistic interpretations of experimental research through artists' "hands on" access to the relevant materials, data, debates, conferences and tools available in life science as well as in physics, computing and engineering labs. However, it soon became apparent that some scientists benefited from listening to the artist's aesthetic development and knowledge of semiotics, highlighted by lectures by the artists on contemporary art and by watching their processes of making art happen. This incubator continues to encourage further collaboration between both sides, ranging from the discursive to the exchange of research practices and methodologies. The outcomes are difficult to generalize, because all the experiences differed in many ways, but let's begin with our own statistical popularity of the need for this kind of incubation. Over the past 14 years, 40 scientists have hosted over 40 artists in their labs as residents, devoted to diverse disciplines including integrative biology, genomics, forest snow and landscape research, aquatic science, cognitive science, psychology, physics, micro-technology, computer systems, ecology, artificial intelligence, neuroscience and medicine.[8] The artists also came from very diverse fields of practice — poetry, media, sound, design, drawing, dance or film — and they applied to very specific cultures for scientific research. They all aimed to find strong images and revelations that

8 A comprehensive list of science lab partners from 2000–2014 is available on the artists-in-labs program website, accessed 20 February 2016, www.artistsinlabs.ch.

"speak" new thoughts or apply familiar strategies like satire, chiasmus, irony, characterization, simile or oxymoron to communicate their interpretations. What follows here are a few "case studies" of artists who have benefited from their exposure to scientific evidence, by engaging in immersive collaborations with ecologists, computer science experts, and neuroscientists. In these four cases, which are extended by the artists and scientists themselves in this book, knowledge can be cumulative experience that they have developed from their own field of practice and, as well, those "truths" abstracted or appropriated from science.

For those who are interested in art and ecology, these "truths" from the sciences are representative of a "movement" of artists who are interested in eco-sustainability. Beginning in the 70s with artists like Mel Chin[9] this "movement" has now grown into a community with thousands of members. Many of these artists who have worked alongside environmental scientists find their hybrid art contextualized by the following questions: What is our relationship with the natural environment in the 21st century? How has technology influenced the way we interact with this environment? What are the possibilities and problems posed by technology in relation to environmental change? What is the future of the natural environment and society?

When artist Christina Dell Giustina applied to our program, she was aware that these inquiries are part of a shared concern about the degradation of nature with biologists and ecologists. In her residency with eco physiologists at WSL, she used her own learnt methods of drawing, prose and interaction to understand how, over time, the stomata, the tiny interactive plant cells breathe in carbon dioxide and expel oxygen, while water provides various level of nourishment from inside the trunks of trees and can be mapped by processes (i.e. dendrochronology). Her own experiment started with the sonification of this data gathered from the seasonal levels of these nourishments and together with scientists Andreas Rigling, Marcus Schaub and Peter Waldner to design another incubator: A workshop at the primary school in Susten, in the Canton Valais, Switzerland. The outcome was a very beautiful sound concert for all listeners and participants, an ode to nature for the Montreux Jazz Festival. As a member of this audience, I was deeply touched to hear this "tacit" experience, and one that may have changed the lives of those children forever who played this ode. Here sound was used as a strategy and

9 For Example, *Revival Field*, the collaborative work of Mel Chin in 1959 with scientist Rufus L. Chaney, from the United States Department of Agriculture: This work and other eco-artists co-operations can be found at, accessed 20 February 2016, www.greenmuseum.org/c/aen/Issues/chin.php.

to clarify the necessity of the water cycle for the seasonal life forces of the tree, akin to the necessity of the plant's production of oxygen for our survival. Even the scientists say that this experience "stimulated their efforts to gain an overall view on the understanding of the functioning of forest ecosystems and to identify important gaps in knowledge".

This carefully recomposed interpretation of behavioural data from science, was laced with personal visions to promote environmental stewardship among our youth. Here the role of the artist is closer to the idea of a context provider, a definition that has also led artists to share their own methodologies online. For example, the artists-run web site: *www.greenmuseum.org* also teaches others how to do this kind of environmental art. There you will find toolboxes, working methods for educators and sets of communities that recommend creative methodologies for others to try out. Thus very personal levels of interpretative filtration of scientific evidence are transformed into secondary incubators for others to share similar experiences.

Investigations like this can even lead to both artists and scientists to pair up and perform together on the stage. In another experiment called *Heart Culture,* musician Steffen Schmidt investigated the evidence from cartography, while resident at CHUV hospital in Lausanne. There he collected and recomposed the Doppler sound echoes from the patient's recordings of their heartbeats, with the standard diagnostic instrument they normally use: The Ultrasound Machine. However, he became fascinated with the fact that this machine can not only evidence sounds from the opening and closing of the heart valves, but monitor changing velocities and consecutive frequencies of the blood flow through the heart. There he resided with the other researchers in the basement, and composed sound essays with novel sound design artefacts and rhythmic analysis that were re-appropriated as sounds for a concert improvisation. The other performer was the head of the hospital who actually played Ultrasound Machine as a sound instrument on stage. Thus, the collaboration in this incubator taught the scientists how to develop more "careful listening" rather than over-rely on the reconstruction of images by such a machine for their diagnosis. But the aim was also to offer the listeners at the Montreux Jazz Festival a new sensory experience that harked back to Alvin Lucier's experiments with EEG brain analysis[10] and play their part in the broadly conceived realm of aural perception in cognitive science.

10 Related works by Alvin Lucier can be found at, accessed 2 March 2016, www.alucier.web.wesleyan.edu. A video of *Music for a Solo Performer* (1965) can be seen at, accessed 2 March 2016, www.youtube.com/watch?v=7Mb1H8LeGeg.

This interest to combine evidence with visual interpretation is particularly popular in interactive media, where technical experiments by both artists and scientists are conducted that encourage the direct visceral response of the viewer. This nurturing is based on bodily immersion in new information and is paramount to the creation of "affective" experiences (Paul Dourish 1995). Residencies in the neurosciences have turned media artists into longer-term researchers and given them the chance to engage with scientific experiments that are focused on the understanding of bodily perception.

This crossing is an historical extension of art and technology and creative forebears in this fusion can be traced back at least as far as 1966, when *Experiments in Art and Technology (E.A.T.)* organization developed collaborations between artist and engineers. Here Billy Klüver and Fred Waldhauer of Bell Labs in New Jersey worked with artists like Robert Rauschenberg and Robert Whitman (Hulten and Königesberg 1966). However, in the last 20 years, these collaborations have moved into a focus on experiment building that also integrates experts from computer science, neural networks and augmented reality. In the Native Systems labs at the Swiss Federal Institute of Technology ETH, where they specialize on optimization and simulation, but also on uncertain subjects like data mining, haptic learning and artificial neural networks. Here media-artist Marie-France Bojanowski, worked with experts to augment haptic feedback and to explore the control of visual narratives. In this book she documents the process of learning about their visions of a neuro-haptic hand-held computer as well as the physical restriction of the technology to realize them. Together they became a team that grappled with the challenging ideas of mind control, using very basic EEG assistance, resulting in a collaboration that continued long after the end-date of the residency. Here the concerns about the role of technologies to be a mediator between the artificial and natural potentials for embodiment or immersion are shared. In fact, technology nurtures a communication channel for the transfer of knowledge between the researchers. Furthermore, this experience inspired Marie-France to use different visual metaphors than those used in science to transport these ideas to the users. However, it also allowed her to witness the affect of her integration on the scientists. By offering "new ways of seeing" artists can influence the scientific process. As the diaries by the artists in our publications

show, this is a type of experiential learning that is furthered by negotiations and debates about the values of "tacit knowledge" and "explicit knowledge" (Scott 2010). In such incubators, associative brainstorming and logical deduction, are often important methods for information transmission.

Most media artists believe that bodily immersion and hands on activity can cause an increase in sensory stimuli and cross-modal interaction. Our brains are only one part of the complex loop that makes up all of our afferent and efferent receptors. However, it is only through cultural associations that reflection and imagination evolve. In neuroscience, brain plasticity is based on the forming of new connections between brain neurons that are enhanced by the environmental co-stimulation of more than one sense at a time. These conclusions have also been pondered by psychologists who explore how visitors relate to the stimulus of interactive exhibits. At the Exploratorium Museum in San Francisco, for example, it has been found that interactivity promotes memory relations, especially when the exhibits are sufficiently complex to stimulate group discussion (Ilen and Gutwill 2004). However, if these experiments are badly designed, then the opposite happens: A complete lack of know-how transfer!

Another artist who is featured in this book, Nicole Ottiger, experimented with the very mediated platforms and associated methods that provide scientists with information about this level of bodily interaction. Through her prior work as an art therapist and her interest in drawing, she became interested in sensorial experiments that could stimulate brain plasticity through bodily confrontation. During her residency at the Brain Mind Institute at EPFL in Lausanne this interest was nurtured by offering herself as a physical subject in the scientist's experiments. Taking her point of departure from philosopher Maurice Meleau Ponty's suggestion: "In the act of perception, the body plays both a temporal and a central role", she began a series of artistic research that investigated the nature temporal and central sensory perception (Merleau Ponty 1945). Where, for example, is the real edge of the body? What constitutes "the represented self"? In this light she conducted a set of tacit incubator experiments that fosters a coupling of media art and neuroscientific discovery — a mixture of artistic subjectivity and scientific objectivity. In cultural anthropology they also focus on how tacit knowledge connects to the embodiment feedback loop between the body and its representation and the "affect" of our environments on our

bodies and our behaviour.[11] Why, they ask, is the word "affect" so closely aligned with the energetic, dynamic and new; while emotion is often cast as static, deadening, ossifying? This important question about "affect" is explored by both Ottiger and Bojanowski because they want us to re-discover our bodies, our representations and our sensorial complexity in new ways. Even though these practical applications and representations often have unchartered outcomes, they do tie into similar measurements and the behavioural aims that are currently explored on the frontiers of neuroscience.

Today in our overcrowded society, where the emphasis is on personal achievement, I think that these inquiries are also related to our survival. We must strive to understand "how we think about our representations" and its relation to "what we think about our bodies" and if our artistic experiments can become a kind of "canvases" of the collective mind. The aims here are not to disturb or provoke, but to create an interactive space for thought and reflection about the capabilities of our body-mind amalgams. Put another way, artists who are interested in the sensorium and the inner working of the human body are conducting systematic investigations that respond to or are guided by a problem or a set of questions about perception. Here an incubator may even provide a space for others to share these investigations.

For the arts interested in neuroscience, another pertinent and challenging discussion is the emerging field of "Neuroaesthetics". Here cognitive scientists attempt to understanding the neurobiological basis and evolutionary history of the aesthetic judgment so central to art and other creative activities.[12] Only a small amount of contemporary artists are involved in these studies, even though our collaboration would seem essential. Certainly we would contribute pertinent responses to generalizations about the process of looking, but we would seriously question if such scientific tests are applicable to all kinds of art, rather than the mediagenic output of art objects produced for the commercial art world. We claim that it is time for these neuroaesthetic scientists to come to us — the modern artists, and learn something about the semiotics of communication (Scott, Stoeckli 2013).

11 Cultural anthropologists McGrail, Davie-Kessler and Guffin pose the following questions about "affect and embodiment": How must affect theorists understand "language" in order to then oppose it to "felt bodily intensity"? Why is affect aligned with the energetic, dynamic and new; while emotion is cast as static, deadening, ossifying? How must both time and the social be understood such that affect is presumed to come before the social, without being non-social? Finally, what is at stake in the conversations about affect, and what research and analytic tools do anthropologists possess in order to begin to address them? For more information see, accessed 2 March 2016, www.culanth.org/curated_collections/16-affect-embodiment-and-sense-perception.
12 One can find a very positive networked group of cognitive scientists exploring this field on, accessed 2 March 2016, www.neuroaesthetics.net/neuroaesthetics.

Surely, the majority of neuroscientists, would also like to communicate better and more directly to audiences of various kinds — expert, lay and in-between — through publication and coverage in mass media, as well as via the medium of the science museum, whose *raison d'être* is communication between scientists and museum public. But what follows are a set of revealing comments from the neuroscientists who participated in the artists-in-labs program regarding the benefits they attributed to working with artists (Scott 2010).

"Working alongside a media artist allowed us access to different approaches and points of view about our own research and how to bring it to the public."

"It gave us the ability to see an experiment from another perspective and to think about building our own differently."

"We gained a lot of training in answering all those great "why" questions from the artists. We liked to discuss ethical issues with them."

"The know-how transfer of neuroscience is easier than we thought to non-scientists who are interested in perception."

"It was interesting for us to watch the interpretative art process unfold — from conception to production and presentation of the art work."

"We realized that art could be a catalyst for the opening up of more discourses about perception in the future."

How heartening are these responses! We regard them as direction for producing new strategies for the creative commons incubator. We claim that artists can construct interpretative filters for scientific information: Ones that humanize science and investigate the borders of objectivity. But we believe that subjective and cultural themes do not cloud communication channels, force generalizations or cause over-simplifications. In the creative commons ignorant assumptions about either field of practice will help us to work together on our big problems of the future. Indeed, the 1950s idea pushed by artists like French painter Georges Braque that science reassures and the role of the artist is simply to provoke and be ambiguous are extremely old fashioned.[13] Artists are now designing experiments to understand life, to promote post-reflection from a designated audience or even include the public as part of their process. They favour incubators that are tacit and hands-on, where deeper levels of lateral trans-disciplinary communication, problem solving and interpretation can be bred based on a creative commons.

13 A critique on the quote by Braque from 1957: "Art is made to disturb. Science reassures. There is only one valuable thing in art: the thing you cannot explain." Can also be found in Dempster, M A 2014, Risk and Uncertainty in the Art World, Bloomsbury Publishing, London.

At this point, one might ask why practitioners in the arts are leading this inquisition into science rather than vice versa? As I have outlined artists do wish to create experiments from a lateral and critical perspective but with the inspiration from deductive and inductive influences. They want to learn and question the observation of behaviour, collect analogous and postulate information in new ways, and have a chance to learn some robust facts and finally be inspired to help raise issues in the public realm. While in the building of scientific experiments, creativity requires motivation, an access to a body of systematic knowledge, an ability to correctly formulate research problems and to define a comprehensive problem space or search space, art and design experiment building tends to cultivate a very playful process that includes assembly, reduction and even changes in direction. Here creativity is linked to lateral thinking — an open improvisational process of where one is required to "be original". So art and science are pleasantly different from each other in these ways.

In our incubators, we have been particularly interested in alternative approaches to communicating scientific information through artistic interpretations and trying to raise awareness in the scientific community about how images are never culturally-free. This is where the idea of "the commons" finds its cultural nourishment.

However, as most pedagogics have long realized, this "commons" must also become a place where cultural anchorage and social negotiation is encouraged by "hands-on" experimentation (Piaget 1947). I claim that emergent understandings and the provocation of unorthodox responses can only "breed well" in such a practical part of "the commons". In this "commons" we facilitators have strived for artists to open access to information and this is why we document and film each artists' and scientists' creative experiences and problems from past engagements.[14] I am less interested in online blogging by individuals, than in the rich potential for advancing science and other forms of knowledge that might emerge from bringing together individuals from disparate disciplines to work together face-to-face, in the same physical space.

While residencies today exist in varied disciplinary spaces and communities we still need more spatial educational facilitation on the institutional level. I think it is time for educational establishments, for example, to offer combined art and science degrees at all levels, running from Bachelors' degrees through PhD level. Art historians like John Onians, have pushed for a 14 ibid.: Artists-in-labs, Scott (see case studies)

new educational track in art schools called "Neuroarthistory" because he believed perception studies are essential for art students (Onians 2007). But this fusion is also needed for practical experiment-building, where hybrid methodologies can be worked on by teams. There is certainly a need for it — as can be witnessed by the international rise in technically — accessible DIY maker groups, fab labs and hacker groups.[15] These groups often cite that one of the oldest meanings of commons in medieval agricultural communities was the sharing of at least one agricultural field for the nurturing of the team spirit.

Can science ever emerge from art through the building of art experiments? While some artists hope that their work provides a positive answer to this question, others hope that their experiments offer and embody alternative methods of communication to science communication. Some scientists presume that an art-science collaboration should always offer a win-win exchange, with equivalent benefits for each discipline. As I have learnt through my own analogies and observations of the teamwork in neuroscience labs, hatching art and science experiments may require a similar level of coordination that is needed not equal nor competitive.[16] For example, the following hatching procedure for chickens in incubators may carry interesting analogies for teamwork:

The incubator should be placed away from drafts, dirt and out of direct sunlight. The location for know-how transfer in the commons may need to be free from ideas that are cold, hoaxes or over-heated debates

Sanitation is very important to keep down the bacteria, before setting any eggs clean the incubator. The communication pathways in the commons may first have to be cleaned up or clarified by sharing definitions and discourses.

The team must become familiar with the style, materials and calibration of incubator needed for the hatching process. In the commons the tools and the materials may need to be calibrated to suit other disciplines.

The team needs to insure that the temperature fluctuations are normal but an average range kept in place. The level of the discourse in the commons should be maintained by facilitators and regular interactions.

The temperature, humidity and ventilation needs to be monitored by the team. Regular interaction in the commons should be maintained and shared with all the members of the group.

Physical turning of the eggs keeps the embryo from floating and coming in contact with the shell, to which it may stick. Sticking to the shell may result in a poor hatch. Turning the egg, prevents premature adhesion of the embryonic membranes, facilitates movement of the embryo into the normal hatching position. The themes should be rotated so that the successful growth of ideas in both fields of practice can be nurtured.

From this personal experience with "real" incubators, I realized that there is also a mutual team based respect for other experiment building to support a variety of life forms and that this level of care is not only relevant to practitioners in both fields of practice but — thanks to any history of mutually-derived advances — to society at large.

Within this ethic lies the concern that some problems may be unique and therefore may even have to be "grown in" more public incubators with different conditions.

15 As examples of these DIY maker-movements see, accessed 1 January 2016, www.hackteria.org or www.fabfoundation.org/fab-labs.
16 The Visual Systems lab. Neurobiology, University of Zurich. Switzerland, accessed 12 December 2015, www.imls.uzh.ch/research/Neuhauss.html.

These public incubators are places that often scare scientists! Here know-how transfer borders on the controversial, where science-related matters of nature such as genetic research or climate science are often "downsized" for dummies. True, the views of various publics often lack the potentials of a common vocabulary with science. As with so much public discourse, the tone of the discussion can be polarizing because opinions are often already naively formed. Even though such discussions might take place online in the blogosphere, a respectful educational exchange of expert-views is sorely needed. If artists study science, then they can offer scientists new languages and descriptors for communicating their intentions and plans, because they are trained in semiotics, poetic metaphor, visual analogy and critical analysis — educational factors that are often seen as far from the realm of the sciences.

Today we do not need explicit knowledge to be communicated in a top-down fashion, but we do need tacit and semiotic knowledge to humanize science, promote common sense and instigate positive actions for educated members of our society. Just consider this refreshing example, that of Lisa Cartwright, a social scientist who regards molecular and cellular images of the body as "self-portraiture" (Cartwright 1995). She asserts that these images of the scientific analytical gaze shift people's distinctions between the interior and the exterior of the body, but its the behavior of these small life forms in the incubator world, that remind us of cinema and provide us with microscopic windows about our own behavior. How marvelous a means of bringing the lure of the visual to bear on the behavioral problems of the body felt by so many!

References

Bippus, E, 2014, *Bildung im Neuen Medium - Education Within a New Medium*, edited by S Munte-Goussar, M Scheibel, T Meyer, E Bippis, Waxmann Verlag, Münster.

Labinger, J A, Collins, H (Eds) 2001, *The One Culture: A Conversation about Science*, University of Chicago Press, Chicago.

Cartwright, L 1995, *Screening The Body: Tracing Medicine's Visual Culture*, University of Minnesota Press, Minneapolis.

Collins, H, Evens, R 2015, 'The Third Wave of Science Studies — Studies of Expertise and Experience': in S G Brush, *Making 20th Century Science: How Theories Became Knowledge*, Oxford University Press, New York.

Dourish, P, 1995, *Where the Action is. The Foundations of Embodied Interaction*. MIT Press, Cambridge MA.

Ericsson, KA 2006, *The Cambridge Handbook of Expertise and Expert Performance*, Cambridge University Press, Cambridge MA.

Hultén, P, Königsberg, F 1966, '9 evenings: theatre and engineering', in *Experiments in Art and Technology: The Foundation for Contemporary Performance Arts*, 14.

Ilen, S, Gutwill, J 2004, 'Designing with multiple interactives: Five common pitfalls', in Curator 47(2), in *The Museum Journal*, AltaMira Press, Academy of Sciences, Rowman & Littlefield Publishers, Washington DC, pp. 199-212.

Labinger, J A, Collins, H (Eds) 2001, *The One Culture: A Conversation about Science*, University of Chicago Press, Chicago.

Merleau Ponty M 1945, 'The Phenomenology of Perception', in *Histoire de la philosophie, 111. Du XIX Siecle a non jours*, Encyclopedie de la Pleiade, translated by Landes, A D, republished in 2012 by Routledge, Abingdon, Oxon.

Onians, J 2007, *Neuroarthistory: From Aristotle and Pliny to Baxandall and Zeki*, Yale University Press, New Haven.

Piaget, J 1947, *The Psychology of Intelligence*, republished in 2001 by Routledge, Abingdon, Oxon.

Scott, J 2010, *Artistsinlabs: Networking in the Margins*, Springer, Vienna, New York.

Scott, J, Stoeckli, E 2013, *Neuromedia: Art and Neuroscience Research*, Springer, Heidelberg

Nicole Ottiger, is an artist
and researcher who lives and
works in Zurich, but she is
also an art psychotherapist
and deputy head of art
therapy at Ateliers-Living
Museum at the Cantonal
Psychiatric Clinic Wil/SG
Switzerland. She has a Master
of Arts in Art Psychotherapy
from London University Gold-
smiths, and in a BA in Fine
Arts from Lucerne University
of Applied Sciences and Arts.
Currently, she is also a PhD
candidate in Visual Arts at
the University of Plymouth
UK. Her research is focused
on self-representation and
the relationship between
illusory and disturbed "own"
body recognition in the arts.
She received the following
art grants: Agora SNF Grant
for Art and Science in Prac-
tice (2012), ZHdK, artists-
in-labs residency at the Lab-
oratory of Cognitive Neuro-
science (2010) and Studio
Arts Grant at Cité des Arts
Paris (2009), 2008 Studio
Art Grant Fundaziun Nairs.

In 2002, her artist book
Squint/Silberblick was
published with ars pro toto
Verlag, Luzern.

Laboratory of Cognitive
Neuroscience,
Brain Mind Institute (BMI),
École Polytechnique
Fédérale de Lausanne

Our Goals: The research at
the BMI focuses on three
main areas: Molecular neu-
robiology and mechanisms
of neuro-degeneration,
Molecular and cellular
mechanisms of synapse and
microcircuit function up to
the behavioural level and
including metabolic aspects
and sensory perception and
cognition in humans. We
focus on understanding the
fundamental principles of
brain function in health and
disease, by using and devel-
oping unique experimental,
theoretical, technological
and computational ap-
proaches. We also combine
different levels of analysis of
brain activity, so that cogni-
tive functions can be under-
stood as a manifestation of
specific brain processes, as
they emerge from the

collective activity of thou-
sands of cells and synapses.
Synaptic and neuronal activ-
ity in turn are emerging
properties of the biophysical
and molecular mechanisms
of cellular compartments.

Researchers involved in the
Residency: Prof. Olaf
Blanke, Head of the Labo-
ratory of Cognitive Neuro-
science, Dr. Anna Sforza and
Christian Pfeiffer, PhD can-
didates.

bmi.epfl.ch

Explaining the Edge

Thoughts on Self-Representation in Art

A Looping System Forth – Which Art Making and Research Always Will Be!

Thoughts on Self-Representation in Art

A Looping System Forth—Which Art Making and Research Always Will Be!

How is reality generated? While inner perception is contrary to outer perception, what kind of given reality is presented while recording the inner images involved in the displacement of a body? If displacement is awareness and a form of self-consciousness, I attempted to measure this visually, objectively and subjectively in a phenomenological way, using low-tech art equipment (video camera and other visual media). My aim was also to explore how creative a "subject" behaves in scientific test conditions. I worked with the subject's sense of body experience and documented the perspective of the subject in a basic way, with and without neural links to see if I would come up against any correlations. The documented recordings were part fact (reality) and part fiction: fact being short video sequences while the subject was wired up to virtual-reality, and fiction—images created by the artist—based on recollection of awareness and emotions during these tests.□1

Having set out to research about the self/body and consciousness, applying the visual

Based on the interview Nicole Ottiger conducted with Olaf Blanke at the Brain Mind Institute ("A Looping System Forth *which Art Making and Research always will be!*", June 2015)

One of the things I truly appreciated as an artist-in-lab in the Laboratory of Cognitive Neuroscience at the Brain Mind Institute, EPFL Lausanne in 2010, were my long discussions with Olaf Blanke about self-portraiture and art, while the BMI was working on neuro-scientific research about the phenomena of the "self" and concepts of the "corporeal self".

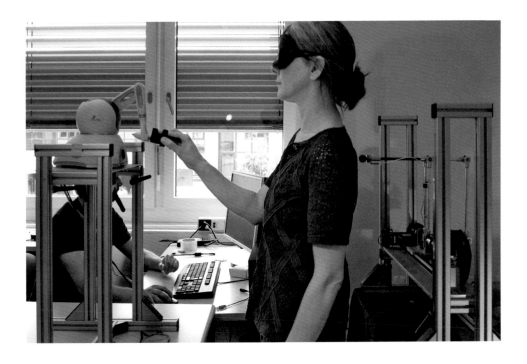

☐ 1 Artist Nicole Ottiger as test subject subject
in the Feeling of a Presence (FoP) experiment (2015)

Nicole Ottiger: Let's first talk about one of the latest discoveries the lab has made—the "unravelling of the ghost".[1] The researchers found a way to induce the illusion of experiencing an uncanny mysterious presence—a ghostly presence.

Olaf Blanke: Yes, for a long time these ghostly sensations have been described by people outside the clinical context. However, in my work as a medical doctor and neurologist I also met several patients who told me about such experiences. The first time I came across somebody who had experienced this in the context of a disease was at the Neurology Clinic of Geneva. I talked to that patient for a long time because back then, neurologists had a lot of hypotheses, but nobody had a good model of how to really explain it. At first I wanted to compare stories by people from a long time ago with

1 O Blanke, *How to down-regulate a "ghost"*, accessed 1 December 2015, www.youtube.com/watch?v=vS5QAqMyPjU

arts as my medium, I also wanted to determine what roles immersive, virtual environments take and play in "measuring" self-consciousness. These aims did not change throughout the residency but evolved the more I learned and the more aware I became. I had access to lab equipment, scientific literature and the lab's databank. I attended the weekly lab meetings, lunch lectures and conference lectures, PhD Seminars as well as discursive meetings with Olaf Blanke, all of which shaped my thinking.

My project contained the following three aspects

1 *"I" as the subject and object of experiences* (I can only feel to be my experiences) — when I perceive, think or feel something, then the "I" seems most present. Being a subject (test-person) in a number of lab experiments intensified this "experiencing" of the self in relation to specific questions about the consciousness of the self and subjectivity that neuroscientists strive to experimentally control and measure. I immensely enjoyed these test conditions as they were "live", active, hands-on opportunities to understand what the scientists were researching, through experiencing one's own self reactions and behaviour in such conditions. I also could reflect about the many forms of experiments, which in some cases I used in my art practice.☐2

2 *The "artist" as a scientific researcher,* exploring "right" and "left" brain contribution to art making and art perception. In collaboration with Olaf Blanke and Anna Sforza (post-doc researcher in psychology) we devised a way to "experimentally measure" the influence of brain hemispheric lateralization in art perception, systematically. I developed a pilot study, through discussion, and first trials with re-adjustments to account for subjects' behaviour and unpredictability in such tests — linked also to finding the most suitable method of test instruction, and how to account for the risk of chance, and how to randomize the test. I came to appreciate just how creative neuroscience can be. From the sixth month I was able to begin with controlled scientific collecting of empirical, experimental data about the right

very recent ones to see whether they had the same experience. They may have suffered from the same disease, which could be migraine or epilepsy; but others who experienced the same sensation were completely healthy. It was very nice for patients to know that they are not the only ones in the world who have such a strange experience, because it really is a sensation.

This is what most of them told me: "you're walking, you're sitting, you're standing, you're lying in bed and then you suddenly have the strong feeling that somebody is just behind you, very close — at arms' length" — normally that was what the patient said — "and never in front, never to the right, never to the left, always in the back. And when you look around, there is nothing there. And when you look back to the front, the convincing, very convincing feeling is that somebody was

☐ 2 *Video Ergo Sum Series, Third Person no. 3* (2010/11)

Laboratory of Cognitive Neuroscience, Brain Mind Institute (BMI)

and left hemispheric contribution to art style and perception. I was excited! The first such experimental study was about perception of style: *drawing hand (right and left) & artist.* The second perception of style study involved *epoch (early and late cubism) & artist.* The third study was to re-confirm the data from study 1 in a different sample. This procedure was conducted to validate the first results, but also to see if we could develop a setup that is PC based allowing future reaction time measurements (RT) and accuracy analyses.

Almost since the very beginning we discussed "using" the artist and her tools and ability to make a visual work to learn more about the hemispheric lateralization and art perception. Thus, the fourth study was based on classical work on hemispheric specialization, where for example a lexical decision task using right visual field (RVF) dominance for word/non-word discrimination, is carried out. We set up an experiment in which I drew selected images after a single visual exposure. The exposure time was 50 milliseconds, and flashed to a point outside the fovea (> 10°).[1] Images were presented to the right visual field (RVF), left visual field (LVF), and I drew the images with either the right hand (RH) or the left hand (LH). The RVF-RH and LVF-LH setups can therefore be considered to be "pure" left hemispheric and right hemispheric drawings. This experiment is still ongoing.☐ 3/4

3 *The artist researching the genre self-portraiture,* within the mediums photography, drawing, painting and video. With a long personal interest and history of self-portraiture, a central question remained constant throughout my residency: Why do artists make self-portraits and what makes them so particular in comparison with other self-representations? Other persistent questions include: What is the self? What is I/me? What is the body? How/why does a body sometimes dissociate? What is the body in space? What is the appearance of one's own body? The feeling of being in your own body and to possess it, is a fundamental human experience and closely linked to our subjective first-person perspective of the world. But

there"—it is like feeling a presence like the one between you and me right now, but of course I can see you and I can hear you as opposed to the patients who have experienced this "ghostly" sensation of a presence. Neurologists have debated about this phenomenon for long time: is it a hallucination? Is it an illusion? But how can it be a hallucination when you can't see it, when you can't hear it? I interviewed many such individuals, and in one particular individual we were able to induce the sensation in a repetitive fashion. Each time we directed a light current to a certain part of that young patient's brain during diagnostic evaluations, the presence appeared. This convinced us that there is a clear biological underpinning of it, and we observed a certain number of other illusions that we have now been able to induce by building a robotic stimulation system, also using virtual reality.

where it originated and how it works, is very much an on-going research. And, is it important for artists? These questions led me back to concepts of self-portraiture.

In a self-portrait the artist renders the intimate representation of the own personal self and it may be regarded as a method of investigation on oneself, both physically and emotionally. While rendering a self-perception the artist extends the represented self beyond the perceived self. In some painted and photographic self-portraits the painter is represented twice — a reduplicative phenomenon,[2] as the *painting painter,* by choice of technique and mode of expression, and, as the depicted subject the *painted painter.*[3] How the artist represents his/herself is ultimately the artist's decision and therefore it does reveal self-consciousness. The painted artist is often depicted as having a vision that is both directed to the world, at one's own appearance and as a source of insight (inner awareness). In virtual surroundings of today's world (digital media) we are generating lots of virtual selves. In art representation a virtual self was always observed and recently it seems to have re-gained a figurative (bodily) element.

By example of an artwork series (*Third Person, Video Ergo Sum Series*) that I created during the residency, I demonstrate the methodology and reflect on artistic practice within a scientific environment.

We normally experience our conscious self as localized within our body. However, in certain neurological conditions such as out-of-body experiences, this spatial unity may break down leading to a striking disturbance of self-consciousness.[4] Laboratory of Cognitive

1 The fovea centralis (the term fovea comes from the Latin, meaning pit or pitfall) is a small, central pit composed of closely packed cones in the eye.
2 Blanke, O 2007, 'I and Me: Self-Portraiture in Brain Damage', in J Bogousslavsky, Hennerici, MG (eds), *Neurological Disorders in Famous Artists — Part 2*, Front Neurol Neurosci, Karger, Basel, vol 22, pp. 14–29.
3 Cf. Bonofoux, P 2004, *Moi! Autoportraits du XXe Siècle*, Milan; Pächt, O 1991, 'Das Selbstbildnis', in: E Lachnit (ed), *Rembrandt*, München, pp. 65–78.
4 Lenggenhager, et al 2007, 'Video Ergo Sum: Manipulating Bodily Self-Consciousness', in *Science 317*, pp. 1096–99.

Nicole Ottiger: What is that installation like, for a test-subject?

Olaf Blanke: You, as a test person would be standing. A manipulator would measure your arm movements, and then we use a robotic device, which uses the signals coming from the manipulator, and feeds them back to your body. While you move your arms to the front, we have a "Lao-tse" robot finger programmed so that it touches you in the back.[1]

Nicole Ottiger: Is the robot calibrated to my own speed of touch?

Olaf Blanke: It's calibrated to your speed, to your force and also to your timing and the place. While I move to the right, the robot finger would move to the right. If you do this synchronously, meaning if it touches you on your back, you feel it at the same time as you move your hand, there is no illusion. But you have the strange sensation of touching yourself in the back when you're extending your arm forward, which is

Thoughts on Self-Representation in Art

A Looping System Forth — Which Art Making and Research Always Will Be!

Neuroscience (LNCO) researchers found that during multisensory conflict, participants *felt* as if a virtual body seen in front of them was their own body.[5] Participants also mistakenly localized themselves towards the virtual body and thus to a position outside their own bodily borders.[6]

A version of the LNCO's experimental tool and set-up designed to use conflicting visual-somatosensory input in virtual reality to disrupt the spatial unity between the self and the body[7] was adapted and used to explore the virtual nature of the self in artistic practice. I (as the artist) wore a virtual reality (VR) setting—VR goggles[8] connected to a video camera—that immersed me into the body of my avatar while drawing my self-portrait *("Third Person", Video Ergo Sum Series).*

The neuroscientific experimental set-up and method is a simple yet intriguing one: It makes use of video-projection and virtual reality technology in order to enable me to get a view of my external self, of my own body, from behind, in 3D creating the impression that I was standing two meters in front of myself during the art making process. This external, "behind-the-body" perspective is confusing since we normally only see ourselves from a first person perspective. We look out onto the world though our eyes, but we cannot perceive our heads (unless we look into a mirror) and we cannot see ourselves from behind. We do not have the ability to see ourselves the way others see us. The possibility to project an external, imitated out-of-body perspective of myself onto a head mounted display (HMD)—a set of VR goggles that I wore and thus projecting myself on a virtual plane ahead of me—was strange, exciting and very quickly accepted as a "normal non-normality". I consider it a stage further in comparison to the wonderful painting of Rene Magritte's called *Not to be Reproduced* (1937)[9] because it is three-dimensional in space, however pixelated and perceived in real-time. I felt as if I was performing the

5 Ibid.
6 Ibid.
7 Ibid.

8 V-Real Viewer 3D SVGA HMD with 800 × 600 resolution, 35° field of view.

physically impossible. Nevertheless, it's a convincing feeling that you touch yourself, which was actually the starting point of our research. Next we tested the effect of delay; in other words, when you moved forward, the robot finger did not move, but if it moved shortly afterwards, then the subjects came up with another explanation, which is: "There must be somebody else behind my back touching me".

Nicole Ottiger: It's interesting—on a mini video clip of this study[2]—one sees the arm tied up to cables, a hand and dominant finger extending to and from, almost like drawing in the air.□[2]

Olaf Blanke: You could certainly use or induce the robot to move, because you are moving. It's on a long and curved stick, like a very strange brush, but yes you should definitely try

2 Accessed 16 February 2016, actu.epfl.ch/news/ neuroscientists-awaken-ghosts-hidden-in-our-cor-12

☐ 3 Drawings made in LVF-LH (3a) & RVF-RH (3b) setting
☐ 4 Drawings made in LVF-RH (4a) & RVF-LH (4b) setting

situation in Magritte's above-mentioned artwork, making me question my perceptions of reality and calling for self-reflexivity.

I videotaped my drawing process, generating too many images rather than too few, in order to find the most interesting phenomena (depicted in the images) related to the drawing process. The drawing process in one particular setting took somewhere between ten and thirty minutes on average.□5

Wired up to VR-goggles (with an angle limitation of 35 degrees, and connected to a transmitter that is synced to the image frame rate, or in some settings changed to asynchronous) and a video camera, I was standing in the upright position, and drawing on paper, sized 1 × 1.5 meters, which hung on a wall in front of me. I was free to move and turn around

9 René Magritte, *Not to Be Reproduced* (La reproduction interdite), 1937, Oil on canvas, Museum Boijmans Van Beuningen, Rotterdam. The artwork depicts a man (backside view) standing in front of a mirror, who sees his own self incorrectly reflected as the backside view again (the book on the mantelpiece is however reflected correctly).

□5 Experimental Setup of Video Ergo Sum

it with drawing, because it's in a way related to visually being at a distance from yourself as the self-portraits you made in the *Video Ergo Sum* series. With this robot finger experiment you would have a very strange loop and of course, normally you are blindfolded—that would be interesting—you could be totally blindfolded, but also seeing it will be quite interesting, because what you draw—visually—could give you a feedback onto your back; as if your back were a canvas. Yes, nice, we have another project here, Nicole!

Nicole Ottiger: Looking back to my own artist-in-lab residency of 2010, how did you become familiar with our differences in artistic and scientific vocabulary? I remember some of the lab members even cultivated a very nice "arty" sense of language—I think that also has a lot to do with your own familiarity with the arts, Olaf, or maybe it is easier in

in whichever way I wanted. During the actual physical act of drawing I always only saw the view of myself from behind, projected in front of me, at a distance of two meters (the abided distance between the position of video camera to myself, as stipulated by the neuroscientists who devised the original experiment). We deliberately chose this particular distance because people who have had neurological out-of-body experiences reported being at distances of at least two meters outside of their real body.

I started with synchronized stimulations, which didn't seem very interesting at first. It took the time-delayed setting to push me into a different perceptive mode. Being familiar with one's own first person perspective harbours a certain danger of "knowing". I therefore tried to outsmart myself by using a time delay of 32 microseconds to attempt to see "anew". A time delay is an equivalent to an asynchronous condition where you see yourself as a non-real perceptual illusion. I experienced body-time movements that were not in synch with the visual input.

Repeating the drawing experience again and again set off a re-familiarization but interestingly also a growing awareness for the complexity of the basic idea behind the virtual reality set up. I had to adapt to abnormal constraints by, for example, deciding "how" to draw in a time delayed condition where the visual information was lagged. Drawing in this asynchronous mode I found myself in a permanent state of being slightly incorrect. In this condition I had felt not only estranged from the first person, but also from the third person, the virtual self. The condition of being asynchronously stroked whilst drawing led to a fixation; localization around the physically "felt" touched area but it also led to a concentrated overworked zone on the visual level in the drawing.☐6

With my head often wrapped up all in black cloth to avoid peripheral sight, I felt strangely cocooned in the virtual projected room, and somewhat detached from the rest of my body (although I could see my body in front of me)—it was as if my blind spot had

neuroscience. What I am asking is: Has the different vocabulary between myself and the scientists developed? Has it been a handicap or a starting point for interesting discussions?

Olaf Blanke: There are many links, between neuroscience or cognitive science and art. They are of course both very difficult to make sense of, from both sides. Art and Science have a long-term relationship that has to evolve further through shared processes and of course there are fields like neuro-aesthetics or aesthetics which link to perception, to consciousness and to the feeling of different states in respect to art. Psychologists, cognitive scientists and also some parts of basic neuroscience research (particularly human neuroscience) constitute most of the neuroscientists who are interested in the arts. I don't know whether it is more contemporary art or the "established" art in the museum,

☐ 6 Artist's visual field wrapped in black cloth in the Video Ergo Sum setup

but generally speaking there is definitely an interest among neuroscientists. However, it has always struck me that we don't really have a "neuroscience of art" or at least of the visual arts. Much more serious work remains to be done in what is called "neuro-aesthetics".

Nicole Ottiger: Yes, I agree! Neuro-aesthetics is very controversial however, maybe we'll come to that later.

Olaf Blanke: Okay, but this field is also quite separated from the rest of neuroscience because it's difficult to do. When you try to quantify something like art making or art perception, it's very tricky, of course. There were and are people in my Lab at EPFL that have an interest in art and were interested in interacting, even maybe to try and design an experiment together with you, where it's not just you observing us but we get to observe you! It's great that we chose to look together

shifted and situated itself to the space in front of my visual field □6. My field of vision within the virtual plane on the inside of the VR goggles is an artificial LED, white and subtly pixelated, which affected the choice of my drawing material. At first I used a pencil to draw but since the video camera is projecting visual material to the artist from two meters away it was almost impossible to see the actual strokes in the first drawing attempts.

Then I spontaneously added a small hand-sized mirror as a visual aid, a tool that no one in the LNCO Lab at that time had put to use, to be able to look at myself from the front. I was curious to see if anything would change with this added feature and this is what happened: I was immediately able to record my reflex, my response to this stimulus, which was a reversal of the first person perspective. Normally the camera shows just a specified-angle look onto a space, but the mirror allows a lot of flexibility, a reflex-ability for me as an artist, who now not only "sees" the actual front, but also the rear-view and other aspects of the room, and also the position of the camera that I am drawing. In this mirror-sequence stage of drawing, in spite of seeing the unfamiliar back view of myself projected "in front" of me, I felt unexpectedly closer to something at a distance, behind myself—I would go as far as to say, I felt closest to that position two meters behind me. □7

In the drawing process itself I was somewhat tactical and seemingly blind at first, then increasingly more familiar, able, playful and adaptive of the situation—I intuitively familiarized myself with the situation by trying things out: How far can I lean/turn towards the camera to gain the absolute maximum of the available sight? And what do I achieve with this strategy? If I turn into the camera, observe and study the visual space, then turn around and draw from the remaining image repressed on the mind—is that a form of irrational intuition? Or is it bodily consciousness guiding my hand? To what degree does or can memory consist of perceived information? Is it reliable? What happens if I use a mirror as well? And

at the interaction of the hemispheres and on self-portraiture—of course it's an interesting area: How does a painter represent him or herself? In self-portraiture there are many ways one could do such a collaboration between art and science. We could ask, for example, why does self-portraiture usually show the face or the front of the body? Has anybody portrayed herself from the back? From the side? Why not draw yourself five times in the same self-portrait? There are endless research questions. Our collaboration during the residency got us started quite quickly and lead to fascinating discussions.

And yes, it was important that we chose a topic that is of interest for the artist and a topic that is of interest for the scientist, because the techniques are very different to study or investigate the phenomena. When there is this

so the mind begins to question everything and deconstructs its confidence in "seeing" as a truth. There is an interface (an interference almost)—a transfer point or transition between what the mind sees and what the body knows it is seeing/not seeing that the artist eventually experiences. The translation of this experience into an image requires more than perception, it demands a subjective re-localization.

What the artworks themselves exert onto a viewer is an important part of art perception, which provides clues to the type of self-portrayal. The resulting drawings are representations of my "Self" that I saw through a device, a machine, in other words through an extension of the self. The drawings are also inevitably interpretations, and not just pure studies portraying the outer appearance of my bodily self. The artistic realisation and translation of what one sees, into a visual entity on paper, goes through the body. The body consciousness shapes what we see into something more. The drawn results also include "clues" about the

□ 7 Video *Ergo Sum* setup – the mirror setting

common-ground-topic, then this collaboration can actually proceed very nicely and quite quickly which it did in our case. I would say we took on two projects in one during the artist-in-labs residency. One is what you started—(1) this interest you have always had about self-portraiture and it was clear that there were many things to explore on that range, but at the same time—(2) we explored a completely different idea: how the right and the left side of the brain are involved in art making and art perception. This was also an interest I had, which is why we kicked it off quickly as well.

Nicole Ottiger: Do neuroscientists see art as an invaluable resource? Do you think neuroscience sees art as an increasingly invaluable resource?

Olaf Blanke: Each neuroscientist would say yes to both questions but most neuroscientists would say, "well we don't

emotional state at the time of experiencing, and a curiosity for what I, as the artist, was aware of, as I perceived the self and the body within the virtual space at a particular point in time, bearing in mind that virtuality is both a space and a non-space. Irrational and immaterial awareness is made visible though pen strokes, along with the varying contrasts, and through the composition of the artworks themselves.

In this experiment with the virtual self, I was aware of my attempts not only to localise the body and my outer appearance, but also my self-consciousness, looking within myself as well.

It is not so simple to discern today's artistic expression of the self-portrait, because representation is also about the method and/or technology, which often cause a shift in the representation. The contemporary style of artistic depiction of a bodily reality sees the self, fictionalized to transpose an autobiographical relation, one that simultaneously points at, challenges, or displays the artist's awareness of an external perspective on him/herself. This

□ 8 Selfie (2015)

know how to study it". There is a huge potential to develop this field and I think that's also the problem. Rather, the tendency has been to get the neuroscientists and art historians to work together or psychologists and art historians, but what is even more relevant is to work directly with an artist in the research collaboration. That can be in many fields: drawing, painting and other forms of visual arts. To some extent we have already done this together, by using some of the research findings or technologies and by directly involving these findings in the art making process, but it takes time. Then one has to totally adapt the technologies one develops, because they have to be perfectly adapted for the art making process. Otherwise it would just be a hindrance or just a visualisation of the research technique or something similar.

self-expression extends both autobiographical and art practice concerns, morphing into a devious contradictory, double-edged position between being the object of review and the critic at the same time.[10] Cultural and literary critic Joost de Bloois (2007)[11] points out that in being his/her own critic, the artist manoeuvres him/herself within the unique position of being both inside and outside the field of artistic practice which I often felt in the laboratory as well as in the experiments. In my experience, this permanent parallel or double role within self-reflection, which de Bloois observes as a new theoretical strategy,[12] provides us with potentially new artistic subjectivities.

Within the scientific environment I found that "staying true" to my artistic values was important and indeed a double action. On the one hand, I was using artistic practice as a visual tool to explore some neuroscientific ideas of my bodily self, self-location and perception, and on the other hand, I purposely deployed specific neuroscientific methods to inspire myself, and initiate further reflection on perception through experimentation and exploration in art, which did not always appear to have scientific reference at first glance.□8 Sight/vision and "how" we perceive is dominated by our mind rather than by the eye. The question still remains: "What goes on, within vision itself every time we perceive something?".[13] According to Merleau-Ponty "vision must be thought of in terms of a 'delirium', an 'ecstatic' state",[14] which I believe is an interesting and necessary notion for art making that often captures some hidden and obscure element of an ecstatic or transformed moment within the complex processes between mind/brain, perception and self-consciousness.

10 de Bloois, J 2007, p. 19, 'The artists formerly known as... or, the loose end of conceptual art and the possibilities of 'visual autofiction', in *Image [&] Narrative* [e-journal], p. 19.

11 Ibid.
12 Ibid.
13 Alloa, E 2008, 'The madness of sight.' In: Horstkotte, S & Leonhard, K. (eds) *Seeing Perception*, p. 40–59, here: p. 40.
14 Ibid., p. 40.

For an artist to work together with a scientist long-term is very challenging, because for experiments, once they are fixed, you don't really change anything anymore. You keep the test very, very systematic and you advance in very, very small steps. And as an artist, once you discover something, you may not be particularly interested in it anymore! I assume you may want to develop more and more possibilities and associations very quickly and be unconstrained. Then again, some science researchers may also be working this way. But for the art historian, who looks at art from his or her rocking chair and can take a big distance, consistency is an easier task to undertake. In the field of neuro-aesthetics the question is often: What is art and what can we learn from the brain about creativity? How do people choose certain kinds of art? But the really interesting part, at least for

References

Alloa, E. 2007, 'The madness in sight', in S Horstkotte & K Leonhard (eds) *Seeing Perception.* Cambridge Scholar Publishing, Newcastle.

Blanke, O 2007, 'I and Me: Self-Portraiture in Brain Damage', in J Bogousslavsky, & M G Hennerici, (eds.), *Neurological Disorders in Famous Artists Part 2.* Karger, Basel et.al., pp. 14–29.

Blanke, O. 2015, *How to down-regulate a "ghost",* accessed 1 December 2015, www.youtube.com/watch?v=vS5QAqMyPjU.

Bloois, J. de 2007, 'Introduction. The artists formerly known as...or, the loose end of conceptual art and the possibilities of "visual autofiction"', in *Image and Narrative,* (online) Issue 19, November 2007, *Autofiction and/in Image,* accessed 1 December 2015, www.imageandnarrative.be/inarchive/autofiction/debloois.htm.

Bonafoux, P 2004, *Moi! Je par soi-même. L'autoportrait du XXe siècle,* Éditions Diane de Selliers, Paris.

Lenggenhager, B et al (2007), 'Video Ergo Sum: Manipulating Bodily Self-Consciousness', in *Science* 317 (09/2007), pp. 1096–99.

Pächt, O 1991, 'Das Selbstbildnis', in E Lachnit & O Pächt (eds), *Rembrandt.* Prestel, München, pp. 65–78.

me, is between the creative act of making art and how to understand and participate in shaping and understanding those processes.

Nicole Ottiger: Do you think artists could provoke more?

Olaf Blanke: Well, if it is "just to provoke", no. But I think in science you mainly need to provoke in the sense that you want to make people curious to learn and understand what something is about. I think this idea of provocation is about encountering a dialog, making something more empowering, and arrive at a focus of attention. Then it is important if you provoke or arise this curiosity from the audience. In today's world overloaded with information it is always difficult to make people listen to you and find interest in what you do. In this sense, it's an important part of our daily business to provoke. You can provoke yourself by making your art, but

you can also provoke the audience and probably some art historians or specialised public groups, and so I think, in this sense it's important yes.

Nicole Ottiger: It seems to me that art-culture is somewhat invisible in the scientific institution or scientific community, however, we are currently seeing an extraordinary new collaboration of the two in cyberspace and in technology. What do you think about this?

Olaf Blanke: You are right, contemporary art has cultivated an amazing fascination with technologies over the last decades, but apart from video, it was always very difficult to really bring it into the science laboratory. Of course we have some technology in our studios but we cannot rely too much on a bunch of engineers to make our ideas possible. Sometimes engineers might be necessary for the art making process. Even if you can afford access to the technology, you know the artist often needs to have full control over the technology that is utilized. Today, with an interactive media platform like virtual-reality, some very affordable head mounted displays with some form of tracking are available, so these devices become a new kind of tool in the arts. These tools use visuals and sound at the same time, enabling cross-modalities and changes to the process. I can imagine that as an artist you're naturally drawn to these new types of tools, to work scientifically, to go with the times. I mean we should probably not forget the old art forms, but if you create novel links then this is fascinating.

Many of the technologies we needed or we would have liked to have in the lab did not really exist before, so we often had to develop some of them ourselves and we were lucky in a way to be at EPFL, with the proximity to engineering colleagues. So we decided that we should really continue to try to search new techniques and we should

also take inspiration from fields that are not directly related to neuroscience. Of course, in the end we always have to and want to bring it back to neuroscience questions. But for the study in the self and the debating of the self, we had to use and rely on robotics, on computer science in addition to the standard neuroscientific techniques, and this is what we have tried to do here in the last ten years in the lab. I'm very happy that some of the people, of my friends and colleagues, who were in the lab also partly continue this kind of work in their own labs.

Nicole Ottiger: Since I often saw you encourage intuitive processes within your lab, I was wondering, what place does "intuition" have as a functional tool in neuroscience? Do you see your PhD students working with it and might it help them to move on to do stunning things? Normally scientists have a lot of constraints that might affect their "intuition". I read that in the late 1870's, the psychophysicist Gustav Fechner worked under the assumption that there is a correspondence between the physical properties of stimuli and the intuitive sensations that they cause. Of course, at the time when he studied there was no possibility to observe the neural processes. Now today, the relevant empirical scope, limits, and prospects of the cognitive neuroscience of aesthetics are fiercely debated. Again, in large measure this is due to a lot of disagreements and arguments about the nature of aesthetic experience. So I was wondering: What is your position on the term "Neuroaesthetics"?

Olaf Blanke: Neuroaesthetics is a broad field, it can include many things, it means aesthetics and its relationship to the brain. It's a fantastic research topic and a very important one. Unfortunately, there are not many scientists who can study this topic. Although neuroscientists understand vision quite well, also sound perception and even bodily

perception quite well, we often don't understand art perception, art making and art evaluation or judgements. You can easily count the number of journals, the number of papers that exist on neuro-aesthetics — it is still a small research topic. Slowly, there are more recent developments and more studies and articles being published. I think that in order to make the field particularly interesting it would be good to involve other domains, not to give most of the power to neuroscience and to the empirical scientists, but to really make sure that this is a truly trans-disciplinary field. All the questions are there, and some scientists and artists have asked them and written about them over the course of the last 60 years, but nobody is really taking it up. There is a new Max Planck Institute in Frankfurt that will work on art and neuroscience. It will be dedicated to aesthetics including neuroscience and social sciences or both parts of the musicology and literature, but again no visual artists.

Nicole Ottiger: And you? I have the impression that you are making a difference between the terminology "neuroaesthetics" and "neurology of art".

Olaf Blanke: I don't know if it's really a difference, but in the neuroaesthetic fields that I have seen so far, some art historians, some neuroscientists, some psychologists, maybe even some clinical researchers like neuropsychologists are engaged in research about topics like art processes in relations to Alzheimer's disease, strokes or autism. Then there are popular writers like Oliver Sacks who has written about these deficits or impairments, and many others. But it's still not really a research with the artist, so a "neuroscience of art" would focus on art making and even more on the creation process, maybe,

3 Blanke, O & Ortigue, S 2011, *Lignes de Fuite. Vers une neuropsychologie de la peinture*, Presses polytechniques et universitaires romandes, Lausanne.
4 Accessed 10 February 2016, www.sarn.ch/activities-2/sarn-activities-2014/sarn-unconference-2014/

than on the perception part. The most interesting question to me is probably: What happens in the brain when you make art? Of course, it may not be one particular moment, but there is something in there we haven't studied: How do you make artworks? That may be the most difficult question to answer. I have tried to write about this in my book *Towards a Neuropsychology of Painting.*[3]

Nicole Ottiger: How do you think that my stay in your lab, contributed to the way in which scientists think about their own research?

Olaf Blanke: Well, there are lot of things to say about that. The discussions we had in that year shaped some of our new experiments, not only the experiments we did together, but also how we approached other ways of progressing. For example, we discussed the art making process and how to draw in the left hemisphere—that definitely needs more thought. In particular: What does a neuroscientist think about these levels of perception? Can they be directly translated? This was accomplished actually in that particular series of experiments *(Left and Right Hemisphere Experiment Series, 2010–11)* and led us into a new experiment *(Shooting Moments, 2013–14).* We even demonstrated this in the Geneva show—*Symposium Parenthesis.*[4] What happens when people react to different possibilities when they see at the edge of vision? We went very far in this investigation, which is very close to what an artist does. It was an interactive neuroscientist-artist-collaboration, in which you are the ultimate subject of your own experiment, a process that is somewhat controlled. We scientists did not just assist you, we took part—although we had to have an artist, of course, to control the choices of the pictures for the experiment. However, as I mentioned before, this is not neuro-aesthetics, it is trying to come up with another way of understanding

the art making process. It entailed vision and movement, painting and drawing and what happens in between, and then what you did was much more important. You took it further, when you decided you didn't want to sketch over and over because it gets boring. But that you can start other things and start drawing on different surfaces and with other media and turn this into fascinating art and meanwhile learn about your own creative process.

What I would like to do in "neuroscience of art" or "neuropsychology of art" is to go further into looking at the art making process beyond the current research in neuro-aesthetics. Of course, one can place "neuroaesthetics" and "neuroscience of art" together—which we did. But when I came to your studio in Zurich, it was really fascinating for me to see, that you really continued the process. Of course in the lab the time is much too short to do any of this, but when I saw your work in your studio I noticed that this art-science collaboration is very useful and it can actually be used in research! I really had the feeling that this is a start of a new form of looking at your work—for both you and me. And, yes, I think this may also be an inspiration for other artists in this trajectory. It's like a looping system, which research always is and which art making is as well—you work every day, you see this thing, you are happy, you start again. I guess this is so, but to have both particular systems in the loop and to explicitly exploit or use the brain of the artist would be a new way. Therefore it is clear for me that you can come back any time you want. Hopefully it's clear from this interview that having an artist, a painter in the lab was also pure fun, very interesting, very exciting.

Arnd Schneider is currently a Professor of Social Anthropology at the University of Oslo and was formerly Reader in Anthropology at the University of East London and a Senior Research Fellow at the University of Hamburg. He writes on contemporary art and anthropology, migration and film. He has co-organized international conferences *(Fieldworks: Dialogues between Art and Anthropology* at Tate Modern, London in 2003 and *Art/Anthropology: Practices of Difference and Translation* at the Museum of Cultural History, University of Oslo in 2007. He curated (with Cecilie Øien) the exhibition *The World Kaleidoscope: Images and Objects from Fieldwork in Anthropological Research* (2008), and (with Astrid Anderson and Cecilie Øien) *Behind the Screen: Anthropologists work with Film* (2013), both at Galleri Sverdrup, University of Oslo. He organized (with Caterina Pasqualino, CNRS) the international symposia *Performance, Art and Anthropology* (2009) and *New Visions: Experimental Film, Art and Anthropology* (2012) at the Musée du Quai Branly, Paris.

Art and Anthropology [1]

The present chapter intends to delineate and assess the future potentials of the main fields of the anthropology of art. I will not engage here in the definitional issues surrounding the term art, nor provide a generic review of the historic literature, all of these have been covered sufficiently elsewhere (e.g. Morphy & Perkins 2006, Svašek 2007).

The chapter is divided into five main headings: 1) agency and relationality, 2) art worlds, 3) mimesis and appropriation, 4) materiality, 5) phenomenology, skills and creativity, and 6) practice. These categories are used as heuristic devices to structure the argument, as well as to introduce other themes (such as "aesthetics") which will be referred to in contradistinction. In fact, many studies in the anthropology of art belong to more than one of these categories, or even point beyond them altogether. Moreover, the field of the anthropology of art borders and partly overlaps with neighbouring sub-disciplines of visual anthropology, and material culture; as well as larger disciplinary fields, such as archaeology, art history, art theory and art practice, and visual studies in general.[2]

There have been several attempts to integrate and confront perspectives and provide a more transdisciplinary view (e.g. Marcus/Myers 1995; Westerman 2005; Schneider/Wright 2006, 2010, 2013). However, an impression remains that whilst anthropologists of art in recent decades have been keen to broaden their theoretical outlook to include the most contemporary theorizing on art by other disciplines, the effort of practitioners from these disciplines to engage with anthropological studies of art has been less forthcoming, except in the neighbouring discipline of archaeology, and to some degree, in art history.

Agency and Relationality

This essay will begin with what is, arguably, the most important recent theoretical contribution to the field: Alfred Gell's landmark volume *Art and Agency: An Anthropological Theory* (1998). The following discussion lays out its principal argument, assesses its impact, and points to some criticism. Gell's book signified the most radical departure yet in the anthropology of art, and its impact was not only

1 This essay was first published in the *Sage Handbook of Social Anthropology*, (2012), vol. 1, edited by R Fardon, O Harris, T Marchand, M Nuttall, C Shore V Strang, R Wilson, London, p. 56–71, where it contains a fuller bibliography. 'Art and Anthropology' by Arnd Schneider. Reproduced by permission of SAGE Publications, London, Los Angeles, New Delhi and Singapore.
2 It is symptomatic of anthropology of art's relatively marginal status that up until very recently no journals existed exclusively dedicated to the subject. The closest is perhaps the interdisciplinary *RES: Anthropology and Aesthetics* edited by Francesco Pellizzi at the Peabody Museum of Harvard University, with its strong emphasis on aesthetics and art history. *Gradhiva*, since 2009, retitled *Anthropology of Art*, published at the Musée du quai Branly (and which had Michel Leiris among its originating editors), has been another important journal venture—in this case closer to museology, but also with a deliberately trans-disciplinary focus. Other journals which regularly publish articles on art by anthropologists, are the *Journal of Material Culture Studies*, as well as visual anthropology journals, such as *Visual Anthropology*, and *Visual Anthropology Review*, if the subject falls into a broader category of visual culture analysis.

felt in anthropology (Thomas/Pinney 2001), but also in neighbouring disciplines, especially of archaeology and art history (see Osborne/Tanner 2007). Significantly, some of its arguments can also be related to some theorizing in contemporary art theory (Bourriaud 2002) though it had itself virtually no reception in that field.

In *Art and Agency*, Gell sets out to develop a theory of art which is genuinely anthropological. For Gell, anthropological theories are about "social relations"; *contra* American cultural anthropologists he does not allow for a separate concept of "culture". "Culture has no existence independently of its manifestations in social interactions" (Gell 1998, p. 4). Therefore, an anthropological theory of art also has to be about the social relations instantiated by, and expressed in, the past and present through art objects (or "indexes", in the terminology of Piercean semiotics which Gell applies, 1998, p. 13). Gell uses the notion of "abduction" for this process, by which he means that artworks become socially effective once their agency is inferred (or "abducted") by those who view and use them. Artworks ("indexes") then can be both the *"outcome, and/or the instrument of, social agency."* (Gell 1998: 15; his italics). Despite the fact that there is no direct reference to Bruno Latour (e.g. 2005), the idea that objects or things (here artworks understood as indexes) can have social agency seems to resonate with the main tenets of actor-network-theory. However, Gell would probably not subscribe to the idea that objects/things can have social agency, *irrespective* of distributed and abducted human agency — for him they have this agency precisely as part of social life.[3] For Gell then, artists are but one of the social actors in his theory of the art nexus, where, depending on their relational position, prototypes ("the entit[ies] which the index represents visually", 1998:26), artworks (indexes), recipients (who abduct agency from the index) all exert agency (1998: 27). All of these social agents can appear either as agents-in-action or be acted upon as "patients", depending on their position (1998: 26).

Importantly, Gell's theory is not restricted to the art of non-western societies (long the domain of the anthropology of art), but explicitly addresses also modern and contemporary art (e.g. the work of Marcel Duchamp), and is meant to be applicable to all art. Gell builds on Marcel Mauss's notion of the objectification of social relations,

3 Cf. The following the statement: "I am concerned with agent/patient relationships in the fleeting contexts of *social life*, during which we certainly do, transactionally speaking, attribute agency to cars, images, buildings, and many other non-living, non human beings." (Gell 1998, p. 22; my italics). In this sense Morphy's charge that Gell focuses too much on the agency of objects themselves seems exaggerated (2009, p. 22) — and it is precisely on this ground that Leach (2007) who takes a more object-centred approach to agency, takes Gell to account.

and Marilyn Strathern's (and Roy Wagner's) ideas of fractional person-hood. Gell also expands on the arguments of Nancy Munn (e.g. 1986) regarding the transformations, in various stages (the final being within the "Kula Ring" exchange) of Gawa canoes, Susanne Küchler's (e.g. 2002) analysis of Malangan masks, and Edmund Husserl's theory of time (already expounded by Gell 1992b). Extending on this body of theory, Gell considers artworks (including modern and contemporary art) as distrib-uted objects of the extended mind, where agency (of a creative individual over time), can be read from different biographical events (instantiated as artworks) during an individual's life course. Gell, then, sees artworks both as process, where an artwork can go through several stages of idea, sketch, finished work, and later copies, as well as being part of a larger temporal series during an artist's life-time (1998, p. 233). Such theoriz-ing, where temporalities rather than individual indexes (read: artworks) are essential, has important implications for the concept of style and, indeed, the intrinsically related category of repetition, "without (which) art would lose its memory" (ibid.). This structural thinking about art sig-nificantly resonates with, even by contrast, the much earlier theoretical work *The Shape of Time* by art historian George Kubler (1962) and his conception of series of art objects — changing over time — as being the markers of time.

This essay is not the place for a comprehensive review of Gell's important contribution which has already been provided by others.[4] However, it is crucial to point out that Gell offers a general theory of art production and circulation, where art is seen as a "system of action" (1998, p. 3, 6); the emphasis is clearly on "doing" and "social relations" which signifies a sharp break with theories emphasizing communication and meaning, as well as cross-cultural aesthetics (1998, ix).

With its stress on relationality, Gell's theory also foreshadows an interesting, and as yet little explored link (with more recent theorizing in contemporary art theory, namely Nicolas Bourriaud's short, yet influen-tial programme of *Relational Aesthetics* (2002). In it, the French cura-tor-critic suggests that contemporary art is not so much about concepts and individual, physically autonomous artworks, or even the system of the art-world, but instead about the social relations instantiated by art-ists as artworks. Social relations, in other words, then become the mate-rials artists work with, directly reflecting the processual nature of making art, rather than being confined to physically circumscribed material

4 For example, Thomas/Pinney (2001), Osborne/Tanner (2007), and therein Davis (2007).

artworks. Thus, an invitation to, and celebration of, a dinner party by Rirkrit Tiravanija *(Untitled*, 2002), including the multiple social relations instantiated before, at, and after this event, become the "artwork", rather than just consisting of an installation or other physical object. For Bourriaud (2002, p. 25) then art consists of objects producing sociability (or tangible models of sociability) which is suitable for producing human relations. Ultimately, according to Bourriaud, artists use time as material, in that they now produce temporarily social relations apparently outside the traditional institutions of the art world (2002, p. 70).

By contrast, critiques of Gell have underlined the continuing importance of symbolic meaning (even semiotic approaches, see Layton 2003, pp. 458–461, Morphy 2009, p. 14), as well as cross-cultural aesthetics (Layton 2003, Morphy 2007, 2009). Thus Layton sees art as "a culturally constructed medium of visual expression" (2003, p. 461), and Morphy insists on taking into account the "knowledge and presuppositions that people bring to bear when acting in relation to objects" (2009, p. 20) in clear contrast to purely social action. Other critics have suggested that Gell goes too far in developing a comprehensive theory of material culture, whilst at the same time excluding certain fields of symbolic empirical enquiry, such as art as language-like communication (Arnaut 2001, pp. 191, 198). Bowden (2004) pointed to the lack of an account of aesthetic values of the societies discussed in the book. Winter (2007), too, whilst appreciative of Gell's concept of agency, considers aesthetics still worth consideration, as one has to "see art both as a system of meaning encoding propositions about the world and as a system of action intended to change the world, precisely because the excitation generated by the work lies in the interaction between the two" (Winter 2007, p. 62).

Gell was deliberately not interested in art world studies (despite his acknowledgment of the importance of institutional theories, 1998, p. 8). However, it is what might be called his symmetric anthropological approach, aiming to deal with the art of both non-Western and Western societies (cf. Wolbert 1998), and encompassing potentially all world art, which provides the link to the next section.

Art-Worlds

Following the early article "The Artworld" by philosopher Arthur Danto (1964), "Art worlds" has been a very influential and productive concept introduced into empirical sociological and anthropological studies by the

sociologist of art Howard Becker (1982). Art here is not any longer seen as an autonomous product, the outcome of individual creativity, but the interplay of various actors within the institutional framework of the art-world, for instance, artists and their assistants, gallery owners, collectors, museums, and art critics. This institutional theory of art has wielded an important influence in anthropology, with numerous studies focusing on local art worlds (e.g. Ericson 1988, Plattner 1996, Colloredo-Mansfield 1999 in anthropology — the latter two with a strong economic focus; cf. also Simpson 1981 in urban sociology). The advantage of an institutional theory is that it allows functionalist analysis and description of the actors in the artworld. The disadvantage lies in its too narrow units of analysis which prevents a more dynamic analysis of other spheres and zones, beyond strict physical-spatial confines (such as a city or a neighbourhood, often the focus of artworld studies), such as power, international capital, the transnational/global art market, the influence of international arenas of art appreciation (among them art fairs, biennales etc., the making of digital art, as well as exhibiting, and sales of artworks through the internet[5]).

A variation of the art-world paradigm, though not directly influenced by it, perceives the different spheres of the art-world from the viewpoint of the objects, as artworks, artifacts or otherwise defined. In this case, as in Clifford's (1988) "art-culture system" (or, similarly, in Susan Vogel's (1988) "art-artifact" distinction), the emphasis is on how the object changes status in any of four semantic fields, of 1) authentic masterpieces, 2) the zone of authentic artifacts, 3) the zone of inauthentic masterpieces, 4) the zone of inauthentic artifacts (Clifford 1988: 223). A main advantage here, whilst retaining an emphasis on the present, is that an art-system (or a "total" art world) can be historicized. This allows us to account diachronically for the historical changes in the status of objects, for example when they are transformed from ethnographic artifacts (collected under colonial regimes) to art objects in contemporary galleries and museums, and to explore interests and ideologies connected to such changes. How objects change their ascribed values of authenticity, and are variously, magical and religious objects, collector's items, contemporary art objects, or indeed tourist art (for which see also the ground-breaking early study by Graburn 1976), is described and analysed in detail in an important study on African art by Steiner (1994). A dynamic and multi-sited ethnography, including the perspectives of the Pintupi Aboriginal painters, white "art-worlds" in

5 Cf. also Marcus/Myers (1995, p. 30–35), Hall 1995, MacClancy (1997), Brydon 2001, Svašek (2007, p. 90–94).

Australia and the US, leads Myers (2002) to a significant reformulation of the concept of art, in that "to designate cultural products as art is itself a signifying practice, not a simple category of analysis." (2002, p. 7). This then ushers the move forward to study institutions (art agencies, galleries, museums etc.) that "make objects into art" (ibid). Whilst rejecting any simple universality of art, and of aesthetics, Myers in fact shows, how these categories are produced, and historically changing according to the social actors involved; he insists that even in societies, such as the Pintupi (or, for that matter the Venezuelan Piaroa; see Overing 1996) which do not, or very little verbalize aesthetics in relation to their art making, aesthetics nevertheless remains an important category in their practice of art making (Myers 2002, p. 118).

Thus in its classical form (i.e. Danto, Becker), the concept of "artworlds" arguably has eclipsed its importance and straightforward applicability (if not validity), for current and future research on global art worlds. It now has to be combined with more dynamic, less spatially and institutionally bounded approaches, to account for the complexity and variety of current art production. In this sense, Svasek's (2007) more processual approach to art production seems to be a move in the right direction.

Any simplified idea of geographically bounded art worlds is also being surpassed by the recent upsurge in world art studies (e.g. Zijlmans/Van Damme 2008, Belting/Buddensieg 2009, also Weibel/Buddensieg 2007, Belting/Buddensieg, Weibel 2013). This new trend partly takes inspiration from geographically and conceptually wide-ranging studies by some art historians (e.g. Da Costa Kaufmann 2004), as well as evolutionary, and neurological approaches to global art history (e.g. Onians 2008). Rather than conceiving of clearly demarcated regional, national, urban (even metropolitan), as well as provincial art worlds, in the new paradigms the global art production of all cultures and times becomes the dominant focus, whilst not denying important differences in power and historical development. For instance, Wilfried van Damme proposes that world art studies should be "… doing for the for the visual arts what musicology does for music — or what, for example, linguistics does for language or religious studies for religion: to approach its subject matter from a global perspective across time and place and to study it from all relevant disciplinary viewpoints imaginable, ranging from evolutionary biology to analytic philosophy." (Van Damme 2008, p. 27). Further, such a multidisciplinary perspective on the visual arts includes three

broad areas: research on the origins of art, intercultural comparison, and finally, artistic exchanges between cultures, or interculturalization (see also Zijlmans 2008; as well as in a more ethnographic vain, Venbrux/Sheffield/Welsch 2006).

Garcia Dos Santos (2009), however, puts his finger on a fundamental problem which arises when studying world art: the continuing distinction between "contemporary" (largely Western) and "ethnic" arts. He suggests that the problem is not so much the existent economic inequalities in the global art world, but the one-sided ontological status afforded to art through the Western lens. Extending his argument with the work of Eduardo Viveiros de Castro (1998), Dos Santos (2009, pp. 169–171) demands that we must rethink the apparently unitary concepts of "world" and "art", which are after all those of the West, by acknowledging different ontological systems existing contemporaneously, such as those of Amerindian perspectivism and Western individualism, or Amerindian "multinaturalism" and Western "multiculturalism".

The unevenness of the global art world, however, has to do with the West's historic expansion, and the exoticist appropriation of the art of others as "Primitive Art". In the wake of the criticism of the important "Primitivism in 20th Century Art" show at the Museum of Modern Art in 1984, this debate has been extensively covered (e.g. Clifford 1988, Vogel 1988, Price 1989, Hiller 1991, Errington 1998). The recent opening of the Musée du Quai Branly has sparked similar controversy around the question, of how the art of non-Western peoples should be presented in a contemporary museum (Price 2007, also Shelton 2009). Whilst some of this debate is specific to the French context, others issues reflect a continuing, but at times rather stale debate (on which Clifford 2007, p. 12 rightly commented that "it admits of no solution") in the anthropology of art, museology, and material culture studies on the status of objects and their presentation, namely of whether these should be objects of art for primarily aesthetic appreciation, or objects (artifacts) presented with ethnographic context. That other possibilities exist, surpassing the simple art /artifact dichotomy, and which involve what new museology in this field has called the "source communities", including non-Western contemporary artists, which have their own distinctive criteria of art appreciation, and develop their own collaborations with collections and exhibitions, has been shown convincingly by the *Pasifika Styles* exhibition at the Museum of Anthropology and Archaeology in Cambridge (Raymond/Salmond 2007), as well as other ventures, such as the "reciprocal

research network" encouraging collaborative research with "Originating Communities, First Nations Organizations, Researchers, Students, Museum Professionals, Academic and Cultural Heritage Organizations." (University of British Columbia Museum of Anthropology 2010).

Art-world studies, with their interdisciplinary focus, are a particularly fruitful field for anthropologists to engage with, when combined with an emphasis on the viewpoints of "source communities" (see above) and more specifically, the different ontologies among those producing, circulating and collecting art.Mimesis and Appropriation

A classical functional art-world approach, whilst good at mapping out different actors within it, is also insufficient to account for change in transnational and other cultural flows. It must be combined with, and eventually transcended by, more dynamic concepts, doing justice to the fluidity and interconnectedness of global artistic production, for instance through Appadurai's concept of different "scapes" (1996). For this reason, approaches which do not focus on a functionalist whole (the "artworld"), but rather on what individual actors do with cultural material (here: art), are better suited to understand questions of cultural change in a globalized world. Mimesis and Appropriation are two such concepts which have been successfully employed in this context. Taking his inspiration from the Romance literature scholar Erich Auerbach (2003, [1946]), where mimesis is not only the imitation but also representation of reality by writers, mimesis was used by Fritz Kramer (1993, [1987]) to analyse African artistic appropriations, in masks, sculptures, ritual and performance, of European colonial influences as well as other foreign cultures (Islam, or different African cultures). Mimesis for Kramer (1993: ix), "arises from the confrontation with an alien reality whose underlying premises are not shared by the outside observer." Mimesis is rooted in the "compulsion to imitate", and "in mimesis one conforms with what one is not, and also should not be." (Kramer 1993, pp. 249, 250) Yet, ultimately, appropriating moves through mimesis serve the wish to recognize oneself, both in European and African artistic expression (1993, p. 245). Michael Taussig on the other hand, taking his lead from Walter Benjamin's idea of the mimetic faculty (1933), and reformulating Frazer's (1911) notions of sympathetic and contact magic, investigates mimesis as a dialectic process between perceiver and perceived where both the "original" and the "copy" have power over each other (Taussig 1993, xviii, pp. 38, 59). A fundamental characteristic of mimesis is to "get hold of something by means of its likeness", through

copy and imitation, as well as sensuous connection (and this precisely relates to the two types of magic distinguished by Frazer) (Taussig 1993, p. 21; also pp. 24, 52). Interestingly, Gell also found Taussig's point highly intriguing, but doubted whether humans, had, as somehow supposed by Benjamin, an innate "mimetic faculty" (Gell 1998, p. 100). For Kramer and Taussig, whose approaches usefully complement each other, mimesis is directly related to cultural appropriation.

Nicholas Thomas's work on the specific exchange relationships between Europeans and Pacific peoples has also contributed to theorizing appropriation in stressing reciprocal possibilities of transformation through object exchanges, particularly in relation to alienability and inalienability (Thomas 1991). Thomas has also applied the idea of appropriation as a two-way exchange, to the art of European settlers in Australia and New Zealand (2001, pp. 139, 150).

However, up until very recently, the concept of appropriation has not been used much in a systematic fashion in the anthropology of art. Another rare exception are Marcus and Myers (1995) who suggest that appropriation "...concerns the art world's ideology, discursive practices, or micro-technologies for assimilating difference (other cultural materials) in various ways. Such an assimilation of difference is generally accomplished by stripping cultural materials of their original context, or using representations of an original context in such a way as to allow for an embedding of this influence within the activities and interests of producing art." (1995, p. 33). With a stress on appropriation's role in the global art world, Schneider (2003, 2006a, 2006b) has attempted to provide a new theoretical grounding for the concept, by lending ita hermeneutic angle , when otherwise appropriation has negative undertones and the emphasis is often on power differentials between appropriators and those appropriated from. Appropriation is here conceived as a strategy with which individual artists work with materials outside their own cultural context to create something new. Often, such work is linked to constructions of new identities. However, rather than emphasizing simple taking out of context and taking from the other, this approach stresses the implicit potential of learning, and, in a hermeneutic sense, of understanding the other. For instance, in a study of urban-based Argentine artists who appropriate from indigenous cultures, Schneider (2006b) showed that a number of strategies of appropriation are used and combined with physical techniques, such as copy, travel, physical acquisition of objects (by collectors), and performance, to create new meanings and contexts

for the "original" objects (such as pottery in a ceramics workshop), which can only be understood jointly with their new material interpretations.

Roger Sansi (2007) has worked with the concept of appropriation to investigate the multiple processes of incorporation and reworking of cultural materials in Brazil (from indigenous, African and European sources), and how this process is linked to different interest groups and changing constructions of national identity. His examples are fetishes and monuments surrounding the Candomblé cult in Brazil. His argument is that culture can only be appropriated once it has been objectified, in a process of historical construction (Sansi 2007, pp. 1–8, 145). In fact, according to Sansi (ibid., p. 5), processes of objectification are necessary to make culture, including art, available for new historical construction, and reformulations of identity and alterity, beyond paradigms of hybridity and syncretism (Garcia-Canclini 1989, Steiner 1994).

Rupert Cox (2003), on the other hand, uses the concept of mimesis, via Taussig, to analyse the processes of embodiment and aestheticization behind Japanese Zen practices, especially the tea ceremony and martial arts. Cox is particularly interested in the appropriation of bodily techniques through successive processes of imitation, adaptation, and transformation. Thus for Cox, the central question is, how highly formalized Japanese art practices, such as the tea ceremony *(chado),* the martial arts (for instance, *Shorinji Kempo),* and flower arranging *(ikebana),* develop "a body [for the participants] capable of expressing and experiencing aesthetic quality through imitation" (Cox 2003, p. 105). This bodily capability Cox sees directly related to the mimetic faculty (as understood by Taussig's reading of Benjamin). Studies of appropriation and mimesis show how important the materiality of things (including those classified as "art") is in revealing the hermeneutic potential of appropriation, or said otherwise, the learning process implied when working with other cultural materials.

Materiality

Through physical processes of working *with* materials, and *in* techniques of other (cultures), artists and anthropologists in fact learn *about* and, on occasions of collaboration, *with* the other. Learning by doing, that is knowing through practice, has been important for anthropologists to understand cosmologies, world views, and more generally, the culture of their research subjects, even if this approach has been outside of the mainstream of anthropology.[6] This kind of learning and knowing through

art practices, in fact, is an essential ingredient of creativity that we will address further in the next section. Taking its inaugural lead from material cultural studies (promoted since the mid-1980s at UCL by Daniel Miller and Chris Tilley), the notion of materiality has now diversified, to include the notions of agency in objects, both as the extension of human agency (Alfred Gell), as well as independently of it (Bruno Latour). These approaches are now being used across fields of anthropology, archaeology, and art history.[7] "Thinking through things" (Henare et al. 2007) then has become something of a programmatic orientation for these recent research directions, sometimes also involving collaborating artists, such as in the *Pasifika Styles* exhibition (Raymond/Salmond 2008). Importantly, as Henare et al. point out, things have to be considered on their own terms, as constituting meaning, not in need of further interpretive action (2007, pp. 1–3). Things, in this understanding, *are* concepts, and do not have referential or indexical qualities, as objects or artifacts — they are "conduits for concept production" (ibid., p. 5). It is clear from such recent lines of research that materials themselves — which after all constitute the "material of art" (as an important study by art historian Monika Wagner is called, 2001) — have enabling and constraining effects on the process of artistic creativity, including practices of cultural appropriation. Arguably, one of the most fruitful approaches so far on materiality has been Susanne Küchler's work towards the concept of the "Material Mind" — the idea that cognitive intelligence, is not only distributed, but actively effective through a range of materials, enhanced by recent advances in nano-technology and engineering (Küchler 2007, 2008). Materials, such as "intelligent fabrics" which can change according to environmental and bodily requirements (as well as many other adaptive and creative, intelligent materials) show how we cannot think any longer of an individual mind, with its isolated locus in the human brain. These specific properties, as Küchler says, "carr[y] our own mind beyond bodily confines." (2008, p. 110) — a process, arguably, which had already started with the invention of tool-making. Yet to consider the "material mind" as Küchler (2007) calls it, and specifically intelligent materials, has important implications for the processes of art-making and its analysis. First of all, many cultures have experimented with thinking *through,* and thinking *with* materials, specially fibres from plants and animals — in fact, cognitive processes are often expressed through and stimulated by these materials, the Andean case of the

Arnd Schneider

6 But see as historical examples, Bunzel (1972 [1929]), Reichard (1997 [1934]), and more recently, Guss (1989).
7 For a good critical evaluation, see Knappet 2005, also Knappet/Malafouris (2008, xi).

khipu writing and counting devices represents just one such case. Secondly, textile arts, as well as comparable arts and techniques of lashing and basketry, arguably have been at the root of contemporaneous and later developments in indigenous abstract architecture both in the Andes and in the Pacific (Paternosto 1996, 2006, Küchler 2007). Thirdly, it is but a short step to import, or indeed appropriate, the cognitive insights and capacities from "intelligent" materials, both ancient and contemporary, to the realm of art.[8]

Phenomenology, Skills, Creativity

Whether artistic creation is the expression of collective or indeed individual creativity has been a long-standing debate in the anthropology of art. After the dominance, with few exceptions, of approaches emphasizing collective creation (especially in small-scale societies) in the first half of the 20th century, the more recent approaches emphasized the contribution of individuals in the creation of art (e.g. Gerbrands 1967). This stronger focus on creativity was given renewed impetus by Lavie/ Narayan/Rosaldo (1993, p. 5) who stressed creativity as fundamental to the emergent construction of culture, following here closely Roy Wagner (1975), and the work of Victor Turner to whom their edited volume is dedicated.

Another emphasis is provided by studies which take their lead from phenomenological approaches, in the wake of philosopher Merleau-Ponty. Two trends are to be identified, one which has developed into the anthropology of the senses (e.g. Stoller 1997, Classen 2005, Howes 2007), the other inspired by Tim Ingold's (e.g. 2000, Ingold/Hallam 2007) interests in the appropriation of nature, perception and use of the environment, which requires and trains process of skills and creativity (also Grasseni 2007). The first strand emphasises experience-based sensuous knowledge and has been important in identifying areas beyond the spoken and written word, as important for anthropological research, such as smell, taste, and haptic senses, as well as synaesthesia, and for instance, in the work of Paul Stoller (1987), extra-sensorial experiences with sorcery. Whilst the first strand, with its emphasis on the direct experience of the senses, would be very fruitful to combine with approaches to materiality, there has been as yet little cross-theorizing, and studies have been produced largely separately in each field (but see Steven Feld's work since 1982 in collaboration with musicians, and more

8 see also Teshome/Wagmister (1997) and Wilson (2002, pp. 215–218, 253).

recently with visual artists, e.g., Feld (2010), and also Pink (2009) for another recent attempt to bridge these strands of enquiry, in this case in close affinity with visual anthropology and its methods). The phenomenologically inspired anthropology of the senses has been important to open up and emphasise the importance sensorially rich environment for anthropological study. Whilst it offers potential for the study of art, this has only been taken up by a few of its practitioners (cf. Stoller 2006). Michael Taussig's significant body of work (e.g Taussig 2004, 2009), whilst not belonging to any of the two aforementioned strands, also highlights the senses in anthropology with relevance for the study of art, but comes from an altogether different reading of the neo-colonial or neo-imperial enfolding of the West's senses into non-Western sensibilities, taking inspiration from and pointing beyond Walter Benjamin's critical work, and combining experimentally forms of diary, montage, and critical analysis.

The second approach, emphasizing skills and creativity, has been more explicitly connected to art studies and practices, and has led to a specific practical interest in artistic techniques and genres, and forms of representation and notation, such as in sketchbooks and fieldnotes (Ingold 2007, Wendy Gunn 2009; see also next section "Practice"). For instance, in an article on the weather, Ingold (2005) sees light as the fundamental perceptual quality, and artists, such as Christina Saenz have made Ingold's ideas productive in their own work (see also Schneider/Wright 2010). With regard to creativity, Ingold & Hallam identify four important types of improvisation: "generative, relational, temporal, and the way we work." (2007, p.1)

Significantly, Ingold and Hallam also relativize Western notions of creative genius as opposed to copying, but instead look for creativity also in seemingly repetitive artistic practices, such as Javanese dance, Chinese and Japanese calligraphy, in order to re-evaluate the notion of creativity itself, and challenge its Western universal pretensions. A number of studies, especially in relation to material practices of weaving (and other textile arts), as well as building techniques, have demonstrated the creativity implicated in processes of learning, imitation, repetition, and alteration, or change (e.g. Ingold 2007, Marchand 2009).

Practice

The interest in research into skills and creativity, has also led to a renewed interest into exploring research practices with artists, in the form of

collaborations. Practice, based on experience and skills (as outlined in the previous section), has been a major theoretical concern of anthropology, and the very same anthropologists who have been at the forefront of this debate (Stoller, Jackson, Ingold) have also been engaged in advocating new ways of practice in fieldwork.

In a quite literal sense of practice as a form of *doing* and *making*, this has focused on how artists' techniques and research strategies, especially drawing (see also Powell/Oppitz 2001), can be made fruitful for the anthropological research process (Gunn 2009; also Ingold 2007). Thus Gunn (2009) reports on a three-year collaborative project between the Anthropology Department at the University of Aberdeen and the Fine Arts Department at the University of Dundee. In this project, which culminated in an exhibition, the aim was "to transcend the boundaries within ways of working-knowing specific ... to art, anthropology and architecture", and further, "... to move beyond established approaches in anthropology that treat art as a repository of works, already complete and available for analysis. Instead, our focus was not the creative processes that continually bring these works into being, along with the persons in whose lives they are entangled" (Gunn 2009, p. 1). Working "true to materials', artists, architects, and anthropologists were making a number sketchbooks, notebooks, installation and showcases, each showing different engagements with materials, situations or situated contexts, and types of notation (Gunn 2009, pp. 9, 19). Much of the work (Gunn 2009, p. 25), was inspired by the broadly phenomenological approach of Tim Ingold (2000, 2007) as referred to in the previous section, as well as Christina Grasseni's notion of "Skilled Vision", meaning the "training of vision in professional, scientific, and everyday contexts" (Grasseni 2007, p. 1).

In a broader sense, scholars have explored collaboration *with* artists in ethnographic fieldwork. Rather than working on artists as research objects, here artists become partners in collaborative fieldwork research (for examples and critical review of such projects, see Schneider 1996, Schneider/Wright 2006, 2010). Here artists and anthropologists work in experimental ways to develop new terms (kinds) of research and representation (e.g. exhibition projects, cf. McDonald/Basu 2007). The notion of experiment in and with the arts is of interest (Schneider 2008), as it points beyond received notions of experiments in the natural sciences, which rather than producing reproducibility in static laboratory settings, create "epistemic things", as historian of science, Hans-Jörg

Rheinberger (1997) calls it, an insight which has important implications for anthropology, as Marcus has outlined recently: "The account that Rheinberger gives of scientific practice in pursuit of epistemic things resonates with ethnographic inquiry, revised from the regime of conventional empricism that was its originary model. This overlap of an artistic and scientific aesthetic of practice around the notion of experiment has been one of the more promising background conceptual environments for carrying out the refunctioning of ethnography at the intersection of art and anthropology ..." (Marcus 2008, p. 42).

Collaborations as incursions into each other's fields of practice are not without problems and Foster (1995), in this context, has pointed to "artist's envy", that is the desire by each side to emulate the practice of the other (often for the shorter ends of one's own professional achievement, and without taking into account political and economic interests prevalent in the art world and academia), and not evaluating the full political responsibilities. For instance, Schneider (2010) in his collaborations with contemporary artists in the Argentine province of Corrientes found that different expectations to the project (a participation in, and documentation of, the procession of a local patron saint) had to be carefully negotiated, bridging different understandings of art, anthropology, and more generally educational and economic capital brought to the project. Ethics has been another important area that recently has come to the fore in the work with and on contemporary artists. Anthropologists, including those working on art, have been very aware of ethical issues, working with "traditional" (albeit changing) societies, for instance with Aborigines in Australia (see Morphy 2007). Yet for those working with Western art school educated artists this is an entirely new area, as contemporary artists often deliberately transgress ethical boundaries (precisely to show their historical and cultural contingency), whereas the majority of anthropologists, have now adopted ethical codes (for example, those of the professional associations, such as the American Anthropological Association), which have developed from anthropology's chequered record of involvement in colonial and neo-colonial and neo-imperial enterprises which continues into the present. That mainstream anthropology, so far, has not opened itself up to more engagement with the arts, is not only a result of its traditional forms of representation of research, which except for visual anthropology, is still delivered in academic book and article format, but also with a resistance, both practical and theoretical, to central ways of working and

representing in the arts. Lucien Taylor in this respect diagnosed anthropology's "iconophobia" (1994), its fear of images, whilst Chris Pinney (1992) found that moving images rather than still images (as also reproduced in books) were found threatening by anthropologists because of their inherent multiplicity of meanings, and Alfred Gell (1992) suggested that anthropology should not submit to the enchantment of art. One might well add "chromophobia" (Batchelor 2000), the fear of colour, to this catalogue to characterise mainstream anthropology's aversion against artistic practices (see also Schneider/Wright 2010).

However, contemporary art and anthropology have much to offer to each other, especially in the fields of practice and research design. Most art school programmes now offer research based MAs and PhDs, and the notion of research more generally, is being theorized in the contemporary arts. Visual Anthropology programmes have been at the forefront of promoting practice-led PhDs in anthropology, whilst Tim Ingold and Wendy Gunn have been active to apply insights from artistic practices to anthropological research. George Marcus, following from the early work of the "Writing Culture" critique, has been advocating a theoretical engagement with the contemporary arts, centering on the experimental open-ended nature of the anthropological research process. Thus project preparation /hypothesis, artistic research /data gathering, representation, become parallel and joint research strategies. It is here, in the parallel and critical re-elaboration of research (and fieldwork in particular) as an experimental form in both art[9] and anthropology, that the importance of practice resides (Marcus 2008, 2009, 2010, Schneider & Wright 2006, 2010, 2013).

Outlook

Art and anthropology then have largely reconfigured their relationship to each other in recent decades. The anthropology of art has finally overcome what had been an artificial distinction between western and non-western art. When, formerly, it dealt only with the latter as its objects of study, it now studies the arts globally. More recently, anthropology has also started to engage with theory and practice from contemporary artists, art criticism and art history. In the anthropology of the visual (which encompasses now fields covered by both the anthropology of art, as well as visual anthropology), this has already included art history's "iconic turn" (Mitchell 1986), and anthropologists can further learn from

9 Including design and design theory, see for example Barth/Razaein (2007).

even more recent approaches in art history and theory, such as *Bildwissenschaft* ("image science") and *Bildanthropologie* ("icon-anthropology"), promoted by scholars such as Hans Belting (1998, 2005), and Horst Bredekamp (2003).

Importantly, the anthropology of art, which since the 1960s has matured into conceiving of human artistic creativity not only as a collective expression of the social or culture, can retrieve for its own practice the notions of creativity and experiment, in dialogue with art practice and theory (Schneider 2008). Thus, as we have seen in this essay, notions of creativity, circulation of objects, agency, relationality, multi-sited research locales in global and hybrid art worlds, and importantly, the idea that art practice itself can have an influence on how the study of global art practices is exercised, now have important theoretical implications for anthropology's engagements with art. In sum, rather than thinking of two clearly separated fields, one being the investigating subject (anthropology), the other being the passive object of research (art), the two disciplines are endeavours of knowledge production, involved in setting experimental research agendas which can enter into fruitful dialogue.

References

Appadurai, A 1996, *Modernity at Large: Cultural Dimensions of Globalization*, University of Minnesota Press, Minneapolis.

Arnaut, K 2001, 'A Pragmatic Impulse in the Anthropology of Art? Alfred Gell and the Semiotics of Social Objects', in *Journal des Africanistes*, 71(2), pp. 191–208.

Auerbach, E 2003 (1946), *Mimesis: The Representation of Reality in Western Literature*, Fiftieth Anniversary Ed. Trans. W Trask, Princeton University Press, Princeton.

Barth, T, Raein, M 2007, 'Walking with wolves: displaying the holding pattern', in *Journal of Writing in Creative Practice*, 1 (1), pp. 33–46.

Batchelor, D 2000, *Chromophobia*, Reaktion, London.

Becker, H 1982, *Art Worlds*, University of California Press, Berkeley.

Benjamin, W 1986, 'On the Mimetic Faculty', in *Reflections*, Schocken, New York.

Belting, H 2001, *Bild-Anthropologie. Entwürfe für eine Bildwissenschaft*, Fink, München.

Belting, H 2005, 'Image, Medium, Body: A New Approach to Iconology', in *Critical Inquiry*, 31 (2), pp. 302–319.

Belting, H, Buddensieg, A (eds.) 2009, *The Global Art World: Audiences, Markets and Museums*, Hatje Cantz, Ostfildern.

Belting, H, Buddensieg, A, Weibel, P (eds.) 2013, *The Global Contemporary and the Rise of New Art Worlds*, ZKM, Karlsruhe, MIT Press, Cambridge, Mass,

Bourriaud, N 2002 (1999), *Relational Aesthetics*, Les Presses du Réel, Paris.

Bowden, R 2004, 'A Critique of Alfred Gell on Art and Agency', in *Oceania*, 74 (4), pp. 309–24.

Bredekamp, H 2003, 'A neglected tradition? Art history as Bildwissenschaft', in *Critical Inquiry*, 29 (3), pp. 418–428.

Brydon, A 2001, Review of: Plattner S, 'High Art Down Home: An Economic Ethnography of a Local Art Market', in *Ethnologies*, 23 (1), pp. 326–329.

Bunzel, R L 1972 (1929), *The Pueblo Potter: A Study of Creative Imagination in Primitive Art*, Dover, New York.

Classen, C (ed) 2005, *The Book of Touch*, Berg, Oxford.

Clifford, J 1988, *The Predicament of Culture*, Harvard University Press, Cambridge, Mass.

Clifford, J 2007, 'Quai Branly in Process', in *October*, 120, pp. 3–23.

Cox, R 2003, *The Zen Arts: The anthropological Study of the Culture of Aesthetic Form in Japan*, Routledge Curzon, London.

Danto, A 1964, 'The Artworld', in *Journal of Philosophy*, 61, pp. 571–584.

Davis, W 2007, 'Abducting the Agency of Art', in R Osborne, J Tanner (eds), *Art's Agency and Art History*, Blackwell, Oxford.

Errington, D 1998, *The Death of Authentic Primitive Art and Other Tales of Progress*, University of California Press, Berkeley.

Feld, S 1982, *Sound and Sentiment: Birds, Weeping and Song in Kaluli Expression*, University of Pennsylvania Press, Philadelphia.

Feld, S 2010, 'Collaborative Migrations: Contemporary Art in/as Anthropology: Steven Feld in Conversation with Virginia Ryan', in A Schneider, C Wright (eds), *Between Art and Anthropology*, Berg, Oxford.

Foster, H 1995, 'The Artist as Ethnographer', in G Marcus, F Myers (eds), *The Traffic in Culture: Refiguring Art and Anthropology*, University of California Press, Berkeley.

Frazer, J 2002 (1911), *The Golden Bough: A Study in Magic and Religion*, Dover, New York.

Gabriel, T H, Wagmister, F 1997, 'Notes on Weavin' Digital: T(h)inkers at the Loom', in *Social Identities*, 3 (3), pp. 333–344.

Garcia Canclini, H 1995 (1989), *Hybrid Cultures: Strategies for Entering and Leaving Modernity*, University of Minnesota Press, Minneapolis *(Cultura Hibridas: Estragias para entrar y salir de la modernidad*, Grijalbo, Mexico City).

Gell, A 1998, *Art and Agency: An Anthropological Theory*, Clarendon, Oxford.

Gell, A 1992a, 'The Enchantment of Technology and the Technology of Enchantment', in J Coote, A Shelton (eds), *Anthropology, Art and Aesthetics*, Oxford University Press, Oxford.

Gell, A 1992b, *The Anthropology of Time*, Berg, Oxford.

Gerbrands, A 1967, *Wow-Ipits: Eight Asmat Woodcarvers from New Guinea*, Mouton, Den Haag.

Grasseni, C 2007, 'Introduction', in C Grasseni (ed), *Skilled Visions: Between Apprenticeships and Standards*, Berghahn, Oxford.

Gunn, W (ed) 2009, *Fieldnotes and Sketchbooks: Challenging the Boundaries between Descriptions and Processes of Describing*, Peter Lang, Frankfurt a. M.

Guss, D 1989, *To Weave and Sing: Art, Symbol, and Narrative in the South American Rain Forest*, University of California Press, Berkeley.

Hart, L 1995, 'Three Walls: Regional Aesthetics and the International Art World', in G Marcu, F Myers (eds), *The Traffic in Culture: Refiguring Art and Anthropology*, University of California Press, Berkeley.

Henare, A, Holbraad, M, Wastell, S (eds) 2007, *Thinking through things: Theorising artifacts ethnographically*, Routledge, London.

Hiller, S (ed) 1991, *The Myth of Primitivism: Perspectives on Art*, Routledge, London.

Howes, D 2003, *Sensual Relations: Engaging the Senses in Culture and Social Theory*, University of Michigan Press, Ann Arbor.

Howes, D (ed) 2007, *Empire of the Senses: The Sensual Culture Reader*, Berg, Oxford.

Ingold, T 2000, *The Perception of the Environment: Essays on Livelihood, Dwelling and Skill*, Routledge, London.

Ingold, T 2005, 'The Eye of the Storm: Visual Perception and the Weather', *Visual Studies*, 20 (2), pp. 97–104.

Ingold, T 2007, *Lines: A Brief History*, Routledge, London.

Ingold, T, Hallam, E 2007, 'Creativity and Cultural Improvisation: An Introduction', in T Ingold, E Hallam (eds), *Creativity and Cultural Improvisation*, Berg, Oxford.

Kaufmann, T D C 2004, *Toward a Geography of Art*, Princeton University Press, Princeton.

Knappet, C 2005, *Thinking Through Material Culture: An Interdisciplinary Perspective*, University of Pennsylvania Press, Philadelphia.

Knappet, C, Malafouris, L 2008, 'Material and Nonhuman Agency: An Introduction', in C Knappet, L Malafouris (eds), *Material Agency: Towards a Non-Anthropocentric Approach*, Springer, New York.

Kramer, F 1993 (1986), *The Red Fez: Art and Spirit Possession in Africa*, Verso, London.

Kubler, G 1962, *The Shape of Time*, Yale University Press, New Haven.

Küchler, S 2002, *Malangan, Art, Memory and Sacrifice*, Berg, Oxford.

Küchler, S 2007, 'The String in Art and Science: Rediscovering the Material Mind', in *Textile*, 5 (2), pp. 124–139.

Küchler, S 2008, 'Technological Materiality: Beyond the Dualist Paradigm', in *Theory, Culture & Society*, 25 (1), pp. 101–120.

Latour, B 2005, *Reassembling the Social: An Introduction to Actor-Network Theory*, Oxford University Press, Oxford.

Lavie, S, Narayan, K, Rosaldo, R (eds) 1993, *Anthropology/Creativity*, Cornell University Press, Ithaca.

Layton, R 2003, 'Art and Agency: A Reassessment', in *Journal of the royal Anthropological Institute* (N.S.), 9, pp. 447–464.

MacClancy, J 1997, *Contesting Art: Art, Politics and Identity in the Modern World*, Berg, Oxford.

Macdonald, S, Basu, P (eds) 2007, *Exhibition Experiments*, Blackwells, Oxford.

Marchand, T 2009, *The Masons of Djenné*, Indiana University Press, Bloomington.

Marcus, G 2008, 'Contemporary Fieldwork Aesthetics in Art and Anthropology', in N Panourgía, G Marcus (eds), *Ethnographica Moralia: Experiments in Interpretive Anthropology*, Fordham University Press, New York.

Marcus, G 2009, 'Introduction: Notes toward an Ethnographic Memoir of Supervising Graduate Research Through Anthropology's Decades of Transformation', in J D Faubion, G E Marcus (eds), *Fieldwork is Not What it Used to Be: Learning Anthropology's Method in a Time of Transition*, Cornell University Press, Ithaca, NY.

Marcus, G Myers, F 1995, *The Traffic in Culture: Refiguring Art and Anthropology*, University of California Press, Berkeley.

Morphy, H 2007, *Becoming Art*, Berg, Oxford.

Morphy, H 2009, 'Art as a Mode of Action: some Problems with Gell's Art and Agency', in *Journal of Material Culture*, 14 (5), pp. 5–27.

Morphy, H, Perkins, M 2006, 'The Anthropology of Art: A Reflection on its History and Contemporary Practice', in H Morphy, M Perkins (eds), *The Anthropology of Art: A Reader*, Blackwell, Oxford.

Munn, N 1977, 'The Spatiotemporal Transformation of Gawa Canoes', in *Journal de Société des Océanistes*, pp. 39–51.

Munn, N 1986, *The Fame of Gawa: a Symbolic Study of Value Transformation in a Massim (P.N.G.) Society*, University Press Cambridge, Cambridge, MA.

Museum of Anthropology (University of British Columbia), accessed 14 May 2010, www.moa.ubc.ca/RRN/about_overview.html.

Myers, F 2002, *Painting Culture. The Making of an Aboriginal High Art*, Duke University Press, Durham, NC.

Onians, J 2008, *Neuroarthistory: From Aristotle and Pliny to Baxandall and Zeki*, Yale University Press, New Haven, CT.

Osborne, R, Tanner, J 2007 (eds), *Art's Agency and Art History*, Blackwell, Oxford.

Paternosto, C 1996 (1989), *The Stone and the Thread: Andean Roots of Abstract Art*, University of Texas Press, Austin.

Paternosto, C (ed) 2001, *Abstraction: The Amerindian Paradigm*, Palais des Beaux-Arts, Brussels.

Pink, S 2009, *Doing Sensory Ethnography*, Sage, London.

Pinney, C 1992, 'The Lexical Spaces of Eye-Spye', in P Crawford and D Turton (eds), *Film as Ethnography*, Manchester University Press, Manchester.

Powell, R (M Oppitz, ed) 2001, *Himalayan Drawings*, Museum für Völkerkunde, Zurich.

Price, S 1988, *Primitive Art in Civilized Places*, University of Chicago Press, Chicago.

Price, S 1993, 'Provenances and Pedigrees: The Appropriation of Non-Western Art', in D S Whitten and N E Whitten (eds), *Imagery and Creativity: Ethnoaesthetics and Art Worlds in the Americas*, Arizona University Press, Tucson.

Price, S 2007, *Paris Primitive: Jacques Chirac's Museum on the Quai Branly*, University of Chicago Press, Chicago.

Reichard, G 1997 (1934), *Spider Woman: A Story of Navajo Weavers and Chanters*, (Introduction by Louise Lamphere), University of New Mexico Press, Albuquerque.

Rheinberger, H–J 1997, *Toward a history of epistemic things: synthesizing proteins in the test tube*, Stanford University Press, Stanford.

Raymond, R, Salmond, A 2007 (eds), *Pasifika Styles: Artists Inside the Museum*, Museum of Archaeology and Anthropology, Cambridge, Otago University Press, Otago.

Sansi, R 2007, *Fetishes and Monuments: Afro-Brazilian Art and Culture in the 20th Century*, Berghahn, Oxford.

Santos, G D L 2009, 'How Global Art Transforms Ethnic Art', in H Belting, A Buddensieg (eds), *The Global Art World: Audiences, Markets and Museums*, Hatje Cantz, Ostfildern.

Schneider, A 2003, 'On appropriation: a critical reappraisal of the concept and its application in global art practices', in *Social Anthropology*, 11 (2), pp. 215-229.

Schneider, A 2006a, 'Appropriations', in A Schneider, C Wright (eds), *Contemporary Art and Anthropology*, Berg, Oxford.

Schneider, A 2006b, *Appropriation as Practice: Art and Identity in Argentina*, Palgrave, New York.

Schneider, A 2008, 'Three modes of experimentation with art and ethnography', in *Journal of the Royal Anthropological Institute (N.S.)* 14, pp. 171-193.

Schneider, A 2010, 'Contested Grounds: Fieldwork Collaborations with Artists in Corrientes, Argentina', in *Proceedings of the Conference "Performance, art et anthropologie"*, Musée du quai Branly, Paris, accessed 1 March 2016, http://actesbranly.revues.org/431#ftn5.

Schneider, A, Wright, C (eds) 2006, *Contemporary Art and Anthropology*. Berg, Oxford.

Schneider, A, Wright, C (eds) 2010, *Between Art and Anthropology*, Berg, Oxford.

Schneider, A, Wright, C (eds) 2013, *Anthropology and Art Practice*, Bloomsbury, London.

Shelton, A 2009, 'The Public Sphere as Wilderness: Le musée du quai Branly', in *Museum Anthropology 32*, 1, pp. 1-16.

Steiner, C 1994, *African Art in Transit*, Cambridge University Press, Cambridge, Mass.

Stoller, P 1989, *The Taste of Ethnographic Things: The Senses in Anthropology*, University of Pennsylvania Press, Philadelphia.

Stoller, P 1997, *Sensuous Scholarship*, University of Pennsylvania Press, Philadelphia.

Stoller, P 2006, 'Circuits of African Art/Paths of Wood: Exploring an Anthropological Trail', in E Venbrux, P Sheffield Rosi, R Welsch (eds), *Exploring World*, Waveland Press, Long Grove, Ill.

Stoller, P, Olkes, C 1987, In *Sorcery's Shadow: A Memory of Apprenticeship among the Songhay of Niger*, University of Chicago Press, Chicago.

Svašek, M 2007, *Anthropology, Art and Cultural Production*, Pluto, London.

Taussig, M 1993, *Mimesis and Alterity*, Routledge, London.

Taussig, M 2004, *My Cocaine Museum*, University of Chicago Press, Chicago.

Taussig, M 2008, *What Colour is the Sacred?*, University of Chicago Press, Chicago.

Talyor, L 1996, 'Iconophobia: How Anthropology lost it at the Movies', in *Transition*, 69, pp. 64–88.

Thomas, N 1991, *Entangled Objects: Exchange, Material Culture and Colonialism in the Pacific*, Harvard University Press, Cambridge, Mass.

Thomas, N 2001, 'Appropriation/Appreciation: Settler Modernism in Australia and New Zealand', in F R Myers (ed), *The Empire of Things: Regimes of Value and Material Culture, School of American Research Press*, Santa Fe, NM.

Thomas, N, Pinney, C (eds) 2001, *Beyond Aesthetics*, Berg, Oxford.

Venbrux, E, Sheffield, P, Welsch, E (eds) 2006, *Exploring World Art*, Waveland Press, Long Grove, Ill.

Viveiros De Castro, E 1998, 'Cosmological deixis and Amerindian perspectivism', in J*ournal of the Royal Anthropological Institute*, N.S., 4 (3), pp. 469-488.

Wagner, M 2001, *Das Material der Kunst*, C.H. Beck, München.

Wagner, R 1975, *The Invention of Culture*, Prentice Hall, Englewood Cliffs, NJ.

Weibel, P, Buddensieg, A (eds) 2007, *Contemporary Art and the Museum: A Global Perspective*, Hatje Cantz, Ostfildern.

Welsch, R, Venbrux, E, Rosie, P S (eds) 2006, E*xploring World Art*, Waveland, Ill.

Westermann, M 2005, 'Introduction: The Objects of Art History and Anthropology', in M Westermann (ed), *Anthropologies of Art*, Clark Art Institute, Yale University Press, New Haven.

Wilson, S 2002, *Information Arts: Intersections of Art, Science, and Technology*, MIT Press, Cambridge, Mass.

Winter, I 2007, 'Agency Marked, Agency Ascribed: The Affective Object in Ancient Mesopotamia', in R Osborne, J Tanner (eds), *Art's Agency and Art History*, Blackwell, Oxford.

Wolbert, B 1998, 'Getrennte Kunstwelten. Überlegungen zu einer systematischen Anthropologie der Kunst', in *Anthropos*, 93, pp. 189-196.

Zijlmans, K 2008, 'The Discourse on Contemporary Art and the Globalization of the Art System', in K Zijlmans, W Van Damme (eds), *World Art Studies: Exploring Concepts and Approaches*, Valiz, Amsterdam.

Zijlmans, K, Van Damme, W (eds) 2008, *World Art Studies: Exploring Concepts and Approaches*, Valiz, Amsterdam.

Jérémie Gindre works as an artist and writer in Geneva. He studied in Geneva at the University of Art & Design and he took part in the artists-in-labs program at the Swiss Centre for Affective Sciences, the Geneva Neuroscience Centre and the Brain and Behaviour Laboratory (all University of Geneva) in 2011. His other residencies include the Stúdió FKSE (Budapest 2002), Ivalo (Finland 2003), The Villa Arson (Nice 2006), 20qm (Berlin 2009), The Wallace Stegner House (Eastend, CA 2012) and the European Archaeological Centre of Bibracte (France 2013). Jérémie Gindre is represented by the Chert gallery in Berlin and his work is deeply marked by an interest in geography and history. He is particularly influenced by aspects of geology, archaeology, conceptual art, neuroscience, apiculture and tourism. His mediums are diverse—novels, short stories, essays, articles, comic strips and photographic novels. He has presented his work, which combines drawing, sculpture and text, in numerous exhibitions including: Kunsthaus Baselland (Basel), la Bibliothèque Humaniste (Sélestat), Circuit (Lausanne), gallery Chert (Berlin), Kunsthalle Fri-Art (Fribourg) and La Criée (Rennes). His writings have been published by Motto, Dasein, Fink, Attitudes and Rollo Press, and his latest book, *On a eu du mal* was published by les Éditions de l'Olivier.

Taken together, the Geneva Neuroscience Center (Centre Interfacultaire de Neurosciences, CIN) and the Swiss Center for Affective Sciences (SCAS, or Centre Interfacultaire en Sciences Affectives — CISA) of the University of Geneva pool resources from over 60 research groups from the University of Geneva and from 6 departments of the University which dedicate their research to the understanding of the human brain, behaviour, and emotion ranging from molecular and neuronal research to social, psychological, philosophical and artistic research.

Researchers involved in the residency: Prof. David Sander, Director of the Swiss Center for Affective Sciences, University of Geneva, Prof. Didier Grandjean, Swiss Center for Affective Sciences, University of Geneva, Dr Alison Montagrin, Swiss Center for Affective Sciences, University of Geneva, Prof. Sophie Schwartz, Geneva Neuroscience Center, University of Geneva, Dr Arnaud Saj, Geneva Neuroscience Center, University of Geneva.

The Geneva Neuroscience Center and the Swiss Center for Affective Sciences jointly coordinate the Brain and Behaviour Laboratory (BBL).

www.affective-sciences.org
neurocenter.unige.ch
www.bbl.unige.ch

Neglecting

Adaptation

Conceptual Art and Its Links to What We Do

Jérémie Gindre

Adaption

Conceptual Art and Its Links to What We Do

My work revolves around the concept of discovery, because discoveries have always been a motor for history. I have always been interested in how things are discovered, and I have always been particularly interested in the history of natural sciences. So out of the choices that were offered in that year's ail program I naturally gravitated towards neuroscience and the Affective Science Center. I was in a state where I was still interested in contemporary art and literature, but I felt compelled to leave that scene, and be confronted by other things and to find new dynamics. And I found that in this scientific field, where I am "the" artist, I am not just one artist among many. I became "their" artist.

The science at NCCR was a great resource for stories. There are so many things to tell in relation to the research about topics like perception or spatial disorders or amnesia. Every time something does not function as it should in our brain, it can open up into a very strange, beautiful or sad story. Since I wanted to adapt knowledge from neurosciences into

Comments by the NCCR researchers and the article
Artist in Residence at SCAS and CIN[1]; some additional quotes
from the video interview with Jérémie Gindre,
from the artists-in-labs program DVD.

David Sander investigates how emotions are elicited, expressed, and regulated. He is also interested in understanding how emotions drive attention, memory, and decision-making. His research brings together behavioural data as well as brain imaging

1 'Artist in Residence at CISA and CIN', in *Affect & Emotion: Newsletter of the NCCR Affective Sciences*, November 2011, Vol. 2, No. 4, p. 4. accessed 2 February 2016 www.affective-sciences.org/system/files/newsletter/Newsletter_vol2_issue4.pdf.

stories, I met with many scientists. I listened a lot and started to learn their language and discover their ideas. I wrote pages and pages of notes in notebooks: information, concepts, and curiosities. And I asked many questions. The inspiration for the story about a person with hemi-spatial neglect disorder stems directly from my conversations with NCCR researchers.

I went to the conferences to get to know the people in the center. I had the chance to be there as a tourist. When I had a question, I could directly ask the specialists. So I was a very studious tourist for the first three months.□1

There were three short stories, which "came" to me quickly, one of them is about "Visual Neglect". That is a disorder that can occur in patients who've had a stroke in their right hemisphere. This person might have distorted perceptions of every left-sided sensory input. What he hears, sees, touches or smells he will have a tendency to neglect it. That means he will still receive the information, but

his brain will ignore it. I decided to write a story about a person who has this form of "visual neglect". To do that I didn't only need to know about the disorder, but also how the person feels and how their general perception of the world is affected. There is always a connection between my stories and the scientific background. Sometimes I stay very close to the science and sometimes it is very far removed. Sometimes only little of the science remains, sometimes there are many things united in one story.

After I had written my first stories I gave them to the researchers and professors who I had worked and discussed with. Their feedback was most interesting because they experienced them as both casual readers and specialists. And one could feel that while reading, they felt torn between those two positions. That means in one moment they were immersed in the story, and in the next they recognized information they had told me, or perhaps it was incorrect and they needed to give me more information.

data from healthy subjects and brain-damaged patients in order to better understand the emotional response to relevant visual, auditory, or olfactory stimuli.

Among the researchers who collaborated with the artist-in-residence Jérémie Gindre, David Sander was particularly interested in exploring how his work relates to emotion, from the rich and diverse perspectives that Jérémie brought to the Center.

Prof. David Sander
Director of the Swiss Center for Affective Sciences, and of the E3 Lab, University of Geneva

Jérémie has his own approach to art and, as I discovered as well, his own approach to science. I was impressed by his willingness—and capacity—to be involved in the seminars and workshops that we organized on emotion. He understood many of the specificities of our research, both in terms

Jérémie Gindre

Swiss Center for Affective Sciences, Geneva Neuroscience
Center, Brain and Behaviour Laboratory

☐ 1 Art and science interaction at the research lab.
☐ 2 Image from Gindre, J 2013, *On a eu du mal,* Editions de l'Olivier, Paris.

Affective Style

Excerpt from my short story *Moitié Moins*, in: *On a eu du mal*, Editions de l'Olivier, Paris, 2013

"This track leads along the river bed by 200 m, then it leads up to the sports field. The stairway has been built by a group of foresters who have made the steps uneven. The wear has made some of them darker and it's not a surprise when Claude stumbles at the top. Oh Shit, what was that…? He has lost his left shoe because the laces had opened, or had not even been bound in the first place. He knows that he should really pay attention to these things but at the same time, he always notices too late. The shoe is lying further down but luckily it was stopped by a dead branch. He climbs down to retrieve it, and takes his time to put it back on and to tie the laces by leaning on the highest step in front of him. To make sure, he turns his head. The rest of the stairway starts to move." □ 3/4

The scientists were friendly and we had a lot of fun. We had lunches, coffees and picnics together and it was easy to share ideas with each other. They were curious about me,

□ 3 Image from Gindre, J 2013, *On a eu du mal*, Editions de l'Olivier, Paris.

of approaches and content. He was aware of the limits of the scientific perspectives, and could bring his art to scientific topics. An important aim was to create artwork based on our scientific knowledge. It was a unique opportunity to have a truly interested and committed artist coming to the lab to really interact. We had several meetings, and exchanged ideas and books. I really see his residency as an exchange period. Our researchers' reaction was extraordinarily positive. We were very happy to see how PhD students and Postdocs reacted to his presence and interventions. We also all learnt a lot as Jérémie organized several meetings in "his lab", the place where he works. It was great to see 30 or 40 researchers going there to hear him explain to our researchers the basics of conceptual art and all the links he could make with what we do in terms of the books he already read and

and they complimented me on my shoes. I explained my project to each new person I met, and they nodded. Weeks, months passed. Once a scientist asked me to help him on the setting of an experiment: He asked me for several scenarios of peculiar contexts, and he was happy with the result. Often, their topics made me think about the work of artists, writers or filmmakers. So I told them about that. A few times I invited all of them to come to my studio, in order to show them books. And also to the museum of modern and contemporary art. I read their articles and books and explained these things to my friends. I was thinking about it all the time. I spent my days in classrooms, auditoriums and down in a basement lab. It was mainly fascinating and sometimes repetitive, even boring. I was in the fMRI once and assisted with many scans, though I was not interested in technology.□6/7 I privileged conversations and conferences. I often had headaches, because of the Power Point presentations but they asked my advice and we joked a lot during the summer academy and

the annual ski meeting. We danced in a club and shouted out the lyrics of old songs, I felt like a visiting cousin.

From the very beginning I took notes about art pieces, novels or movies that seemed connected to what they told me. Then, I invited them to my studio and to exhibitions. I was aware that it was an unique opportunity. It was intense and I learned a lot. It was like back in the school days, but more fulfilling. I tried to stay focused on my project and it was easy. The ideas popped up like mushrooms in autumn. I tried to be patient. They invited me to collaborate on a publication they were working on. Like other scientists of the lab, I wrote an article and I co-wrote the introduction with a professor. But I waited four months before I started writing fiction. I wrote a first story and then a second. I reviewed a story written ten years ago and with my new knowledge I was now able to improve it. I tried to integrate science rather than illustrate it. I used various contexts and characters. The scientific ingredients were about

the individual discussions he already had with many of our colleagues. Now that his residency period is over, we are exploring various avenues of collaborations. I am convinced that his approach is relevant and complementary to the one I have, in order to understand many aspects of emotion.

Prof Didier Grandjean
NEAD Lab, University of Geneva

This research group examines the psychological and neuronal processes involved in emotion and the affective dynamics related to different kinds of auditory, olfactory, and visual stimuli. How the human mind is able to build up a verbally accessible representation of emotion from an auditory stimulus and which kinds of brain processes are involved in this capacity is one of the major axes in their research.

□ 4 *Feeling Like This*, (drawings) ail, exhibition & conference
LES AMIS IMAGINAIRES at Fonderie Kugler, Geneva 2011

Different clinical syndromes, such as depression, Parkinson disease and anxiety disorders, are also investigated in order to better understand how emotion interacts with cognitive functions such as attention and inhibition. Finally, "Music and emotion" is also an important topic of the research conducted by the Prof Grandjean's research group.

During Jérémie Gindre's residency, the research team had a lot of interactions discussing different psychological and neurological syndromes, and how the human brain and mind is able to build up an accessible representation of emotions and feelings. Such interactions with scientists had not only an important effect on the work done by Jérémie Gindre but had also a more indirect impact on the scientists developing new original perspectives in their own work.

☐ 5 *Gindre, J 2013, On a eu du mal, Editions de l'Olivier, Paris.*

Prof. Sophie Schwartz
Sleep and Cognition Neuroimaging Laboratory

This research group studies the role of sleep and emotions in learning and memory processes. Our research focuses on distinct facets of neural plasticity: perceptual and emotional learning, offline replay of neural activity, and selection of relevant information to be consolidated. Another recent interest in the lab concerns the role of the dopaminergic reward system in risk seeking, creativity, and dreaming. In our projects, we assess brain functions in healthy adult volunteers, as well as in neurological and psychiatric patients, using functional MRI (fMRI) and electroencephalography (EEG).[6/7]

I am focused on brain research at the Department of Neuroscience. I study the influence of sleep and dreaming

memory, hypnosis, mindfulness meditation, hemi-spatial neglect, personality changes, bipolar disorder, ruminations, hallucinations, dreams, the sublime and shame. I asked some scientists to read those stories, to get their advice and scientific tips. They gave favourable advice and good tips, for example on the relevance of sleep in emotional functions.

Following this collaboration I really want to continue this discussion with the scientists. So I will continue to come here and see the things they do and they will visit my exhibitions and read the books that I will write. Yes, we really got along very well. It was a sweet parenthesis. Though I stayed home, I felt like I had moved to another country. It was inspiring to use things outside of the realm of my usual influences. It was hard to accept the end of the residency, so we extended the collaboration for a few more months. We organized a small exhibition and a colloquium to confront both artists and scientists with various topics related to imagination. We chose the title *Imaginary Friends*, firstly because one of the main topics of discussion was the imagination, and secondly to make a small joke around the question of whether artists and scientists are indeed "imaginary" or "real" friends. A lot of people came and it was interesting. After that, I edited a newspaper with the drawings I made during my residency, as a thank you gift for the scientists and as a bridge to a larger public.□4 I also published one of the stories in an independent publishing house (Gindre, J 2013, *UN TROU CÉLÈBRE*, Motto, Berlin). Afterwards, I published a collection of five short stories with a major publishing house.□5 It was an important step to release these stories for an audience that was not aware of the whole process. The book received a lot of press and I spoke about my learning experience on the radio several times. I invited the scientist to the readings and they came—these were emotional moments. Two years later, I started collaborating with archaeologists, based on the same principle.

on memory. My second field of interest is emotion, which links my research to the Swiss Center for Affective Sciences. During his residency, I am sure Jérémie could really understand quite well, almost like a scientist, what type of research we are doing. I know that some reports from patients with brain lesions were quite striking for Jérémie. Personally, I had the same fascination the first time I heard about some deficits that patients may present after selective brain damages. For example, how is it possible that a patient may be unable to pay attention to anything that is on his or her left? Or selectively lose the ability to recognize people's faces? We had many lively discussions and Jérémie also participated in some of our experiments. It was a great pleasure and enlightenment to have Jérémie in the lab because he would always ask very precise, smart, and challenging

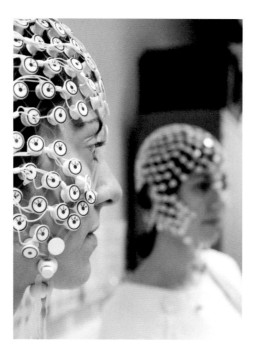

References

The final novel related to this residency is entitled
One Helluva Hole and it was released by Motto Books.
ISBN: 9782940524327. For more information see:
www.mottodistribution.com/shop/one-helluva-hole.html

Gindre, J 2013, *Un trou célèbre*, (novella) Motto Books,
Berlin.

Les amis imaginaires, A colloqium with Vidya Gastaldon,
Jérémie Gindre, Irène Hediger, Patrizia Lombardo,
Emmanuel Mellet, Christine Mohr, Sophie Schwarz,
Evariste Richer, Shimabuku, Jim Shaw, Fabrice Stroun,
Patrik Vuillemier and Fonderie Kugler, Geneva, 2011

☐ 6 EEG (electroencephalogram) a sensory apparatus to record the Beta, Gamma and Alpha waves of the brain
☐ 7 MRI (Magnetic Resonance Imaging) experiments to measure brain activity when the subject is given certain tasks.

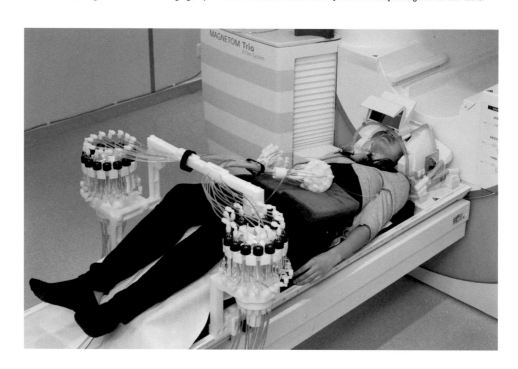

questions. He also introduced me to books that were connected to what we were doing in our research, for example regarding our studies on dreaming.

Well, I cannot read Jérémie's novels like a reader would without any background in neuropsychology. In his book, Jérémie was inspired by some of the strange and fascinating deficits that we can observe in patients who suffer from brain damages. He used these observations as a way of distorting the world experienced by the protagonists in his novels, but the reader is not supposed to know that. Therefore, he or she will perceive a form of altered reality without knowing exactly what is wrong. But since I know what he's talking about, I somehow cannot let myself be fooled by the narrative.

Dr. Arnaud Saj
Geneva Neuroscience Center

I also liked to work with Jérémie. He came by several times and we talked about my clinical work. Then, he also accompanied me to two sessions with patients. He assisted me while I was doing evaluations. It's always good to do that with another person to be sure that what you see is real. This way, Jérémie could see how a patient with Visual Neglect behaves. After that, we met several times when we were reviewing patients with special symptoms. I tried to involve Jérémie many times so he could see different examples of spatial perception disorders.

Susanne Witzgall is head of the cx centre of interdisciplinary studies at the Academy of Fine Arts Munich funded by the BMBF. From 2003 to 2011 she was an assistant professor at the Department for Art History at the same institution and in summer term 2013 a guest lecturer at Newcastle University. From 1995 to 2002 Witzgall worked as a curator for the Deutsches Museum Bonn and the Deutsches Museum, Munich. She has curated and co-curated several exhibitions among them *Art & Brain II* (1997/98), *The Other Face* (2002), *Say It Isn't So* (2007) and *(Re)Designing Nature* (2010/1) and is the editor and author of numerous books and articles on contemporary art and art and science, including *Kunst nach der Wissenschaft* (2003), *New Mobility Regimes in Art and Social Sciences* (with Gerlinde Vogl and Sven Kesselring, 2013), *Power of Materials/Politics of Materiality and Fragile Identities* (both with Kerstin Stakemeier, 2014 and 2015).

Overlapping Waves and New Knowledge

Susanne Witzgall

Hierarchy and stereotyping still appear to determine the relationship between art and science today, even if the attitude towards scientific research processes and artistic practice has changed in the meantime, leading to a new assessment of these different epistemic cultures. The images of science as universal, objective, and steadily advancing, on the one hand, and of art as predominantly individual, dominated by subjectivity and intuition, on the other, have lost considerable credibility and become less distinct. The various deconstructions of science in the 1960s and 1970s, stemming from linguistics and postmodern relativism and placing emphasis on historical contingency and the social construction of scientific findings, theories and objects of knowledge, were not the sole cause for this development, but also more recent investigations of scientific practice inspired by anthropology. Constituting knowledge "no longer within the abstract space of conceptual history and the history of ideas", they present it "within its contingency and local situatedness, within the historic context of its *production*" (Rheinberger, Wahring-Schmidt, Hagner 1997, p. 8). Furthermore, the capacity of art to generate knowledge and engage competently in research has been increasingly recognized over the course of the last decade, while emphasis has been placed on its rational and intersubjective aspects. Regarding the relationship between art and science, the present discourse on artistic research clearly shows, however, that certain presumptions and hierarchizing comparisons still persist. For example, artistic research is frequently analyzed in a one-sided manner and construed as something that generates implicit, practical, or sensual knowledge — a knowledge that is difficult to verbalize and rather shown or felt, a knowledge that, although credited with cognitive and rational qualities, nevertheless must be distinguished from a theoretical-discursive knowledge (insight through terms). We must cast a critical view on these generalizing and polarizing descriptions.[1] Based on sensible and conceptual differences, they go hand in hand with the reflexive reference to a concept of scientific research with which artistic research contends and from which it feels compelled to distinguish itself. This operation frequently entails the concern that scientific research practices could ultimately take the upper hand and deprive artistic research of its specific artistic-aesthetic qualities.

1 Katrin Busch, for instance, has already rightfully pointed out that there is reason to object to the "attempt of a clear distinction between sensual and conceptual insight", that the "arts based on research" — meaning those arts, which are founded on humanistic and text-based research practices — "leave as little room for work on the enclosure of aesthetic experience as is authorized for their exclusion from the sciences." (Busch 2009, p. 141).

Defining the relation, the difference between art and science, plays a pivotal role when artists and scientists come together. In order to find out whether interdisciplinary cooperation between art and science produces new findings and *how* this might occur, it is necessary, in my opinion, to address precisely the quality of this relationship. Overall, the aim here must be to determine and substantiate the relation, the difference between art and science, in such a way as to avoid hierarchy and stereotyping. The latter often enough diminish and reduce art to the role of explanatory illustration, silent visual imparting, or as a welcome element of mayhem in interdisciplinary contexts, while regarding science, by contrast, as the guardian of research. Such essentialist conventionalism and asymmetric perspectives have a significant impact on the epistemic quality of interdisciplinary encounters.

Gilles Deleuze's concept of free difference, as illustrated in *Difference and Repetition* (Deleuze 1994), offers, I would argue, a more fruitful way of considering the relationship between art and science as symmetrical and non-hierarchical. While he does not refer to this relationship specifically in his text, Deleuze's concept allows us to consider the distinction between art and science not as negative, or devaluating, but as positive difference. To be thought positively, Deleuze maintains that difference must not be understood from the perspective of representation, from conceptual and sensible differentiation, from differences and deviations in sensation. While representation has, meanwhile, lost its moral origins and premises, rooted as they were in Plato's differentiation between archetype, copies, and simulacra — a distinction that only recognizes a connection between copies and archetype on account of the copies' inner reference to being and truth, correlating to that of the archetype. These valuative premises remain pertinent "in the distinction between the originary and the derived, the original and the sequel, the ground and the grounded". Such differentiation sustains the complementarity between archetype and copy, animating "the hierarchies of a representative theology," (ibid., p. 265) within which difference is subordinated to "instances of the Same, the Similar, the Analogous and the Opposed" (ibid.).

In regard to defining the relationship of art and science, this would mean that differentiation based solely on sensible distinctions and similarities risks hierarchizing artistic and scientific representations. Yet, the very question, whether artistic knowledge, in contrast to scientific, manifests itself as showing or feeling, whether artistic representations

of reality should be considered more intuitive and more individual than scientific ones, is precisely the question that encourages the sort of evaluative operations described above. This is true of any comparison of artistic manifestations of knowledge and research concepts with those of science that is based primarily on direct intuition. In such comparisons, difference is locked in the purely sensible and in representation, defined *ex negativo* and always simply in relation to the other that is prior to and beyond difference, identical with itself. Insofar, according to Deleuze, it is merely a *"reflexive concept"*, a "mediating and mediated difference" (ibid., p. 34).

To avoid this, to turn difference into a positive, to free it from its static and eternally hierarchical containment within the conceptually conformist intuition, within the sensible, and to instead comprehend difference as an active, eventful principle — Deleuze desires to deliberately "think difference in itself independently of the forms of representation" (ibid., p. 19). In order to achieve this, he leaves the surface effects of representation behind, descending into the depth of Being, which he himself regards as (given) difference. This Difference of Being is a(n) (individuating) difference of intensive quantity, which precedes those which we know as generic and specific differences, or individual differences (compare ibid., pp. 38). From the surface effects, at the same time, Deleuze delves into the depths, where he reaches the Idea or the virtual-ideal: To him, Ideas represent "genuine objectivities", made up of "differential elements and relations" and equipped with a specific mode — "the problematic" (ibid., p. 267). What this means is that the Idea, in its multiplicity and differentiality, thus implies diverse questions and indeterminations. To Deleuze, the Idea distinguishes itself, then, through a multiplicity, the elements of which initially have neither "sensible form nor conceptual signification, nor, therefore, any assignable function. They are not even actually existent, but inseparable from a potential or a virtuality" (ibid., p. 183). It is precisely this character of the Idea that renders possible the manifestation of difference as something freed from all subordination. Only in a subsequent step must these elements of the Idea's manifold indetermination be defined in reciprocal relations.

This process of determination within which the problem-Idea, the virtual-ideal, becomes something sensible and "relations coexisting within the Idea" begin "to differenciate themselves in qualities and extensities". Deleuze calls "Individuation", following Gilbert Simondon. Individuation emerges like the act of solving the problem-Idea or rather

like the Idea's "actualisation of a potential and the establishing of communication between disparates" (ibid., p. 246). Through Individuation, differential relations of the Ideas "are actualized [...] within intuition along lines differenciated in relation to other lines" and then form "the quality, number, species and parts of an individual" (ibid., p. 312). In this way, too, are formed — one might add, in view of science and art — scientific and artistic practices, their fields of action, sub-disciplines, styles of writing, manifestations of knowledge and modes of representation.

Sensible differences, then, following Deleuze, gain their ontological foundation through the difference of Being, which, in its multiplicity and indeterminate virtuality, evades any system of valuation. This ontological foundation of difference has recently received unforeseen support. Deleuze's concept of Being as (intensive) difference and the Idea as a virtual multiple structure of differential relations corresponds, in my opinion, in several key points to recent philosophical conclusions from the area of quantum field theory, as formulated by physicist and philosopher of science, Karen Barad. As a radical deconstruction of classic ontology, Barad maintains, quantum theory shows that "physical particles are inseparable from the void, in particular they intra-act with the virtual particles of the void and are thereby inseparable from it"; in this way, the infinite "plethora of alterities given by the play of quantum in/determinacies" (Barad 2014, pp. 159–160) includes a continual process of doing and undoing identities. Thus, "even these smallest bits of matter are of fathomless multitude" (ibid., p. 160), they are — to voice Barad and Deleuze simultaneously — of a multiplicity generated through the interplay of infinite alterity. Hence, "ontological indeterminacy, a radical openness, an infinity of possibilities, is at the core of mattering" and constitute the "condition for the possibility of all structures in their dynamically reconfiguring in/stabilities" (ibid.). Barad appears to assume a similar primary difference of Being and detects in the elementary particles of quantum field theory a similar virtual, manifold indeterminism of differential relations as utilized by Deleuze for his problem-Idea. Yet, through Barad, Deleuze and his concept of positive difference gain a rather highly contemporary neomaterialist foundation.

In close connection with Deleuze's concept of positive difference and its new materialist foundation in Barad, we can now understand difference in the relation of art and science as something already grounded within differential Being and a multiplicity of the Idea, the virtual-ideal. With that, the difference between art and science becomes a positive

distinction. Its non-hierarchical quality beyond demarcation, degradation, and negation, attains ontological legitimation. Yet, to more precisely define this difference, we cannot look to Deleuze's problem-Idea, for, as he maintains, it is pre-individual and, thus, not conscious, since the virtual-ideal occurs prior to the act of individuation. Instead, we must more closely examine the processes of individuation and actualization of the relations of difference between disciplines, genres, species, individuals, entities, methods and concepts, before they materialize in the surface effects of representation. The analysis of such individuation and actualization processes — be it from a long or even relatively short-term perspective — however, serves not only to more closely define the difference between art and science. It also holds entirely different possibilities concerning the ethics of epistemic processes and the insightful interdisciplinary cooperation between artists and scientists.

 In the second part of this essay, I would now like to elaborate this idea further on the basis of Barad's work. According to her, the boundaries and determinations of any given phenomenon (whether natural or simulated) cannot be accepted as given, for they emerge through epistemic practices and processes of knowledge generation. These practices therefore, have not only themselves emerged through precedent, long-term individuation and actualization processes but play an active role in the continued actualization of relations of difference, in the differentiation of phenomena. In natural scientific practice it is precisely the intra-action of phenomena with scientific apparatus that plays a key role in constituting clear boundaries and properties of phenomena. As Barad explains — making reference to Niels Bohr — it is not simply an object preexisting the experiment that is observed in an experiment but the entanglement and inseparability of apparatus and object under examination (cf. Barad 2007, e.g. pp. 142–143 and p. 151). Here, Barad rejects an essentialist naturalism that considers material phenomena something science need merely discover and disclose through its practices. At the same time, however, she opposes pure constructivism, which assumes that phenomena — as Donna Haraway has already criticized — are produced alone through "our own 'semiotic technologies' for making meaning" (Haraway 1991, p. 187). Like Haraway, Barad believes phenomena are material and discursive at the same time they are "material-semiotic" actors (ibid., p. 200), continuously (re)produced through a material-discursive intra-action. Thereby, the concept of intra-action explicitly highlights a process that occurs within phenomena and which causes

them to materialize, making them relevant — in contrast to interaction between phenomena, which assumes that entities are already clearly defined and distinct.[2]

The scientific experimental system with its research apparatus can be understood as merely one of the facets of manifold knowledge practices, which *"are specific engagements that participate in the (re) configuring of the 'world'"* (Barad 2007 [note 16], p. 91) — and, according to Barad, through their practices first constitute "differential boundaries between humans and non-humans, culture and nature, science and the social" — and, we might add, between art and science (Barad 2007 [note 16], p. 140). Which knowledge practice one applies, which boundaries it draws, which differences it produces, makes a crucial difference and is, therefore, linked with a peculiar responsibility for these boundary-drawings.

It becomes imperative, then, as Barad maintains, that we are aware of the effects brought about by the particular boundary-articulations, the production of differences and their materializations. This requires, amongst other things, a specific practice Barad terms "diffractive methodology", which can be understood as a kind of analyzing tool and transdisciplinary approach, interrelating aspects of different disciplines. In particular, by reading the fine details of different disciplinary approaches through one another, this practice illuminates boundary-making and its material-discursive nature.

In this context, the physical concept of diffraction, which commonly describes the overlapping or refraction of waves upon encountering an obstacle,[3] serves Barad as a tool to deliberately conceive knowledge generating involvements and interferences of subject, apparatus, and explored phenomena as performative and processual. This diffractive methodology accounts for the "relational ontology" at the core of her theory of "agential realism", which states that each phenomenon only differentiates itself in relation to and through intra-action with other phenomena, apparatus, humans and non-humans. Thus, as Barad explains, diffractive methodology "does not take

2 So far widely unmentioned is the fact that Barad's statements on this issue correspond to those of Bruno Latour and Hans-Jörg Rheinberger. In their research on scientific practice and knowledge generation, they have discovered a similar entanglement of apparatus and objects of investigation, or rather of human and non-human entities, of scientists, previous knowledge, data, institutions, recording systems and objects of research — basically, all those components that in some way participate in the practice of science. According to Hans-Jörg Rheinberger, epistemic things, for example — things that pertain to the "endeavour of knowledge" within scientific experimental systems, those things that should be researched — are initially located in a condition of vagueness and precariousness, of provisionality and indefiniteness. To (re)define and give it a new shape, or rather produce it, the appropriate technical conditions (instruments, recording apparatus, model organisms...) are required (Rheinberger 1997, p. 30).
3 Quoting Richard Feynman, Barad draws no distinction between interference and diffraction in this point (compare Barad 2007 [note 16], p. 80).

the boundaries of any kind of objects and subjects of these studies for granted but rather investigates the material-discursive boundary-making practices that produce 'objects' and 'subjects' and other differences out of, and in terms of, a changing relationality" (Barad 2007 [note 16], p. 93). At the core of diffractive methodology lies the belief that material-discursive practices do not simply produce different descriptions of the world, determined from some observational position putatively outside it. They are, in fact, non-representationalistic and produce, as I have already described above, through direct involvement of subject and its apparatus with the object of investigation, "different difference/ diffraction patterns", that is, different "material configurings" (Barad 2007 [note 16], p. 184) of the world, which include certain aspects and exclude others, creating specific patterns through certain refractions and overlapping, or rather making them visible. Diffractive methodology now enables us to consider precisely these entanglements and interrelations by reading different disciplinary approaches through one another. The aim thereby should be "to place the understandings that are generated from different (inter)disciplinary practices in conversation with one another [...] to engage aspects of each in dynamic relationality to the other" (Barad 2007 [note 16], pp. 92–93). According to Barad, diffractive methodology — rather than reflexive methodology, which accepts representations as mirrorings of reality — allows us to trace the genealogy of epistemic boundary-making processes.

Barad explicates diffractive methodology primarily in reference to the relation of natural science and the social, or rather social theory, in an effort to critically rethink their relationality. I would like, here, to apply diffractive methodology to the very different nature of the relation of art and science, as well as to the concrete collaborative practice between artists and scientists, and at least begin to flesh out two aspects I consider important for a potential cooperation of art and science. In the context of my explication, above, of Deleuze and his concept of positive difference, I would, first, argue for a closer examination of individuation and actualization processes of artistic and scientific apparatus, axioms, and practices. In other words, of the tools and agents of scientific and artistic boundary-drawing, which themselves emerge from this very practice and which deal directly with the basic prerequisites for scientific and artistic work. Secondly, I maintain that Barad's concepts of diffraction and diffractive methodology offer a model through which we can gain new insight within the dialogue of art and science, insights

that go beyond the mere illuminative analysis of particular disciplinary boundary-drawing practices and the generation of difference.

As I have discussed above, Deleuze's concept of individuation draws on the thought of Gilbert Simondon, for whom individuation can be understood as an ontogenetic process that takes place similarly in a wide variety of areas — be it physical, biological, or psychic individuation, or even the individuation of knowledge. Simondon regards mediation as the "true principle" of individuation, while considering the relation of the individual to the world and the collective, as a "dimension" of the individuation process. Here, too, relation is not to be understood as the connection between already constituted terms or independent entities but as a relation "in the context of the being itself, a relation belonging to the being" (Simondon 1992, p. 312). Interestingly, this understanding of relation and mediation in its particular combination bears a striking similarity to a process in the course of individuation described by Karen Barad's concept of intra-action referred to above. Moreover, according to Simondon, an individuation in progress is a transductive process whereby the philosopher introduces a process, which opens up to a temporal developmental dimension that seems to be lacking in Barad's concept of intra-action. Simondon understands the transductive process as a complex process of organization, modification and transfer conserving and integrating opposed aspects, which he illustrates in the example of crystallization: "The simplest image of the transductive process is furnished if one thinks of a crystal, beginning as a tiny seed, which grows and extends itself in all directions in its mother-water. Each layer of molecules that has already been constituted serves as the structuring basis for the layer that is being formed next [...]." Simondon distinguishes between simple and more complex domains of transduction. While the former occurs as progressive iteration, in the case of more complex domains, "such as those of living metastability or psychic problematics, it might progress at a constantly variable rate and expand in a heterogenous area" (ibid., p. 313). In the area of knowledge, the transductive process indicates the actual course taken by invention. Its progress is neither inductive nor deductive, but rather transductive, "correspond[ing] to a discovery of the dimensions according to which a problematic can be defined" (ibid.).

The concept of transduction highlights, in our case, however, not only the material-discursive practices of knowledge production at a specific moment, but also the mechanisms of transfer and modification

between growing and constantly changing dimensions and components of scientific and artistic epistemic systems. We can thus gain insight in precedent individuation processes and the concomitant transfers and modifications of significant structural elements of certain systems of knowledge. But not only that. In connection with the dynamics of intra-action — or, to borrow Simondon's terms, in connection with mediation as a principle of individuation and its relational dimension — the transduction process suggests that the systems of scientific and artistic knowledge production are themselves transformed in the process of their continued individuation through interdisciplinary encounters and collaborations. As complex metastable systems, they could, in the long-term, through their mutual communication with elements of another discipline, expand into unfamiliar epistemic areas, wherein new knowledge is generated.

Karen Barad's concepts of diffraction and diffractive methodology, however, appear to offer prospects for an interdisciplinary dialog between art and science to gain knowledge in the short and medium-term. So, the mutual reading-through-one-another — by both artists and scientists — of various disciplinary forms of entanglement with the world would not only illuminate the particular peculiarities of respective boundary-drawing practices and generated differences, but in a united epistemic practice it would, at the same time, produce new difference or diffraction patterns, thereby generating new forms of knowledge. Let us now remain within Barad's metaphor and extend it to scientific-artistic collaborative projects, where various types of difference and diffraction patterns encounter each other: a diffraction pattern forms when two waves overlap or when one wave encounters an obstacle (for example, an experimental apparatus). When waves overlap, areas of enhancement (constructive interference) and diminishment (destructive interference) emerge. When two different diffraction patterns are superimposed, further constructive and destructive interferences will generate new patterns. The result is very complex, new, second-order diffraction patterns. The precondition for this second-order pattern is, this time, too, that both diffraction patterns be similarly strong, so that no one pattern will drown out the other.

Admittedly, this model appears very abstract. It would need further testing and practice by way of examples to show how it may be applied to tangible, real-life collaborations between art and science and to determine what it means, in particular, when diffraction patterns of

art and science overlap.[4] Another shortcoming of this metaphor is that it appears, initially, to be trapped in a representational mode and makes reference to optical effects that Deleuze equates to simulated identities. Barad herself, however, emphasizes time and again that her argumentation is not analogical, that diffractive methodology is not to be understood in analogy to the physical phenomenon of diffraction. In fact, she works against a reliance on existing optical phenomena, such as one of reflection, using the visual metaphor of diffraction solely as a model for thinking (Barad 2007 [note 16], p. 88). For Barad, diffraction represents a productive model of thinking precisely for a non-representational methodical approach. As such a model of thinking, my extension of Barad's metaphor to second-order diffraction patterns, emphasizes two closely related aspects of the cooperation between art and science:

1 The overlapping of two different knowledge-generating engagements and interferences of subject, apparatus and examined phenomena can produce new diffraction and difference patterns of intra-active epistemic boundary-drawings and shape-givings.

2 This occurs, however, only — and this point should not be underestimated — when the different diffraction patterns of both disciplines are equally strong, when they do not exist in an hierarchical relationship, as otherwise neither perceivable constructive interferences nor destructive ones can develop. This can only occur, however, when — as I have maintained above — we consider the distinction of art and science as positive difference.

4 At this point one can ask the legitimate question, why I am assuming an encounter of two different diffraction patterns and not simply a common diffractive process, in which the scientist or the artist represents just another actor within the intra-active processes of material-discursive boundary-drawing. The reason for this is that both the artist and the scientist have cultivated their particular tools and their specific approaches to the world in a long preceding individuation process from among which they produce differences. These are not to be discarded ad hoc; au contraire, they can be fertilized for interdisciplinary collaborations in particular. A common diffractive methodology, however, could only develop within the long-term mutation process — based on Simondon's transduction concept and described above — of different systems of metastability.

References

Barad, K 2007, *Meeting the Universe Halfway. Quantum Entanglements of Matter and Meaning,* Duke University Press, Durham, London.

Barad, K 2014, 'On Touching — The Inhuman That Therefore I Am (V.1.1)', in S Witzgall, K Stakemeier (eds), *Power of Materials/Politics of Materiality,* e-book, diaphanes, Zurich, Berlin, pp. 153–164.

Busch, K 2009, 'Wissenskünste', in E Bippus (ed.), *Kunst des Forschens. Praxis eines ästhetischen Denkens,* diaphanes, Zurich, Berlin, pp. 141–158.

Deleuze, G 1994, *Difference and Repetition,* translated from French by Paul Patton, Columbia University Press, New York.

Haraway, D 1991, *Simians, Cyborgs and Women: The Reinvention of Nature,* Routledge, New York.

Rheinberger, H-J, Wahring-Schmidt, B, Hagner, M 1997, 'Räume des Wissens: Repräsentation, Codierung, Spur', in idem (eds), *Räume des Wissens,* Akademie-Verlag, Berlin.

Rheinberger, H-J 1997, *Towards a History of Epistemic Things: Synthesizing Proteins in the Test Tube,* Stanford University Press, Stanford.

Simondon, G 1992, 'The Genesis of the Individual', in J Crary, S Kwinter (eds), *Incorporations,* Zone Books, New York, pp. 296–319.

Sandra Huber is a Swiss-Canadian writer and researcher currently doing a PhD in Humanities at Concordia University in Montreal, Canada. In 2011 she held the Swiss Artists-in-Labs residency at the Center for Integrative Genomics at the University of Lausanne, Switzerland. She holds a BA in English from Simon Fraser University and an MA in Creative Writing from the University of Toronto. In2008she founded the online journal *Dear Sir,* and from 2010 to 2014 she worked at Hatje Cantz Verlag in Berlin, Germany. Her interests lie mainly in consciousness, technology, feminism, and mysticism. She is the author of *Assembling the Morrow: A Poetics of Sleep* (Talonbooks, 2014).

Center for Integrative Genomics (CIG), University of Lausanne

The research focus of the Centre for Integrative Genomics (CIG) is based on three main missions. The first is to pursue first-rate research programs in the biological sciences, and the second is to develop an outstanding teaching program. Finally, we both develop and support biotechnology platforms that offer cutting-edge technologies to the Lémanic research community (see www.leman-academy.com/careers/) and beyond. CIG centers on genome structure and function, in different experimental systems and different techniques. Our research is performed by an international community of scientists where interactions are numerous both in formal and informal settings.

Researchers involved with the artist: Prof. Dr. Nouria Hernandez, Prof. Dr. Paul Franken, Dr. Thomas Curie, Prof. Mehdi Tafti, Yann Emmenegger, Giannina Luca.

www.unil.ch/cig

Dreaming

A Poet Goes to Work at a Sleep Laboratory: A Journal in Five Parts

Jumping Past the Barriers of Language

A Poet Goes to Work at a Sleep Laboratory: A Journal in Five Parts

Jumping Past the Barriers of Language

At first I wanted to take poetry and write about what I was experiencing in the lab, but when I got there the form of the poem totally changed. I began to want to turn brainwaves into text somehow, instead of writing a more straightforward poem—they were every-where, on every screen in the lab, and they were visible phenomena trying to explain in-visible phenomena. For me, this was a major inspiration. Words in a way are like this: a long unfolding process, and at the same time like sculptures set in still-frames. Written poetry is a lot about taking words and placing them in a visual system across the page. So what I started to do was to transfer the brainwave into actual words and thereby to kind of cross the states of waking and sleep. I was surprised by how active sleep was, by the fact that it's not an unconsciousness state, but an altered state of consciousness. So I wanted to make sleep come awake in a way. Words are always awake. They're an act of focussed consciousness. In-terfacing waking words onto sleeping brain-waves became the basis of my project. By doing

Comments by Dr. Thomas Curie, the CIG researchers as well as the artist in the artists-in-labs film interviews

Prof. Dr. Paul Franken, Center for Integrative Genomics CIG, University of Lausanne

In my lab, we focus on re-search of sleep and energy ho-meostasis[1] as well as circadian clock genes[2] and we use QTL[3] analysis and genetics of EEG[4] activity as methods. The big question in our field of re-search is to find out why we sleep. It's maybe an obvious question to most people, but on a scientific neurobiological

that, I thought, maybe I could get people to reconsider their biases about sleep and waking and about the nature of consciousness as a more multi-dimensional force.

Part I

I arrive at the Center for Integrative Genomics (CIG) in early February, a concrete cube framed by sharp alps and the creamy pastel green of Lac Léman, a backdrop I'll see first thing every morning for the next nine months. Nicole Vouilloz, who is Assistant Director of the CIG, leads me up to the third floor sleep labs run by Paul Franken and Mehdi Tafti and I'm set up with a key and an office. As I walk in, the objects seem exotic and sterile: syringes, cultures, centrifuges, cylinders. This "office" is a laboratory.

I spend most of my time during these early days away from my desk, exploring and trying to fathom what goes on in the three or four rooms that comprise the sleep laboratories, trying to engage in conversations with PhD students and postdocs about bioelectrical events, synaptic plasticity, the fact that sleep is not, as I've understood it for most of my life, the flipside of waking, but an autonomous and active state made up of discrete stages. Guided by Yann Emmenegger, the sleep lab technician, I begin learning to score out stages of sleep in the brainwaves of mice. I meet the mice. They're housed in the basement of the CIG, literally underscoring the studies that transpire in the labs above.

In these early days, I basically attend more meetings and lectures than I can count and I feel as though my brain might explode with all this new information. I have to start reminding myself that I don't need to understand everything in the way that the biologists and neuroscientists do; I'm not necessarily here to conduct biochemical experiments, but ones of a different kind. On Mondays and Wednesdays, I attend a course on genetics and am fascinated by the concept of introns and exons in the genetic sequence. Written onto the board in chalk: "genetique → gsd-vevneqeticijmcque." All the hidden things.

level, it is not well described or known how sleep serves us. There has been a long series of publications but we have not made much progress in the research. Perhaps through genetic analysis we can identify the molecules that are important for sleep and for how fast we get tired and so forth. So our goal is to find the molecular correlates and align these processes. Sandra behaved like a student, coming to do her PhD here. And the methods that she was using were pretty much the same: just investigating, reading literature, asking a lot of questions, in fact

1 Homeostasis is the property of a system in which variables are regulated so that internal conditions remain stable and relatively constant.
2 A circadian rhythm is any biological process that displays an endogenous, entrainable oscillation of about 24 hours. Core circadian 'clock' genes are defined as genes whose protein products are necessary components for the generation and regulation of circadian rhythms.
3 Quantitative traits are phenotypes (characteristics) that vary in degree and can be attributed to polygenic effects, i.e., the product of two or more genes, and their environment. A quantitative trait locus (QTL) is a section of DNA (the locus) that correlates with variation in a phenotype (the quantitative trait). The QTL typically is linked to, or contains, the genes that control that phenotype. QTLs are mapped by identifying which molecular markers correlate with an observed trait. This is often an early step in identifying and sequencing the actual genes that cause the trait variation.
4 Electroencephalography (EEG) is typically a non-invasive (however invasive electrodes are often used in specific applications) method to record electrical activity of the brain along the scalp.

Language is everywhere. There are too many ideas being scribbled into the pages of my notebooks—the difficulty will not be in finding inspiration, but in narrowing down a single project.

I get an overwhelming sense that I could fill a life with this work. Nine months is one teensy breath. At the same time, I feel my own alien-ness at the CIG. My new colleagues will sometimes ask me, "what exactly would you like me to show you?" and my response of "whatever you're doing" is mostly met by a power point presentation at their desk. They are both curious and suspicious of what I'm writing. "Are you going to write about me?" they ask. I half enjoy this perception of myself as some kind of undercover journalist. In a way, what I'm doing does seem like detective work, but not of the journalistic kind. As much as I'm trying to wrap my head around what it means to work as a scientist, it's equally hard for them to understand what it means to be a poet. In April, I show one of my colleagues a fragment of concrete poetry by Christian Bök and he responds that it seems intellectual. "Isn't poetry supposed to be beautiful?" he asks.

Part 2

The visual representation of the brain in sleep surrounds us.

Neural oscillations run smoothly across nearly every screen, making the brain/mind a surveyed and predictable mechanism.

Maybe it's because of their omnipresence or maybe it's the fact that they are a clear rhythm not unlike the rhythm of writing, heartbeats, footsteps, speech—I quickly focus in on the EEG: First, the brainwaves of mice. Nearly everyday, wild-type and transgenic mice are kept awake in hopes that their brains, once "harvested," will reveal a secret of sleep by the very act of being deprived of it. We look at sleep by its absence. In the sleep lab, they ask: Is there a minimal unit of sleep? Is sleep held in cortical columns? Is sleep held in genes? "What" is it? "Where" is it? What can we do when sleep goes wrong? Sometimes, I help keep the mice awake

for us, it was just a normal type of research to get acquainted to the field and to how we work.

Dr. Thomas Curie

We all sleep a third of our lives and nobody knows what the function of sleep is really all about. I discovered that the mystery around this large question could be researched by the aesthetic aspects of certain EEG traces. During my PhD work I had already been exposed to technologies that are able to visualize brain activity, scientifically of course, but also aesthetically. In addition, although I did not directly work on this subject, I knew of course that sleep is related to dreams—and again nobody knows the precise function of dreams yet. For centuries, scientists and people in general thought that during sleep the soul is able to leave the body,

during their sporadic sleep deprivations and I'm not sure how I feel about this.

After getting comfortable with scoring stages of sleep in the brainwaves of mice, I start making trips to the CIG's adjunct sleep laboratory, the Centre d'investigation et de recherche sur le sommeil (CIRS) at the Centre hospitalier universitaire Vaudois (CHUV), where, with the help of Dana Andries, a technician there, I start learning how to score sleep in humans. The nurses are amused by my presence at the hospital—watching them work, asking them questions, taking notes from a corner as they set up their patients for sleep. They ask me what brought me as an artist to start working with science. They tell me about their dreams. They are warm and curious and it is a different thing altogether to be in a hospital.□1/2/7 At the lab, the foundational questions surrounding sleep are tackled; here patients come to benefit from those findings if they can.

On July 5, I stay overnight at the hospital in order to have my sleep transposed into a

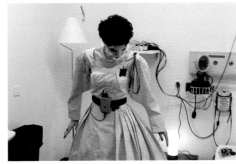

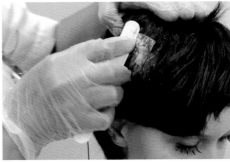

□1 Sandra Huber presents herself as a subject for artist's sleeping tests
□2 Electrodes from the EEG being placed on the scalp

especially during phases of dreaming. Today there still is the assumption of a tight relationship between sleep and loss of consciousness or unconsciousness. In psychology, the relation between science and imagination is explored, which is a big part of poetry. Poetry is of course part of the art-science interface. For the most enlightened of scientists, poetry is related to Baudelaire, Verlaine, Rimbaud, and is even more familiar if the poets are writing poems with rhyme schemes. By becoming increasingly specialized, concepts of culture are lost. And consequently, the arrival of a poet in a research lab is a shock, even in a laboratory as open-minded as the Center for Integrative Genomics, which had already received other artists before Sandra Huber. Thus, I think it was hard for Sandra in the laboratory at first. In general, scientists do not exchange with each other, and even less when they

polysomnogram.[1] Hooked up to electrodes and plugged into an Embla patient unit, most of the night is spent awake. There's this bizarre split that happens at this point between the personal and the professional. I become both researcher and participant, and my sleep, a behaviour, is invited to be an artefact. The next day, I return to score out the stages of my sleep and see the result of this invitation: there are only a few hours to score. Life and work will from here on have this start to overlap. Insomnia finds me. It comes to say that sleep does not appreciate being prodded so closely. In the context of my project, which is starting to involve combining sleeping and waking states in order to reflect how proximate they are (and how little sleep resembles a "tiny death," as it has widely been treated in poetry), my "bad" sleep is somehow fitting, but not at all comfortable.

I now have the data from my brain and body and will start to work with it. I'm no longer just an observer. I am what I'm observing.□3

Part 3

These days I spend hours analyzing my data in every possible way. I read Ron Silliman's *The New Sentence*,[2] Lyn Hejinian's *Strangeness*,[3] William James's everything; I start looking at each line on the EEG as a sentence; what is the difference between a line of poetry and a line of electroencephalography? I wonder what the interface of EEG is saying about the behaviour of sleep, the connections between surface and semantics. Hours are spent at my desk with articles and textbooks on neuroscience and biology. I realize quickly that I need to find a way to compose directly onto the brainwaves themselves, and I manage to locate an old typewriter on the fifth floor. With a piece of carbon paper between a print-out of brainwaves (each sheet = thirty seconds),

1 Polysomnography (PSG), a type of sleep study, is a multi-parametric test used in the study of sleep and as a diagnostic tool in sleep medicine. The test result is called a polysomnogram.

2 Silliman, R 1987, *The New Sentence*, Roof, New York.
3 Hejinian, L 2000, *The Language of Inquiry*, University of California Press, Berkeley.

have to explain things to non-scientists. There is always this very old conception that you have to earn your place in a biological laboratory and that it takes time in general to be accepted within the laboratory. Most of the time, though not all the time, scientists are haughty and proud and do not take literature and arts seriously. They believe they are for dreaming, just for fun, because they cannot bring new ideas to the understanding of the world. This is a very old and reductionist conception, but it is still at work sometimes. In addition, the conditions for a non-scientist are harder because science is like a foreign language; furthermore, every section of science has a different language, so sleep science has a particular language that people have to learn in order to start exchanging. But this is the same for any other field. Poetry also has his own language. Thus, sharing knowledge

□ 3 Data collected from Sandra Huber's brain during sleep
Screenshot: Manolis Pahlke, Sleepwriter Programmer

on two different disciplines means, at first, jumping past the barriers of language. The realms of every field are different and have to be tamed by the person who wants to understand and finally be immersed. The scientific realm is full of people wearing white lab coats, talking about molecules and numbers, working with mice, etc. It's a foreign environment for anyone who has never worked in a research laboratory. It's simply another world, similar to the first time someone discovers Picasso paintings, the Sistine Chapel paintings, or even when a person sees the earth from space for the first time. There are codes, a language, and all of what is specific to a community.

Sandra and I often talked about the origin of sleep and sleep in marine mammals, such as dolphins. Dolphins are able to have one hemisphere that is sleepy while the other

I start to type along the alpha, delta, theta, and sigma lines, rolling the sheet out after every line and repositioning it for the next. This doesn't go so well. On the plus side, I hear technology has advanced. □4/5

During this time, I've started to follow an experiment. It's lead by researcher Valérie Hinard and I tag along as she works on keeping cortical slices of mice alive in a CO_2 incubator.

She leads me into a room where the incubator is kept and I'm immediately reminded of those old Frankenstein movies with the bubbling vats of liquid. Here it's on a smaller scale, granted, but the sounds and visuals are not far off. Valérie describes what she and her team are noticing as the experiment progresses: the cortical slices "choose" to exist in a sleep state unless prodded into a waking one. This could suggest, she says, that sleep is the default state of the living organism. I'm a total sci-fi nerd so of course I ask, "like in *The Matrix?*" I expect her to laugh. She's straight-faced. "You could say that," she says.

Part 4

Sleep science is, and I write this as an artist and scholar and human who sleeps and wakes, more fascinating than I had ever thought (and I already thought it was pretty awesome). The last two months at the CIG go by quickly. I'm at once closest to and farthest from the creative part of my project. I'm still learning. This is one thing I became aware of during my residency: there is no break between learning and creating, there will never come a time when I say, "Ok, great, I know enough now". It's more like on the end of one answer to one question comes umpteen more questions without answers, and you just have to start working in the middle somewhere.

The beauty I found working at the CIG is a kind of beauty that comes in the tension between trying to know and not quite ever knowing, in mystery and in the efforts to peel it back: it's in movement and the chance, with poetry or art or imaging or experimentation or whatever it is you do to engage, to always be revitalizing or releasing from the metaphors

hemisphere is awake. We also discussed what scientists call "local sleep" in the human brain. Briefly, some neuronal networks in our brain can sleep while at the same time some others can stay awake. Finally, we exchanged theories about the nature of sleep itself and the idea that sleep is the default vigilance state, which currently is a very popular theory. Sandra added her artistic perspective. Sometimes it may be easier to postulate hypotheses when you are not part of the field, although I think the more she was involved in the understanding of sleep the less she found herself an outsider of the scientific work. In my case, I am trying to figure out what art and poetry can bring to my scientific view on EEG. As a scientist, EEG waves reflect the activity of the whole brain. Depending on what they look like (in terms of amplitude and frequency), the scientist can determine the stage

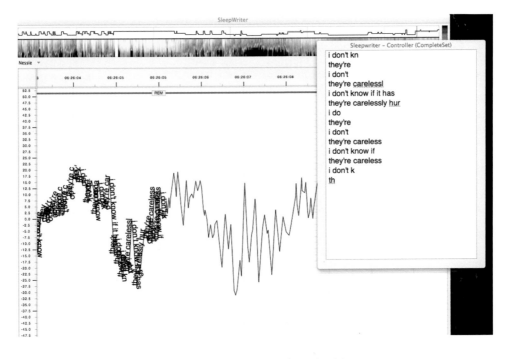

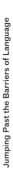

A Poet Goes to Work at a Sleep Laboratory:
A Journal in Five Parts

☐ 4 Work in progress — mapping the poetics of sleep
☐ 5 Writing along the sleep data from the EEG results
Screenshot: Manolis Pahlke, Sleepwriter Programmer

Jumping Past the Barriers of Language

we create and the actions they ask of us and bind us in.

Before I left, I gave a final presentation on the work I'd done so far. During the question period, an unexpected discussion happened on language and poetry. "But we can hardly read that," one of the audience members comments in response to a slide of my brainwaves turned into words. "What is the use of words if we can't read them?"

I remember when I was in school, studying poetry with greats like Stephen Collis — it was drilled into me that language is not a tool of communication to use at whim. It's older and bigger than us, and I remember I loved this idea, and I tried to convey it here. What followed was a discussion on how affronted we tend to feel when meaning is rift from language.

In retrospect, I was surprised by the discussion, thinking maybe the questions I'd get would lean more toward the scientific part of my project. But there is this: what happens when we can't read what's written? Sleep is illegible. This is maybe part of the reason we have such difficulties finding "where" it is located, and "what" it is. We are looking at sleep while we are outside of it, awake, and the language it speaks, from this angle at least, is asemic.

Part 5

Coming back to this journal five years after the residency, I'm coming back to a project I've recently finished. In November 2014, *Assembling the Morrow: A Poetics of Sleep* was released by Talonbooks (Vancouver), a work that took over four years to put together. I had little glimmers of this realization already at the CIG: that I didn't know exactly what this project had opened and what it would entail to follow it through.□6

The thing about sleep is, the more you get into studying it the more enigmatic it becomes and the more it makes you reflect on the nature of being and self. It's multifaceted. Not just biology and neuroscience and poetry, but threads of philosophy and consciousness

of each vigilance state: deep sleep (NREM stage), "dreaming" sleep (REM stage), or waking. I learned how to associate a physiological meaning with a type of wave, but I have never tried to think about what it might naively match. The poet, like a child, comes to discover the meaning of these EEG waves, and sheds a new light on these cerebral fluctuations. Then, the scientist has to empirically prove the "real" meaning of these images. Watching Sandra work allowed me to think differently about the function of sleep. Another topic we shared ideas on was "dreaming".

When a sleep researcher gives a public talk, I noticed that he/she generally answers to two repetitive questions: first, "how much sleep do we need (to be healthy)?" and secondly, "why do we dream?" The function of dreams is still unknown, although there are many scientific hypotheses. The

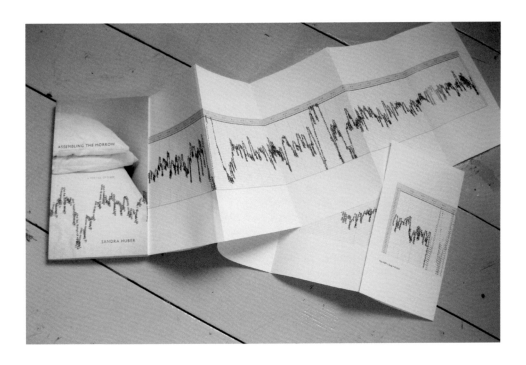

□ 6 Huber, S 2014, *Assembling the Morrow: A Poetics of Sleep*, Talonbooks, Vancouver

artist can perform and optimize different directions that scientists often can take. I think we will never be able to know the actual dreams of a person. But art can help us to imagine, and in that way the scientist can become an artist. As the French philosopher Claude Debru said: "The researcher's dream is faced with a philosophical dilemma. Faced with such complexity of the facts and causes, the biologist can only be a creator in the strongest sense. As a painter or a sculptor, he has to create new realities, imagining or discovering them."[5] In some other experiments, it is poetry that comes directly to science. In the Xenotext experiment, the Canadian poet Christian Bök[6] engineers a life form from a poem. His poem, translated into a gene named X-P13, is introduced into a bacterium,

5 Debru, C 2009, *French Studies in the Philosophy of Science: Contemporary Research in France*, A Brenner, J Gayon (eds), Springer Science & Business Media, Dordrecht, p. 15.
6 Bök, C 2015, *The Xenotext*, Book 1, Coach House Books, pp. 16.

studies came in; if one wanted to continue in this direction, theology and mysticism would come in as well, and those are areas I'm currently looking into in my work right now.

A lot happened in the field of sleep science after I completed my residency. In 2010, sleep researcher Giulio Tononi put out *Phi: A Voyage from the Brain to the Soul,* going into a discussion of consciousness-as-information, which leads to the hypothesis that consciousness is something that can be built (think: connectome). Paul Franken pointed me toward two papers put out in 2011 and 2012 on "local sleep" by research teams led by Vladyslav V. Vyazovskiy and Lino Nobili, respectively, where they demonstrated how islands of sleep exist in the waking state and islands of waking exist in the sleeping state, throwing off any assumptions that sleeping and waking are discrete states of being. Valérie's paper *Key Electrophysiological, Molecular, and Metabolic Signatures of Sleep and Wakefulness Revealed in Primary Cortical Cultures* came out in 2012 and for me it's still one of the most intriguing of them all: the concept that sleep may be our "default state," even in vitro, prompts the question—what for? In my book, I spend about seventy pages trying to string these and other theories together into an essay that "prefaces" the poem (I know, a seventy-page preface...). With programmer Manolis Pahlke, I was able to evolve from my little typewriter vision to an app called SleepWriter, which turned my brainwaves into a writeable vector. While working a day job at a publisher, I would come home every evening and spend hours composing my neural oscillations, taken from that one night of fitful sleep registered in the summer of 2010. Slowly, when my project came to a close, my insomnia disappeared. As I stopped inspecting sleep, it stopped inspecting me.

It's not an exaggeration to say that I'm not the same writer I was before I stepped into the Center for Integrative Genomics back in the winter of 2010. I will never stop following and being inspired by sleep research, and especially by how words and states of the mind can be explored through experimentations and

which produces a red fluorescent protein, meaning that somewhere the poem caused the bacterium to write a response to its own poem.

Most of the time, there is almost no relationship between the artist, her/his work, and the scientist. I suppose scientists (including myself) felt distant with Sandra because she was an artist. But listening, observing, learning about the other is always hard work. In the end, mixing disciplines is the future to a better understanding of the big questions in the humanities. That was the case for physics and chemistry, mathematics and biology, medicine and music, and now more and more with arts and science. This way has always been about creating other windows to see the same things differently. When you become an expert, you become a student standing "on the shoulders of a giant to see the world

recombinations. In fall 2015, I started a PhD at Concordia University in Montreal to work with automatic writing and trance writing. I'm looking again from the angle of cognitive science and consciousness studies, bringing it into a realm of interactive gaming and mysticism to access altered states of the mind. This time from a waking perspective.

☐ 7 Apparatus to record the blood pressure in relation to the brain activity in the Sleep Lab at the CHUV where the artist Sandra Huber was the sleeping subject.

around you differently," said Jean-Pierre Astolfi, a researcher in educational sciences.[7] Sandra's approach is quite unique, as far as I know, and it was an immense opportunity to participate in the two "scientific/artistic" presentations. As a scientist and a citizen of the world, I am convinced that all aspects of artistic work and in this case the poems written by Sandra, effect my judgment of science, but not necessary consciously. It will continue to influence my way of thinking and problem solving. Art can certainly help scientists to think differently. Sandra's art has given me a new way of viewing issues by opening a new perspective on sleep studies. Science and especially biology or the experimental sciences have a reductionist approach sometimes. Scientists conduct experiments to understand the causality or

7 For more information about the educational approach work of Jean-Pierre Astolfi see: accessed 1 March 2016, https://fr.wikipedia.org/wiki/Jean-Pierre_Astolfi

the function of one parameter. Sometimes, but not always, scientists can make mathematical models to picture reality. Art is more evasive, it allows one to create, to imagine, to dream. With her poetic view, Sandra reinvented the different waves of how the EEG trace sleep.

In my case, participating in this experience helped me to reconsider my scientific work, erasing the boundary that exists between art and science since there is not only the empirical part of scientific data but also all that we can imagine from our scientific data. And most of the time, scientists neglect or forget this imaginative part. They need answers, and necessarily answers coming from their scientific experiments. The presence of an artist in a scientific laboratory can provide new insights on scientific work and maybe also scientific work can be used as a basis for an artwork. So the approaches of the scientist and the artist are complementary. Both have to be shared to develop knowledge. And to do such sharing, the particular fields of science and art have to be explained by many different people. I hope that Sandra and I accomplished this from our different points of view at the two events. I imagine in the future that in a scientific symposium there could be different perspectives brought in by philosophers, writers, and scientists to discuss issues such as the questions surrounding sleep, life, death, and happiness.

Research creations are common between scientists and artists. The researcher—like the artist—tends to observe the beauty of the world and wants to understand this beauty. In science as in art, there is always this fascination of observing what is moving, what will evolve. There is always this idea of seeing the world around oneself differently and giving it meaning. Of course, the scientific approach is not the same as the artistic process, but both seek to see beyond the visible, the invisible, to understand human culture

better. In the past, the two disciplines were not so separate from each other, and the artist could also sometimes be a scientist. Leonardo da Vinci was an artist, but he was also a discoverer of data on the human body and a technical inventor. Some contemporary artists look at behaviour through building robots. A person may therefore use both approaches to solve the same idea. Therefore, perhaps science and art are not as separate as we currently think they are. Science is sometimes lacking in emotion. It is based on the knowledge necessary for the development of tools.□6 Science is objective, reproducible, and universal. Therefore it becomes independent from the one who thought up a concept. But science in this universality is reasonable and incomplete. Science needs objectivity and accuracy when poetry is subjective and requires multiple meanings. Science is accurate; it uses the values of units such as the angstrom, millisecond, volt, or hertz. Poetry uses imagination and talks more about moments. As Bachelard says, "scientific truth is only an approximate truth."[8] And along those lines, the scientist tries to project ideas in the imaginary world in order to answer his questions just as an artist does in his work. For a better understanding, science has to feel more, sometimes, so that science can encourage more creative potentials. Researchers are currently trying to capture emotion in neuroscience; to give scientific meaning to feelings. They often create words for this that could even be poetry. Art helps science to feel the emotions. "Nothing ever becomes real till it is experienced," said the poet John Keats.[9] This is usually what art brings to science. Art allows science to be sensitive and to then contribute to something beyond these two domains; and that is trying to understand the world and the universe.

8 McAllester Jones M, Bachelard G, 1991, The translated version of Bachelard G, *subversive humanist: texts and readings*, University of Wisconsin Press, Madison.
9 Barnard, J 1987, *Collection of Writings by John Keats*, Cambridge University Press, Cambridge MA.

Several months later, after Sandra had left the laboratory, we were invited to give a presentation/workshop about sleep and poetry at the *Montreux Jazz Festival's Art and Science on Stage*. My supervisor Paul Franken gave me the opportunity to be the scientist beside Sandra, and we really started to have a discussion together. That was our first real meeting. As part of the artists-in-labs program SNF AGORA grant: *State of the Art — Science and Art in Practice* we presented together at the 2013 *Montreux Jazz Festival* and at the Literaturhaus in Vienna in 2014. For both events, the goal of our presentation was to illustrate the artistic/poetic side of sleep and, in parallel, scientific basics of sleep processes, in order to demonstrate how both disciplines can reciprocate and be complementary. Art and poetry explain processes differently than science. The artist can see things in the EEG that the scientist cannot and the other way around. By writing a poem about the EEG, art allows humans to observe the world better and maybe even to "create" it as Schopenhauer said. This is the case when scientists cannot find any more functions for a process such as sleep. In this way, the enormous advantage of these events is to bring out new ideas by mixing people from different backgrounds.

In my opinion, another important goal in this collaboration was to share scientific knowledge with Sandra, but also with the public, and at the same time to receive critiques and new questions from non-scientists. I think that explaining the basis of sleep to non-scientists has always been a means to share scientific knowledge, and a civic duty of one who has had the chance of going to a university. It's an exchange that continues the learning process. No one can claim to know everything and everyone learns from one another everyday.

During the experience of these two events, I was impressed by everything that Sandra had learned in terms of sleep science. The way she immersed herself was largely longer and more in depth than how a scientist would immerse her- or himself in the arts. She is now used to complicated concepts like EEG, neurons, neurotransmitters or synapses, and has adapted very easily. I suppose that somehow these words originally had a different colour for her than for scientists like myself. Maybe the EEG signals initially were something like a path to the human soul for her, a link to death.

It may sound naïve, but I found the poems written on the basis of the EEG waves very beautiful. In addition, sometimes during Sandra's presentation there was the sound of breathing at the same time as the plotting of the brainwaves, and these oscillations, these rhythms show how sleep is a living process and not a dead process as it was thought to be for a long time. As Sandra said, "there is a long-standing tradition in poetry to compare sleep with death." However, sleep is a very active process and in this poem written on the EEG traces I find that art is much closer than science in the interpretation of sleep.

Lisa Blackman is Professor in the Department of Media and Communications at Goldsmiths, University of London, where she develops theories across media psychology, embodiment, subjectivity, body and affect studies, future psychology and science studies. She was trained in psychology and sociology. Her publications include; *Hearing Voices: Embodiment and Experience* (Free Association Books, 2001); *Mass Hysteria: Critical Psychology and Media Studies* (Palgrave, 2001) with V. Walkerdine, *The Body: Key Concepts* (Bloomsbury Press, 2007); and *Immaterial Bodies: Affect, Embodiment, Mediation* (Sage, 2012). Her forthcoming book, *Haunted Data: Social Media, Affect, Weird Science and Archives of the Future*, explores critical research in relation to subjectivities within the context of the 'computational turn'. Her work in the area of embodiment and voice hearing has been acclaimed by the Hearing Voices Network, Intervoice. She has also made a substantive contribution to the fields of critical psychology and body studies. In this context she co-edits the journal, Subjectivity (with Valerie Walkerdine, Palgrave) and edits the journal Body & Society (Sage). She is a key advisor to the Hearing the Voice project, Durham University (Wellcome Trust) and is part of an upcoming sub-project, "Voices Beyond the Self.

Inventive Experimentation: Weird Science, Affectivity and Archives of the Future

Introduction

This chapter will explore the positivity of particular art-science collaborations as potential laboratories for exploring, analysing, and inventing new methods and forms of knowledge production. My aim is to explore how particular collaborations can intervene and shape what Derrida (1995) termed "archives of the future". My own contributions to this problematic are based upon a series of reflections on my own experiences of collaborating with and across the humanities and the sciences; this is specifically in the context of experiences and phenomena that often signify as anomalies, puzzles, abnormal perceptions and sometimes as signs of psychopathology. For readers not familiar with my work, I have always been interested in phenomena that challenge and disrupt distinctions between self and other, inside and outside, past and present, the human and the technical, material and immaterial and the natural and the cultural. This includes phenomena that trouble individualized conceptions of the body and demonstrate how bodies can be moved and extended by human and non-human actors and agents — this includes priming, automaticity (the feeling of being moved by someone or some*thing* else), suggestion and voice hearing.

These phenomena raise questions about agency and invite us to explore more distributed forms of agency. They also orientate our attention to more intensive registers of experience; that is those experiences, which circulate and exist largely below the threshold of conscious awareness and attention.

This includes what I have termed "threshold phenomena", such as suggestion, automaticity and voice hearing as well as phenomena often associated with the paranormal and occult; this includes telepathy, mediumship, clairvoyance, automatic writing and related practices. I write from the position of somebody initially trained within the psychological sciences, but who left the discipline some twenty-five years ago to work in the neighbouring disciplines of both sociology, and latterly within media and cultural theory and body studies. My focus in relation to psychology has been on *outliers,* looking particularly at what becomes disqualified, and exists in submerged, disguised or displaced forms in relation to the so-called proper archives of psychology.

In my recent book[1] I have explored the challenges threshold phenomena pose to atomized and individualized conceptions of cognition, affect, subjectivity and bodily integrity. I approach the challenges,

1 Blackman, L 2013, *Immaterial Bodies: Affect, Embodiment, Mediation.* Sage Publications, London and New York.

possibilities and potential problems with collaboration across art and science by genealogically examining what often gets excluded or rendered illegitimate by forms of science which achieve the status of veridicality; that is what is accorded truth-status or becomes a "fiction-which-functions-in-truth" (see Blackman and Walkerdine 2001). My focus particularly is on what I term "weird science"; that is science which is disqualified, disavowed and occluded, but which circulates in submerged or displaced forms. I term this potential archive "haunted data" and I am interested in the potential of this data to be re-moved within particular scenes of entanglement (see Blackman 2015 a and b). I argue that weird science offers an interesting data source for collaborative experimentation, given its close links to inventive science and to the creation of novel forms of experience, expression and behaviour. I have been influenced latterly by the concept of *historiality* developed by the science studies scholar and philosopher, Hans-Jörg Rheinberger (1994). The neologism historiality refers to the close entanglement of science with storytelling.

One of Rheinberger's focuses is on controversies in science; what comes back even though at some point the controversy might have been considered resolved. His attention is on those submerged narratives, repressions, displacements and excesses, which create alternative directions. These virtual murmurings or traces have the potential to contribute to the dynamism of science. As he argues, "experimental systems contain remnants of older narratives as well as fragments of narratives that have not yet been told" (p. 77). His concept of re-moving (that is putting something back into circulation or movement) is a hauntological method that pays attention to those traces which return and demand our attention. It is interesting that as a trained molecular biologist Rheinberger was also open to philosophy and cultural theory and was influenced by Derrida, Bachelard, Foucault, Cangelheim and Haraway. He is a good scientist to think with I would argue.

I have argued in previous writing that threshold phenomena have attracted trans-disciplinary attention and collaboration (particularly across art and science), both historically and in the present. They offer an interesting site for exploring the questions, problematics and issues at the heart of this book. One important issue I want to explore in this chapter is the extent to which threshold phenomena invite research methods and forms of experimentation, which are performative and work with psychological processes as transitive, indeterminate and contiguous

with the symbolic, aesthetic, technical, historical, material and immaterial dimensions of what it means to be embodied. My interest has always been in radical and creative practices, which open up interesting questions about embodiment and technology and how to think, analyse and even perform and mediate these relationships. I am committed to a version of science that is open, inventive, adventurous and creative. What is at stake in these collaborations and inventive relationships will be the subject of this chapter.

Interlude: Weird Science

What counts as weird science? Usually weird science gathers together experiences and phenomena which most psychologists consider improbable or impossible. Weird science is marked by either endorsement or scepticism and the cultivated scientific attitude of scepticism is where critical commentary usually lies. Usually the potential openings of weird science quickly end up in the realm of conspiracy theories! However, there are many more stories to be told about weird science, which open to what I have termed "future psychologies". Before I develop this argument I will give the reader two examples of weird science, which have confounded scientists. The first relates to the phenomena of voice hearing and was published in an article in the *British Medical Journal* in 1997.

The article has circulated as an object of curiosity, fascination and disbelief as it confounds many of the inherited dispositions of science and scientists working with the question of what it means to hear voices. The article was passed to me whilst working with and collaborating with the Hearing Voices Network (HVN); a social movement of activists, experts by experience, scientists and interested professionals who reject the assumption that voice hearing is largely a sign and symptom of a meaningless epiphenomena of disease (see Blackman 2001). The second relates to a recent article published in a cognitive neuroscientific journal, which attracted the attention of broadcast media. It explores the vexed question of what it means to enter into suggestive relations with another, human and non-human. Both examples demonstrate the importance of trans-disciplinary collaboration and provide entry points for artists and scientists interested in exploring the improbable and impossible, as I will go on to demonstrate.

Azuonye, I 1997, 'A Difficult Case. Diagnosis made by hallucinatory voices', in *British Medical Journal*, 315, pp. 1685–1686.

In the article above, the reader is told that a woman starts to hear voices telling her she has a brain tumour. She had never heard voices before or certainly never heard voices that do not have the quality of inner speech or dialogue and that feel as if they come from somewhere and somebody else. To be clear, she heard two voices that were supportive but which repeated to her with urgency that she must see a doctor. She promptly did and was reassured by her doctor that she did not have a brain tumour but was rather showing signs of a paranoid hallucinatory psychosis. This reassurance led to her seeing a psychiatrist who reiterated this diagnosis of the situation prescribing her with psychotropic drugs that did not take the voices away. They were persistent interlocutors who refused this diagnosis and continued on their aim to convince the voice hearer of their validity and for her to continue to seek confirmation of her brain tumour. Due to the persistence of both the voices, and the tenacity of the voice hearer, the psychiatrist organised a brain scan to reassure the woman that her voices were signs of a psychiatric disorder. The brain scan revealed a brain tumour, which was removed. Following surgery the woman recounted how she heard the voices for the last time, where they thanked her for listening and then left her in peace.

This study confounded and still confounds psychiatry as it suggests that voices can be supportive, reassuring, prophetic and meaningful in the context of a person's life and autobiography. This is considered an impossible statement for many scientists, however, fairly recently such a proposition attracted the attention of an interdisciplinary Wellcome funded project, "Hearing the Voice"[2] led by a cognitive scientist and a cultural theorist. They had become interested in the practices and efficacy of the Hearing Voices Network and wished to explore the basis of the kinds of interventions being made. This project has amplified, modulated and worked within the interstices, gaps, contradictions and anomalies, which the archive of experimentation and evidence amassed. They have explored the challenges the HVN and their practices have presented to legitimate science.

At the same time the project has attempted to re-interpret the practices and forms of experimentation developed within the network through a particular set of cognitive psychological theories of inner speech. These have largely been disqualified by their own findings

2 Accessed 10 March 2016, www.dur.ac.uk/hearingthevoice

and have led to a variety of conclusions, which confirm many insights made by cultural theorists and voices hearers who have been part of the network over the years. One of the key challenges is how to work with psychological processes as more transitive, distributive, relational, embodied and contiguous with the technical, material, immaterial, symbolic, historical, aesthetic as entangled processes and practices. I will not focus on this example as I have written about what this presents to biosocial understandings of voice hearing elsewhere (see Blackman 2016), but it is a good illustration of the need to sometimes abandon inherited dispositions and work with more inventive propositions (see Stengers 1997).

Suggestive Technologies

The second example relates to an experimental set-up exploring the capacity of experimental subjects to engage in automatic writing; that is to enter into suggestive relations with a planchette[3], such that under particular experimental conditions, they might experience their own arm moving and writing, "as if", it were being moved by someone or some*thing* else. Firstly let's explore what is assumed about suggestion or what it might mean to enter into suggestive relations as this question was enacted within this very specific contemporary neuroscientific experiment. The experiment was already controversial when it became the subject of a recent BBC Radio 4 documentary, which was broadcast as part of the *All in the Mind* series. The documentary titled, *Hypnotic Suggestion, Automatic Writing, Magic and Memory* was broadcast just before Christmas in 2014 and was framed as an exploration of suggestive processes that might after all be real (that is be accompanied by concomitant changes in brain activity) and therefore worthy of scientific experimentation, authorization and legitimation. This experiment was considered controversial, particularly as it used a device associated with psychic research and phenomena; that is the technique of automatic writing.

The analytics of the experiments was a typically positivist empirical analytics framed within an individual-social dualism or subject-object bifurcation. It is assumed by the researchers that suggestion is a pre-existing object. It is uncovered or disclosed by a particular psychometric measuring device or technique, which identifies highly suggestible people. These people are

3 A planchette is a metal ball supporting a round glass disk with a rod on which a pen or pencil could be attached. If a person holds the pen or pencil the planchette will move around, creating particular motor rhythms or automatisms because of its rolling movements.

then considered more open to suggestion, and to the possibility of a particular experimental apparatus producing altered experiences of movement, sensation and thought. In this case the experimental apparatus uses the technique of automatic writing, hypnotic suggestion, a specially constructed writing frame and a mock MRI scanner to simulate what are described as dissociative and passivity phenomena or "producing analogues" (Walsh et al 2014, p. 35). Passivity phenomena are taken to correspond to the phenomenological experience of automaticity, the feeling of being moved or directed by someone or something else. This is also described as an "alien phenomenology". Within this study this is viewed as a common experience, which links dissociative phenomena (the experience of doubleness or dividedness); with experiences of trance that might be found in Shamanic cultures; and with what are considered psychopathological symptoms such as thought control that might be found within schizophrenia. The feeling of automaticity was achieved using particular techniques of hypnotic induction.

The *apriori* of the experiments, which were carried out by a team of neuroscientists at Kings College, London, is that the normative psychological subject is aware and has ownership of their thoughts and movements and importantly is in control of them. This sense of control and ownership can be modulated by techniques of hypnotic induction, such that, in the case of this experiment, subjects could be made to experience their own hand moving and writing as if it were being guided by an extra-personal entity. This concept of suggestion has of course a long history which has been documented in numerous and different ways.

One of the places it appears is in discussions of media practices and technologies where it has a long history within the history of media studies. It has also shaped a popular discourse surrounding the supposed effects media have on particular groups considered more suggestible to its effects. I have explored this "discourse of the vulnerable mind" in relation to the significant influence that the crowd psychologist, Gustave Le Bon had on the discipline (Blackman and Walkerdine 2001). We explored specifically the way his theories articulated, sedimented and reproduced classed, raced, sexed and gendered understandings and connotations of suggestion to be found at the intersection of group psychology and evolutionary biology. This discourse was challenged by understandings of crowd behaviour, which came to the foreground following the death of Princess Diana in 1997 and the media coverage, which surrounded this.

As we argued at the time, the media discourse swung between mass hysteria and people power allowing the surfacing of arguments, which challenged this "theory of the social".

...."many commentators had failed to engage with what the lives of ordinary people had been like except to comment on the new media communities of soaps or the absence of sociality. Indeed, the problem goes further than this. The form assumed by any revolution, uprising or mass movement from below is always a surprise and cannot be contained within pre-existing discourses. Psychological and sociological discourse cannot contemplate ordinary people as agents of transformation, except in and through a theory of government and hierarchical leadership that privileges political action and whose inverse is the hysterical mob that does not know what it is doing. In these traditions discourses and social changes are always described as political transformation. These theories of the social in which the state has a central place contain an implicit notion of hierarchically ordered sociality, a notion of ordinary people as disempowered, and a notion of ordinary people as irrational. Hence crowd emotions, unorthodox spirituality and the spontaneous actions of ordinary people are forever pathologised" (Blackman and Walkerdine, 2001 pp 188–198) .

Now let's return to the neuroscientific experiments and their examination of the phenomenology of alien control. There was an important anomaly in these experiments, which confounded the scientist's own inherited dispositions and created a tension. This tension is recognised as potentially challenging and exceeding the *apriori* and interpretations they are working with, but which they leave hanging as a puzzling curiosity. The apriori they worked with assumed that suggestion within these experiments is both a pre-existing object (a set of personality characteristics measurable using a particular measuring device identifying highly hypnotisable subjects), as well as a set of experimental techniques derived from hypnotic induction, which can alter thought, action and experience. There is also an assumption made in these experiments that "hypnotic phenomena must be experienced as involuntary and effortless" by hypnotised subjects (p. 33). This is highlighted as a set of cultural beliefs or "expectancy effects" about hypnotic suggestion, which are tied to "explicit learning" (thought insertion, alien control of movement, loss of awareness). This anomaly raises the important question of how beliefs or discourses surrounding what it might mean to enter into suggestive relations relate to people's experiences

of automaticity. In other words how even phenomena, which are experienced as automatic, visceral and involuntary are historical all the way down (also see Martin 2014).

This is an interesting question and one that had the experimental set-up been more trans-disciplinary would not have been surprising for many cultural theorists working in this area[4]. However, the set-up was positivist and did not make any moves towards the humanities or the arts or towards more interesting and relevant propositions. The experiment actually opens up to a very interesting question; what might suggestion become within very specific conjunctures and modalities of experimentation? This question assumes that cultural beliefs about what it means to enter into suggestive relations are part of the apriori that must be worked with. Therefore what it might mean to enter into suggestive relations must always be situated, qualified and re-qualified by the experimental apparatus under question. This means that any general claims about suggestion, or indeed threshold phenomena must be handled with caution. This invites more inventive forms of experimentation, which can displace positivist analytics (also see Blackman 2014).

It is a shame that the neuroscientists remained largely unaware of a series of inventive experiments carried out by Gertrude Stein, the modernist avant garde writer, who whilst studying for an undergraduate degree in psychology in the late 1800's, carried out her own experiments into automaticity, suggestion and automatic writing. I argue that these experiments open to much more interesting and relevant propositions (see Solomons and Stein 1896). This includes the assumption that one should not ask what is suggestion, but rather what it might be possible to produce if one works against certain habits of attention? However, this lost history of psychology has largely been disqualified, appearing sometimes as an example of weird science, but mainly as a ghostly presence that does not enter into the scene of experimentation.□1/2

Stein wasn't attempting to simulate a trans-historical or transcultural object suggestion. Rather she was attuning to the creative indeterminacy, processual and contiguous nature of psychological processes as they might be produced and enacted within a specific experimental apparatus. Importantly Stein argues she is working against certain "habits of attention". This includes the important apriori popular at the time that suggestion should be understood through a hierarchical discourse where one submits to the

4 I include here the important work on suggestion by Christian Borch, Jackie Orr, Stefan Andriopoulos, Isabelle Stengers, Jonathan Crary, and my own work, particularly as developed within *Immaterial Bodies*.

will of another. In these experiments I argue she attempted to attune to what it might be possible to achieve through actively engaging with the affordances of the experimental apparatus. Her attention to the materiality of the experimental culture is arguably an orientation, which was taken into art and modernist writing practices, rather than being taken up within the psychological sciences. She was perhaps working with discourses, practices and theories of the social, which were surpassed and disavowed by the rise of suggestion as a discourse of the vulnerable mind. This discourse became instantiated across the human sciences at the turn of the twentieth century. The traces in these experiments reveal what suggestion could be or might become and open up to a "future psychology". It connects with Stengers' astute observation that "above all, what do we really know about this suggestion that we are supposed to avoid?" (Stengers 1997, p. 103). As she goes on to argue, "isn't it ridiculous that with respect to the phenomenon of hypnosis, whose enigmatic character Freud has always recognised, we are still at the level of invoking Hitler, drugs or the music hall".

Future Psychology and Art-Science Laboratories

These two examples I hope show why art-science collaborations are so important. They also illustrate the importance of artists and scientists challenging their own inherited dispositions and working together to shape inventive propositions. This includes paying attention to the material cultures of experimental practices and laboratories and to what Steve Brown (2012) has termed the social technology of scientific experiments. Brown uses the concept of social technology to explore how experiments are shaped according to a particular arrangement of forces, or what he terms the "experimental device". The experimental device consolidates and enacts specific contingent histories of what counts as a proper psychological experiment and sets up the rules governing the status of evidence and how this might be authenticated, legitimated, verified and evidenced. The scientific method, a shorthand for such a contingent history of experimental practice within psychology, is meant to guard against spurious claims, unfounded evidence, statistical error and to contribute to the accumulation of scientific fact and knowledge.

 As I hope to have illustrated in this chapter what might be of interest are psychology experiments, which work with phenomena that exceed the conscious rational subject and which usually appear within psychology as anomalies, paradoxes, and puzzles. Psychology is largely

viewed as reductionist and deterministic, based on establishing connections and relationships, which close down the invention and enactment of what the Belgian science studies philosopher terms "innovative propositions" (Stengers 2000). There is however much more in the histories of psychological experimentation and its transdisciplinary incarnations, which challenge this reductionism. I will close the chapter with one further example, which is part of my current research[5]. I hope that the chapter can be read as a provocation to both artists and scientists as to why sciences of oddities, exceptions, anomalies and puzzles offer an interesting data source for the exploration and shaping of inventive science.

Feeling the Future Controversy: A Retroactive Ending

In my current research I am exploring two contemporary science controversies which re-move earlier science controversies. One concerns a horse from the 19th century who could tell the time and solve complex multiplication puzzles by stamping his hooves. This earlier largely unresolved controversy comes back within a contemporary controversy concerning the phenomena of priming. This is associated with a classic study carried out by the Yale cognitive scientist John Bargh. I have written about this elsewhere if readers are interested (see Blackman 2015a and b). The second controversy concerns an already controversial figure within psychology Daniel Bem. We are told he is a gay Cornell professor with an unusual gender non-conforming past. He had married and had children with Sandra Bem, the late women's studies professor[6]. A pre-publication version of an article based on some experiments he carried out into precognition (the capacity to apprehend and feel the future) was circulated on Bem's website before it was published in a prestigious psychology journal (Journal of Personality and Social Psychology). This caused a furore and became known as a buzz or blather on Bem. The controversy became a media event, where within the context of post-publication-peer-review (the practices through which journal articles are modified post publication as they are commented upon on websites, blogs, tweets, Facebook etc) the article achieved a reach and traction within a mediatized realm. It even registered on the Science Commons; a web application that organizes and curates information about the impact and reach of scientific articles on social media.

The experiments became the source of controversy courting

5 *Haunted Data: Social Media, Affect, Weird Science and Archives of the Future.*
6 see Sandra Bem's (1998) autobiography *An Unconventional Family* for an account of their life together, including their commitment to 'egalitarian partnering' and 'feminist child-rearing' practices.

the media and even appearing as the subject of the American political comedy show, *The Colbert Report* with the attention grabbing headline, *time-travelling porn.* There was a media stir and flurry of attention and led to Bem appearing in Season 2, Episode 5 of the American documentary series, *Through the Wormhole* presented by Morgan Freeman, in an episode asking *Do We have a Sixth Sense?*[7] He appeared on the CNN and the MS NBC news and was interviewed by ABC, Al-Jazeera and Fox news; various newspapers and bloggers picked up on the experiments' and amplified their apparent comedic and entertainment value. Indeed on the basis of this attention Bem suggested to his gay partner that Dustin Hoffman might play him in the film version of the controversy!

The controversy has left contagious trails composed of montages of hyper-links, some of which have been assembled into accepted versions of events, and others that have been rendered insufficient, nonsensical and have been redacted or exist below the radar. These ghostly links sometimes open to detours and dead-ends and often to submerged and displaced actors and agents. This is what I call *Haunted Data* and my aim is to follow and re-move what becomes submerged, occluded or disqualified within this controversy. As many scientists have lamented, post-publication-peer-review is opening science up to publics who can now engage with science in mediatized environments and in ways that can exceed either endorsement or scepticism. The "shadow media" of blogs, websites, Twitter, google+ posts, comments on articles in open-access journals and so forth (Chow 2012) are potential carriers of "low theory" (Halberstam 2010). Low theory can take us to "the unplanned, the unexpected, the improvised, and the surprising" (ibid, p. 16). It can also disclose the liveliness of data; the opportunities for data to be mined for its radical or virtual potential and put back into circulation.

I treat this and the other related controversy I have followed as a "scene of entanglement" (see Chow 2012), using techniques more associated with art. This includes collage, montage, tinkering, bricolage and a distributive and refractive method indebted to the work of Barad, Haraway and Chow. The aim is to stage, dramatise, frame and interfere with existing epistemic foreclosures. The aim is to proliferate visibilities and to make explicit those links or ghostly traces, which would be erased or covered over if one were to engage in visualizations of patterns of aggregation and correlation based on metrics and semantic analysis. As a strategy it helps to disclose points of epistemic anxiety and instability.

7 Accessed 12 February 2016, www.imdb.com/title/tt1930067.

This orientation to science is informed by the tactic of anti-disciplinarity aligned to the work of Michel Foucault and brought into queer theory by Jack Halberstam in their recent book, *The Queer Art of Failure*. Drawing on Foucault's concept of "subjugated knowledges" Halberstam argues that we might turn to what gets rendered nonsensical, irrelevant, insufficient, inferior and buried below to refuse and resist normalization. As Halberstam cogently shows, Foucault's tactic of "anti-disciplinarity" was directed to those knowledges "that are below the required level of erudition or scientificity" (ibid., p. 11; Foucault 2003, p. 11).

My aim is to take this strategy into the realm of science and to mine, poach and exploit the potential of weird science for art and science. This diffraction of psychology through the weird, strange, ridiculous and ludicrous is offered as a queer strategy for the playful contamination of science. This strategy has more in common with what psychology might have become if it had constituted psychological processes as fundamentally entangled, indeterminate, processual phenomena. These archives of the future exist in psychology's disavowed past and return in the controversies as insistent traces to be mined, poached and put to work in new and newly emergent conjunctures and contexts. These have largely become submerged, displaced or exist as an absent-presence within the contemporary neurosciences.

As scientific data I am treating the theories and data as imaginaries that have after-lives beyond their status as scientific data. Although we might consider the capacity to feel the future as improbable or impossible we might consider that this imaginary is being invested in and materialized within quantum computing, software, business strategy, practices of speculative forecast and pre-emption; quantum teleportation and quantum cryptology and algorithms which attempt to change the past within open systems, sometimes called programming in the subjunctive (including retroactive update). These are algorithms, which attempt to change computational pasts and are therefore seen to step sideways in time. It is perhaps therefore not a surprise that a series of experiments claiming that pre-cognition (the capacity to anticipate and feel the future) is possible should attract attention, both inside and outside science.

Conclusion

The experiments reveal or disclose interesting speculative questions about what it might mean to experiment when time-travel is assumed to

be probable or possible. What might it mean to experiment with impossible or improbable things? What interests me is how this area, which brings together quantum physicists and psychic researchers brings back some of the proto-performative approaches to science and to psychological phenomena, which have been lost, overlooked or actively disqualified by contemporary psychology and the neurosciences. I argue that in the context of inventive science we need to move beyond either endorsement or scepticism. This relates to Stengers' argument that there is a need for "innovative propositions" to open the sciences up to creativity, invention and surprise. This is surely why art-science laboratories and forms of collaboration are so important.

One of the interesting debates related to this controversy is the supposed difference between the empirical and theoretical. These lines are blurred in the histories of psychic research, which are re-moved by this controversy, where it becomes possible to devise apparatuses, which experiment with impossible or improbable things. Frederick Myers who coined the term telepathy in the 19th century, for example, argued that he did not know whether telepathy existed but was more interested in what it was possible to produce or invent if one worked with particular assumptions about what might be possible. Myers argued that telepathy was a "mere designation", and implies no hypothesis (Hacking 1988, p. 436). It was what he also called a "neutral term" (ibid.).

The historian of science, Ian Hacking suggests in this early research on psychic phenomena, that the questions were taken to be technical or empirical rather than theoretical. Although of course the critical commentary and discussions on how to explain particular experimental results (their modeling perhaps) was lively and unsettled. Bem's studies foreground this counter-factual statement and draw attention to the performative nature of all experimental apparatuses, and what it might be possible to produce if one assumes that precognition is possible for example. As Bem invites us to consider: How is it possible to believe impossible things?

Bem's inspiration came from the White Queen in Lewis Carroll's *Alice Through the Looking Glass*, where he cites her view of memory as key to the reversal of known psychological effects that he claims to be working with. Perhaps in light of the arguments made in this chapter, the conclusion is best left to the White Queen herself, as quoted by Bem in the write-up of his controversial experiments (see Bem 2011, p. 13). The ultimate conclusions are for those who might work with the traces of

these experiments to produce future psychologies. These futures might open to archives of the future and to new possibilities for trans-disciplinary collaboration across the arts, humanities and sciences.

The concept of "retroactive facilitation of recall" is aligned to The White Queen's view that memory that only works backwards (from present to past) is a poor memory. As he suggests, in Lewis Carroll's *Alice Through the Looking Glass,* the White Queen explains to Alice that the citizens of her country have precognitive ability; or, as she puts it, "memory works both ways" in her land and she herself remembers best "things that happened the week after next." When Alice says that "I'm sure mine only works one way ... I can't remember things before they happen," the Queen disparagingly remarks, "It's a poor sort of memory that only works backwards". (Carroll 2006, p. 164 cited in Bem, 2011, p. 13)

References

Bem, D 2011, 'Feeling the Future: Experimental Evidence for Anomalous Retroactive Influences on Cognition and Affect', in *Journal of Personality and Social Psychology,* advance online publication. doi: 10.1037/a0021524

Blackman, L 2016, 'The Challenges of New Biopsychosocialities: Hearing voices, Trauma, Epigenetics and Mediated Perception', in M Meloni, S Williams, P Martin (eds), *Biosocial Matters: Rethinking Sociology-Biology Relations in the Twenty-First Century,* Wiley-Blackwell.

Blackman, L 2015a, 'The Haunted Life of Data', in G Langlois, J Redden, G Elmer (eds), *Compromised Data. From Social Media to Big Data,* Bloomsbury, London.

Blackman, L 2015b, 'Social Media and the Politics of Small Data: Academic Value and Post Publication Peer Review', in *Theory, Culture & Society,* published online before print 17 June 2015, doi: 10.1177/0263276415590002.

Blackman, L 2014, 'Affect and Automaticity: Towards an Analytics of Experimentation', in *Subjectivity,* 7 (4), pp. 362–84.

Blackman, L 2012, *Immaterial Bodies: Affect, Embodiment, Mediation,* Sage/TCS Books Ltd, London, New York.

Blackman, L 2001, *Hearing Voices: Embodiment and Experience,* Free Association Books, London, New York.

Blackman, L, Walkerdine, V 2001, *Mass Hysteria: Critical Psychology and Media Studies,* Palgrave, Basingstoke, New York.

Brown, S 2012, 'Experiment: Abstract experimentalism', in C Lury, N Wakeford (eds), *Inventive Methods: The Happening of the Social, Routledge,* London, New York.

Carroll, L 2006, *Alice's adventures in wonderland and through the looking glass* (Original work published 1871), Bantam Dell, New York.

Chow, R 2012, *Entanglements, or Transmedial Thinking about Capture,* Duke University Press, Durham, London.

Derrida, J 1994, *Specters of Marx: The State of the Debt, the Work of Mourning and the New International,* Routledge, London.

Foucault, M 2003, *Society Must Be Defended,* Picador, New York.

Halberstam, J 2010, *The Queer Art of Failure,* Duke University Press, Durham NC, New York:.

Martin, E 2013, 'The potentiality of Ethnography and the limits of affect theory', in *Current Anthropology,* 54 (S7), pp. 149–158.

Hacking, I 1988, 'Telepathy: Origins of Randomization in Experimental Design', *ISIS,* 79 (1988), pp. 427–451.

Rheinberger, H-J 1994, 'Experimental Systems: Historiality, Narration, and Deconstruction', in *Science in Context,* 7 (1), pp. 65–81.

Solomons, L, Stein, G 1896, 'Normal Motor Automatism', in *Psychological Review,* 3, pp. 492–512.

Stengers, I 1997, *Power and Invention: Situating Science,* University of Minnesota Press, Minneapolis.

Walsh, E, Mehta, M, Oakley, DA, Guilmette, DN, Gabay, A, Halligan, PW, Deeley, Q 2014, 'Using suggestion to model different types of automatic writing', *Consciousness and Cognition,* 26 (5), pp. 24–36.

Steffen Alexander Schmidt currently runs the MAS/CAS Cultural Media Studies at ZHdK and works as lecturer for film music, opera and music in contemporary dance. He studied musicology, semitic languages and Italian literature in Berlin. He started improvising on the piano at the age of 14 and learnt classical piano with the Zen-Buddhist oriented method. After a PhD in musicology based on musical rhythm, he started several collaborations with dancers and actors with contemporary dance and theatre groups in Berlin. His research was on musical performance, composition and choreography. In 2004 he moved to Zurich to collaborate on the concept of "intermediality" and in 2009, his post-doc Habilitation focused on the relation between music and dance in the 20th century. In 2011 he was awarded an artists-in-labs program residency at the Lausanne University

Hospital (CHUV) and performed the results *signs of life* based on the history, emotions and rhythms of the heart beat and technical diagnosis, at the *Montreux Jazz Festival* and at swissnex in San Francisco. The project is still developing as work-in-progress and towards a series of sound essays.

Cardio-Vascular Surgery Unit at the University Hospital Lausanne (CHUV)

The Cardio-Vascular Research Lab is the centre of innovation at the Department of Cardio-Vascular Surgery at *Centre Hospitalier Universitaire Vaudois* (CHUV) in Lausanne, Switzerland. Research and development at the Cardio-Vascular Research Lab covers all steps from basic science to clinical application including in silico, in vitro, ex vivo, and in vivo studies. Simulation, rapid prototyping, advanced imaging, experimental, and clinical studies are all focused on cardio-vascular problems and better cures for the future. At the Department of Cardiovascular Surgery at CHUV we cover any type of surgery that involves the heart and the vessels: Coronary artery disease, congenital heart disease, valve disease, aneurysms, mechanical circulatory support, transplantation and so on.

Researchers involved in the Residency: Prof. Dr. Ludwig K. von Segesser, Director of the Cardio-Vascular Research Laboratory, Dr. Saad Abdel-Sayed, Project manager, Cardio-Vascular Research, Dr. François Bovay, Dr. Xavier Jeanrenaud, Head of the Division of Echocardiography, Dr. Andrew Lubman, Dr. Giuseppina Milano, Steven Taub, Manager Cardio-Vascular Research, Caroline de Watteville, Arts Director.

www.cardio-vascular.chuv.ch

Rhythm Making

Heart Culture

Our Everyday World Received an Additional, Literally Unheard Dimension of Sound

Heart Culture

Our Everyday World Received an Additional, Literally Unheard Dimension of Sound

My project was driven by the idea of building bridges between medical and musical knowledge concerning heart sounds, embedded into a broad cultural perspective. While medical methods are focussing on pathological phenomena, the question of the heartbeat's groove is left to musical culture. There, it is just simplified in theoretical derivations of pulse, or left to the mechanical beat of pop music. Instead, the symbolic meaning is overwhelming, playing a big and important part of our culture. Visual artists investigate a more culturally reflected view of heartbeats. □1

I originally thought of producing *Portraits of Heart Sounds* by following statements by visual artist Christian Boltanski and his projects on heartbeats. These statements culminated in his work *Archives du Cœur* (2010). Listening to your own heart sound is like a last self-portrait.[1] However, I wanted my musical material to come from real, existing heartbeats. From there, a composition would be built around the heart sound in order to give the heart's owner an actual musical interpretation

These comments and reflections are by
Ludwig K. von Segesser, the director of CHUV

In a university setting you basically have three objectives: you have patient care, that's the medicine of today, you have education, that's medicine of tomorrow, and you have research, that's medicine of the long-term future. Cardiovascular surgery is device driven and our research is problem-oriented. If you want to repair the heart in a neonate, you have to try

□1 One of the many conversations
in the cardiovascular research lab at CHUV

of his or her heartbeat. On the other hand, such a musical arrangement might also give physicians a more detailed sound analysis of the heartbeat itself, by stressing musical pitch or rhythmic accents and percussive sound characteristics of the heart sounds and murmurs, so as to underline the acoustic anomaly, e.g. a holosystolic murmur of a mitral stenosis.[2]

While collecting the heart sound material and working in the research lab at the Centre Cardiovasculaire of the CHUV, I would have liked to compare the medical perspective of listening to the heart with my own perspective of listening as a musician. In this way, the musical arrangement might reflect the results of the interdisciplinary discussion. This aim changed for several reasons. In my first approach I studied medical auscultation

1 On Boltanski see: accessed 3 January 2015, www. deutschlandradiokultur.de/ ein-herzschlag-fuer-die ewigkeit.1013.de.html?dram: article_id=168296
2 "Holosystolic murmur" is the heart murmur heard during the cardiac cycle when the heart chambers contract. "Mitral stenosis" is a disorder in which the heart's mitral valve does not fully open, restricting the blood flow.

to do this with his or her own tissue so that it can grow. But in adults, usually you don't have this option and you have to have spare parts—such as valves, vascular prosthesis, pumps, pace makers, sutures, implants and so on. Most of those are less perfect than the ones that nature has provided us. They're not as durable as we would like and they can be improved. And that's where our research goes. We try to improve the devices that are available for fixing the problems the body has.

Steffen Schmidt, our artist-in-lab, is a composer, musician, and teacher and all of these competencies were reflected in the impression we got when he first started working in our lab. That was confirmed later when he started recording all the sounds possible—and sometimes impossible—during our clinical activities in order to integrate a

through Internet courses from online universities, mainly on mitral stenosis, opening snaps,[3] third heart sounds,[4] etc. But during my stay in the lab I became aware of how difficult it is to record valuable material of the heart sounds. Today, doctors in hospitals prefer to work with echocardiography, which produces a sonogram of the heart. As a result you get images, even though these images are directly derived from ultrasound. To record the results I had to be right next to the doctors during the echo exams of patients. From there I recorded the Doppler sounds, which are the sound sources of the echo. This experience was a strange discovery! The sound is completely different from the usual "lub-dub", which is received through the stethoscope or through phonocardiography,[5] because one can hear the information of the heart valves opening and closing. So I studied the echo's Doppler sounds, the different possibilities of filtering those sounds, and all the noises the machine produces by itself. Additionally, I was introduced to the phonocardiograph sound

archives of the hospital itself, which contained a great deal of material for didactic exercises. Physicians and surgeons in a hospital are very busy, so it was almost impossible to find someone to discuss the heart sounds in detail. And even if it happened, there was the problem of communication. It was very difficult to talk with doctors about their acoustic impressions and listening experiences. The language of "careful listening" was missing, one which only existed in writing. Second, it was ethically impossible to receive official permission for me to ask patients if I could record their individual heart sounds. These incidents led me to change my perspective, which is part of the

3 A sharp, high-pitched click in early diastole (the part of the cardiac cycle when the heart refills with blood following contraction), associated with the opening of the abnormal valve in cases of mitral stenosis.
4 The "third heart sound" is a rare extra heart sound that occurs soon after the normal

two "lub-dub" heart sounds. It is associated with heart failure.
5 A phonocardiogram is a plot of high fidelity recording of the sounds and murmurs made by the machine called phonocardiograph, or "Recording of the sounds made by the heart during a cardiac cycle."

selection of them into his compositions. He was well integrated into the everyday life of the unit. He participated in our rounds and read our reports, he saw and heard the patients, looked at the pictures of the diagnostic workup and was in the operating theatre. He participated in everything and got an extensive understanding of how we work.

One has to understand here, that in a surgical cardio-vascular department at a hospital there are many sounds with specific meanings. This includes not only voices in structured reporting as well as small talk similar to many other gatherings, but also very specific sounds related to diagnostic equipment, monitoring, and alarms. Some of these sounds are amplified from the heartbeats and reflect normal cardiac function versus malfunction in a heart suffering from a disease. Other sounds are synthetic with a biological

ail project process: the identity of an artist in a lab environment is to be on the inside and on the outside at the same time. Therefore, I conducted further studies in sound walks and essays that attempted to reflect this hybrid position of being in-between.

During my stay in the lab I studied many different approaches to research based on the polygraph and on the metaphorical significance of the heart in cultural science.□2 This investigation led me into a huge trans-disciplinary perspective that lay between different scientific research: medicine, biology, psychology, philosophy, musicology and in general a review of many artistic approaches to the "metaphorization" of the heartbeat.□3

Caroline de Watteville, head of *Rencontres Arts et Science* at the CHUV, was the one who introduced me to the work of visual artists like Christian Boltanski and Bill Viola. In the art context, one of the most fascinating pieces of art was by Bill Viola's *Science of the Heart* (1982). In this installation, the heart's metaphorical meaning clashes with the images of the physiological organ, bringing together the two separate forms of knowledge in a paradoxical situation. While studying these different scientific and artistic approaches, I made sound recordings of the hospital so as to document this environment of medical heart research. My aim was to produce a soundscape of the heart, or better, a sound walk, which mirrors the sound world around the heart science and how this science was managed through the canonical version of society's privileged knowhow a high tech hospital. This sound walk, which included my own recordings of the hospital's intensive care unit, entrance hall, the doctor's patient visits, etc. was edited, looped and recomposed through effects to create a situation between objective noises and incidents on the one hand, and subjective perspectives on the other. The result was not only a subjective walk through the hospital, but also a reflection of the ail project's setting: how the artist's identity is a heterotopic place between the inner and outer perspectives.□4

□2 CHUV: Museum devoted to the history of artificial prothesis and heart instruments used in Heart Surgery.

☐ 3 Steffen Schmidt explains
the sounds produced by the echocardiogram

☐ 4 Prof. Karl Ludwig von Segesser
explaining current heart research at CHUV

base like the one the pulse oxy-meter[1] creates. It represents
the heart rhythm with an intermittent tone on one side and
shows the degree of oxygen saturation of the blood circu-
lating in the arteries through a specific continuously adjust-
ing frequency. Then there are the alarms that sound when
any anomalies occur. They are very different than the rest
of the soundscape and purposely designed to be disturbing.
They are necessary, of course, and it is good to have them,
but they are not really welcome, especially if there are too
many of them at the same time.

In addition to these sounds, our artist-in-lab recorded
the noises of the elevators, the movements of the beds, the
ring tones of the phones in the ward, etc. In the operating
room, there were the mur-
murs of the ventilators, the

1 Pulse oximetry is a non-invasive method for monitoring a
person's oxygen saturation.

The *Sound Walk* was planned to be the companion track of an entire performance with which I would play live piano. By performing the pre-recorded sound walk with live piano, I wanted to build relations to the "tonality" and rhythm structures of the hospital's sounds. Thanks to the collaboration of the Montreux Jazz Festival, this sound walk was actually performed at *Didactica* in July 2011. The performance was very special. I asked the head of the lab, Prof. Dr. Ludwig K. von Segesser to join me in the performance with his echocardiogram. He performed its noises and sounds on the stage and they were amplified through a PA system. In agreeing to this idea, von Segesser contributed to the premiere of perhaps the most bizarre trio at this festival consistent of the pre-recorded sound walk, a live piano and a live echocardiogram.□5/6

After the successful premiere I had several possibilities to repeat the performance, but without Prof. von Segesser and his echocardiogram machine. Aurélie Coulon and Swissnex made a San Francisco performance possible in May 2013. There I developed a version of the sound walk with live percussion. In this performance, the noises I produced live with an empty paper box and a plastic bottle could underline the compositional structure from the sound walk and produce sonic similarities with the heart sound material. The aim here again was to produce a space between inner and outer perception. In addition, I could also work with a live heart sound, which was provided by Aurélie. Later, a repeat of this live heart sound performance was conducted in September 2014 at the Musée de la Main in Lausanne.

Since the research period in the lab (3/2011 to 11/2011) the performance has steadily continued to develop. The sound walk is developing more into a "sound essay", a composed imaginary discussion-construction between different arts and sciences. The heart sounds themselves became more and more sound designed artefacts, like electronic beats.

□ 5 Scanned image from the heartbeats recorded at the concert at the *Montreaux Jazz Festival* 2011

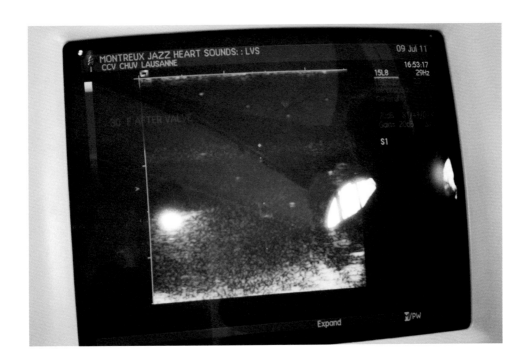

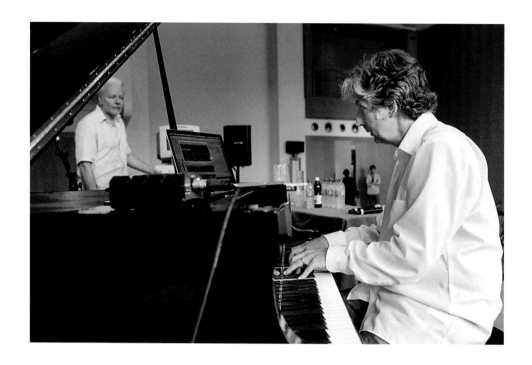

☐ 6 Steffen Alexander Schmidt and scientist L.K.v. Segesser improvising
with the echocardiogram as an instrument and the piano at the *Montreux Jazz Festival* 2011

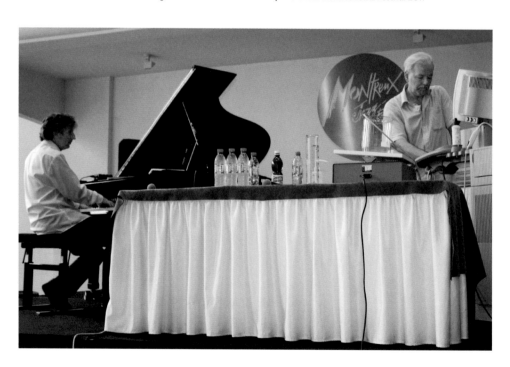

At the end of my stay in the lab, the different cultural codes of the heart became more important. I started integrating different sonic and aesthetic representations of the heart, dealing with Edgar Allan Poe's *The Tell-Tale Heart* and Schubert's Lied *Gretchen am Spinnrade*, as well as Michael Jackson's opening of *Smooth Criminal* and Kraftwerk's *Electrocardiogram* from *Tour de France*. Ole Hoystad's *Kulturgeschichte des Herzens* ("Cultural History of the Heart") became a central theoretical issue. My method of research was to take aspects from different disciplines, documenting them in a research diary and confronting them with the sound diary I made during my stay in the lab.

The sound walk I produced there, was thus developing into a sound essay. Taking the idea from Chris Marker's *Sans Soleil* film essay (1982) where he contributes to the philosophy of time perception under a Dionysian aesthetic concept, I planned a two-part piece of approximately 20 minutes in length, in which the musical question of inner and outer perception was focussed. The first part should follow the "classical" concept of a sound walk. It reflects my path to and through the hospital, starting in the Metro of Lausanne and leaving the hospital with the ambulance helicopter. After having passed the entrance hall with its strange kind of muzak (which is subjectively marked through a distortion effect to reflect my own critical point of view), I arrive at the sixth floor to change my dress, which also gives a different identity, becoming a part of the hospital's staff. This critical transition of taking another hybrid identity between inside collaborator and outside artist is marked by a looping of sounds of the dress machines, which suddenly trespasses the quality from noise to music.

This short description of the first part of the sound walk should explain my method of building up the narrative structure between sound and space, to create an imaginary sound architecture, shifting between objective noise and subjective sound.

In the second part, I enter the lab (elevator, opening door, starting the computer, noises of writing on the keyboard), which

sounds produced by the monitoring devices, the rattling of the instruments, the crooning of the coagulator,[2] the blubbering of the suction devices, the squeezing of the roller pumps, the buzzing of the bubble detector, low level indicators, and pressure sensors, the clicks of the valves of the circulatory support systems including balloon pumps and artificial hearts, the humming of the cell spinning devices, and of course, the computer generated keystrokes, confirmations, alerts in combination with the voices of the experts.

Later on in the residency, Steffen Schmidt pushed his search for sound much further and together we explored the bowels of the hospital, which was a very impressive experience. A hospital with a thousand beds has a huge department for making available all the media required for daily

2 A surgical device that uses electrical current or light to stop bleeding.

introduces the numerous relations that are linked with heart culture in the online world: a scientific introduction into the anatomy of the heart is heard, counterpointed by Edgar Allan Poe's *The Tell-Tale Heart* and sonic representations of the heart (stethoscope sounds and echo sounds). The 3D printer of artificial hearts, which are produced in the lab, plays a major role. This amazing machine has two motors, which behave like two different voices of a bizarre musical instrument. It played in the background while I was writing my research diary. I took many recordings of this strange musical instrument. In this second part I collect many different perspectives of the heart sound (very freely in rhapsodic, Fantasia form, and not systematically built). The middle part reflects different heart sounds I've found in the hospital through the musical technique of a fugue. The end of this second part returns to the idea of a sound walk, leaving the hospital through the sound of a helicopter. (The helicopter is very crucial in urgent situations of heart transplantation.)

This second part is not purely a sound walk, although the beginning and end represent its gesture; instead, by entering into the imaginary discussion of the different scientific and artistic perspectives of heart cultures, it approaches more of a sound essay. This project was just a beginning, a first approach to a huge phenomenon, which is relevant to all fields of high and everyday culture. Through the dimension of sound, the essay form reflects, in my opinion, the best way of entering into the world between inner and outer perception, which was a central aspect of the whole ail project, as well as a general conflict in perception between objective and subjective. This might be just an illusion, because our whole perception is taken from an inside perspective. But one should consider that sounds and noises from the outside world have more objective relevance for communication than music. We can follow this difference very clearly in film science, where sound-design is a part of the film, while music (the musical score) has always the status of a comment outside the film.

work and also all sorts of back-up machinery. This includes air-handling systems with huge fans, having blades the size of a man—a set (and noises) perfect for an action film. Furthermore, we discovered chilled water, hot water, and ultra-pure water preparation systems in rows, several dozens of elevator drives and brakes, and multiple emergency power generators with heavy diesel engines able to handle full load within 60 seconds, and so on. Of course, all these engines are the opposite of quiet, and thus, Steffen Schmidt's recordings provide an additional dimension of an otherwise hidden world.

Our three-dimensional everyday world, with its fourth dimension of time, received an additional, literally unheard dimension of sound through the artist-in-lab. This became particularly apparent in our laboratory for experimental surgery, where Steffen Schmidt moved from recording "grand

In my opinion, it would be a very fruitful interdisciplinary or trans-disciplinary research field to develop and investigate the symbolizing strategies of the heart in different sciences and arts, to compare phenomenon from different sights and to find a language, which communicates different approaches. First steps of networking have been made in this research, to build up a research cluster, with little result until now.

Especially in music theory and history there is an interesting analogy between the heart sound and the birth of motif thinking and thorough bass, two very important issues of baroque and classical music from 17th century on to the early 20th century. One could claim that there is a strong analogy to the heart sound. Music, representing affect, has not only built up emotional signs through musical representations like pitch gestures ("Musikalische Figuren") or major/minor scales, but also by imitating the physiological functions of the body: tempo, rhythm, measure, character and frequency. It is striking that the ideal, neutral heart sound is almost identical with the so called "folk tune fourth", an upbeat jump from the dominant to the accented tonic, as one can hear in Mozart's *Kleine Nachtmusik,* or in the bass line of the piano in Schubert's Lied *Gretchen am Spinnrade* after Goethe's poem. The meaning of the words *Mein Herz ist schwer* ("my heart is heavy") is translated into the bass line, giving the drive of the expressed agitation. Music since 1700 hence would express an invisible body language, which is directly linked to the emotional representation of the body through the breath and the heartbeat. This is not expressed through dance, but through the inner movement, as if amplified and acoustically symbolized, which describes an idealistic place between the immaterial soul and the visual gesture.

As a musicologist and cultural scientist this project has led me to a new aspect of musical ontology and to trans-disciplinary perspectives. As a composer and musician I developed the format of the sound essay, which seems the only adequate way to tackle the

sounds" like those from the cryo-centrifuge,[3] the lab-mixer, various perfusion systems and simulators, the computer operated laser cutter, and the three dimensional printer to studying synthetic sounds produced by the cardio-vascular measuring and imaging equipment. The most impressive example of an unexpected development achieved by combining the forces of the artist and the surgeon-scientist in this experience is the promotion of the echocardiography equipment designed for diagnostic purposes in the experimental and clinical setting into a new synthesizer able to generate entirely novel sounds.

At this stage, one has to understand, that the sound produced by an echocardiography machine is a synthetic

3 A cryopump or a "cryogenic pump" is a vacuum pump that traps gases and vapours by condensing them on a cold surface. A laboratory centrifuge is a piece of laboratory equipment, driven by a motor, which spins liquid samples at high speed. There are various types of centrifuges, depending on the size and the sample capacity. Like all other centrifuges, laboratory centrifuges work by the sedimentation principle, where the centripetal acceleration is used to separate substances of greater and lesser density.

above described phenomena of the perceptive tension between inner and outer space. It might also work as a certain prototype of artistic research.

I would like to finish with a statement of the heart's function in counter culture. As we can see in many artistic pieces of literature and music, the heart has a certain meaning of signifying the truth. For example, in Wackenroder/Tiecks *Herzensergießungen eines kunstliebenden Klosterbruder*[6] (1796), the title already exudes that there is a level of intimacy, which is not to be taken as an official statement, and that is at the same time a guarantee of the "real" truth. While the rational argument of a political debate, or the academic proof of a philosophical statement are "rotten" through their character of a corrupt rhetoric society, the chance to express something through the heart marks a place beyond. There, its symbolic meaning receives the value of a counter culture, in which also—or perhaps especially—music takes a dominant role in conveying this intimacy. Listening to music cultivated a way to understand the intimacy of the true message. That might be one reason why people don't like to talk about musical matters. The most horrible and hysterical idea in Poe's *The Tell-Tale Heart* is that intimacy becomes official. In the protagonist's mind the polygraph already exists—the imaginary. It might be just a question of time before a polygraph function is included in the equipment of future detectives—perhaps dressed in beautiful sounds, derived from the heart.

My research, which shows a development from a very clear musical idea, has led me to a huge project of interdisciplinary approach. It led me to the attitude of being careful with the connections one can build with knowledge. That is the reason why I changed the project's title from *Signs of Life* to *Sonic Representations of the Heart* and finally to *Cultures of the Heart*. The very first and most

6 There is no official translation into English but the title could be approximately translated as "Outpourings of an Art Loving Monk's Heart".

one based on ultrasound on one side and the Doppler phenomenon on the other. The latter is due to the frequency shift of reflected sound waves due to the movement of an object, typically represented by a passing motorcycle or a car. Well, in medicine, we are not following cars, but red cells and fluids in the blood stream. To give an example, the beating heart provides pulsatile blood flow, which can be recognized by the ultrasonic equipment as changing velocities and consecutively changing frequencies resulting in synthetic sounds and eventually reconstruction of images.

With Steffen Schmidt we studied physiological and non-physiological synthetic sounds generated by ultra-sonic equipment in vivo and later in vitro. For the latter purpose, an additional physical phenomenon was added: resonance. Of course resonance has a positive connotation for musical

important step of a serious scientific approach would be to identify the different cultural contexts that our heartbeat is a part of.

References

Attenhofer JC, Valsangiacomo Büchel, E 2006, 'Diagnostik bei kongenitalen Vitien: Stethoskop, Echokardiographie und/oder MRI?' in *Kardiovaskuläre Medizin* 9, pp. 311–323.

Benthien, C, Wulf, C 2001, *Körperteile. Eine kulturelle Anatomie*, Rowohlt, Reinbek bei Hamburg.

Borgdorf, H 2009, 'Die Debatte über Forschung in der Kunst', in A Rey, S Schöbi (eds) *Künstlerische Forschung. Positionen und Perspektiven*, Zürcher Hochschule der Künste, Zürich, pp. 23–49.

Erne, P 2008, 'Beyond auscultation – acoustic cardiography in the diagnosis and assessment of cardiac disease', in *Swiss Medical Weekly* 138, pp. 31–32, pp. 439–452.

Herbert, BM 2006, *Kardiosensibilität, Emotionsverarbeitung und Verhalten: die Bedeutung der Herzwahrnehmung für zentralnervöse Emotionsverarbeitungsprozesse und Verhaltensregulation*, Dissertation LMUMünchen, accessed 1 December 2015, https://edoc.ub.uni-muenchen.de/5751/

Hoystad, O 2005, *Kulturgeschichte des Herzens*, Böhlau Verlag, Köln.

Kümmel, WF 1977, *Musikund Medizin*, Verlag Karl Alber, Freiburg, München.

Lachmund, J 1997, *Der abgehorchte Körper: Zur historischen Soziologie der medizinischen Untersuchung*, Westdeutscher Verlag, Opladen.

Mäkelä, M, Nimkulrat, N, Dash, DP, Nsenga, FX 2011, 'On reflecting and making in artistic research', in *Journal of Research Practice*, Online Issue 7 (1), Article E1, accessed 1 December 2015, jrp.icaap.org/index.php/jrp/article/view/280/241.

instruments, but much less so in mechanics where it can be responsible for braking glass and bars made from steel. For the artificial sound generated in our laboratories we relied on moving fluids, ultrasonic detection, the Doppler shift, and resonance, allowing for build-up of sounds that had not existed previously. Steffen Schmidt, the composer, later combined these new sounds with sounds generated by traditional instruments thus creating his own soundscapes. This experience followed a similar path like the mechanical sound generation by tone wheels in the original Hammond organs, the integration of noise into music by Pierre Henry, the appearance of all electronic R-C based oscillators[4] and synthesizers, and the culmination by the combination of all by the possibilities of digital signal processing.

4 A "RC" oscillator is a linear oscillator circuit, which uses a combination of resistors and capacitors.

Jens Hauser currently holds a dual post-doctoral research position at both the Department of Arts and Cultural Studies and at the Medical Museion at the University of Copenhagen. He is also an affiliated faculty member of the Department of Art, Art History and Design at Michigan State University and a faculty member at the Department for Image Science at Danube University in Krems. His focus is on media studies andart curating, the interactions between art and technology, trans-genre and hybrid aesthetics. His curated exhibitions include: *L'Art Biotech* (Nantes 2003), *Still, Living* (Perth 2007), *sk-interfaces* (Liverpool 2008/ Luxembourg 2009), *The Article Biennale* (Stavanger 2008), *Transbiotics* (Riga 2010), *Fingerprints...* (Berlin 2011/Munich 2012), *Synth-ethic* (Vienna 2011), *assemble | standard | minimal* (Berlin 2015), *SO_3* (Belfort 2015) and *Wetware* (Los Angeles 2016). Hauser serves on international juries of art awards such as Ars Electronica, Transitio or Vida, as well as of several national science foundations. He was also a founding collaborator of the European culture channel ARTE in 1992 and has produced numerous reportages and radio features for German and French public broadcasting services. He has also published essays in print journalism and in art books for many years.

Biomediality and Art

Jens Hauser

> Every work of art has its irresoluble contradiction in the 'purposefulness without purpose' by which Kant defined the aesthetic; in the fact that it is an apotheosis of making, of the nature-ruling capacity that, as a second creation, postulates itself as absolute, purpose-free, existing in itself, whereas after all the act of making, indeed the very glorification of the artefact, is itself inseparable from the rational purposefulness from which art seeks to break away. The contradiction between what is and what is made, is the vital element of art and circumscribes its law of development, but it is also art's shame: by following, however indirectly, the existing pattern of material production and 'making' its objects, art as akin to production cannot escape the question 'what for?' which it aims to negate.[1]
>
> Theodor W. Adorno, *Minima Moralia*

Most unexpectedly and clearly provocatively, Adorno's questioning of the allegedly shameful relationship between what is made and what is, and of artistic production as "second nature", takes on new significance at a moment when more and more artists are employing methods of bio-technology as a tool and means of creative production. Such art of transformation in vivo and in vitro, a practice that manipulates, subverts and aestheticizes biological systems and organisms at the minutest level, often flirts with the believability and corporeality of the biological entities involved, with whose "vitality," whether apparent or real, the viewer might feel connected. The desire to negate any aspect of instrumental rationality in what Adorno metaphorically understands as the life element of art as a utopian end in itself — similar to the living — seems, in this case, to be understood biologically-literally, when biological artefacts made real in the context of art, despite their technical arrangement in the laboratory, call up effects of authenticity and immediacy. From an art historical perspective, these artefacts are connected to a longing for aesthetic "life-likeness" (Fehrenbach 2012, pp. 30–39) that extends from early anthropomorphic statues to myths of artists' works "coming to life" and the animation of inanimate malleable material through to notions of the artwork as an organism in itself, and on to robotic and software simulations of digital media art. Yet, artefacts created in a bio-scientific context pose a very different and pervasive question — namely, that of utilitarianism, that is, of the expediency and instrumental rationality from which art, according to Adorno, perpetually strives to free itself. Quite unwittingly, Adorno appears, in this context, to be a media art theorist avant la lettre, reading behind the oscillation between aesthetics and finality the respective "pattern of material production" as the decisive force — in other words, the perpetually evolving technological media behind forms, appearances, products and insights — and art's relationship to them.

New art practices, increasingly more common since the 1990s, that operate beyond symbolism, simulation and representation and employ a broad spectrum method from the life sciences are suited, for a variety of reasons, to serve 1 Adorno 1978, p. 226.

as epistemic indicators of a continually changing concept of mediality, not only in art. As such, I have described these strategies of organic media-art since 2003 as instances of biomediality (Hauser 2016), these include life enabling milieus (i.e. biological media that turn biological systems into something), technical means (i.e. biomedia through which biological systems make something) and instances of measurement (i.e. media of biology that do something with biological systems). This kind of art shows how, under the influence of the natural scientific disciplines, the focus of the concept of mediality of the humanities themselves is expanded. For when the technology of media changes, so too changes our concept of what a medium is. Cultural studies and the natural sciences, seen in the Modern period as two distinct fields of understanding, are, thus, equally affected and inextricably linked, despite their different methodologies and purposes, precisely through technological media. Biotechnologies make the potential of life forms, cells and other organic entities technologically useable and create new *biomedia* by converging various information and laboratory processes. Biological components and processes are arranged and optimized to be employed for purposes beyond their organic end-in-itself. At the same time, the rise of biology to the status of the leading science both in the humanities and in contemporary art, has led to the inflation of biological metaphors, motifs, models and discursive allusions. It is a given across the disciplines that the evolutionary, adaptive, reproductive and emergent qualities of biomedia take over and expand the functional triad of media based on physical laws — store, transmit, process. Most frequently, artists purposefully link instances of biomediality with preexisting media, extending, among others, script, sculpture, tele- and mass communication, photography, interactivity, etc. into the biomedial. For example, DNA structures are often used in place of traditional storage media to save extra-biological data. It will not go unrecognized by media theorists that strategies of this type follow what Jay David Bolter and Richard Grusin describe as the logic of remediation (Bolter, Grusin 1999), in other words, existing media are continuously shaped by newer ones and each new medium putatively "fills a lack or repairs a fault in its predecessor" (Bolter, Grusin 1999, p. 60). According to this logic, it is a persistent characteristic of media evolution *per se* that a medium "appropriates the techniques, forms, and social significance of other media and attempts to rival or refashion them in the name of the real" (Bolter, Grusin 1999, p. 65, emphasis J.H). New media, then, would always initially conceal

their technological character and appear transparent, as a result of the higher degree of reality of the things they mediate. In a second stage, however, they would be revealed bit by bit in their hypermedial inter-weaving — and thus thematized as precisely those instances that, in fact, produce what they pretend only to mediate. This is how we can explain what initially appears to be a paradoxical phenomenon that artists can operate simultaneously with the fascination of immediately "living" art and the fascination of biotechnological operations. These now include transgenesis, the synthesis of DNA sequences and their cloning into bacteria, the use of retroviruses, molecular biological imaging media, such as gel-electrophoresis and DNA chips, so-called *biobricks* of syn-thetic biology, cell and tissue cultures in nutrient media, self-experi-ments with immune biology, neuro-robotic constructions, hybridization and cloning of animals and plants, as well as the recontextualization of organisms serving as laboratory models — to name a few.

Though the particular case of biomedial art is not representa-tive of the current trend to popularize the research activities of the arts and the sciences under the banner of artistic research or arts-based research, it is nevertheless surprising how, in competing interpretations of the aesthetics and the finality of this genre, the specific biomedial aspects are disregarded. Apparently the concern, there, is either with the desire to draw as seamless a line of history as possible in an attempt to tell the story of "aliveness", or the desire to idealize the reconciliation of artistic and scientific creativity, associated with the name of Leon-ardo Da Vinci, wherein the experimental in art is equated with experi-mentation in the laboratory.

At first, the temptation is certainly great, given the "creative potential" of biotechnological art, to place it in a long tradition of ani-mation myths, in which the artefacts created by artists in a sort of Pro-methean-demiurgic act of creation, feed on a narrative that extends from the sculpture of Greek antiquity to Pygmalion motifs to Golem and Frankenstein through to mechanical automata with all the appearance of life[2] and on to the concept of the work of art as a living organism (Wae-tzoldt 1905). The allegedly accomplished act of animation performed by the artist in *in vitro* and *in vivo* art — while biological entities, here, are manipulated and "loosely coupled" they are indeed not created *ex nihilo* — appears to perfect "what was once seen as the unattaina-ble vanishing point of the artistic

2 Horst Bredekamp speaks, in connection with the cabinets of wonder of the 16th and 17th centuries, of a "chain of collections[:] natural history — antique sculpture — art work — machine" (Bredekamp 1993/2007, p.73).

quest, as descriptive metaphor, ideal and quality criterion of art and the act of artistic production — namely, that works of art are 'living beings' or can best be understood through concepts deriving from the area of biological life processes" (Pfisterer, Zimmermann 2005, p. VII). In the logic of a motif-based and image studies approach, these aesthetic models redeem themselves as the "clearly compulsory reinterpretation of older phantasms," (Fehrenbach 2005, p. 138) for, as Frank Fehrenbach writes, "the fictions of a living art so, too, delineate a biotechnological desideratum, at times nostalgic, at times utopian. Combinatorics of attributes as the composition of the discrete and the production of the living, as such, being the central aesthetic guiding concepts of the Renaissance, point to that ideal germ out of which sprouts to this day the phantasm of a genuine production of chimera as art. [...] Transgenic art — was already on the agenda of Early Modernism" (Fehrenbach 2005, pp. 139 and 153). Such readings contrive four centuries of development in the practice of art for the benefit of that "most durable artistic paradigm" (ibid., p. 158) and see, for example, the "semi-living" sculptures of the *Tissue Culture and Art Project* as little more than an effort to update "one of the most powerful paradigms of aesthetic production, the animation of Pygmalion's ivory statue" (ibid., p. 138). Relevant technical factors, such as the intentional and purposeful selection of specific biotechnological methods by artists themselves, fall, as a matter of course, through the cracks of such a reading focused on motif rather than mediality. Sigrid Schade, in this regard, critiques the "repressed mediality of modern and contemporary art" (Schade 1999, p. 269) in art historical discourse, complaining that it is typical for the interpretation of contemporary media art "to make unreflected references to pre-modern art history where traditional artist myths are applied to the new demiurges of the computer age," (ibid., p. 270)[3] whereby the "opposition of art and media [...] is a foregone conclusion," (ibid., p. 270) despite the fact that "we have already experienced a century of avant-garde movements whose signature, among others, was to cross traditional genre boundaries and hierarchies and, through the confrontation with technological development and the emerging culture of mass media, to sound out and employ the possibilities and effects of new media" (ibid., pp. 270–71).

According to the second commonly seen pattern of interpretation, artists who employ biotechnologies as artistic media are, as a matter of course, put in a broader group of art-researchers working

3 Schade, here, references *pars pro toto* a book contribution by Horst Bredekamp (Bredekamp 1992, pp. 134–147).

in interdisciplinary teams to reconcile art and science, attempting to close what C.P. Snow refers to as the gap between the two cultures, between the human and natural sciences (Snow 1959). Often, what is being referred to, here, are practice-based doctoral programs for artists, mainly for the purpose of gaining access to academic positions. All the while, however, the assumption behind the postulate of alternative knowledge production and knowledge transfer is, naturally, though not rightfully so, that "science" means the natural and not the human sciences. By contrast, historians of science, such as Hans-Jörg Rheinberger, see the contemporary urgency of a "practical turn" toward a concrete investigation of epistemological production in order to emphasize the very making and the material means of research technologies in the debates concerning an adequate notion of science and "disclose even the natural sciences and scientific knowledge of nature itself as cultural phenomena in their historical specificity and, insofar, to pull them over to the side on which the humanities have always found themselves" (Rheinberger 2015, p. 34) — whereby not only the sociology of science and philosophy of technology are meant here. In particular, it is the contemporary network of experimental systems, e.g. with the requisite technical arrangement of model organisms, that must be examined self-reflexively as "the genuine working units of contemporary research" beyond merely results and insights. For in them "the scientific objects and the technical conditions of their production are inextricably interconnected. They are, inseparably and at one and the same time, local, individual, social, institutional, technical, instrumental, and, above all, epistemic units. Experimental systems are thus impure, hybrid settings. It is in these 'dynamic bodies' that experimenters shape and reshape their epistemic things" (Rheinberger 1997, pp. 2–3). Yet, a certain degree of precision is lost in general talks about *artists in labs,* or under the heuristic umbrella of *art from the laboratory,*[4] whereby the notion of "laboratory" is all embracing, lumping together such divergent medial practices as wetware *manipulations,* soft and hardware *simulations* and visual *representations.* This critique is reiterated by Oron Catts, artist member of the *Tissue Culture and Art Project* and co-founder of the Australian art and science collaborative research laboratory SymbioticA. Since 2004, SymbioticA has

4 Ingeborg Reichle thus turns to Bruno Latour's statement "that the very difference between the "inside" and the "outside", and the difference of scale between "micro" and "macro" levels, is precisely what laboratories are built to destabilize or undo and understands the laboratory, now, as "a space for the theoretical and speculative development of ideas [...], in which reconfigurations of natural and social orders and their relations to one another take place. In laboratory practice, just as in artistic practice, objects are taken out of their 'natural' environment and placed in a new field of phenomena" (Cf. Latour 1983, p. 143 and Reichle 2005, pp. 3–4).

offered international workshops for artistic-biotechnological practice and, thus, the project explicitly works against the idealization of the laboratory, as a space out of which shielded expertise is disclosed to the public, preferably in the form of spectacular new insights and sensational pictures. Catts ironically sums up a taxonomy of the various antagonistic positions available to the artist in the lab working with biotechnology: "1) the illustrator, 2) the commentator/representer, 3) the visitor/guest/onlooker, 4) the appropriator, 5) the entertainer, 6) the user, 7) the industry worker, 8) the hoaxer, 9) the hobbyist/amateur, 10) the after-hours/under-the-table, 11) the mail-order/ready-made, 12) the researcher/embedded in science/technology setting" (Catts 2008, pp. 120–121). Even if the risk cannot be eliminated that artists simply adopt logical and institutional constraints, Catts still favors the last option that they should be "'getting their hands wet' [since] it is important for some non-biologists to enter the life science lab and engage with the manipulation (not just visualization) of life in the most direct and experimental way (literally, the phenomenological way…). The knowledge one gains by the multisensorial experience of dealing with life in such a way is something that neither text book nor image can provide" (ibid.). In Symbiot-icA's workshops, the basic infrastructure for the in-home biotech atelier or for hobby associations with *open-source* ethos is designed, as it would be taken up and further developed by the trend of DIY biology and biohacking some years later.

The latter contributes not unsubstantially to the fact that in the discussion of these practices the technical-medial behind the aesthetic, and the political behind the finality of those instances of biomediality come into focus. In biohacking and do-it-yourself biology scenes, artists are present, though not represented predominantly. In keeping with the scene's own self-understanding (a good percentage of biotech-artists, no doubt, share these values), a traditional concept of art is, however, neither suited nor conducive to the functionality of a community of like-minded people that sees itself as a subcultural system. While "art" is slowly but surely mutating into a bad word, here, "hacktivism" takes on all of its former positive connotations. Yet, there was a time when the biotechnological art movement continually defended itself against its appropriation by digital media art, its structures, machines, metaphors and institutional workings, and was, for a long time, the target of open animosity and condemnation on the part of digital culture proponents for its wetware practices. This explains the massive historical blindness

in the *biohacking* and *DIY* scene, whose "first association in the field, DIYbio.org, was launched in 2008 in Boston," (Landrain, Meyer, Perez, Sussran 2013, p. 116) according to its own descriptions. What is interesting about this development, however, is, above all, the insertion of the biotechnological into a medial progression. For in the milieu of *biohacking* and *DIY* biology and its tinkering with hardware, software and experimental wetware protocols, it is explicitly emphasized that these practices are about the "direct transposition of free software and hacking practices into the realm of cells, genes, and labs" (Delfanti 2012, p. 163). No wonder, then, that in many places "wetware corners" were set up in already existing hacker spaces and media art associations and firmly anchored in the paradigms of computer culture and tactical *hacktivism*.[5] These practices follow a creative and political paradigm of appropriation having its forerunners in Super 8 film clubs, video groups, local open-access TV channels and computer hacking movements. In these circles, too, workshops are organized, online tutorials are offered and construction plans for inexpensive laboratory equipment, such as PCR thermocyclers as "molecular copy machines," are exchanged.

It seems fitting, at this point, to examine the transformation or, respectively, the expansion of the concept of media through the influence of biology and the technologies applied to it, as well as to move beyond an understanding of media as strictly communication media. While it is widely accepted that media technology, as set forth in Friedrich Kittler's now canonical definition, deal with the "transmission, storage, [and] processing of information," (Kittler 1993, p. 8) it is worth considering how characteristics of the organic and its technical medialization, on the one hand, can fulfill these functions in their own way and, on the other, how they introduce certain kinds of "biological inbetweenness" whose dynamics are not congruent with "physical inbetweenness". Certainly, we can apply the paradigm of storage to the genetic information "stored" in DNA, of transmission to viruses and messenger RNA, of processing to "natural" protein biosynthesis and instrument-based biotechnologies, such as cellular or DNA computing, with which biological systems are theoretically capable of emulating activities performed today as a matter of course by physical media. Yet, a new orientation of the concept of

5 Some examples of important structures in the USA include *Genspace* and *DIYbio*, their European counterparts in France *La Paillasse*, in Denmark *Biologigaragen*, in the Netherlands *Waag Society*, in England *Madlab*, in Indonesia *HONF*, as well as the international network *Hackteria*. Many initiatives have been supported by the European Union's *Studiolab* program. Accessed 31 August 2013, Cf. www.genspace.org; www.diybio.org; www.diybio.eu; www.lapaillasse.org; www.biologigaragen.org; www.madlab.org.uk; www.natural-fiber.com; www.hackteria.org; www.studiolabproject.eu.

media also requires thinking beyond media concerned with the storage, transmission and processing of information to include natural scientific conceptions of media, even older ones. As Erik Porath reminds us, the loan word "medium" in the 17th century in its translation from the Latin into modern European languages was used more frequently in the context of the natural and not the human sciences, "before it was, then, in the second half of the 18th century, superimposed by connotations through a broader understanding of 'medium' as 'intermediary element' and, more generally, as 'means' or 'tool'" (Porath 2008, p. 254). While "the earlier natural scientific meaning of 'medium' (precisely in the sense of element) as carrier of physical and chemical processes [constitutes] a central criterion for a 'materiality of media' and, thus, a specific, above all, experimental way of dealing with substances, materials, their characteristics and effects in the natural sciences," (ibid.) the focus on functions of communication causes us "to lose sight of the natural scientific relevance of mediality," so that "cultural studies and traditional media studies [approaches] generally lack consideration of *natural science* and its history" (ibid., p. 256). A cell biologist, even today, is more likely to think of a nutrient solution than a television as a medium. Insofar, Robert Mitchell is right in his analysis that so-called "bio art" is an amalgamation of various media concepts: "On the one hand, bioart draws on the more familiar sense of ,'medium' as a material means through which thoughts, information, images, sounds, colors, and textures are stored and transmitted from one place or time to another. [...] On the other hand, bioart also draws on the sense of 'media' that is used by biologists, for whom the term refers to fluids or solids that are employed to keep living cells developing, dividing, and transforming during the course of an experiment. Bioart links these two conceptions of media by situating biological media and technologies within a milieu — namely, the art gallery — that has traditionally been associated with the sense of media as a means for storage and communication" (Mitchell 2010, p. 11). Moreover, with regard to the natural scientific concept of media, we must add the media of measurement, observation and simulation, which have increasingly influenced knowledge production in the field of biology since the 18th century.

In many cases, the interpretation of generated forms and claims is inadequate, and a differentiated examination of precisely these fundamental instances is necessary. To this end, I have suggested the concept of biomediality in order to situate biotechnological art in the space

between "life" and "media". The term biomediality, then, defines that ensemble of all topical and functional *enabling* factors that arise as a result of the organization of living organisms or biological processes, be they technically manipulated or just appropriated to be made usable, from the microscopic to the macroscopic. Biomediality, then, can be understood as a special form of loose coupling[6] of de- and re-organized biological entities (such as, at lower levels, nucleotides and cells or, at higher levels, laboratory organisms) that, despite their own vital potential, are conceived as indifferent vis-à-vis what they mediate. Such atomism differentiates itself qualitatively, however, from that of media understood merely physically, in that organisms as a central point of reference are or were, in the first instance, organized. To an extent, then, we might define microscopic loose coupling as organized atomism. This can deal with organic processes, with substrate that enable life phenomena, or with environments; alternatively, it can deal with experimental systems or convergent media, microorganisms, individual organisms, as well as parts or populations of them — all can potentially serve as objects of technologization and, hence, as media or mediators without any proper purposefulness, even in combination with other media. In contrast to many physical media, as well as to visual and communication monomedia, in fact, they cannot be defined through stable, fixed carrier media. Depending on context and application, there are functional differences that, nevertheless, evidence numerous points of overlap at the material and technical levels. I would like, here, to distinguish the following instances of biomediality: biological media, biomedia and media of biology.

1 Biological Media: Biological media are to be understood as regulable media in the sense of milieu; as existential media that turn biological systems into something, that surround a body and enable its internal functions. These can be physical-abiotic parameters, water, light, temperature, pressure, magnetism, and air to breathe or to enable pollen flight — in a macroscopic sense, the environment. Mesoscopic existential and transport media within organic bodies include blood, urine, amniotic fluid, as well as cerebral and spinal fluid, or, at the microscopic level, cell plasma. Alternatively, in experimental systems, such as laboratory cultures, milieus are simulated under controlled circumstances through the use of incubators, culture vessels, work benches equipped with humidifiers and gas feeds, as well

6 The point of departure is the atomistic principle of loosely coupled, independent physical units that, according to early media philosophy of Fritz Heider, make media functions, such as transmission, mediation and processing, and their perception, possible (Cf. Heider 1926/2005, pp. 109–157).

as nutrient media with amino acids, salts, vitamins and buffers, enriched with serum to activate cell and tissue growth.

2 Biomedia: *Biomedi*a are media as transformative-generative means, whereby biological systems do something outside the parameters of their inherent organic purpose as such. Biomedia as technologized biological processes, then, are "active biofacts," (Karafyllis 2003) as described in Eugene Thacker's concept of *biomedia,* i.e. as a "particular instance in which the 'bio' is transformatively mediated by the 'tech'" (Thacker 2004, p. 6). They can be considered "processing bodies," whereby the concept of "bodies", here, can include molecules, organisms and populations. This encompasses, for example, spliced or synthesized gene sequences, the use of viral promoters to transfer DNA sequences into foreign genomes, the immortalization of cell lines to create unlimited growth capacity, the programming of cells as synthesis factories, the production of laboratory organisms, such as knock-out mice, transgenic animals or clones, as well as convergence technologies or wet-dry cycles, bioinformatics and biocomputing.

3 Media of Biology: Media of biology are those employed to measure, analyze and observe; media that do something with biological systems; dispositives, in other words, in which one organic system reveals something about another. They serve knowledge production and, viewed historically, are functionally positioned in the tradition of microscopy and micro or cell cinematography. Yet, now, within the acceleration in molecular biology, no longer mere physical-optical apparatus are being employed, but biological systems themselves are technologically turned into representational units. At the smallest level, these can be, for example, fluorescent biomarkers, biosensors, DNA chips, or the separation of molecules with enzymes in so-called gel electrophoresis. Apparatus are created in which organic processes or life forms are turned into biomedia in order to serve as media of biology. At a macroscopic level, organisms themselves can serve as ecological indicators, e.g. like sensitive amphibians.

 With these three categories, a variety of strategies of art drawing on biomediality can now be exemplified. The two case studies discussed here for each of the three categories are intended to make clear that in a genuine biomedial analysis the epistemic dimension is equally as important as the aesthetic.

1 As a first example of the artistic focus on biological media in the sense of milieu, as existential media that turn biological systems into

something, we will examine Adam Brown's series of functional gallery installations, *Origins of Life*[7] — developed by the artist in cooperation with the physiologist and philosopher of science Robert Root-Bernstein and the atmospheric chemist Maxine Davis, both of Michigan State University. The installations unfold as highly aestheticized miniature models of the Earth's atmosphere as live experiments that, in principle, re-enact Stanley Lloyd Miller and Harold Clayton Urey's infamous "primordial soup experiment" at the University of Chicago in the 1950s (Miller 1953, pp. 528–529), commonly considered proof of the hypothesis of chemical evolution. In the original experiment, Miller and Urey recreated the atmosphere present, to the best of their knowledge, some 4 billion years ago in early Earth history, including a sterile mix of methane, ammoniac, hydrogen and demineralized water (vapor) in glass flasks, which was exposed to intermittent electrical discharges. Within the first week of the initial experiment in 1953, the scientists produced a number of simple amino acids. Brown's installation positions his art in a sphere far beneath the visible and creates the enabling conditions for the production of the biochemical building blocks of life — amino acids. He attempts to make these threshold phenomena at the boundary of lifelessness something we can experience at a variety of sensuous levels to simultaneously *"feel knowledge and know feeling".*[8] *Origins of Life* is intended to allow us to experience "science as a cultural, sensory, sensual and aesthetic experience". The specially designed Marx generator is conceived as a "functional stainless steel sculpture"(Root-Bernstein 2010). Particular emphasis is placed on the sensory vectors offered to recipients of the work: the artificial thunderstorm intended to induce the chemical reactions, the slowly developing color changes of the water in the "primordial soup" of the lower laboratory flask, or the injections of thick brown masses near the Wolfram electrodes. The installation does more than merely create a "miniature world;" it is "a sort of theater [...] in which evolution plays out" (ibid.). From an epistemological perspective, *Origins of Life* questions the mechanisms of experimental knowledge production, metaphors of science, such as "the primordial soup," and its importance of "aesthetic edification," since "notably, the aesthetic elements of science are what often attract scientists to their subject in the first place" (ibid.).

A second example of art that emphasizes the role of biological

7 The title is a play on the eponymous essay by the Russian biochemist Alexander Iwanowitsch Oparin, which first appeared in 1924 in Moscow and whose theories on the evolution of life in a reduced Earth atmosphere were taken up by Harold Clayton Uray and his student Stanley Lloyd Miller in the early 1950s (Cf. Oparin 1924).
8 Formulated in the demonstration video on the work *Origins of Life*. Accessed 15 March 2016, www.adamwbrown.net/projects-2/origins-of-life-experiment-1.

media is an installation from the *Tissue Culture and Art Project* entitled *Victimless Leather*. Here, miniature jackets grow out of immortalized animal and human cell lines in an incubator at "body temperature" in fluid nutrient media, a utopic vision of leather clothing without animal victim. Bit by bit, the cells form a living layer of tissue supported by biodegradable polymer matrices in jacket-like form. With the increasing viability, today, of xeno-transplantation, "leather," here, is seen not as a dead surface but as a trans-species interface. The incarnate jackets pretend to have immediate presence, yet as biofacts, to borrow Nicole Karafyllis' term, they constitute a "trick, applied across the fields of science, of allowing living material to grow as natural material, although it is considered technology and is cultivated for specific purposes" (Karafyllis 2008, p. 42). Growth as a process suggests a self-dynamic, though "directed growth ensures from the beginning that technical control." The growth process veils "the phenomenal invisibility of technology where it is simultaneously known to be present" (Karafyllis 2008, p. 56). Yet, is *Victimless Leather* truly without a victim (Cf. Senior 2008, pp. 76–82)? Here, the medium, the growth medium itself, literally becomes the *message*—it does, in fact, contain fetal calf serum as a growth stimulator.[9] Despite its title, then, the status of victim is merely shifted, veiled behind technology. Deliberately disguised as techno-positivism behind the title, it is the very neglect of media in experimental and productive systems that goes hand-in-hand with the standardization and industrialization that is being addressed by the Tissue Culture and Art Project. The work's interpretive key is, thus, concealed, *ex negativo*, in the biotechnological itself.

2 As a first example of art employing biomedia as transformative-generative means, whereby biological systems do something, Jun Takita's transgenic sculpture *Light, only light* comes into focus. Here, the functional expression of an animal gene sequence from the firefly in a living sculpture of moss is achieved. Takita is interested in the dependence of all creatures on light in the circle of life. To create *Light, only light*, a magnet resonance scan was used to create 3D images of Takita's brain, which were then turned into a, slightly enlarged, resin model. This sculpture was, in turn, covered with a bioluminescent transgenic moss, creating a fine green film on its surface. To this end, the artist employed the small physcomitrella patens moss, a common model organism used in

9 Fetal calf serum (FCS) is derived from the fetuses of pregnant cows. The calf's heart is punctured and blood withdrawn until the fetus' heart stops beating. Serum drawn from unborn animals contains more substances important for the growth of cells.

plant developmental biology,[10] introducing to it the luciferase gene ena-
bling the moss to emit a weak green light that can be seen with the naked
eye in absolute darkness after a long period of visual adjustment. Takita
exhibits his luminous brain as a chimera organism and, at the same time,
as an ambivalent achievement of the human brain, whose cognitive ability
makes such biotechnological applications possible and develops trans-
genic plants capable of emitting light — something only a very few ani-
mal species can do. Moreover, *Light, only light* is conceived as a minia-
ture garden, as contemporary analog to Baroque horticulture, land art,
landscape painting and still life, whereby viewers are symbolically con-
fronted with themselves and, phenomenologically, with the boundaries
of their own perception. Because it employs a gene-manipulated organ-
ism, the work is required to be exhibited within a sealed Plexiglas show-
case.[11] Here, biotechnological markers are employed as biomedia for a
purpose other than that for which they are intended in molecular biol-
ogy, where they commonly serve as *media of biology.*

Joe Davis' *Bacterial Radio* represents a further example of work
with *biomedia.* This piece features, at least in its production phase, a
living, conductive radio circuit made of genetically altered *E. coli* bac-
teria. The bacteria were altered with a modified gene sequence from
the orange marine puffball sponge *Tethya aurantia.* Naturally, this gene
forms the sponge's glass skeleton of silicatein needles through bioen-
capsulation. Instead, it now enriches metallic conductors and semicon-
ductors. Davis plays explicitly with the once popular hobby of making
crystal radios, or detector receivers — simple radios that can be made
with few components and work without any special electrical source,
because all of the necessary power is generated by the electromag-
netic waves of the emitter the radio receives. Davis is interested, here,
in the transition of physical to biological systems, and in the alterna-
tive knowledge continually generated by do-it-yourself practitioners as
a subversive counterpole to the profit-based entertainment electronics
industry, or even the commercial biotechnology sector. For, the trendy
field of synthetic biology, castigated by its critics as "extreme genetic
engineering," (Cf. ETC Group 2007) lures its talents in a pied piper-like
manner with its alleged open
source-, DIY- and hacking spirit.
Davis' "processing bodies" take on,
here, a socio-political and episte-
mological dimension, beyond their

10 The authors' laboratory at the University of Freiburg
assisted the artist beginning in 2009 with the completion of
the moss layer (Reski, Frank 2005, pp. 48–57).
11 The method of presentation bears strong resemblance
to the historical thought experiment of the brain-in-a-vat,
in which a dissected brain is kept alive in a fluid solution with
electrical impulses that appear to simulate a real environment
and a real body.

organic, however, abstract presence. While synthetic biology applies the principles of engineering to biology, Davis does the reverse by applying biological principles to those of electrical engineering, when growing an anachronistic radio circuit. Ironically, he contrasts the inflationary circuit metaphor and its logic of plannable engineering with the poetics of tinkering.

3 Joe Davis also frequently employs analytic media of biology in his artistic production to produce images, for example, DNA chips in a series of micro-representations he calls *DNAgraphies*. The series is dedicated, ironically, to a single visual reference in the history of painting — Gustav Courbets *L'Origine du monde* [Origin of the World] from 1866. The *DNAgraphies* constitute a subversive appropriation of media of biology associated with measurement, analysis and observation. In DNA chip technology, precisely defined single-stranded DNA fragments are deposited as probes on small glass or plastic plates. On these defined positions, they bind to likewise single-stranded complementary sequences in the substrate to be analyzed. The hybridized fragments, then, can be scanned as pixels on the array. Joe Davis makes use of DNA chips for iconic representation, whereby the DNA probes on glass serve as "photographic 'emulsion'" and "form latent images […] subsequently 'developed' with other DNA molecules, proteins, and precious metals (gold and silver), and in some cases, fluorescent markers" (Davis 2003, p. 63). It warrants noting that Davis himself calls attention, here, to his metaphorical use of the terms "emulsion" and "development" by putting them in scare quotes and emphasizing the change in media. Not only are "emulsion" and "development" biochemically indistinguishable, in this case, but "images created with DNA media are theoretically of much higher resolution than images created with conventional photographic media," because "DNA molecules are much smaller than the halide grains used in ordinary photography" (Davis 2003, p. 63). The aesthetic object "lives" through a combination of the iconic reference to painting in the bio-photographic medium. Davis allows nucleotides to metonymically embody the "origin of the world" and parallels the chemical structure of heredity with Gustave Courbet's painting *L'Origine du monde* — both have, after all, "spent most of [their] history hidden from view; waiting to be revealed" (ibid.). Davis plays, here, on the widely circulated anecdote that the painting *L'Origine du monde* was repeatedly concealed by its owners — the psychoanalyst Jacques Lacan was said to have hidden it behind a landscape painting by André Masson. The visual citation of

Courbet's painting, historically positioned in the period of Realism, contains, moreover, stylistic and media historical references. It places it historically in that epoch in which the now solidly entrenched photographic technology wielded considerable influence on the changing self-understanding of painting. Reference is made, here, not only to the intentionally naturalistic representation and the framing, presumably inspired by photography, that cuts out head, arms and lower leg and trains the gaze on the naked female genitalia, but to the fundamental principles of realism themselves. It is not only that Courbet, in the catalog to his anti-art establishment exhibition entitled *Pavillon du Réalisme,* calls for the production of "living art" (Courbet 1855).[12] He also demands that art derive its inspiration from everyday life rather than romantic ideals — a demand that Davis applies to the increasing influence of natural scientific knowledge on our everyday lives today, and to the necessity for artists to be versed in these fields of knowledge.

As a final example, Paul Vanouse employs media of biology in his performative gel electrophoresis installations to deconstruct and parody the metaphor of "genetic fingerprinting" (Cf. Hauser 2011). Gel electrophoresis is a technique for separating molecules commonly employed in fundamental research, in paternity tests and in forensic genetics. In this chromatographic process used for the representation of nucleic acid sequences, DNA molecules travel in an electrical field through a sequence-gel at various speeds depending on their size. The resulting bands create a readable distribution pattern. As the visual outcome of apparent mechanical objectivity, it is these abstract banding patterns that have become familiar to the public as "genetic fingerprints".[13] Vanouse demonstrates, in contrast, the technical constructedness of this biological identity card, putatively inscribed in each of our bodies by "mother nature" herself. His work attempts to *downgrade* the scientific authority of the "objective" DNA fingerprint to the status of a "subjective" portrait. Going against the popular belief that the process yields immutable properties directly as the body's imprint, Vanouse, in his *Latent Figure Protocol,* subverts the logics of DNA fingerprinting. While the viewer of the installation can observe the visual appearance of the bands in the *live* performance, the artist creates figurative images from known DNA instead of the customary abstract chromatograms from unknown DNA

12 Courbet speaks, here, of 'art vivant'.
13 Vanouse carefully examined the terminology choices of British scientist Alec Jeffrey, whom he depicts as an 'ad executive after a lucky advertising campaign' citing an anecdote in which Jeffrey says, 'If we had called this 'ideosyncratic Southern blot profiling' nobody would have taken a bit of notice. Call it 'DNA fingerprinting' and the penny dropped' (Cf. Vanouse 2011, p. 63).

samples, by combining various enzymes, primers and molecular probes. These images, it must be noted, are images made *out of DNA* and not images *of* DNA. As the process advances the iconic and symbolic motifs of these figurative images become slowly recognizable: *ID, 01*, the copyright symbol, the symbol of infinity, the pirate skull and bones, and the emblematic chicken and egg. Technically speaking, gel electrophoresis, as Hans-Jörg Rheinberger writes, constitutes a "form of indexicality [...] since, in this case, it is the actual parts of the sample that make up the chromatogram directly" (Rheinberger 2007, pp. 306–307). Vanouse, then, in his "counter laboratory," stages the material aspects of experimental production. With gel electrophoresis, Vanouse consciously chooses a process having technical analogies to photography and to the long history of the imprint as a supposedly authentic trace of the body in art history, back through to the *Vera icon.* He demonstrates that *media of biology,* that is, media of measurement and analysis, themselves contribute actively in the production of that which they pretend merely to mediate, while tempting to erase their medial trace in the process. For the production of evidence counts as particularly successful when it does not appear to be contaminated by its technical arrangement, but "when it is made to disappear in the object" (Rheinberger 2010, p. 10). Through this *presentation of production,* Vanouse thematizes a wide spread blindness to the medial, taking "recourse to materials being used or being produced in scientific working processes," as Hans-Jörg Rheinberger explains. He continues, "this is an ingenious — scientifically and artistically effective — way to keep the media of knowledge production in the game, in all their opacity, an antidote against the spontaneous tendency of the sciences to make them disappear behind the thick curtain of what scientific papers refer to as 'Materials & Methods'" (Rheinberger 2011, pp. 102–103).

It appears, then, that the interconnection of aesthetic and technical means into media composites in artistic strategies of this kind raises the question of their material and medial adequacy. In the context of biomediality, the question unfolds as a new variant of an old problem in art history — not only in the form of the classical *paragone* as a battle of artistic genres, but also as a fundamental problematic of the classical avant-garde of the late 19th and 20th centuries with its increasingly technologized aesthetic and social upheavals that legitimated themselves primarily through material-medial qualities. One of the main difficulties lies in the fact that the question of media adequacy of the object is tied

to the relationship between the modalities of its technical and creative production, on the one hand, and its rather media-unspecific and often trans-historical motifs and metaphors, on the other. Thereby, the inter-laced levels of reflection — object, metaphors, technology, epistemologi-cal context, the role of art, etc. — at times pertain to vastly different peri-ods. While the techno-sciences today have themselves become powerful producers of aestheticized images, this kind of artistic strategies call for an analysis that is not based primarily on imagery but on material media and epistemic connections. Phenomena that once assumed the form of artistic images are being translated, scattered and fragmented, here, into a variety of instances of mediality — they are not only means to an end but fully integrated elements of the aesthetic object. After the par-adigm shifts brought about by the linguistic, performative and pictorial turns, an epistemological turn emerges: Art here is no longer merely concerned with the aesthetic transposition of knowledge, but of know-ing and feeling how knowledge is produced.

References

Adorno, TW 1978, *Minima Moralia. Reflections from a Damaged Life*, translated by EFN Jephcott, Verso, London, New York.

Bolter, JD, Grusin, R 1999, *Remediation. Understanding New Media*, MIT Press, Cambridge.

Bredekamp, H 1992, "Der Mensch als zweiter Gott". Motive der Wiederkehr eines kunsttheoretischen Topos im Zeitalter der Bildsimulation', in KP Dencker (ed.), *Interface 1. Elektronische Medien und künstlerische Kreativität*, Interface 1, pp. 134–147.

Bredekamp, H 2007 (1993), *Antikensehnsucht und Maschinenglauben. Die Geschichte der Kunstkammer und die Zukunft der Kunstgeschichte*, Wagenbach, Berlin.

Catts, O 2008, 'Contribution to an Online Discussion', in S Anker, JD Talasek (ed): *Visual Culture and Bioscience. An Online Symposium*, Baltimore.

Courbet, G 1855, 'Le réalisme. Introduction', in *Du réalisme*, Paris.

Davis, J 2003, 'L'Origine du Monde', in J Hauser (ed.), *L'art biotech*, Filigranes Editions, Nantes/Trézélan.

Delfanti, A 2012, 'Tweaking Genes In Your Garage: Biohacking Between Activism And Entrepreneurship', in W Sütz, T Hug (eds), *Activist Media and Biopolitics. Critical Media Interventions in the Age of Biopower*, Innsbruck University Press, Innsbruck.

Dencker, KP (ed.) 1992, *Interface 1. Elektronische Medien und künstlerische Kreativität*, Interface, Hamburg, pp. 134–147.

ETC Group 2007, *Extreme Genetic Enginering. An Introduction to Synthetic Biology*, Online-Publikation, accessed 12 April 2016, www.etcgroup.org/files/publication/602/01/synbioreportweb.pdf

Fehrenbach, F 2005, 'Compositio corporum. Renaissance der Bio Art', in *Vorträge aus dem Warburg-Haus*, 9, Akademie Verlag, Berlin.

Fehrenbach, F 2012, 'Quasi animata forma. "Living Art" in the Early Modern Period', in M Wellmann (ed.), *BIOS—Concepts of Life in Contemporary Sculpture*, Berlin, pp. 30–39.

Hauser, J (ed.) 2011, Paul Vanouse. *Fingerprints... Index—Abdruck—Spur / Index –Imprint –Trace*, argobooks, Berlin.

Hauser, J 2013, *Biotechnologie als Medialität. Strategien Organischer Medienkunst*, Dissertation, to be published in 2016, Bochum.

Heider, F 2005 (1926), 'Ding und Medium', in *Symposion. Philosophische Zeitschrift für Forschung und Aussprache*, Vol. 1, newly published with original page numbering by Dirk Baecker, Berlin, pp. 109–157.

Karafyllis, NC 2003, *Biofakte. Versuch über den Menschen zwischen Artefakt und Lebewesen*, mentis, Paderborn.

Karafyllis, NC 2008, 'Endogenes Design und das zweite Hymen. Gewebe und Netzwerke als Modelle für Hybridität in Bioart und Lifesciences', in E Gaugele, P Eisele (eds), *TechnoNaturen. Design & Styles*, Schlebrügge, Vienna.

Kittler, F 1993, *Draculas Vermächtnis. Technische Schriften*, Reclam, Leipzig.

Landrain, T, Meyer, M, Perez, AM, Sussan, R (eds) 2013, 'Do-it-yourself biology: Challenges and Promises for an Open Science and Technology Movement', *in Systems and Synthetic Biology*, 7 (3).

Latour, B 1983, 'Give Me a Laboratory and I will Raise the World', in K Knorr-Cetina, M Mulkay (eds), *Science Observed: Perspectives on the Social Study of Science*, SAGE, London.

Miller, SL 1953, 'A Production of Amino Acids Under Possible Primitive Earth Conditions', in *Science*, 117 (3046).

Oparin, AI 1924, *The Origin of Life*, Moscow.

Pfisterer, U, Zimmermann, A 2005, 'Foreword', in U Pfisterer, A Zimmermann (eds), *Animationen/Transgressionen. Das Kunstwerk als Lebewesen*, Hamburger Forschungen zur Kunstgeschichte. Studien, Theorien, Quellen, 4, Akademie Verlag, Berlin, p. VII.

Porath, E 2008, 'Begriffsgeschichte des Mediums oder Mediengeschichte von Begriffen? Methodologische Überlegungen', in E Müller, F Schmieder (eds), *Begriffsgeschichte der Naturwissenschaften. Zur historischen und kulturellen Dimension naturwissenschaftlicher Konzepte*, de Gruyter, Berlin, p. 253–257.

Reichle, I 2005, *Kunst aus dem Labor. Zum Verhältnis von Kunst und Wissenschaft im Zeitalter der Technoscience*, Springer, Vienna, pp. 3–4.

Reski, R, Frank, W 2005, 'Moss (Physcomitrella patens) functional genomics — Gene discovery and tool development, with implications for crop plants and human health', in *Briefings in Functional Genomics and Proteomics*, 4 (1), pp. 48–57.

Rheinberger, H-J 1997, *Toward a History of Epistemic Things. Synthesizing Proteins in the Test Tube*, Stanford University Press, Stanford, pp. 2–3.

Rheinberger, H-J 2003, 'Präparate — "Bilder" ihrer selbst', in H Bredekamp, G Werner (eds), *Bildwelten des Wissens. Oberflächen der Theorie*, Kunsthistorisches Jahrbuch für Bildkritik, 1 (2), Akademie Verlag, Berlin, p. 10.

Rheinberger, H-J 2007, 'Spurenlesen im Experimentalsystem', in S Krämer, W Kogge, G Grube (eds), *Spur. Spurenlesen als Orientierungstechnik und Wissenskunst*, Suhrkamp, Frankfurt a. M., pp. 306–307.

Rheinberger, H-J 2011, 'Risking Reason: The Productive Tension of Art and Science in the Work of Paul Vanouse', in J Hauser (ed.), *Paul Vanouse. Fingerprints... Index—Abdruck—Spur / Index –Imprint –Trace*, argobooks, Berlin, pp. 102–103.

Rheinberger, H-J 2015, *Natur und Kultur im Spiegel des Wissens*, Universitäts Verlag Winter GmbH, Heidelberg, p. 34.

Root-Bernstein, R, Brown, A 2010, *unpublished project description*.

Schade, S 1999, 'Zur verdrängten Medialität der modernen und zeitgenössischen Kunst', in S Schade, GC Tholen (eds), *Konfigurationen. Zwischen Kunst und Medien*, Fink, Munich.

Senior, A 2008, 'In the Face of the Victim: Confronting the Other in the Tissue Culture and Art Project', in J Hauser (ed.), *sk-interfaces: Exploding Borders—Creating Membranes in Art, Technology and Society*, Liverpool University Press, Liverpool, pp. 76–82.

Snow, CP 1959, *The Two Cultures*, London.

Thacker, E 2004, *Biomedia*, University of Minnesota Press, Minneapolis.

Vanouse, P 2011, 'Counter Laboratories, Inverted Suspects and Latent Signs', in J Hauser (ed.), *Paul Vanouse. Fingerprints... Index—Abdruck—Spur / Index –Imprint –Trace*, argobooks, Berlin.

Waetzoldt, W 1905, *Das Kunstwerk als Organismus: Ein Aesthetisch-Biologischer Versuch*, Dürr, Leipzig.

Oliver "Olsen" Wolf is currently a PhD Student at the Queen Mary University of London. He studied at the ZHdK (2005) and was resident artist-in-lab at the Artificial Intelligence Lab (University of Zurich 2010). In 2007 he created a science-fiction group called *Sesselastronaut* to focus on how technical objects could become "antennas for the imagination" in two ways. One way is the futuristic, visionary, and euphoric qualities of techné, (automatons, cosmonautics and cognitive science research). The other way it is through the construction of sculptures, objects, and installations that play with an imaginary surplus: realities and fictions produced by the affective qualities of technological objects. These experiences add to the idea of technology as the effort to save effort or to facilitate life or foster Daseins-comfort. For example, objects like a robotic hairbrush that can witness a sunrise *(Uruca Caliandrum* 2010) or a collected set of definitions of technical objects that can be found in encyclopedia entries from all over the globe about UFOs *(Definitions of the Undefined)*. Therefore, his research is about ways to create an opening so we can look at technological objects as more than inanimate collections of atoms and molecules.

The Artificial Intelligence Laboratory (AI Lab), Department of Informatics, University of Zurich.

The main goal of the Artificial Intelligence Lab researchers was to elucidate intelligence, one of the oldest and most mysterious conundrums of mankind! We explored the notions of *embodiment* and *autonomy,* factors that have dramatic implications for our understanding of intelligence. We also try to understand behaviour and the relation between brain processes, body (morphology and materials) and environment; insights that might contradict classical Cartesian positions. Many of our researchers are fascinated with how morphological and material characteristics of an organism might take over a large part of its functionality and to develop a synthetic methodology — through the process of "understanding by building". This process requires the marrying of engineering and science with evolutionary design- Bionics and bio-robotics, who try to learn from Nature.

Researchers involved in the Residency: Prof. Dr. Rolf Pfeifer, Dr. Max Lungarella, Postdoctoral Researcher, Dr. Daniel Bisig, Postdoctoral Researcher, Naveen Kuppuswamy, PhD Student, Shuhei Miyashita, PhD Student.

Hovering

Telemonies — Walking Through the Eigenplot

The Bigger the Apparent "Distance" between the Disciplines, the Greater the Surprises

Telemonies —Walking Through the Eigenplot

In my original proposal I wanted to study the dynamics of robots within an environment created by itself through sonification: a system equipped with acousthesia or what I call an "aural sensitivity" that enables the robots to interact with and navigate by sound within their environment. This very sound is being created by the noise of their own movements. The result causes self-organized behavioural patterns and slowly, various compositions of feedback noises and movements emerge.

During my stay here the original project slightly changed. On the one hand it got more complex because I applied a lot of principles that I had learned here, on the other hand it got easier for me to communicate by learning a new vocabulary and different mechanisms. Finally it evolved into a project, where I was building a complex environment with a simple structure. I developed an "air table", where different robotic modules can float. These robots create sound in relation to each other, which are just basic feedback noises caused by microphones and loudspeakers on the modules.

Based on comments by Rolf Pfeifer and the Artificial Intelligence lab researchers as well as on comments from the DVD documentation by Shuhei Miyashita and Naveen Kuppuswamy

Rolf Pfeifer, The Artificial Intelligence Laboratory (AI Lab), Department of Informatics, University of Zurich

The Bigger the Apparent "Distance" between the Disciplines, the Greater the Surprises

In relation to the interest by the resident artist Oli "Olsen", the Artificial Intelligence Lab has been exploring the concept of "embodiment". We often ask: What is the role of the body in the development of intelligent behavior? And in order to answer that, we study how embodied systems behave in

□ 1 Models leading to the stretched membrane module
□ 2 Air table designed to float the objects or modules

The idea is that they show what I would call "phonotechtic" behaviour, which is to follow the sound that is created by themselves. So you end up having a kind of sensory motoric coupling by the movement towards each other. This is the local behaviour on each module. And globally the whole thing should end up in an aleatoric composition of feedback noises.

I have always been interested in the fact that technology is actually an antenna for our imagination. I'm attracted by apparatuses that kind of "turn themselves on" and are therefore

trapped within their own functionality (like vacuum cleaners that can clean their own dirt). I wanted to explore the "imaginary surplus" that emerges from the apparatuses and our innate attraction to these "lifelike" processes, what the Polish science fiction novelist Stanislaw Lem calls "The Species Reflex".[1] For example, in Switzerland there is a robotic sound installation that creates an automatic replacement bus service (2009) when the train service has broken down. It measures the rail service, and a robot equipped with a microphone and a radio transmitter, perpetually generates feedback noises of various kinds, depending on its position and movement relative to signals that the radios receives on the transmitter's frequency. This robot fulfils its own main function for its own sake, evolving the dynamics needed to oscillate between utilitarian and aesthetic demands. □1/2/3

Telemonies — Walking through the Eigenplot is a project similar to the accompanying

1 See Lem, S 1961, *Solaris*, first English language edition published by MON, Walker (US) 1970.

□ 3 Olivers Wolfs work station at the AI lab.

□ 4 Collaborator: Japanese engineer Shuhei Miyashita sits on the floor to contemplate AI from a different perspective

measures in this rail replacement bus service but much more dynamic. In this project I wanted to explore the dynamics of a system, the improvisation of machines and therefore need to construct robots within an environment created through sound. Over the course of the residency, the initial aims changed only slightly but the method to build it went through many transformations. Most of them were the result of various discussions with other people from the lab. For example, to achieve the desired locomotion of the robots, they went through a whole "evolutionary" process. The design went through various iterations constantly improving the behaviour of the robots based on trying and evaluating many different materials and forms.

Before my residency, I always associated artificial intelligence with the words by Scottish poet, journalist, and songwriter Charles Mackey: "The immense variety, that neither are nor can be, but can be thought and believed"[2]. When I came to the lab I hoped to learn more about how the scientists critique Artificial Intelligence, while I use the same time and infrastructure to improve my technological skills in hardware and software. Furthermore, I wanted to get an insight into scientific methods that they use to generate an outcome and how to approach and deal with problems.

My residency started in March 2010 with a very warm welcome by around fifteen researchers. I was given a desk in between them and I made little detours to sneak into the various projects happening there.□ 3/4 Each researcher was trained to give a quick elevator pitch on their project, so soon I had a sense of the variety of projects and how they're presented, but their curiosity towards me seem to be bridled at this stage. In the fourth week after my arrival at the lab I was given the chance to give a talk, accompanied by a presentation showing some of my works and practice, in the framework of the weekly meetings happening there. I showed that my

2 Mackay, C 1992, *Zeichen und Wunder: Aus den Annalen des Wahns*, Eichborn, Frankfurt am Main.

nature. This we call biologically inspired robotics. The main aim of the resident artist-in-lab, Oli "Olsen", was to construct a group of robots sliding on an air table. The robots are circular, equipped with a ring of permanent magnets, an elastic membrane that can be deformed via an electrical motor, which enables the robots to change the direction of movement affected by how air from the table is deflected in different ways. The inner edge of the table is also equipped with magnets. The robots can attach and detach to the edge of the table and to each other. When the robots attach or detach dynamically, they start to self-organize, slowly creating new patterns. In addition there are LEDs and sound generators on the robots. This led to an appealing kind of living theatre, one that tracked the constantly changing movements. This project

Oliver "Olsen" Wolf

☐ 5 The movement of the caterpillar: Oliver Wolfs inspiration for the movement of the hairbrush.
☐ 6 Oliver Wolf's solar-powered hairbrush-robot, that walks towards the sun to be recharged

The Artificial Intelligence Laboratory

artistic practice was certainly not about how to take a photo or layout a poster! After this talk my status among the researchers changed. I got some very nice feedback and I started having discussions with various people. Initially the talks were about the purpose of art and science, which kept going on long tables, during lunchtime in the Mensa and wich eventually led to technical topics like space exploration and robotic movement. I also visited lectures offered by the Department of Informatics. One of them was a lecture by Professor Dr. Ruedi Füchslin on "artificial life" that covered topics like natural and artificial complexity, complex and dynamical systems, swarms, collective behaviour and living technologies. It gave me many insights on the range and complexity of the field of robotics. In another inspirational one about "bio-inspired robotics" by Dr. Lijin Aryananda, a theoretical as well as practical insight into ingenious forms and mechanisms found in nature was articulated. In this lecture I especially liked the balance between theory and hands-on work, so with the help of Lijin and her assistants my knowledge on hardware and programming increased extensively by attending a set of her classes. In one artistic offspring from this class, I created a robotic hairbrush entitled *Uruca Caliandrum*. □ 5/6

Although the purpose was unclear—I promoted it as "sense-fiction". Actually the purpose of this hairbrush robot still remains unresolved to this day, but because of its creepy and eerie movements it is considered a very attractive robot by most people in the lab.

Slowly, a tighter network evolved around me with other researchers like Shuhei Miyashita and Naveen Kuppuswamy. My connection to Shuhei was mainly due to his work on self-assembly and the effects of morphology. With Naveen, it was his interest in sensory-motor control, soft robots & movement control strategies for complex/compliant robots and his dedication to open-source software.

I was very inspired by my regular discussions with Shuhei—he has a very nice way of seeing things and I learned how to was demonstrated to the public in various exhibitions and to other researchers here at our lab.

Shuhei Miyashita: Phd Student

I talked a lot to Oli about "life forms". My interest is to find out what "living systems" are. In other words, I am asking: What is life? In order to resolve the mystery of life, I am building a certain kind of molecular robots that can self-assemble and thus behave like a living organism. If you take a look at biology, you realize that there is no "central control", there is no global observer in the system. But there are large amounts of molecules involved that interact with each other and synthesize a symphony to achieve living activities. What we have tried recently, was to see whether we can realize enzyme activity, not with molecules but with magnets.

communicate clearly. He immediately understood what I was talking about and helped me find the focus of my project. He gave me a couple of interesting and inspiring papers on self-assembly and complex systems. Furthermore he helped me to clarify some of the vocabulary, which not only helped me to get a better idea of what I was doing but also helped to present the project to the regular incoming visitors of the AI Lab. Together with Shuhei I also sketched possible scenarios and sorted out desirable procedures for further development of the robots, some of them based on the readings provided and others based on the outcome of small experiments we conducted together. Shuhei was attracted by the air-table I built and told me that if I had brought it in earlier he most probably would have used it for some of his own experiments, because his test-bed used water as the medium which made the electrical robots much more vulnerable.

The exchange with Naveen was on a smaller scale, focusing on the internal control and behaviour of the robot, particularly about the use of different actuators and sensors and how to make the control more efficient by improvement of the software and different hardware, for example using different mathematical equations. □7 On the other hand, Naveen also made me aware that the tools and theories for understanding intelligence — as the theory of embodiment — can itself be used as a medium for creating art. In traditional engineering many of the physical phenomena such as compliance, turbulence, friction or viscosity were viewed as a nuisance to be minimized. The principle of embodiment looks at them as properties inherent to the systems that can be suitably harnessed the way I'm trying to exploit them in my design. Naveen assisted me for example, in the evaluation of different linear actuators I obtained. The outcome of this was documented and spread amongst the lab, which was highly appreciated. He advised me to start using a membrane to activate my modules, which I ended up doing.

Naveen also gave me an introduction on 3D software to prototype the frame of my

□7 Bio-mimicry: The octopus and the machine developed by Naveen Kuppuswamy to grab objects underwater.

And we actually succeeded in resembling enzyme behaviour using magnets! If you take a look at the energy consumption it's exactly the same, whether it is magnets or molecules that cause enzyme reactions.

Naveen Kuppuswamy: Phd Student

I was also actively involved in Olis development, as I conducted projects like "Motor Primitive inspired Reduced Order Control of Redundant

□ 8 3D print-module with membrane and electronics
□ 9 Sketch of how the membrane module works

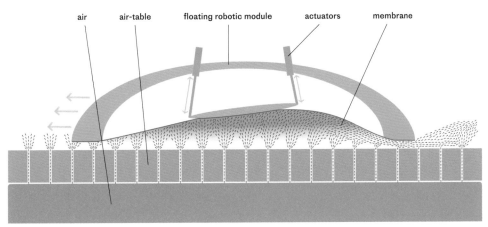

air air-table floating robotic module actuators membrane

Robots" and the "Curvature Dynamic Model for Continuum Robot arms". I talked to Oli extensively about these projects. The first time we worked together, I helped Oli with the mechanical design of a robot, which moves around inside a hairbrush, causing strange noises and movements. He called

robots. The cornucopia of the 3D printer was most probably one of the busiest machines within the lab.□8

Because Naveen's work required a lot of analysis about tracking an object's movement, he really helped me to set up my first "real" scientific experiment. I wanted to evaluate the behaviour of many small robots by tracking their movements and later plotting their positions and inter-distances over time.

Once Dr. Max Lungarella, an electrical and software engineer and specialist in research and development in robotics, was working in the office next to me and swung by once in a while to give me feedback on the work. His comment was that aside from its attraction, it really illustrates the "attractive" ideas around embodied artificial intelligence that the lab is pursuing. Although I never really tried to prove the robustness of this comment, the feedback confirmed a statement by my favourite film director, Sergei Eisenstein[3]: "Science has its ions, electrons, and neurons. So, art must have its attractions."[4] Over time it just seemed to get easier and easier to communicate with everyone.

In general I had a lot of freedom at the AI Lab, I had access to almost all the machines and infrastructure. The people and facilities at the lab not only gave me very good insight into the current state of the art in robotics, the passing of these 9 months also made me realize that my technical knowledge increased so as to make use of the infrastructure. At the end I was able to do my own 3D printing, to develop my own programming skills and furthermore improve my knowledge of electronic components in particular sensors and actuators and their wiring into electronic circuits.

In my projects, I learned how to examine the relevant physical (morphological/material) properties in my system. For example the role

3 Sergei Eisenstein was a Latvian Film Director and pioneer in the use of montage: a specific process of film editing, accessed 1 March 2016 en.wikipedia.org/wiki/Sergei_Eisenstein#Film_theorist.
4 Cited in Zielinski, S 2008, *Deep Time of the Media: Toward an Archaeology of Hearing and Seeing by Technical Means*, MIT Press, Cambridge.

it the "hairbrush-bot". My own general interest is to find out how a creature can learn to control itself, given the fact that it has a very complex body. How does one learn how to control your movements? Humans have articulated limbs with bones, so it is relatively simple for me to imagine that setting muscles at certain values gives me nice, clean angles when flexing my arm. But how do you control your angles when you are completely soft? You have no angles! This is why I am focusing on the octopus in my research. Oli was interested in the control architecture for redundant (and compliant) robots based on reduced-dimensional control. My research is inspired by neuroscientific theories of biological motor primitives and spinal force fields. The octopus's self-learning architecture is tightly coupled to its sensors, actuators and

1 "Tribolons" are self-assembling robots of about 3–4 cm in diameter.

played by these properties in the dynamical behaviour of my system helps me to identify the intrinsic behaviour. Actuating the system at some minor point (i.e. changing the properties of one single agent) results in different behaviour of the robots. As mentioned above, my project went through a couple of iterative processes for improvements. As there was a budget to spend for material I could try and share different modalities. Although in the encountered scientific experiments the budget is on another level, in contrast the artistic approach is quite low-cost. Although both share this iterative process, driven by the respective imagination and vision to produce an outcome. So as a conclusion, I greatly benefited from the synergy of this group here at the AI Lab (based on the fact that curiosity is not killed by the cat nor by robots), its wonderful heterogenity, and the empathy of the people. I left thinking that I have an adequate base to further explore more parts of the prototypes of the Teleonomies modules, as the next step here is to approach the field of sound processing.

□ 12 Rolf Pfeifer, Head of the AI LAB, explaining an AI experiment

the dynamics of its body. The aim was then to simplify the control problem of how an octopus arm reaches out and holds onto things for support. I work with a replica of an octopus's arm made of silicon, which is chosen specifically to be as similar as possible to a natural one. With this I built a robot that is a reduced order model of the behaviour using flexure (curvature), inspired by the reduced dimensionality in the peripheral motor system of an octopus. When I move the silicon arm in the air it has this weird shape and quite uncoordinated behaviour. But the moment I put it in water, it starts to look completely different. One of the simplest reasons for this is that it's neutrally buoyant, meaning that it's basically almost weightless in water. One of the key aspects we study in the project is that for a soft body, patterns are enough to make it react. The arm is oblivious to the shape

of objects—any object I put into its way in the water tank, it is able to grab just fine.

As you can see from the above reports, the interactions between our researchers and Oli have been extremely beneficial for both sides. Oli was very ingenious! He actually could build things and he had ideas about what he could do and then he would go to the researchers and ask: Well, how can I build this? He even contacted companies for hearing aids, because he wanted to produce sounds or he wanted the modules to understand sound. So I think he was an unbelievably lively source of ideas. And I think he could only realize a fraction of them, but I am sure he's not going to run out of ideas. The outcome is absolutely fantastic for such a short period of time.

It was a pleasure to have Oli around and I think he had a very positive influence on the scientific creativity of the people in the laboratory. There were no particular difficulties in communication since we have had many artists in our lab in the past, and Oliver is already very experienced with electronics and mechanics. He was familiar with the scientists' and engineers' perspective and vocabulary. He very quickly familiarized himself with our research projects of which self-assembling "Tribolons"[1] were especially close to his own interests. Because Oliver always had great ideas, the labbers were more than happy to help with technical details. Because artists typically have little funding, they often have to come up with novel, "cheap" solutions, which is 100% in line with our philosophy of "cheap design" of the morphological, material, and environmental characteristics. Our interaction was always one of mutual respect and inspiring, though it is hard to pin down exactly what scientific insights were gained from his project. We clearly recognized that artists are very creative and we also believe that

the artists we had in our laboratory saw that engineers are equally creative, just in a different domain. We have always been working in interdisciplinary teams. The point is that unexpected ideas often emerge when dealing with disciplines that are seemingly entirely disjoint from the current project. Perhaps we might hypothesize: the bigger the apparent "distance", the greater the surprises (but also, the more difficult to communicate).

This exchange was always inspiring and fun. I liked those Teleonomies modules very much but to turn this research into a scientific paper may be difficult and perhaps besides the point. So, in that sense, there may not be a clear sense of direct reciprocity but the mutual inspiration will transpire in future endeavours on both sides. Still, we have to be aware of the fact that scientists and artists have completely different goals, which requires different types of knowledge and different mind-sets. Working together with artists in an artistic project is typically fun and pleasant for scientists, because many constraints such as systematics, scientific rigor and the need to publish, simply do not exist. Moreover, we still have contact with Oliver—he has made friends and colleagues here for life.

However, similarly to visiting scientists, the minimum duration should be one year: research and development as well as artistic creation always take time—much more than you anticipate. So having longer stays would definitely be an improvement for any artist-in-residence program.

Dieter Mersch is Professor for Aesthetics and since 2013 director of the Institute for Critical Theory at the Zurich University of the Arts. He studied mathematics and philosophy at the Universities of Cologne and Bochum and then philosophy at the Technical University Darmstadt. From 2004 to 2013 he was the Chair for Media-theory and Media Studies at the University of Potsdam and from 2010 to 2014 he was also director of the DFG (The German Research Foundation) Training Centre *Visibility and Visualisation*. Hybrid Forms of Pictorial Knowledge. His main areas of interests are Aesthetics and Art Theory, Picture-theory, Media-Philosophy, Semiotics, Language-Theory and Communication. He published several books, such as *Introduction to Umberto Eco* (Hamburg 1993, in German: Einführung zu Umberto Eco); *What shows itself. On Materiality, Presence, and Event* (Munich 2002, in German: Was sich zeigt. Materialität, Präsenz, Ereignis); *Event and Aura. Investigations on Aesthetics of Performativity* (Frankfurt/M 2002, in German: Ereignis und Aura. Untersuchungen zu einer Ästhetik des Performativen); *Introduction to Media-Theory* (Hamburg 2006, in German: Medientheorien zur Einführung), *Post-Hermeneutics* (Berlin 2010, in German: Posthermeneutik), *Ordo ab chao/Order from Noise* (Berlin/Zurich 2013), and *Epistemologies of Aesthetics* (Berlin/Zurich 2015).

Aesthetic Difference: On the "Wisdom" of the Arts

What sort of knowledge is transmitted through the arts? How does art produce knowledge, if it does so at all? This essay seeks to address these questions. No doubt, all the answers we attempt to give to these questions are bound to be insufficient, which is partially due to the simple fact that we try to formulate them in a non-artistic medium of academic discourse. For its part, however, this fact confronts us with questions about the relation between artistic practice and aesthetic theory, between the "labor" of the aesthetic and the philosophical reflection.

Asking the most general question in this context — how does art think? — is certainly not the same as asking: How does the artist think or what does she think about during her erratic journey of her creative processes? Rather, the question is: What does the specific form, the mediality of aesthetic knowledge consist in? Put differently: How does a work of art formulate its 'arguments'? What characterizes its specific mode of thought in contrast to, say, that of the sciences or the discursive practice of philosophical debate? These questions only make sense if we keep ourselves from the prejudice of attributing all thought to something that thinks, a subject of thought. We need only recall here that the so-called 'linguistic turn' marked the transition away from philosophy's traditional concern with the realm of thought and its foundation in consciousness and towards its interest in the mediality of thought and language and their grammatical and rhetorical underpinnings. Thus, in one of the founding documents of the "turn", the *Tractatus Logico-philosophicus*, Ludwig Wittgenstein did not analyze the "thought" or the "idea" that had been two of philosophy's core concepts up through German Idealism, but rather the logic of the "expression of thoughts" (Wittgenstein 2015, p. 9). For both Wittgenstein and other thinkers of the linguistic turn, the "thinking thing", the subject "that has thoughts", as G.W.F. Hegel put it, no longer plays a crucial role. Rather, decisive are the forms of speech and the structure of their articulation, or, put succinctly, the medium and its forms of praxis, their respective possibilities and limits.

Philosophy has often traced our capacity to think back to our capacity for language. We think because we can speak, because language allows us to follow, formulate, and justify lines of argumentation, posit assertions, and give force — however fragile or debatable — to our convictions. For this reason, the philosophy of the last 300 years has, like Descartes, attributed our ability to think to the self-certain "I" and its ability to express itself in concepts and statements. Thinking is,

above all else, an activity of the mind and its manifestation in language, and is expressed through propositions that can take the form of statements, questions, claims, guesses, the construction of models and metaphors, as well as through fictionalization, narration, and the anticipatory hypotheses of the "as if", whose primary form is the conditional. At the center of all of these forms of expression is the little grammatical particle "as". Something is determined to be "as something else", is narrated "as something", is understood "as something", so that the "as-function" as modal conjunction forms the nucleus of all signification. It is used to produce sense in language. "A thought is a proposition with a sense" writes Wittgenstein (Ibid., p. 31). Meaning is bound to its structure. In propositions, we posit thoughts, interpret them, examine them, weigh them, negate them, or judge them to be "true", "correct", or "false". Further, the copula "is" sits at the core of all statements and judgements. Something *is* something else. For instance, the astronomer might say that the planet Jupiter is a gas giant, and Sigmund Freud might have said that the psyche is repressed drive. Knowledge — that is, the formulation of a conviction — is articulated in these statements. The claim that *something is something else* might also be more precisely understood or expressed with the help of the formulation *"something as something else".* In short, the as-function at the core of signification and the is-structure at the center of the proposition reveal themselves to be equivalents.

From this perspective, there is no thinking, meaning, or knowledge without the medium of their expression: language. In particular, these things would not exist without the functions of is-statements and as-statements, the primary functions of all argumentation, reasoning, and refutation, or, indeed, of the expression of knowledge itself. From the same point of view, however, one cannot say that art thinks, because the work of art is not articulated in the form of the "is" — at least not necessarily and not in those works where perception is privileged over symbolism. Nor is it articulated in the form of the "as", which remains indeterminate and ambiguous to the senses. So what can it possibly mean when we say that art thinks, that thoughts or meanings are "expressed" in the media of art? Or, in other word, what does it mean when we say that there is a non-linguistic form of knowledge and that the work of art can be understood as a non-discursive mode of "argumentation"?

Let us consider an example. Art puts forth its "arguments" through, what I call "singular paradigms" (see Mersch 2014). They present themselves in the mode of examples. And just the same, only examples can help us grasp the nuances of aesthetic thought (see Schaub 2010). The example that serves as our point of departure is a classic work: Pablo Picasso's 1942 montage *Tête de taureau.* Picasso put an old bicycle seat and some handlebars together in such a way as to make them look like something completely different, namely, a cattle skull. The sculpture's force is derived from its simplicity. At the same time, it exemplifies on multiple levels what I would like to call the "aesthetic episteme", the specific form of knowledge transmitted by the aesthetic and the artistic (see Mersch 2014b).[1] Picasso's unprecedented combination of two everyday objects strips them of their function and thus provokes an alternate mode of seeing, insofar as it allows something to appear as something other. It does so by bringing something new to the sober composition that is not contained in the individual objects themselves. And in doing so, it turns the montage into a complex allegory. One might be tempted to say that the act of combining the objects is analogous to the "is" or "as"-functions of language: a set of handlebars and a bicycle seat are a cow skull. Is this translation into language sufficient? Does it say everything about the work? The proposition does not show how both are combined with one another, nor does it say anything about their spatial arrangement. Beyond that, if one simply wanted to construct an allegory, combining any old set of handlebars with any old bicycle seat would have been sufficient, a fact readily apparent in the many imitations of Picasso's work. But it is the found objects themselves that really make the work, objects that draw much of their force from the very contingency of their discovery. It is the find of *this* specific seat and *this* specific set of handlebars with their wear and tear that allow *this* unique appearance with this particular symbolism to transcend mere formal allegory. And only through these singular objects in their very specificity does the work give us a glimpse of the specter of death and mortality.

We thus have an "as" that acquires its particularity through a "through". In turn, we might define this "through" as the particular composition of the "as".[2] The singularity of this "as" and its composition

1 We must draw a distinction between art and aesthetics. Aesthetics deals with everyday practices of composition, design, and presentation that don't necessarily qualify as 'art'. What distinguishes art from aesthetic practices and makes it art is a specific mode of sensory reflexivity. I will return to this point later. See also Mersch, D 2014b, 'Kritik der Kunstphilosophie. Kleine Epistemologie künstlerischer Praxis', in V Weibel, KP Liessmann (eds), *Es gibt Kunstwerke. Wie sind sie möglich?*, Wilhelm Fink, München, pp. 55–82.

can only be perceived. Thus, every detail becomes significant, and it is this meticulous treatment of detail that makes the work's craftsmanship compelling and effective. Marcel Duchamp called these minute details that are only accessible to perception inframincen: the barely noticeable, inconspicuous elements whose perception requires a degree of attention that must be able to uncover the subtlest properties of the object. Thus, the quality of the leather and its wear and tear, its coloration, the rust on the handlebars, their exposure to the weather, the nakedness of the objects' raw form, the right-angle joining the two objects, their placement on the wall, etc. Every detail, no matter how unassuming, plays a role, shows itself with the other elements, "speaks". Even the bronze that completes the work shows something of that specific quality of the found object. The work and its materials bring together the oldest — the origins of European culture in the worship of the Sacred Bull — and the newest — the ruins of this culture in the wake of the two World Wars. Even despite the noble bronze, Picasso's work reveals this culture for what it was at that time: junk. It is no matter of coincidence that the work was produced in the middle of the Second World War, amidst the cultural break that went along with it: Europe's catastrophe. The cow skull is emblematic of this catastrophe. The central figure associated with the name of Europe, the classic mythological symbol of all Mediterranean cultures is the sanctified animal of the cults of *Apis, Baal, and Taurus*, who presided over the festivities of the earliest cities and thus came to represent springtime in the Babylonian zodiac. The animal's extraordinary significance also seems to show itself in the earliest forms of the first letter of the alphabet, "aleph" or "alpha", which were both originally written as a triangle standing on its point, a form preserved by our A only if one turns it upside down. It appears again, this time transformed into an icon, at the beginnings of European science in the "tetractys" of the Pythagoreans, as well as in alchemy in the mystic Y of the triadic substances *(tria prima)*, the supposed origin and destiny of "everything". Finally, it returns in the triadic form of the "first", the principle of the holy trinity. Picasso's version is composed of old scrap objects cast in durable material that bears, and even fixes, the mark of devastation.

2 The duplicity of the prepositions 'as' and 'through' forms the core of the medial as performance: When something acquires its form *as* something else *through* something else, the 'as' at once acquires medial form, a point formulated succinctly in Friedrich Nietzsche's famous statement: "Our writing tools are also working on our thoughts". Quoted in: Kittler, F 1990, *Gramophone, Film, Typewriter*, trans. G Winthrop-Young and M Wutz, Stanford University Press, Stanford, p. 200. See Nietzsche, F 1981, 'Letter to Peter Gast (Heinrich Köselitz), Feb. 1882' in G Colli, M Montinari (eds), *Briefwechsel: Kritische Gesamtausgabe*, 3.1, De Gruyter, Berlin, p. 172. See also Mersch, D 2010, 'Meta / Dia. Zwei unterschiedliche Zugänge zum Medialen', in *Zeitschrift für Medien- und Kulturforschung*, 2 (2010), pp. 185–208; idem, 'Wozu Medienphilosophie? Eine programmatische Einleitung', in *Jahrbuch Medienphilosophie*, 1 (2015), pp. 13–48.

For sure, all of these considerations play out on the level of the work's configuration, on the level of the origins of its symbolism. And yet, the montage of the waste forms a full circle that not only encompasses life and death, but also the entire cycle of occidental culture. Thus, time and its historicity are unavoidably congealed in the object. Whether or not it was intended, the epoch and its disasters are sedimented in every fiber of Picasso's found objects. And it is precisely thus that the 'thought' embodied in them escapes language. The way they are put together, their "com-position", their simple gesture make an exhaustive discursive explanation of the work impossible. And yet, the composition makes a "thought" perceptible. It is the immediate manifestation of an "argument", if we understand the word in its various senses at once as *argumentum,* a minor drama, and embodiment of a showing and a self-revealing. What's more, the act of bringing together a bicycle seat and handlebars recalls Lautréamont's statement about the "accidental encounter" of "a sewing machine and an umbrella" on a "dissecting table", two objects whose shock-like conjuncture triggers a literal "re-flection", not merely a reflex, but a reversal or a "surreal" effect. Similarly, René Magritte writes in his collection of image-text aphorisms *Les mots et les images:* "An object encounters *[rencontre]* its image, an object encounters *[rencontre]* its name. It comes to pass that the image and the name of the object encounter one another *[se rencontre]*" (Magritte 1979, pp. 60–61). Picasso's piece is a confrontation without precedent, and the relations of its elements to one another are without hierarchy. It thus has a certain similarity with the "arbitrariness" described by Ferdinand de Saussure, its elements connected haphazardly in the sense of the *arbitrarius,* a manifestation without "motivation". And yet, its effects have to be adequately "read": Picasso's *Bull's Head* contains an entire encyclopedia of associations, images, and symbols. The knowledge that it brings forth is thus not a primary function of the aesthetic event, but a secondary effect of the complex interpretive work spurred on by a feeling of uncanniness and terror.

Cognition and Reflexivity

One might conceive of this encounter, this "conjuncture" and the relations that it brings into being as the special accomplishment of a mode of artistic production that has to be interpreted on the basis of its production and the practices bound up with it, and not on the basis of the artist's intention, "genius", or authority. No doubt, intention and authority are of

marginal significance for the interpretation of this type of artistic production, because it is irrelevant whether or not the relations contained in the work were actively produced or passively "came to be". Adopted from branches of aesthetics that lay particular weight on artistic production, this perspective is no doubt indispensable if we intend to analyze the artistic *epistēmē* as the product of a practice or "artistic act". However, the aesthetics of artistic production has a reputation for privileging the subject, reducing artistic invention to the artist's imagination and eccentric creative gifts, and thus of reinstating the 19th century cult of the genius. Just the same, it might appear as if we wanted to attribute the symbolic and performative "force" of Picasso's work to his unique act, an act that can, so the story goes, have its origins in nothing other than in the mind of the artist. In this vein, the interpretation of the work would have an equally important status. And similar to the artist's creative gesture, the labor of interpretation and its endless play of meanings also takes place in the mind of the recipient. According to this line of thought, knowledge is produced through a double process of symbolization that relies on the participation of both the artist-author and his recipients. It follows that, in this reading, both are conceived of as acting with 'ingenuity' and 'intelligence' and thus as thinking agents.

Rather than take this route, we have opted to concentrate on the practice of combination itself. However ingeniously artist and recipient might act, it is sufficient to begin with their practices and to analyze *what* these practices do and *how* they do it. Of course Picasso's work is a symbolic act. The act of symbolization has more or less been the standard form of artistic production during the entire era between the early modern period and modernity, and Picasso's piece is no exception here, insofar as the representation of something (bicycle seat and handlebars) as something (cow skull) stands in the foreground and functions as the primary means of artistic expression. The work's aesthetic argumentation is accomplished through a relation that has the end of making *something else* visible, namely a symbol. However, the decisive factor is not the unique "find" that defines the work, the combination of two objects without precedent, nor is it the fact that its symbolic content is produced *through* a surplus of associations. Decisive is the work's reflexive dimension, which works parallel to its symbolic dimension. The avant-gardes of the 20th century made this self-reflexive dimension of the artwork into a key element of their artistic productions: the reflexivity of the material, the choice of artistic media, the way they are placed together such

that the techniques of montage and the fall of the dice of chance play an equally important role, the 'new' creative principle of letting found objects fall into place. Thus, the work not only has a symbolic dimension, which, in line with the very definition of allegory, "reveals something different". It also makes a statement about itself. That which it "gathers up" and through which it attains its inspiration, that which, in the words of Theodor W. Adorno, makes up its "enigmaticalness" (Adorno 2002, p. 120), the secret of the way it joins its elements in a time that is out of joint, all these things taken together make a statement about the possibility of art in the age of its destruction.

Picasso's work thus contains two moments of knowledge: a "statement" made by the very medium and material of the found object, and a statement about the act of enunciation, about the artistic form of articulation itself and the shape it takes in the object. With a bit of hyperbole, one could almost say that this knowledge is a knowledge generated by art with art through art, that it is art's way of analyzing itself. More than an analysis of something, this self-analysis thematizes art's own mediality. And more than anything else, it is precisely this sort of reflexivity that distinguishes art from non-art. It might be the most significant aspect of the arts' capacity to bring forth knowledge, of their particular form of "wisdom" that separates them from all other modes of generating knowledge.

The Conjunctionality of the Aesthetic "Proposition"

So what sort of knowledge is produced by the aesthetic? And anyways, wouldn't it be more precise to formulate this knowledge in language, in a discourse on the *Tête de taureau?* And if this were the case, wouldn't that imply that art is a form of conjecture or experience whose indirect mode of expression remains ambiguous and whose tendency towards devolving into an endless series of interpretations remains inferior to the clarity of scientific propositions? But if one considers Picasso's found object montage as a "proposition" in itself and compares it with the discursive propositions that we needed to approach it and describe it, then it becomes readily apparent that the discursive mode by no means has the upper hand here when it comes to simplicity. Rather, it is precisely the "force" of the sculpture that reveals itself to be the distinguishing factor. As with Picasso's piece, artistic works do not express the "as" of their signification through a judgment that says things are this or that, nor do they do so by listing off a series of attributes. The "is" is not the dominant factor

in artistic predication. Art deploys other means. Metaphorically speaking, the aesthetic "proposition" makes a leap. *It leaps through its specific mode of combination.* The combinatio is a "putting together". It combines at least two elements that were not connected with one another beforehand. Instead of being based on the copula, the *combinatio* is founded in the "and", in addition or in conjunction, which has the particular property of simultaneously connecting and separating. Hence, both the separation of elements and their connections are always visible side-by-side in works of art, precisely because they operate in the aesthetic, in the realm of perception. Whether it be foreground or background, temporal succession or spatial coordination, the work of art does not permit any hierarchization of its elements. This is why the 'artistic proposition' and the leap it makes are never unambiguous. They play with the openness and ambiguity of the conjunction in such a way that the connection of elements produces an irresolvable tension. The simplicity of the artistic 'statement' and its "wit" in the form of "wittiness" or cleverness — understood in the 18th century as a significant aspect of the artist's *ingenium* — are definitive for the combination, the "cut" of the montage. Combination and montage are founded in the principles of continuity, contrast, and contradiction. And in contradistinction to the discursive *contraditio* and its logical consequences, the montage's contradictions coordinate the contrasted elements alongside one another, holding them in perpetual suspension, transformation, or imbalance.

When asking questions about the arts' mode of formulating propositions, their e*pistemology,* or the specificity of artistic knowledge, we are inquiring into a *form of knowledge production that operates in the mode of the "And",* or in the mode of *conjunctionality* (see Mersch 2015). The "And" here stands for the wealth of other conjunctions that can connect or separate two elements, such as "Or", "both … and", "not only … but also", "neither … nor", etc. It would thus be more appropriate to speak of a hinge between conjunction and disjunction. In contrast to the copula, they do not bring about the synthesis between subject and predicate that defines the logic of determination. Rather, they produce a literal *"composition",* the kernel of which is difference. If art thinks, then it thinks in the medium of "com-position". It puts (ponere) together (com) dissimilar elements, bringing them into a common context or "constellation" (Adorno), but in such a way that the dissimilarities of the dissimilar are preserved while their differences remain perceptible. Art's mathematics is thus not one of resolution, but of unification. While the

copula merges subject and object into one another, the 'com-position' emphasizes and retains the singularity of its parts. The "And" proceeds not through negation, but through affirmation. Its relations can unfold in space, like in an installation, or in time, like music or poetry, or they can be rhythmically accented, bringing a unique dynamic into the artwork's specific mode of temporalization.

And yet, simply putting together whatever happens to be lying around isn't enough. Certainly, every random series of things or actions forms an aesthetic arrangement, but that does not mean that every such arrangement makes sense, produces knowledge, or stakes out an artistic position. In order to produce aesthetic knowledge through an artistic arrangement, the work's conjunctionality must *transcend* the sum of the arrangement's parts, must refer to something that goes above and beyond the arrangement itself, must stage an *inversion in the 'And'* that reveals an Other or an *alterity*, or gives rise to a sudden insight. In the words of Rainer Maria Rilke's *Fifth Duino Elegy*, the work's conjunctionality forms that non-discursive nexus where the mere constellation, its "laborious nowhere" "leaps around and changes" "from the pure Too-little [...] / into that empty Too-much; / where the difficult calculation / becomes numberless and resolved" (Rilke 2011, p. 361). Wittgenstein referred to this shift as a "change of aspect" (Wittgenstein 1958, p. 193; idem 1988, p. 103, p. 111, p. 333). In contrast to discursive propositions, which always either express a judgment, construct a metaphor, or draw a logical conclusion, the juncture (and interstice) in question here marks that part of the "aesthetic proposition" where its "epistemological leap" takes place. It is the site of a non-subjective reflexivity that plays with perception and its materials, and is located exclusively in the realm of the sensory. In Picasso's piece, it is born out of the encounter between two worn out, discarded bicycle parts. The way they are connected forms a snapshot of the state of a culture whose symbol is the bull's head, while in the same moment, their conjoining serves as a testament to the potentiality of art in general. Only in such a moment does art happen, and thus, only in such a moment does the particularity of the artistic *epistēmē* and its unique form of knowledge come into being.

Catachrestic "Joints"

The various modalities of conjunction and disjunction and the ways in which materials are joined and assembled can thus be seen as the defining elements of artistic knowledge. My claim is that the capacity

of an artwork's joints and assemblages to provoke reflection and produce knowledge stands in direct correlation to the degree to which these joints and assemblages are constructed in a 'catachrestic' way. I use "catachresis" here as a metaphor for the various figurations of those "thing-languages" (Benjamin 1996, p. 73) in which Walter Benjamin saw the language of art itself. "Catachresis" is a rhetorical figure in which an expression wholly divergent from conventional use is forged in order to say something inexpressible or as yet unsaid. For this reason, catachresis is not normally included in the classic canon of rhetorical devices, even if it is sometimes included in its canon of figures. In truth, however, it is an *impossible figure* that exceeds the limits of rhetoric. Like the "joke", it is a "non-figure". The catachresis is often viewed as a transgression or an abuse of language because it goes beyond established meanings and disrupts the distinction between rhetorical registers in order to say something at the margins of the expressible. It enables the speaker to make use of 'other' modes of speaking and of the sorts of inversions manifest in riddles and contradictions, thus allowing her to constructively shape their dissonances and aporias into a third that can only be hinted at.[3] In a certain respect, catachresis proceeds without measure or limit. In the symbolic, it is that monstrosity which reveals a heteronomy that cannot be directly referred to by any one sign but which nevertheless must be saddled in some form of speech. As the semiosis of the non-semiotic, asemiosis of a semiotic process, it crystallizes into something "irresolvable", a chiasmus without cadence.

So to what extent can we even speak of "knowledge" here? My thesis is as follows: *catachrestic joints* in the form of chiasmi, contrastive constellations, or paradoxes — to name just a few — are that which goes beyond the chance 'com-position' of the aesthetic arrangement. They are that which supplements the aesthetic conjunction/disjunction, the configurations of the "aesthetic proposition" that simultaneously connect and separate. It is these catachrestic joints that produce knowledge in art. They form the true sites of artistic creativity. Against Hegel, artistic creativity is not exhausted in "the imagination which creates signs" (Hegel 1894) characteristic of that author-subject who has so often served as the gravitational center of theories of the inventiveness of the arts and their imaginative force. Rather, the mystery of the *creatio* reveals itself to be aporetic, because nothing new can be wholly new (otherwise it would

3 On catachresis and its non-figural use see Mersch, D 2002, 'Introduction', in *Was sich zeigt. Materialität, Präsenz, Ereignis*, Wilhelm Fink, Munich, esp. pp. 28.

remain incomprehensible and alien), and, conversely, the new can never be entirely reduced to something already known without losing its novelty (Mersch 2005). Thus, artistic productivity cannot be grasped as a semiotic process, a fact that becomes readily apparent when one tries to uncover the semiotic content of a complex musical composition, a poem, or a performance that transcends all attempts at documentation. Nor can it be understood as the product of the extravagant eccentricity of the artistic imagination that looks upon its creations as if some kind of "will to art" were preserved in them. Rather, it is founded in a practice of thinking that proceeds in leaps and aporias, that constantly finds new ways of bringing forth curiosities, contradictions, and discordances. These curiosities and contradictions bear witness to the radical risk of an adventure that is characterized by its lack of an explicit goal and determinate end point, an erratic undertaking that philosophy has always associated with transgression and madness. One might say that "art's *esprit*" consists in nothing other (Fliescher 2014).

Aesthetic and scientific knowledge are thus distinct from one another in their very mediality. They literally speak different "languages". The "aesthetic proposition" articulated in the form of conjunctions and disjunctions does not produce a positive, calculable output, nor does it bring forth statements whose content can be summed up as "true" or "false". "Aesthetic propositions" are more approximate to transitions, passages, or agitations that bring the *doxa* of our perceptions, convictions, and maxims and the normative structures of the political and its institutions into a state of *crisis. The aesthetic brings forth knowledge by causing such crises.* Its specific mode of knowledge takes the shape of critique and reflection. In this respect, artistic knowledge has something in common with philosophical knowledge, even if it has less to do with the principles, foundations, and archives of theoretical discourse or the transcendental conditions of possibility of experience and their implicit metaphysical premises. Artistic knowledge takes aim at the unquestioned obviousness of the "distribution" *(partage)* of the sensible (Rancière 2004), the order of the perceptible and imperceptible and the apparatuses that separate art from non-art. It makes our relations to the world of things perceptible, exposes the complexities and forces of technology, deploys the strategic cunning of well-placed inversions, makes tangible the ever growing totalization of the economic and the consequences thereof, and unveils society's power relations and latent forms of disciplining. Such examples could be listed *ad infinitum.* Art

incites such reflections through practices both demonstrative and indirect. Thus, its knowledge is a knowledge of reflection. The knowledge of art is not related to the positive knowledge of scientific research, but to the negative knowledge of disruptions, separations, or dissonances whose discordant nature "makes you think". Its indirectness and "illogical leaps" are a function of the conjunctional figuration of the aesthetic and its paradoxical or chiastic constellations that we found to be the opposite of the grammar of the discursive copula. The leap does not explain. It *demonstrates.* Aesthetic knowledge *illustrates and discloses.* It illustrates by instantiating differences. It does so by engaging in specific *practices of difference* that produce contrary or contradictory formations; experiencing them places one in a state of persistent reflexive unease. Reflexivity is meant here in the sense of an "echo", a "reflection" of that which we think we already know *(epistēmē)* or have knowledge of *(mathēsis),* a reflection that simultaneously unsettles and opens up prevailing epistemic frameworks. The knowledge of art is thus always already a critique of knowledge.

Paradigm 2: The Forced Entropy of Artistic Intoxication

The key distinguishing feature that allows us to conceive of scientific or philosophical propositions and the 'aesthetic proposition' as distinct media of showing and signifying is the respective presence or absence of the attribute of discursivity: while the former are part of a discourse that constructs concepts in order to articulate arguments, the latter is a non-discursive schema that posits contradictions and paradoxes in arguments that proceed in the mode of catachresis. In fact, contradictions and paradoxes are exemplary objects of dispute, capable of producing considerable breaks that discourse and its reliance on the "logic" of predication is compelled to 'do away with'.[4] In the realm of the aesthetic, however, they force one to think in a reflexive way that must be able to simultaneously entertain multiple lines of thought without preferring or excluding any particular solution. Artistic productivity derives its distinctive energy from its ability to wade out this undecidability, bringing it to its extreme in order to bypass the conventional ways of solving a problem. *This also means that we encounter the reflexive knowledge of the aesthetic in those moments when art's catachrestic figurations produce ruptures and fissures that give rise*

4 The idea that the principle of non-contradiction is a necessary condition of thought is present as early as Parmenides, and is explicitly formulated no later than in Aristotle's *Metaphysics.* Its unconditional validity for logical thought derives from the fact that a single contradiction is sufficient to make it possible to use the logical calculus to rationalize any random proposition.

to irresolvable differends. The irresolvable does not generate a trap or an impossibility, but rather a *vexation.* The *vexation* is the emblematic figure of aesthetic knowledge.

Cyprien Gaillard's terrifying, uncanny 2010 installation piece *The Recovery of Discovery* demonstrates this point in exemplary fashion. The piece fused the reception of the work of art with its unbridled consumption, which resulted in the work being completely and utterly destroyed in a matter of days. That which Picasso harnessed in a rich, yet simple symbol the installation brought to the point of "diabolical" entropy with breathtaking speed. An almost sublime light blue step pyramid a few meters in height filled a gigantic white cube. Bathed in the white light, it radiated an almost enigmatic tranquility. The step pyramid formed a constellation. The way it was set up with the exhibition space and the special lighting made for an object that was as symbolic as it was conjunctional. The "joke" (wit), however, was that it was made of a bunch of cases of *Efes* beer. At the opening of the exhibition and in the days that followed visitors were invited to drink the beer as they pleased. Everybody who wanted to could open up a bottle, drink up, and literally guzzle down the "work of art", whose auratic symbolism of course has strong foundations in our culture and the aesthetic tradition of sublime. On opening day hundreds of visitors climbed the sculpture, tore open the cases of beer, and emptied them without hesitation until pieces of the pyramid began to fall apart, beer bottles broke, glass shattered, and the terrible stench of stale beer began to fill the room. After a couple of days, the only thing left of the pyramid was an amorphous pile of trash that bore hardly any resemblance to the work's original shape. The extent to which the sculpture was destroyed and the speed with which its decimation took place were enough to surprise the artist himself. Reception turned into destruction, participation led to ruin. The work's inherent contradiction manifests itself at the precise moment where the reception of the work is joined with its consumption. The enjoyment of culture encompasses its own liquidation. The knowledge of art is thus made into a direct experience of the irreversibility of a process in time that is triggered by the heedless indulgence in a satisfaction afforded without cost or consequence. Its more general correlate is no doubt the shameless dialectic of desire and consumption in the age of capitalism, which lives on the negation of objects, their "nature", and their materiality. In contrast to the thermodynamic principle of entropy, the economic analysis of production and consumption, and the psychoanalytic interpretation

of desire and the death drive, the work of art both puts these things on display and simultaneously critiques them. This critique and this showing are products of the work's perceptibility. Its reflexive knowledge is carried in the wake of a trauma. Its artistic *epistēmē* reveals itself in the end as cathartic.

Can this strategy and ones like it be systematized in some way? There is no real sufficient answer to this question. Art's practices are just as "in-finite" as they are inexhaustible for no other reason than that art necessarily operates in the form of the singular. They always make space for new finds, alternative approaches, and a play of unforeseeable results. This is why we can only ever speak of art in examples, examples that are always more than what abstract reflection can say about them. This implies that art remains wholly inaccessible to a complete reconstruction in discursive propositions, and that it is nevertheless hardly inferior to discursive modes of thinking and explaining. Thus, aesthetic knowledge can *never* be the object of a universalizable definition. And yet, art and aesthetics constitute a praxis of knowing *sui generis* that seems to be, in some respects, superior to that of scientific and philosophical praxes of knowing.[5] What we might call an "aesthetic" or "artistic" epistemology can thus only be approximated or, at best, made plausible through examples. In the end, however, nothing can substitute the immediate confrontation with the arts' modes of praxis and their inherent *epistēmē.*

5 This superiority lies in art's specific mode of showing, so long as it is bound up with a practice of argumentation. On the use of images in this context, see Mersch, D 2007, 'Blick und Entzug. Zur Logik ikonischer Strukturen', in G Boehm, G Brandstetter, A von Müller (eds), *Figur und Figuration: Studien zu Wahrnehmung und Wissen*, Wilhelm Fink, München, pp. 55–69.

References

Adorno, TW 2002, *Aesthetic Theory*, G Adorno, R Tiedemann (ed.), translated by R Hullot-Kentor, Continuum, London, New York.

Benjamin, Walter 1996, 'On the Language of Man and Language as Such', translated by E Jephcott, in M Bollock, MW Jennings (eds) *Selected Writings, Vol. 1, 1913–1926*, The Belknap Press of Harvard University Press, Cambridge, London.

Fliescher, M 2014, 'Witz', in F Dombois, M Fliescher, D Mersch, J Rintz (eds) *Ästhetisches Denken. Nicht-Propositionalität, Episteme, Kunst*, Diaphanes, Zürich, pp. 240–251.

Hegel, GW F 1894, *Hegel's Philosophy of Mind*, 75 (§457), translated by W Wallace, Clarendon Press, Oxford.

Kittler, F 1990, *Gramophone, Film, Typewriter*, translated by G Winthrop-Young and M Wutz, Stanford University Press, Stanford.

Magritte, R 1979, 'Les mots et les images', in A Blavier (ed.), *Écrits complets*, Flammarion, Paris.

Mersch, D 2002, 'Introduction', in *Was sich zeigt. Materialität, Präsenz, Ereignis*, Wilhelm Fink, München.

Mersch, D 2005, 'Imagination, Figuralität und Kreativität. Zur Frage der Bedingungen kultureller Produktivität', in *Sic et Non 4*, 1 (2005), accessed 11 February 2016, http://sicetnon.org/index.php/sic/article/viewFile/139/159.

Mersch, D 2007, 'Blick und Entzug. Zur Logik ikonischer Strukturen', in G Boehm, G Brandstetter, A von Müller (eds), *Figur und Figuration: Studien zu Wahrnehmung und Wissen*, Wilhelm Fink, München, pp. 55–69.

Mersch, D 2010, 'Meta / Dia. Zwei unterschiedliche Zugänge zum Medialen', in *Zeitschrift für Medien- und Kulturforschung*, 2 (2010), pp. 185–208.

Mersch, D 2014a, 'Singuläre Paradigmata. Kunst als epistemische Praxis', in A Sakoparnig, A Wolfsteiner, J Bohm (eds), *Paradigmenwechsel. Wandel in den Künsten und Wissenschaften*, De Gruyter, Berlin, Boston, pp. 119–138.

Mersch, D 2014b, 'Kritik der Kunstphilosophie. Kleine Epistemologie künstlerischer Praxis', in V Weibel, KP Liessmann (eds), *Es gibt Kunstwerke. Wie sind sie möglich?*, Wilhelm Fink, München, pp. 55–82.

Mersch, D 2015a, *Epistemologien des Ästhetischen*, Diaphanes, Zürich, Berlin.

Mersch, D 2015b, 'Wozu Medienphilosophie? Eine programmatische Einleitung', in *Jahrbuch Medienphilosophie*, 1 (2015), pp. 13–48.

Nietzsche, F 1981, 'Letter to Peter Gast (Heinrich Köselitz), Feb. 1882', in G Colli, M Montinari (eds), *Briefwechsel: Kritische Gesamtausgabe*, 3.1, De Gruyter, Berlin.

Rancière, J 2004, *The Politics of Aesthetics: The Distribution of the Sensible*, translated by G Rockhill, Continuum, London, New York.

Rilke, R M 2011, 'Fifth Elegy: Duino Elegies', in E Snow (ed. and trans.), *The Poetry of Rilke*, Farrar, Straus and Giroux, New York, p. 361.

Schaub, M 2010, *Das Singuläre und das Exemplarische. Zur Logik und Praxis der Beispiele in Philosophie und Ästhetik*, Diaphanes, Zurich, Berlin.

Wittgenstein, L 1958, *Philosophical Investigations*, (part 2, section 11), translated by GEM Anscombe, Basil Blackwell Ltd., Oxford.

Wittgenstein, L 1988, *Wittgenstein's Lectures on Philosophical Psychology 1946/47*, PT Geach (ed.), Harvester, New York.

Wittgenstein, L 2015 (1922), *Tractatus Logico-Philosophicus*, side-by-side edition with translations by CK Ogden, D Pears, B McGuinness, accessed 11 February 2016, http://people.umass.edu/phil335-klement-2/tlp/tlp.pdf.

Yvonne Weber is a media artist, who received an artists-in-labs residency (2010) at the Institute for Snow and Avalanche Research in Davos, Switzerland. There she collected environmental data and converted this data into an art form, to make it tangible. In 2014, she worked at the University of Applied Sciences and Arts in Southern Switzerland (SUPSI), on the embodiment of technology *(Re-programmed Art)* and explored the impact of approaches linked to open source hardware and software. Her projects are based on her studies of process and product design (University of the Arts Berlin 2007) and the intersection of art, design and technology. Her aim is to develop generative systems with digital media to create abstract digital information that is both tangible and "real". Her published and exhibited works include the following: CentrePasquArt in Biel, the Swiss Institute of Rome in

Milan, the festival *80+1* and *Movement & Impact* (2009) at Ars Electronica in Linz, Austria. She aimed to shift perception on environmental data by manifesting it as living data, far away from its capture point. In an earlier work *(Moving Memories,* Media Facades Festival, Berlin 2008), she focused on memory by augmenting a "real" building with an interactive facade.

WSL Institute for Snow and Avalanche Research SLF, Davos, Switzerland

The main goals of the SLF are to extract and set in place the daily avalanche forecast, conduct snow and avalanche research and to educate avalanche specialists. We also create expertise for planners and law courts — in case of accidents as well as develop and maintain the measurement and observation networks and the corresponding data flow, from acquisition of the data to their visualization. Because our task is to provide increased avalanche safety in Switzerland by predicting avalanches and protecting people from them, understanding snow is the basis of our research. How, why and in which way do snow crystals form and behave in different conditions.

Researchers involved in the Residency: Dr. Jakob Rhyner, Dr. Matthias Bavay, researcher and IT/data visualization specialist, Michel Bovey, IT engineer and data base specialist, Nicholas Dawes, researcher and sensor specialist, Luca Egli, PhD student, Roland Meister, researcher, Julia Wessels, head of communications. Furthermore many people of the Institute contributed with smaller actions, comments etc. to Yvonne's work.

www.slf.ch

Modeling

Recomposing Snow

Approaching Snow from an Aesthetic and a Pragmatic Perspective

Recomposing Snow

Approaching Snow from an Aesthetic and a Pragmatic Perspective

My residency at the Institute for Snow and Avalanche Research (SLF) in Davos really opened up a new world for me and from the very beginning the object of my research was snow. I arrived in Davos in March and was received very warmly. It helped that I share the enthusiasm of everyone in the lab for the mountains, for snow and for skiing and I often accompanied the researchers on field trips with skis. That was sometimes very exhausting—you really have to be in good shape to be doing this kind of work.

I was constantly filled with wonder and questioning, taken outside of myself. What was it that brought me here? It was a powerful, intuitive feeling: the need to experience the re-materialization of the digital.

At first it was hard for me to be surrounded with so much scientific interest and to defend the Bastille of the fine arts in a place from which art was so manifestly absent. I believe scientists have a different mentality. They always ask very precise questions and I had to learn to formulate my questions clearly.

Comments and reflections by Dr. Jakob Rhyner and the WSL Institute for Snow and Avalanche Research SLF

Every snow crystal that forms in the clouds has a unique form. When the crystals accumulate in an irregular fashion on the ground during a snowfall, an extremely complex material is formed. It is generally powder-like at first, but within a very short time the ice crystals bond together at their points of contact, thus forming a cohesive, porous structure or icy foam.

As modernist poet Rainer Maria Rilke once suggested: Art is indebted to the senses[1] whereas science seems absolutely indebted to facts and common sense. Thus at first it was a confusing, debilitating experience that split my own perceptions—but slowly brought astounding phenomena to light. □[1]

Snow breaks with duality: It is both water and ice. It is intangible, in the sense that it is subject to constant change. With this intangibility in mind I began to build models that might be an interpretation of reality. My laboratory is the computer, so the scientists' knowledge of snow research and my aesthetic response to it were my parameters. Could the result be real physical models?

I had access to all existing data from the lab and in the manner of an archaeologist started digging for treasures in the immense data collection. I received help from the lab researchers who pointed out the interesting

1 Postmodern Poet Rene Rilke: Rilke, R 2013, *New Poems*, Copper Canyon Press, (bilingual edition, translated by Joseph Cadora).

□1 Questions about the snow—the artist marks her presence at the SLF

This structure does not, however, remain intact. Depending on the ambient conditions, such as temperature, wind and solar radiation, it continues to change. The snow structure changes very slowly when the snow is exposed to a constant ambient temperature. The snow metamorphism (transformation of the snow crystals) is driven solely by the physical principle of energy minimisation: the initially dendritic snow crystals "attempt" to obtain a more energy-efficient shape by adopting a coarser, rounder form with a smaller surface area. Such constant temperatures are found mainly in the deep layers of a polar snowpack.

The physical properties of snow, such as thermal conductivity or strength, ultimately depend on the structure of the network in which the ice crystals are arranged. This three-dimensional structure can be clearly reconstructed by

information. I wanted to find a way to bring data about snow from the zero dimension, back into the world of our concrete experience. There are two kinds of data about snow: First, there are the parameters about physical characteristics, such as light reflection, temperature, humidity and density. Secondly, there are the parameters that describe the snow's shape geometrically and morphologically. After researching ways to technically express the physical parameters of snow I focused on geometry and developed a grid system of hexagons — the underlying structure of the snow crystal — that can hold data about the environment and measurements that record the genesis of snow. These physical parameters were retrieved from the zero dimension, on the surface of the computer screen, then reconstructed back into three-dimensional space. ☐7/8

Data visualization is based on measurements (numerical quantifications) and scientists deconstruct the world in order to measure it. They abstract from the concrete experience of their object. And the moment they do so, the media they employ begin to display an even greater precision. I question if anything could be more accurate than the original and how exact is any measurement? An abstraction can, of course, be exact. "But it is certainly not true only that as we only continuously re-construct our world in the digital realm, we can also contribute to it's destruction by use of the same means and acts."[2]

These researchers construct tools, instruments and systems with which to perceive and understand the world. According to media theorist Vilém Flusser, these things are "indirect products of scientific publication", through the use of "calculation and computing" they generate two-dimensional images.[3] These technical images create a process of increasing abstraction of patterns that cannot be changed through ones imagination: a type of media

2 Krampe, D 2008, *Die Ästhetik der Abwesenheit: Die Entfernung der Körper*, Wilhelm Fink Verlag, München, p.128.
3 Fusser, V 1983, *Für eine Philosophie der Fotografie*, European Photography, Göttingen, p. 11–13.

computer tomography, a tool that is similarly used in medicine to examine bone and body tissue. In nature, different influences simultaneously affect the dynamics of the snow. These cannot always be clearly distinguished. Individual aspects are therefore examined separately in the laboratory in order to identify additional pieces of snow's mechanical and thermal jigsaw.

In the lab where Yvonne worked, we have a computer tomograph, which we use to make the three-dimensional structure of snow visible. We can put a snow sample into the machine, which examines the snow through X-rays and enables us to create a three-dimensional model of the snow structure. One of the very interesting things Yvonne had in mind was to try to use our immense depot of data of different snow structures, which we collect all over Switzerland,

genealogy, that can cause us to relinquish our 3D levels of comprehension.

Therefore, these two-dimensional images of snow crystals can carry a very existential component. I started to see this visualization technology not as an extension of the body but as a necessary set of images that can secure and order our existence. The researchers at SLF carry out their research on snow at the very periphery of human habitats, the margins of existence. The terrain is tough on the body and their bodies are exposed and placed into precarious circumstances, for example when they go out into the field to measure the snow.□2

All the instruments and apparatuses they use and carry with them seemed to open a dialogue with the world of this fragile and changing medium. The whole enterprise was aesthetically surreal and acutely precarious! Measuring in this context seems to be archaic with profoundly human aspects and technologies needed to accomplish it. Fresh snow is measured by depth and density. Sometimes the snow that had fallen overnight could not be measured at all: their system only copes with quantities of 0.5 cm or more.

The basis of all research is information, collected and ordered, ideally as a stringent sequence of data. The data is gathered in the field either manually or automatically. So far as I am able to judge, there are two kinds of researchers: those who, to put it graphically, pluck berries according to a predetermined system in the real world, subject them to a regime of measurement, and evaluate the results in order to achieve new knowledge. And those who build virtual systems that reflect some aspect of the real world, but in the quest to simulate reality, to model what cannot be measured, to project future developments, transmute into autonomous, parallel universes. In either case the system provides data in unimaginable quantities, all of them zeros and ones. This is the zero dimension; the realm of the virtual.

I developed an artistic model from collected "new-snow" data. I was inspired by the textile qualities of fresh snow covering the

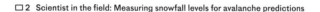

□ 2 Scientist in the field: Measuring snowfall levels for avalanche predictions

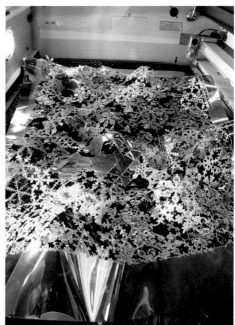

☐ 3 Drawing for the laser cutter programme ☐ 4 3-D cut result of the drawing

and use it for her own project. We use this data in different ways: We have the scientists, who write scientific articles based on them and we have the forecasters who predict avalanches using the data. So it was very interesting to see what an artist would come up with working with the same scientific information.

Her main goal was to investigate the connection between scientific abstract sensor measurement data and the appealing aesthetic form of snowflakes or snow covers from an artist's point of view. Originally, she had the goal to really look into the details of the physics and to try to get out the many different types of crystals in trying to relate them to the many different types of values the data can take. But this detailed physical connection is too difficult because often even us scientists do not know precisely how the details

landscaping entirely and smoothly and decided to make a quilt made of models of snow crystals. I learned that a snow crystal's shape depends mainly on temperature and humidity, so I used all the collected data that described the structure of snow crystals from WSL's data bank. With this information I developed a software that allowed me to survey the snowfall each day. When snow falls, this software can export different images, which are then punched out by a laser cutter.□3/4

I wanted to make tangible that depending on humidity and temperature levels, different kinds of snow stars form and slowly pile up in soft layers. By building a model based on the scientific data, all of the abstract information could be transferred back into space to be touched and seen again. In order to create a more precise software, I had lots of discussions with the researchers about all kinds of snow crystals and about which shape is formed in which conditions. My idea was, that depending on humidity and temperature levels different snow stars would be created which can be stacked on top of each other. This way, all data could be transferred back into space to be touched and seen again.

A question that has interested me since I came to the Institute is the role of God in science — or rather, the relation of belief to scientific knowledge. I grew up in a strictly Protestant, Calvinist society, where God was a given factor. Although I would certainly not call myself a believer, it took me a while to understand why such awe was an issue for me here, but then I realized that it is not the actual existence of a God that was at stake, but the boundaries of science. It became a matter of plotting frontiers of the phenomena of snow: An activity that called for a very delicate touch.

The point is that science is based on the measurable. That is what I have now grasped. There are questions for which scientists seek an answer in science and others, metaphysical ones, for which, spirituality may be responsible. The Institute itself is the incarnation of an ideal, a clearly structured place where space meets time. Here everything is ruled by logic,

of the physical parameters transfer into snow crystals. What I think she did very well, she realised this is not possible in all detail, and brought in her own opinions on how it should be. And she made another beautiful connection actually.

Yvonne pursued her goal tirelessly, with a rich variety of different techniques. These included mathematical algorithms for numerically creating complex snow flake-like structures, handmade and partly CAD[1] made structures out of paper, metal and textile, as well as by photography. Yvonne spent a lot of energy with a variety of internal and external specialists in finding ways to realize and manufacture structures designed by her or the math student's computer algorithms.

1 Computer-aided design (CAD) is the use of computer systems to aid in the creation, modification, analysis, or optimization of a design.

☐ 5 3D analysis helps to understand the formation and behavior of snow.
☐ 6 A SCANCO MEDICAL X-ray CT scanner for examining the snow microstructure.

not only the buildings and furnishings, but also all the human activities that take place in and around them. Fire department regulations forbid the presence of foreign objects in the hallways and corridors, and there is a person officially charged with the enforcement of such proscriptions. There is a woman from Human Resources who ensures with vehement authority that all under her sway keep to the paths ordained for human matter. And a woman in the cafeteria who determines at what times workers in the Institute may and may not consume foodstuffs, either liquid or solid. There are other workers who regularly enter rooms and offices to remove detritus, clean surfaces, and equip toilets with paper—all matter must be located in its rightful place.

It is interesting to observe how these structures affected me. But I found it fascinating to think about the imaginary net of time that encircles everyone in this Institute. People here speak of work-time, block-time, flexitime, and—best of all—over-time. Here nothing is left to chance. Time is professionally apportioned in a system owned by Time Inc., whose products bear the name "Timeware of Switzerland".[4] The Institute's day is infused with a tranquil rhythm: go to work/work/coffee break/work/lunch break/work/coffee break/work/go home—the pulse of time, the most elementary invention of the West. Here at the Institute I understood how controlling and constructing our concept of time actually works. Do artists think of time as raw material to be consumed: my/your/our time—overtime/work time/free time?

Two mutually conditioning aspects of science are the experiment and the laboratory. The lab is a space outside reality in which the search for knowledge—or the controlling of knowledge—is applied, tested and generated. A space dedicated to measurement, where context, reduced to a few known parameters, gives power over what happens. What cannot be measured does not exist. Another space conceived and constructed as a laboratory is

4 Accessed 1 March 2016, www.philosophie.ch/events/single.php?action=date&eventid=702.

Luca Egli, Mountain Hydrology and Mass, Group Snow Hydrology

Yvonne's work was very interesting for us. I myself am deeply interested in the issue of the tension between art and science. I was looking forward to having an artist in our lab and I approached her to discuss my research as well as her work. I was curious to learn about her perspectives on nature. Our approach is scientific and I was interested to understand her artistic perspectives on nature and snow. One of the points we discussed was the phenomenon of snow covering the landscape because it creates a very aesthetic experience, you can think of snow as a smoothing factor. But a snow cover is never even, it can vary. This can be shown by the way the landscape is evened out by snow. I, of course, look at snow very *pragmatically*. My job at the SLF is to find out how much water is stored in the mountains in the form of

the computer—a space of absolute numerical control. Here the experiment is called a model, designed to simulate reality in certain predetermined orders and systems of magnitude. To understand something I make a model. Model and experiment are based on clearly defined preconditions: the power to intervene, manipulate, control. Precision is important for such actions. The model is always a thought-through product of analysis. The result of approaching reality in this way is to concentrate on pattern, a regularity, even a law. □ 5/6

Months of wondering and questioning: what is the per se scientific, what the artistic interpretation? I started to address the most important of all questions: what connects art with science? Once, while I was on the train to Davos one morning thinking about this question, an old science project came to mind called the Stillberg project. In 1970 scientists planted 92,000 trees above the tree line.[5] This reminded me of the project by artist Joseph Beuys in Kassel Germany, in 2008, called *7,000 oaks*.[6] The connection was a real

sign—symbolic and lustily proactive! Of course I would like to plant a thousand trees, but what connects this artwork and science action is intensely human: the creation of sensual, sense-filled artifacts. □ 9/10

In the residency, I discovered that an artifact called the Snow Catcher aroused my fantasy and stimulated me to invent stories of my own origin and function. Standing by itself, this device looks like it might have belonged to an alchemist: an *objet trouvé* freed from all context!

Of particular relevance and in order to understand any new interpenetration of art and science, one must understand the generative character of matter, through which every ones own world and world vision is thus manufactured.[7] It is this generative character that connects my work at the Institute for Snow and

5 Accessed 1 March 2016, www.slf.ch/ueber/organisa-tion/oekologie/gebirgsoekosysteme/projekte/still-berg_2015/index_EN.
6 See Joseph Beuys, 7.000 (2008) Oaks artwork. en.wikipedia.org/wiki/7000_Oaks

snow. This has very practical uses for flooding or power station problems. If snow was not variable, then I would have an easier task: I could go home and measure the snow there. I could measure one meter and then calculate this for the whole area. This would give me my result. But it is not that easy. If I would measure the snow in my garden behind the house, I might only find 20 cm of snow or I might find 2 meters. To register these differences is important, in order to calculate the amount of water, compared to the amount when the snow is melted. In the arts, artists might have a better potential to create life from something dead, from dead materials, and to thereby make tangible what the essence of nature might be, in our case it was snow.

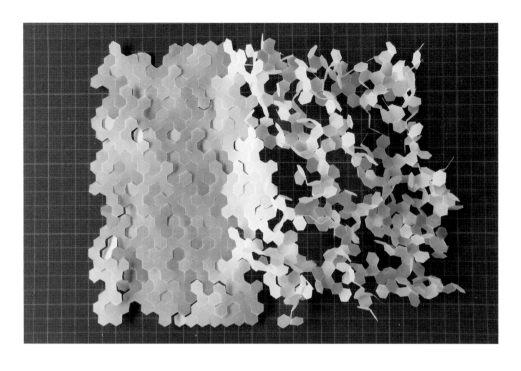

☐ 7 Pulling out the 2-D surface into a 3-D sculptural space
☐ 8 3-D sculptural result

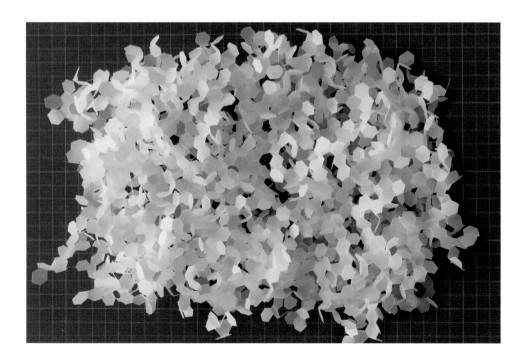

□ 9 Close-up of the art project white-out / snow crystal forms from plastic
□ 10 Breath of Snow: presentation in the foyer of the SLF Davos

Avalanche Research with that of the scientists. Because of snow's fascinating possibilities to create realities on the basis of environmental data, I became possessed with numerical modeling. I became more convinced that these elements could be used to re-connect science with art. Here, within the framework of a Swiss artists-in-labs residency in Davos, I stepped into the world of snow research. Some of my favourite questions became: How to create a scaled up sense of the fourth-dimension from snow, and how can I make a concrete experiential world for the viewer?

Dietmar Kampe once adopted a theory by Vilém Flusser, to point out that even the process of making this transition is interesting: "We must raise ourselves from subjection into active design. As subjects we are less than our own artefacts, as projects we are able to stand upright, for we are what the Greeks called 'anthropos' (Human). It is a matter of returning from regression, having now arrived literally at point zero, the zero dimension of numerical thought. It has been a long road and we must retrace that road, back to the physical world in which we can be and realize our bodies again. That road took us backwards, from space to surface, from surface to line, from line to point; or, in more existential terms, from body to two-dimensional image, from image to written line, from line to moment: the zero dimension of an impossible present."[8] Krampe also states that "The virtual is the possible that is also, always and everywhere, otherwise possible. It has departed from the physical universe, for it negates the conditions of time and space. But in doing so it rejects its own genesis."[9] But this process should not be understood as a critic of virtual representation; rather as Flusser proposed, it should be seen as an opportunity for freedom.

7 Giannetti, C 2004, 'Kunst, Wissenschaft und Technik', in: *Medien Kunst Netz*, accessed 1 March 2016, www.medienkunstnetz.de/themen/aesthetik_des_digitalen/kunst_wissenschaft_technik/3/.
8 Krampe, D 1999, *Ästhetik der Abwesenheit: Die Entfernung der Körper*, Wilhelm Finke Verlag, München, pp. 9.
9 Ibid., S. 22.

Dr. Jakob Rhyner: (former) Director of SLF

As Luca Egli clearly states we focus on Alpine snow packs, particularly in the near-surface layers of the seasonal change, because it is primarily spatial temperature differences that lead to a significantly faster structural transformation of the crystals. In this process, water molecules in the snowpack sublimate and are systematically transported through the pore space into colder regions, where they refreeze. This is an important mechanism, which can very quickly give rise to a hazardous weak layer and thus escalate the avalanche danger. In addition to the dynamics driven by temperature, the snowpack is also constantly subjected to gravitation, which, in the simplest case, leads to a deformation of the ice structure. Therefore, we developed a multi-purpose snow and land-surface model called SNOWPACK, which focuses

on a detailed description of the mass and energy exchange between the snow, the atmosphere and optionally with the vegetation cover and the soil. It also includes a detailed treatment of mass and energy fluxes within these media. Another research project at SLF is called Dynamic of Snow Cover's Spatial Distribution over Alpine Topography. It addresses the description and modelling of the dynamic of snow cover's spatial distribution over Alpine topography at scales of 1 m, 10 m, 100 m & 1 km — 100 km during accumulation and ablation. The main objective of this study was to describe and model the snow cover's dynamics depending on the underlying topography.

It was impressive to see Yvonne motivating external companies to manufacture small samples according to her ideas. Many SLF employees, having started with a kind of "let's see"-attitude, became enthusiastic seeing the richness and beauty of "snow" forms Yvonne created. Using the snow and water data captured by the automatic measuring stations in Davos, she calculated the shapes of snow crystals and transformed them into three-dimensional snowpack sculptures. In the form of computer data, snow is an intangible and invisible material for the artist — it can be neither touched nor seen. The data can be converted into a different form, however, and depicted as a sculpture. When abstracted in this way, the snow becomes visible and tangible again. Given that the hexagon is the fundamental shape of a snow crystal, Yvonne based her sculptures on a grid of hexagons. Using the weather data and the models employed by researchers, she calculated and constructed the geometric shapes of the crystals — their exact form depends on the temperature and moisture conditions — and placed them in the grid. From the grid, she produced an illustration containing a variety of snow structures. With the aid of a laser,

□ 11 Collecting snow samples above the ground level for analysis.
□ 12 The SLF Solar Powered Snow Station in Davos.

she cut snow crystals out of paper, fabric and metal, and finally created the sculptures. Yvonne Weber's works embody the transformation of digital snow into an artificial snow-pack that is at once tangible and artistic.

We used the funds from the ail residency to cover the hardware and material expenses for Yvonne as well as to employ an external mathematics student who helped with setting up advanced simulation techniques for Yvonne. Her stay at the lab was extended until December 31, 2011. After the official end of Yvonne's stay at SLF, we granted her continued access to the lab in order to give her the possibility to further pursue her work. Yvonne's exhibition *Sculptural Snow Data Modelling* was on display at the institute from February 29th until April 25th, 2012.